PA 1326

MW01040146

PAINTING BY NUMBERS

PAINTING BY NUMBERS
KOMAR AND MELAMID'S SCIENTIFIC GUIDE TO ART

Edited by

JoAnn Wypijewski

UNIVERSITY OF CALIFORNIA PRESS

Berkeley · Los Angeles · London

UNIVERSITY OF CALIFORNIA PRESS
BERKELEY AND LOS ANGELES, CALIFORNIA

UNIVERSITY OF CALIFORNIA PRESS, LTD.
LONDON, ENGLAND

FIRST PAPERBACK PRINTING 1999

LIBRARY OF CONGRESS CATALOGING-IN-PUBLICATION DATA
PAINTING BY NUMBERS : KOMAR AND MELAMID'S SCIENTIFIC GUIDE TO ART /
 EDITED BY JOANN WYPIJEWSKI.
 P. CM.
 ORIGINALLY PUBLISHED: 1ST ED. NEW YORK : FARRAR STRAUS GIROUX,
C1997.
 ISBN 0-520-21861-2 (ALK. PAPER)
 1. PAINTING—UNITED STATES—PUBLIC OPINION. 2. PUBLIC OPINION—
UNITED STATES. 3. PAINTING—PUBLIC OPINION. I. KOMAR, VITALY.
II. MELAMID, ALEKSANDR. III. WYPIJEWSKI, JOANN.
ND1140.P26 1998
750′.1—DC21 98-28904
 CIP

COPYRIGHT © 1997 BY VITALY KOMAR AND ALEXANDER MELAMID
COPYRIGHT © 1997 BY JOANN WYPIJEWSKI
POLL COPYRIGHT © KOMAR AND MELAMID / THE NATION INSTITUTE

ALL RIGHTS RESERVED
PRINTED IN CANADA
DESIGNED BY BARBARA DE WILDE

1 2 3 4 5 6 7 8 9

THE PAPER USED IN THIS PUBLICATION MEETS THE MINIMUM REQUIRE-
MENTS OF AMERICAN NATIONAL STANDARD FOR INFORMATION SCI-
ENCES—PERMANENCE OF PAPER FOR PRINTED LIBRARY MATERIALS,
ANSI Z39.48-1984. ∞

THIS BOOK COMPLEMENTS A TRAVELING EXHIBITION OF KOMAR AND MELAMID'S INTER-
PRETATION OF THE "MOST WANTED" AND "MOST UNWANTED" PAINTINGS OF FOURTEEN
COUNTRIES TITLED *THE PEOPLE'S CHOICE*, ORGANIZED AND CIRCULATED BY ICI —
INDEPENDENT CURATORS INTERNATIONAL, TOURING TO MUSEUMS FROM SEPTEMBER 1998
TO DECEMBER 2000.

ITINERARY TO DATE: AKRON ART MUSEUM, AKRON, OHIO, SEPTEMBER 5 – NOVEMBER 15,
1998; ILLINGWORTH KERR GALLERY, ALBERTA COLLEGE OF ART AND DESIGN, ALBERTA,
CANADA, JANUARY 7 – FEBRUARY 6, 1999; NEVADA MUSEUM OF ART, RENO, NEVADA, FEB-
RUARY 25 – APRIL 25, 1999; SANTA BARBARA MUSEUM OF ART, SANTA BARBARA,
CALIFORNIA, MAY 1 – JUNE 27, 1999; THE DUNLOP ART GALLERY, REGINA, CANADA, JULY
10–AUGUST 22, 1999; UNIVERSITY OF MISSOURI — KANSAS CITY ART GALLERY, SEPTEM-
BER 3 – OCTOBER 29, 1999; OLIN ARTS CENTER, BATES COLLEGE, LEWISTON, MAINE,
SEPTEMBER 8 – NOVEMBER 3, 2000.

CONTENTS

What Do People Want? . . . 2

PART 1

America's Most Unwanted . . . 6

America's Most Wanted . . . 7

Blue Landscapes, Bewitching Numbers, and the Double Life of Jokes:
An Interview with Komar and Melamid . . . 8

Master Questionnaire and Poll Results . . . 14

PART 2

Vox Pop: Notes on a Public Conversation, by JoAnn Wypijewski . . . 52

PART 3

Blue World Order?: A Post Hoc Statistical Analysis of
Art Preference Surveys from Ten Countries, by John Bunge
and Adrienne Freeman-Gallant . . . 89

The Paintings . . . 104

Can It Be the "Most Wanted Painting" Even if Nobody Wants It?
by Arthur C. Danto . . . 124

Appendix: Cross Tabulations of the American Poll . . . 141

Acknowledgments . . . 198

Art Credits . . . 201

PAINTING BY NUMBERS

WHAT DO PEOPLE WANT?

Beginning on December 10, 1993, trained professionals working from a central, monitored location in Indiana telephoned Americans to find out what they want in art—fine art, specifically painting. For eleven days the survey continued, as people throughout the forty-eight contiguous states pondered: soft curves or sharp angles? brush strokes or smooth surfaces? "realistic-looking" or "different-looking"? serious or festive? outdoor scenes or indoor? wild animals or domestic? famous people or ordinary? at work or at leisure? On and on, for an average of twenty-four minutes, until all 102 questions had been asked. When it was over, 1,001 adult Americans had been interviewed. They were a statistically representative group, having been selected from all households by a random-probability sampling procedure that included unlisted numbers and was stratified according to state. Their collective responses, the poll results, are statistically accurate within a margin of error of +/- 3.2 percent, at a 95 percent confidence level.

This first-ever comprehensive, scientific poll of American tastes in art was commissioned by the Russian émigré artists Vitaly Komar and Alexander Melamid in conjunction with The Nation Institute, a nonprofit offshoot of *The Nation* magazine. It was conducted by Marttila & Kiley, Inc., a Boston-based public-opinion research firm whose previous clients include the American Cancer Society, the American Civil Liberties Union, the American Federation of State, County and Municipal Employees, CBS-TV, the Children's Museum of Boston, the NFL Players Association, U.S. Windpower, former Governor Michael Dukakis, former Senator Gary Hart, and former Detroit Mayor Coleman Young, among others.

The results of the Komar and Melamid/Nation Institute poll were documented in January of 1994. After studying the data, Komar and Melamid commenced to produce two paintings, *America's Most Wanted* and *America's Most Unwanted.* These were unveiled that spring in an exhibition, "The People's Choice," at the Alternative Museum in New York City's SoHo district. Extensive public discussion of the project began in the March 14, 1994, issue of *The Nation* and was continued in town meetings in various cities at home and abroad over the next three years. During this same period, Komar and Melamid, aided by international polling firms using variations on the American questionnaire, penetrated Europe, Asia, and Africa with their "People's Choice" project. Additional sample populations continue to be identified, so the polling goes on.

To date, the artists have surveyed the opinions of close to two billion people—almost one-third of the world's population—and have translated the numbers into paint on canvas.

What follows is a story of that project.

p a r

If you had unlimited resources and could commission your favorite artist to paint anything you wanted, what would it be? *Me with my girlfriend—when I was*

t 1

sixteen (Anonymous). My daughters at three or four years old—they are seven and twelve now—so I could remember how innocent they were at that age (Brena Potsko, Endwell, N.Y., sales). An

AMERICA'S MOST UNWANTED

Paperback-book-size (4%)

Paintings that are "different-looking" (30%) and feature imaginary objects (36%)

Thick, textured surfaces (40%)

Gold, orange, peach, teal (1%)

Colors kept separate (18%)

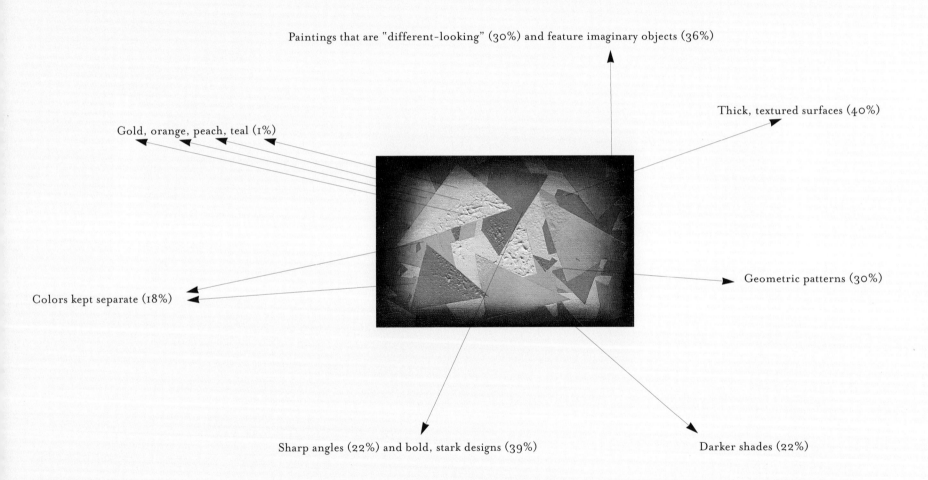

Geometric patterns (30%)

Sharp angles (22%) and bold, stark designs (39%)

Darker shades (22%)

Abstract Painting with lots of purple and green. Something very geometric and industrial-looking. A comment on the state of African society in a Eurocentric world (Michelle Falzone, Ithaca,

AMERICA'S MOST WANTED

Dishwasher-size (67%)

Paintings that are "realistic- looking" (60%)

Blue (44%)

Outdoor scenes (88%) featuring lakes, rivers, oceans, and seas (49%)

Brush strokes (53%)

More vibrant shades (36%)

Colors blended (68%)

Wild animals (51%) in their natural setting (89%)

Soft curves (66%) and playful, whimsical designs (49%)

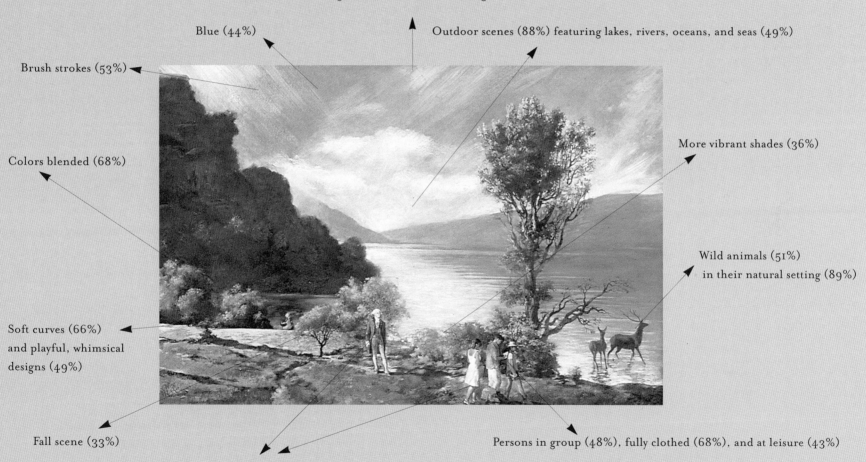

Fall scene (33%)

Persons in group (48%), fully clothed (68%), and at leisure (43%)

Ordinary people or famous—makes no difference (50%)

student). Landscape, or seascape, with ships. Stormy skies darkening (dusk or storm darkness) with sun (indirectly) illuminating portions of the picture. Grays, greens, browns, blues, and blacks

BLUE LANDSCAPES, BEWITCHING NUMBERS, AND THE DOUBLE LIFE OF JOKES:

AN INTERVIEW WITH KOMAR AND MELAMID

Q: How did the idea for this poll start?

ALEXANDER MELAMID: It was a continuation of our work for the last number of years, which was to get in touch with the people of the United States of America: somehow to penetrate their brains, to understand their wishes—to be a real part of this society, of which we're partially part, partially not.

VITALY KOMAR: But, you know, I would say it goes back further. I remember our plan to create paintings for different segments of society in Moscow back in 1977. Then, our idea was not associated with poll, and emigration prevented us from completing it, but we were trying to show that Soviet society, in spite of government propaganda, had many contradictions; that there were different circles, even classes; that, in spite of revolution, everyone really was not more or less same socially. Here in America, before we got results of poll we thought we would have to paint different pictures by income, by race. Instead, we made surprising discovery: in society famous for freedom of expression, freedom of individual, our poll revealed sameness of majority. Having destroyed communism's utopian illusion, we collided with democracy's virtual reality.

This interview was begun in February of 1994 in The Nation *offices by Peter Meyer, Victor Navasky, Katrina vanden Heuvel, and JoAnn Wypijewski. It was later expanded by Wypijewski.*

8

(Joan Hartly, Norman, Okla., archaeologist). Two guys fly-fishing in a central New York trout stream. A bear on its haunches on land with deer, beavers, fall colors, setting sun, and a big brown

Q: And then the Russian poll, like every other poll you subsequently commissioned, yielded results along the American model—an ideal landscape—so it seems you're also colliding with capitalism's looming crisis, the end of frontiers left to conquer.

VK: Here, though, is another reason behind our polls: the search for new co-authors. Everyone works collaboratively. That is why society exists. Even artist who imagines himself to be like God, a solitary creator, is working in collaboration with his teachers, his predecessors, craftsmen who created his canvas and paints, and so on—just as God created world with help of angels. Old romantic view of artist is a travesty of monotheism. Van Gogh suffered as if he were crucified; very few—maybe twelve people only—believed in him. But after he died he achieved immortality. It is no accident, I believe, that early in life he was a preacher.

And now, I would say, conscious co-authorship is only fundamentally new direction in art since discovery of the abstract. Our interpretation of polls is our collaboration with various peoples of the world. It is collaboration with new dictator—Majority. When we were working on a proposal to redesign Lenin's Mausoleum we collaborated with another dictator—Stalin, who supervised original architect. Recently we collaborated with an elephant, who, by the way, is abstract painter; and before that we worked with a realist dog. If modernism taps traditions of early civilization, why not go a step further and explore the prehuman (according to Darwin) animal past? We can enter co-authorship with cultures of elephants, bacteria, plants, with gravitational fields of planets and stars . . .

Q: Not to be too mundane, but getting back for a moment to the actual American roots of the project——

AM: For a couple of years we were working in Bayonne, New Jersey; visiting Bayonne, New Jersey, homes and talking to Bayonne, New Jersey, people. And I realized there that people really want art, but we, the elite artists, we don't serve them. You know, there was only one store in Bayonne where people could buy pictures. It was owned by Arabs, and they sold these Korean landscapes—really inferior, terrible art. I've been to many stores like this—there are millions of them in New York but only one in Bayonne, unfortunately—and it's interesting that most stores that sell art for people are owned by foreigners. There must be something to that, which is why we're working as foreigners, too.

And people buy these terrible pictures, but do they like them, or is it just all they have? Maybe if we ask them, they will give the answer. Because we worked in this studio in Bayonne which was adjacent to a carpet warehouse. And people coming in there—you know, truck drivers, deliverymen, people buying rugs—could see us working. And they would say, Listen, we want to buy this. One guy—a young guy—said, "I will pay you $1,000 for this picture." One thousand dollars! And it was not a kitschy painting. It was a normal, elite painting. So there was a scent of something, but we couldn't grasp it. There were not enough people.

trout on the line of a guy who's wearing a blue jacket under a brown vest and a gray cap (Matt Snider, Ithaca, student). Something Vermeer-like by whoever could best accomplish that. The

Q: So you thought you needed science and scientific consumer research?

AM: We just were thinking about how this society works, and how the rulers in this society get in touch with the people, with real American people. How producers get in touch with consumers. In real life they take polls. Only recently I discovered that the President has his own pollsters, who work on polls every minute. It's a constant poll of the people. I understand the President very well, because he wants to know as much as me, I suppose, even more. But how to ask? Where are these people? It's a very clumsy tool, this poll, but there's no other tool.

VK: I like to remind you of ancient Greece here. Ancient Greek sculptors created the gods' images by average of most beautiful citizens. They measured most beautiful noses, foreheads, mouths, most beautiful bodies, and after that they did simple calculation of average, which they considered image of god. From average they created ideal.

Q: A kind of ancient poll.

VK: Yes, and here we can talk about election system as well, because ancient Greek democracies are our first experience of democracy.

AM: But Greek democracy was founded on totally different basis from American, because idea there was that all the best people would rule themselves, as a nation, and here it's kind of a reverse——

VK: Of course, it was mostly slavery, but democracy if you were considered Citizen. I remember when I was a child I read some book that said Greeks even voted for sculptors. At end of year the most famous sculptors present their works to the people, who have black and white stones. And all citizens put a white stone if they like the work and a black stone if they don't like, until there are small piles of stones before each work. At the end they count and whoever got the most white, the city supports his life for the next year. The city provides him with food, with a place to work, with assistants, etc. It was very democratic, also very socialistic.

idealized figures and beautifully painted textures tell their own story (J. Moore, Washington, D.C., homemaker). A very large tree bearing the severed appendages of all the wars past fought.

AM: But this idea of democracy, of American democracy, is very important, because it was totally different from the Greeks'. It was a really brave and unthinkable break with history, this idea that simple people, innocent people, have some higher truth, are closer to God, are purer than others, and so they should decide. Communism was based on the same idea: the proletarians have nothing, and yet they have something really special—some genetic blessing, God's blessing, you know, to rule us, in a way to be the solution for all our problems, because we give up, we do not know. It may seem ridiculous but this is the basis, at least in theory, of American society, so we follow this with the poll.

VK: You see, Alex and I were both born in Jewish families, and our grandparents (as opposed to our parents) were not complete atheists and did not join the Communist Party. So regardless of our wishes, we originally belonged to minority. We only acquired illusion of belonging to majority as schoolchildren, when we, like everyone else, became Young Pioneers—Stalinist Boy Scouts. This nostalgia, this early desire of ours to break out of mental ghetto, is perhaps the more mysterious reason behind these polls, behind our desire to truly understand the will of the masses.

Q: But in political life it's romantic to believe that the masses rule, and isn't it the same with your poll? After all, someone asks the questions, offers the choices and the range of possible interpretations; and who gets to do that is all a matter of power.

AM: Sure, I understand, but the problem is that we, the so-called superior people, we ask the questions because we're scared; we're afraid of these people, afraid that we won't understand them. This whole system, American system, runs on fear. These people, the masses, are quite powerful, you know; they can be quite powerful, so there's always this threat that if we won't understand them something might happen. Look at Oklahoma City. The point is, whether it's the President or the artist, there's a border between us and the people. There are some channels for communication between the classes but very few, because socially people are almost totally separate. The rulers base their opinion of the people on statistics, and for the simple people there are society columns, *Vanity Fair*. In fact, even the lower classes get most of their information from statistics, so polls are maybe one of the only means of communication between upper classes and lower classes. And what the poll tells, supposedly, is majority opinion. It might be manipulated or there might be perversions, of course, but still this idea of what is majority opinion is very powerful in American culture. This populist idea is really important. And in art, we—Vitaly and I—were brought up with the idea that art belongs to the people, and believe me or not, I still believe in this. I truly believe that the people's art is better than aristocratic art, whatever it is.

Behind it the biggest cow ever, filling the horizon. But in such a way that the udders of the cow are showering the big appendage tree with milk (Bik, Ithaca, lawyer). My mother, a fine old

Q: So what do you make of the fact that the people have spoken for the blue landscape?

VK: I believe it reflects people's nostalgia about freedom. It's a very simple metaphor, and very deep at the same time: closed space and open space. The concentration of idea of closed space, I believe, it's prison. And concentration of idea of open space is a landscape—air, no barriers, in other words, vacation, freedom.

You know, we are not free. We do not choose to be born. We do not choose to inhabit this world, this space, this giant room, or, in language of contemporary art, this installation. But if, initially, life was not act of free will, then freedom does not exist in principle, much less in day-to-day life. In search of freedom, of blue landscape, we can at any time open the big door that leads out of this room, out of this time and space, out of this world and this life. But most of us are not capable of suicide; we are afraid to find out maybe behind this door there is another installation, another, different-colored landscape. So most of us do not choose to leave the room. Most of us wait for door to open by itself—another, maybe final, violation of our will. Meanwhile, we look for smaller freedoms, open smaller doors, which are so numerous in this installation they resemble some labyrinth of modern offices.

You know, life reminds me of office. Employees scribble abstract patterns in legal pads during meetings and leave office during lunch. Within greater enslavement we discover small freedom—so we think. But if we examine closer, this freedom turns out to be a new slavery, with its own smaller freedom/slavery, and so on: our choice of lunch, for example, its price, taste, nutrients, etc.

A concentric structure like Russian matryoshka doll emerges, and we can track this structure down to its smallest particles, to indivisible moments of orgasm and pain, pleasure and suffering. Next installation of "People's Choice" will be like labyrinth of computerized offices. Only question is how to design the "big door" without going to extremes of Freudian interpretation.

Newfoundlander born ninety years ago (Glorie Miller, Oxford, N.Y., photographer). A portrait of the artist—nude!—with a geometric background (Lyn Silverman, Pittsburgh, artist). Joshua

Q: All that in a blue landscape.

AM: It might seem like something funny, but, you know, I'm thinking that this blue landscape is more serious than we first believed. Talking to people in the focus groups before we did the poll and at town hall meetings around the country after, I think people want to talk about art, for better or for worse, and they talk for hours and hours. It's hard to stop them; nobody ever asks them about art. But almost everyone you talk to directly—and we've already talked to hundreds of people—they have this blue landscape in their head. It sits there, and it's not a joke. They can see it, down to smallest detail. So I'm wondering, maybe the blue landscape is genetically imprinted in us, that it's the paradise within, that we came from the blue landscape and we want it. Maybe paradise is not something which is awaiting us; it is already inside of us, and the point is how to figure it out, how to discover it, how to get it out.

We now completed polls in many countries—China, Kenya, Iceland, and so on—and the results are strikingly similar. Can you believe it? Kenya and Iceland—what can be more different in the whole fucking world?—and they both want blue landscapes. So we think that we hit on something here. A dream of modernism, you know, is to find a universal art. People believed that the square was what could unite people, that it is really, truly universal. But they were wrong. The blue landscape is what is really universal, maybe to all humankind.

Reynolds [painting] my children; Titian, portrait of my wife; Eric Fischl, me at sixteen; Rembrandt, me at sixty-five (Derrick Lort). A portrait of my wife with our grandchildren—in their hockey

Q: And how do you respond to people who say that's all very well but the broad public just doesn't know enough about art to be an adequate judge?

AM: I think it's the wrong premise—which is still in fine arts and the visual arts, and not in almost any other art form—that we need some special historical knowledge in order to appreciate art and make art. Just look at music, all this great American music. People don't know notation and still they create fantastic music. But we ask the people who create art to know a lot about art. I don't think it's necessary; everyone knows enough about art, because we're surrounded. The decoration over here on the wall, all the architecture, reproductions in magazines—it's all over. Everyone knows enough about art now to use their own judgment. Even if we want to know more, it's the wrong premise. In the poll we have this question, "How often do you go to museums?" Maybe it's interesting, but as a measurement—if you go to museums or don't go to museums—it has nothing to do with our work here. A museum is an institution. You can believe in God without visiting churches. And that's very important: you don't know about religion, you don't know about how many times you go to church, but still you believe. In the poll we use the word "art" as little as possible, because this word rings the wrong bell. It scares people who think they don't know.

What we need is to create a real pop art, a real art of the people, like the music. Because classical music still lingers on—John Cage, something like this. But the country lives on the pop star. And the hip-hop, rock, that's the greatest thing in the world. We need to make art like these people. We have to learn how they work. That's what is an artist. I want to work like those kids from the ghetto. They know a lot about music—it's not that they don't know. But there is no special knowledge involved. It's true that everyone has a talent. You can pick up a kid from the ghetto—if he is talented, whatever, he can express himself, be a famous, great musician. So why not in art?

National Arts Survey
December 1993
MK 93151

MASTER QUESTIONNAIRE

INTRODUCTION:

Hello, may I speak to the (**YOUNGEST MAN/YOUNGEST WOMAN AS NECESSARY TO MEET GENDER QUOTA**) over the age of eighteen who is at home.

Hello, Mr./Ms. _____, my name is _____ and I am calling from CCI, a national polling firm. We are not trying to sell anything, but we are conducting a survey on some interesting issues and I'd like very much to get your opinions.

01. First, some people are pretty careful about their spending decisions; others aren't. How about you? How carefully do you consider most of your spending decisions— extremely carefully, very carefully, only somewhat carefully, or not very carefully?

Extremely carefully	30%
Very carefully	49
Only somewhat carefully	18
Not very carefully	3
(Not Sure)	*

02. When you have a choice between two products of equal quality, how often are you willing to pay a little extra for a design or style you prefer—all the time, most of the time, only sometimes, or hardly ever?

All the time	9%
Most of the time	30
Only sometimes	38
Hardly ever	21
(Not Sure)	1

(*=less than 1% response)

Next, I am going to read the names of some items which people buy from time to time. Assuming you were shopping for each of these products, please tell me if its appearance or design would be very important, somewhat important, not very important, or not at all important in your decision to buy that product.

		Very	S/W	Not very	Not at all	(Not Sure)
03.	A new car	59%	28	8	5	1
04.	A pair of underwear	19%	28	31	21	*
05.	A television set	33%	40	19	8	1
06.	A winter coat	51%	38	6	4	1

gear. My wife to be done by Modigliani, grandchildren by Ben Shahn (Ross Aldrich, Ithaca, athletic equipment manager). The world as it is! Simple and complex. Fluid and rigid. Conservative and

Next, I will repeat the list, but this time I want you to tell me how important a factor color would be in your decision to buy that product—very important, somewhat important, not very important, or not at all important?

		Very	S/W	Not very	Not at all	(Not Sure)
07.	A new car	49%	32	13	6	*
08.	A pair of underwear	16%	19	35	29	*
09.	A television set	21%	31	29	18	*
10.	A winter coat	56%	32	7	5	*

11. Next, some people feel that color can affect people's moods. Would you say that you strongly agree, somewhat agree, somewhat disagree, or strongly disagree with this idea?

Strongly agree	40%
Somewhat agree	42
Somewhat disagree	11
Strongly disagree	6
(Not Sure)	1

12. And, speaking of colors, if you had to name one color as your favorite color—the color you would like to see stand out in a painting you would consider buying for your home, for example—which color would it be? **(DO NOT READ LIST.)**

Beige/Tan	2%
Black	4
Blue	44
Brown	3
Fuchsia	2
Gold	1
Gray	2
Green	12
Maroon/Burgundy	2
Mauve	2
Orange	1
Peach/Coral	1
Pink/Rose	3
Purple/Lavender/Violet	4
Red	11
Teal/Turquoise	1
White	2
Yellow	2
Other	1
(Not Sure)	2

Q: Do you think it has something to do with the concept of the artist as leader?

AM: That's a concept of the twentieth-century model, and very, very close to us, of course. According to one Russian philosopher—a very nice man, his name is Boris Groys—he said that the only artist of Russia was Stalin, the real artist, the greatest artist on earth, supposedly. Because he could shape the nation. He could change the thing physically, not only in a picture, not only in an illusion, but in the goddamn reality. So he was the master. He was the artist. Because "artist" is understood as Artist, especially in the nineteenth century and in the first half of this century. Picasso always dreamed about this idea; he said we need a totalitarian state in art. He said we need the artist as a ruler—he meant leader, because this was the time of Stalin and Hitler—and he wanted to create this power within *himself*, of course.

Now there is a different perception of what a leader is. The United States is a leader in leaders, because you've created a new type of leader, who doesn't give orders supposedly, but asks people. So that's the new idea of leadership: new leaders conduct polls. Picasso mimicked Stalin, so we try to mimic Clinton. It's a less powerful position, for sure.

liberal. A variety of ideals, customs, and beliefs all thrown together in a huge spherical mass of mud, fire, polluted air, and toxic seas. All this juxtaposed to an ideal world of peace that cannot be

Q: Do you think there's some sense in which even the leaders are losing their grip?

AM: Yeah, we're in kind of a dead end, the whole society. There's a crisis of ideas in art, which is felt by many, many people. Not only in art; in social thinking, in politics. That's one of the other things about this poll, one of the attempts to get out of this, by some maybe funny means—humor helps—because we really don't know where to go, and what our next step has to be.

Artists now—I cannot speak for all, but I have talked to many artists who feel this way—we have lost even our belief that we are the minority which *knows*. We believed ten years ago, twenty years ago, that we knew the secret. Now we have lost this belief. We are a minority with no power and no belief, no faith. I feel myself, as an artist and as a citizen, just totally obsolete. I don't know why I am here, what I am doing. What is so good about me doing this, or any other artist? Looking down the SoHo galleries, or going to the museums, you see contemporary things, and you say, Why? Okay, it can be done this way or that way, or this way, or in splashes or smoothly, but why? What the hell is it about? That's why we wanted to ask people. For us—from our point of view—it's a sincere thing to understand something, to change the course. Because the way we live we cannot live anymore. I have never seen artists so desperate as they are now, in this society.

(ALL EXCEPT NOT SURE)
13. And what color would you say is your second-favorite color? **(DO NOT READ LIST.)**

Beige/Tan	3%
Black	7
Blue	19
Brown	4
Fuchsia	*
Gold	1
Gray	3
Green	17
Maroon/Burgundy	1
Mauve	2
Orange	1
Peach/Coral	1
Pink/Rose	6
Purple/Lavender/Violet	5
Red	16
Teal/Turquoise	1
White	4
Yellow	3
Other	*
(Not Sure)	2

(ALL)
Now I would like to ask about some leisure or recreational activities in which some people participate. As I read each activity, can you tell me if it is something you do frequently, occasionally, seldom, or not at all.

		Frequ	Occas	Seldm	Not at all	(Not Sure)
14.	Attend an amateur or professional sports event	17%	24	28	31	*
15.	Go camping, hiking, or canoeing	17%	22	22	40	-
16.	Grow vegetables, flowers, or shrubs in the garden	34%	20	11	35	-
17.	Go out to see a movie in a theater	26%	35	21	18	*
18.	Paint, draw, or do graphic arts like etching	12%	13	16	59	-
19.	Take photographs as a hobby	23%	26	18	33	-
20.	Go out dancing	13%	22	23	41	-
21.	Play a musical instrument like the piano, guitar, or violin	11%	9	9	70	*
22.	Read a book	59%	24	10	6	-

achieved globally or logically, but individually. A piece that would contradict itself but reflect reality as it is. It would have to be literal yet symbolic so everyone could understand what it is and, at the

23. Listen to music on records, CDs, or audio tapes 77% 16 5 3 -

24. Participate in any sports activity 27% 22 15 35 -

25. Go to a live musical performance, not including school performances 13% 32 28 26 *

26. Collect things, like stamps or coins 18% 12 12 57 *

27. Next, would you say that the way you dress is very important to you, somewhat important to you, not very important to you, or not at all important to you?

Very important 51%
Somewhat important 40
Not very important 6
Not at all important 2
(Not Sure) -

28. Would you say that the way you decorate your home is very important to you, somewhat important to you, not very important to you, or not at all important to you?

Very important 56%
Somewhat important 37
Not very important 6
Not at all important 1
(Not Sure) -

29. In your own home, do you have any photographs of family and friends displayed?

Yes 94%
No 6
(Not Sure) *

30. Now I'd like to ask you if you have any works of art displayed in your home. By works of art, I mean anything that you might put in your home which you consider to be art.

Yes 77%
No 23

(IF YES, ASK Q31–39. IF NO, SKIP TO Q40.)
Now I'm going to read the names of some fairly common types of art that people have in their homes. For each type I mention, please tell me if you have at least one item of that kind of art in your home.

	Yes	No	(Not Sure)
31. Photographs, other than family snapshots	78%	22	*
32. Sculptures or small statues	73%	27	*

VK: Also, art world is not democratic society but totalitarian one. It does not have checks and balances. Individuals who create its laws and criteria are also its main decision-makers. This conflation of executive, legislative, and judiciary is hallmark of totalitarian society. In America any clique can become the totalitarian segment. This happens in Westerns all the time, when corrupt mayor or sheriff becomes dictator of small town. Inevitably, an outsider, with help from courageous locals, restores democracy to the town. Today, new doors are opening for art world's outsiders; individuals with background in computer technology, with understanding of Internet, are entering art world. Outsiders are the movers of history, just as in Westerns.

I remember there was great dissident philosopher in nineteenth century called Chaadayev. Long before Russian Revolution he said maybe the mission of Russia is to give the lesson to humanity. I think Russia made kind of a grotesque—always grotesque—of everything. They made a grotesque of Greek Orthodox Church, because Peter the Great transformed it into pure bureaucratic organization. They made a grotesque of constitutional monarchy before 1917. They made a grotesque of Marxism, and now they are making a grotesque of capitalism and democracy. They always make a grotesque, and Chaadayev said that maybe it's mission of a place we call Russia to give the lessons to humanity. Maybe it's our mission—Alex and mine—to give world some lesson, not in form of final answer but in form of fun-house mirror that reflects a grotesquely distorted answer. The answer's distortion provokes creation of new questions. I like this notion: art as entertainment that poses questions.

same time, give their own individual interpretations. Let yourselves go. Don't be specific, be global! Use all resources you can to paint this gigantic painting (Carlos Rodriguez, Ithaca, art student).

Q: So, paradoxically, in the grotesque we see reality without filters. But then, to follow your analogy, the poll is a grotesque of—what?

VK: It is ideal grotesque of ideal art. Consciously or unconsciously, we are retreading the path of Russia. Under Brezhnev, we founded Sots Art, a nostalgic grotesque of socialist realism; now, along with Yeltsin, we are creating grotesque of democracy and, in this case, its central tool, statistics. The portrait of Uncle Joe is replaced with portrait of Uncle Majority. It is also grotesque of our old love, conceptual pop art—a self-parody, like our self-portrait as Young Pioneers with Stalin. Sometimes we end up ahead. In early seventies we made a polyptych—*Biography of Our Contemporary*—that combined many different styles of painting. In one sense it is our ideological landscape, because it represents landscape of our mind in many different aspects. But it is also a grotesque of pluralism, predating David Salle as well as current Russian notion of political pluralism, which is coexistence of many mafias within a single system. This notion is unexpected alternative to one-party system.

33.	Original paintings or drawings or prints	72%	27	1
34.	Prints or posters	77%	22	*
35.	Reproductions of original paintings	45%	54	1

36. When you select pictures, photographs, or other pieces of art for your home, do you find you lean <u>more toward modern</u> or <u>more toward traditional</u> styles?

Modern	25%
Traditional	64
(Mixed)	8
(Didn't select)	1
(Not Sure)	1

37. If you had to choose from the following list, <u>which type of art would you say you prefer</u>? **(READ LIST. DO NOT ROTATE.)**

Asian	6%
American	49
African	8
European	30
(Other)	2
(Not Sure)	5

38. Which one of these statements would you say <u>applies to you more</u>? **(ROTATE.)**

When choosing pictures, photographs, or other art for my home, I usually try to select pieces that fit into the general decor of my home.	34%
When choosing pictures, photographs, or other art for my home, I focus on whether or not I like the piece.	60
(Not Sure)	6

39. And would you say you prefer <u>older</u> objects or <u>newer</u> objects to collect or decorate your home?

Older objects	49%
Newer objects	31
(Mixed)	19
(Not Sure)	1

A wall-size mural depicting a small forest surrounded by a big city. I would commission Zotton Zabo to render the forest in watercolor. The surrounding city could be painted by some new, more

(ALL)
40. **Now I would like to ask you about the kind of paintings you like, even if you don't own paintings.** Many people find that a lot of the paintings they like have similar features or subjects. Take animals, for example. On the whole, would you say that you prefer seeing paintings of <u>wild animals</u>, like lions, giraffes, or deer, or that you prefer seeing paintings of <u>domestic animals</u>, like dogs, cats, or other pets?

Wild animals	51%
Domestic animals	27
Both	7
Neither	14
(Not Sure)	1

41. And would you say that you like it best when the painting shows them in their <u>natural setting</u>, like out in the field or by a river, or when it looks like they were <u>in a studio posing for a portrait</u>?

Natural setting	89%
Portrait	4
Both	2
(Not Sure)	5

42. Next, I am going to ask you the same question, but I won't limit it to animals. In general, would you rather see paintings of <u>outdoor scenes</u> or would you rather see paintings of <u>indoor scenes</u>?

Outdoor scenes	88%
Indoor scenes	5
Both	5
Neither	1
(Not Sure)	1

IF OUTDOOR SCENES OR BOTH
43. Would you tell me which one, if any, of the following types of <u>outdoor scenes</u> appeals to you most? **(READ LIST. DO NOT ROTATE.)**

Paintings of forests	19%
Paintings of lakes, rivers, oceans, and seas	49
Paintings of fields and rural scenes	18
Paintings of the city	3
Paintings of houses, buildings, or other structures	5
None	*
(All equal/Depends)	5
(Not Sure)	1

44. And which <u>season</u> would you most like to see depicted in these paintings? **(READ LIST.)**

Winter	15%
Spring	26
Summer	16
Fall	33
(All equal/Depends)	9
(Not Sure)	1

Q: Getting back to what you were saying, Alex, about this crisis in art, in society— what do you think is the reason? Do you think it has anything to do with world historical developments?

AM: Well, I do, but maybe it is just my age. I am past fifty, and most people I know, most established artists, are of the same generation—can be younger, can be older, from maybe thirty-five to seventies, because generations overlap—but it's the same historical generation. We were born with Stalin, with communism, and now communism is finished, so it's a time of big change. There is not this same feeling among people my son's age—he is twenty-one—because they are starting over. Like every historical generation, they are starting from scratch, and their history will be the whole of history. This is modernism. Everything that came previous you forget; it doesn't exist. My son doesn't care about Marxism or Stalin at all. It's old history. But that's the whole world for people of my age. It doesn't matter so much what you as an individual believed or what you thought, whether you were in Russia or United States, still it's your history and now it's come to an end. And since we're in majority, then it's the crisis of the whole structure. For most people who rule the cultural world it seems like the whole world is collapsing, and it is in a way, because if the power structure is collapsing then the whole world is collapsing.

VK: I believe that we, because we were born in totalitarian country which was based on nineteenth-century idea of Marxism, that we have very special point of view on these things. Because in nineteenth century people believed that history of humanity was part of their biography. For example, Karl

impressionistic watercolor artist, possibly mixed media. The mood on the edges of the city would be forboding and gloomy. The people picnicking in the forest would not seem to notice this (Davis A.

Marx and Engels called ancient Greek sculptures the childhood of humanity. It's very typical. Now a lot of things changed because Marxism failed and people no longer care about history. They believe only in personal happiness. But I believe that experiments with genetic codes will sooner or later make people immortal, because this mistake in genetic code, which leads to death, could be eliminated. And that means nineteenth-century point of view, Marxist point of view—Marxism representing point of view of future—will again be relevant, because if people will be immortal they will of course consider all history of humanity as part of their biography. Now, I believe, it's only a transit period to the really great scientific discoveries.

AM: I wouldn't like this immortality. People talk about heaven, about eternal life. Who would want this? When we die we finally get to rest; can you imagine having to live again, for all time? No. Or this idea of a land of milk and honey—what is so good about this? Two terrible things, milk and honey, and this is paradise? No.

VK: Personally, I like honey. Maybe it's manifestation of my decadent egoism. Let's conduct a poll about honey and immortality and join the majority.

(IF INDOOR SCENES OR BOTH IN QUESTION 42)
45. Please tell me which one, if any, of the following types of <u>indoor scenes</u> appeals to you most. **(READ LIST. DO NOT ROTATE.)**

Still life paintings of fruit	7%
Still life paintings of flowers	21
Still life paintings of household objects	6
Domestic scenes with people	37
Domestic scenes with animals	10
None	5
(All equal/Depends)	6
(Not Sure)	7

(ALL)
46. Now, some people prefer paintings that deal with religious people or themes. Others don't. How about you—do you find that you tend to prefer paintings that are <u>related to religion</u> or those that are <u>not related to religion</u>?

Prefer paintings that are related to religion	20%
Prefer paintings that are not related to religion	63
(Both/Depends)	15
(Not Sure)	2

47. Next, which one of the following statements is <u>closest to your view</u>? **(ROTATE.)**

Paintings should ideally serve some higher goal, such as challenging their viewers to think about art or life in a different way than they do normally.	19%
Paintings don't necessarily have to teach us any lessons, but can just be something a person likes to look at.	75
(Both/Depends)	4
(Not Sure)	1

48. Now I'd like to ask you a series of very general questions. First, which of the following statements is <u>closer to your own opinion</u>? **(ROTATE.)**

I prefer paintings that are realistic-looking: the more they resemble a photograph, the better.	60%
I prefer paintings that are different-looking: if they're very realistic, I might as well be looking at a photograph.	30
(Both/Depends)	6
(Not Sure)	3

Clair, Ithaca, woodworker). A view of Cayuga Lake in autumn colors with a few white sailboats on the water, blue skies with puffy clouds and foliage in the foreground (Raymond T. Fox, Ithaca,

(IF PREFER DIFFERENT-LOOKING PAINTINGS, ASK Q49–52. ALL OTHERS, SKIP TO Q52.)

49. Do you prefer paintings that <u>exaggerate the dimensions or reality of objects</u> we already know, or ones that <u>feature imaginary objects</u> which have no connection to everyday life?

Exaggerations of objects we know	50%
Imaginary objects	36
(Depends)	6
(Not Sure)	8

50. How about design? Do you prefer seeing <u>bold, stark designs</u> or more <u>playful, whimsical designs</u>?

Bold, stark designs	39%
Playful, whimsical designs	49
(Depends)	7
(Not Sure)	5

51. And do you tend to favor paintings with <u>sharp angles</u> or ones with <u>soft curves</u>?

Sharp angles	22%
Soft curves	66
(Depends)	9
(Not Sure)	3

52. Which patterns do you like better: <u>geometric patterns</u> or more <u>random, uneven patterns</u>?

Geometric patterns	30%
More random patterns	62
(Depends)	5
(Not Sure)	4

(ALL)

53. Do you like to see <u>expressive brush strokes</u> on the canvas or do you prefer that the <u>surface of the canvas be smooth</u>, more like a photograph?

Prefer seeing brush strokes	53%
Prefer that canvas looks smooth	35
(Depends)	10
(Not Sure)	2

54. And how about the paint itself? Do you prefer paintings with <u>thick, textured surfaces</u> or with <u>smooth, flat surfaces</u>?

Thick, textured surfaces	40%
Smooth, flat surfaces	42
(Depends)	15
(Not Sure)	3

Q: Paradise: pro or con? Let's go back to what you said earlier about paradise and the blue landscape. Going up the Hudson River the other day I thought perhaps the blue landscape is the last pure idealization, because with nature, in the instant of contemplation, you can forget that the water is polluted, the air is polluted, that on each side of the river is a strip mall or a faded town or whatever. In the moment of observation, all of that is forgotten, which is something you can't say when you look at cities or factories, or when you think of communism or of the old idea of progress through electricity—all motifs of modernism in one way or another. So maybe when people say they want a blue landscape it's as a kind of icon of a purer reality, the last remnant of faith.

VK: But you are mixing beauty in reality and beauty in art. They are two different kinds of beauty, two different kinds of aesthetic—in art and in life. For example, socialist realism asked artists to represent reality, but it was false reality. Because the basic idea of socialist realism was to depict people as they might be, not as they are. Because we are building ideal society, so we need ideal people. Of course, it was not realism at all, because real people were polluted, real life was polluted. And when people are speaking of blue landscape, I'm afraid they mean real landscape, not painting. They just like to have a reflection of reality in their everyday life; in their apartments they imagine this picture as a window of their freedom. It captures experience of hermits, who go out into desert and so forth. The blue landscape can make people hermits for a second, to meditate. Making people hermits for a second—maybe that is the basic idea of art.

professor emeritus). We would want a seascape with breaking waves and a mermaid colony, but real-looking and not "cartoony." We also want a beautiful sky with some cirrus clouds (Laura K.

Q: But as it's still an idealized scene, do you see parallels between the blue landscape and socialist realism?

AM: No, the parallels are between modernism—late modernism—and socialist realism, of course. That's two sides of one coin. Both came of this idea of aristocrats, of people in power, imposing the culture on the people. A totally inhuman art. Modern art, and Pollock is the best example, is totally inhuman. Huge pictures for museums—now we call them museums; in Stalin times they were called palaces, but basically the same thing—which we rarely see and rarely visit. The sheer size of this painting, it's a totally inhuman scale. And there it can be typified. There's a machine which is called History of Art, which is a structure. And artist fits in this only because he or she is needed for this structure. If, for example, the History of Art needs some parallel lines, there is an individual who makes parallel lines. And this individual fits into this machine, which works by itself; it doesn't care about people or anything else, it just goes by itself.

I heard once Mary Boone [the New York gallery owner] at some seminar say she chooses art because of the quality—and when she sees really good art she makes her decision. I don't believe in this. What is quality? How should we define this quality? Of course she doesn't define, but she believes that there is something inside of the picture which can be qualified as a quality, which from my point of view you cannot say in the modern art. Modernism lived on the idea that art should be new. In the sixties the idea was that something which hasn't been said before, because it's said therefore it's good. There was a very strong idea of what is good and what is bad. And art was judged by this criterion, which is quite a good criterion. Now we're in postmodern times, so we say that we repeat ourselves, and this criterion just collapsed, so then what? Why this artist, not that artist? Why Schnabel is a good artist? Who can tell? I don't know. Can be good, can be bad, but there is no objective truth.

9

55. How about colors—do you like to see the <u>colors blend into each other</u> or do you like it when <u>different colors are kept apart</u>?

Prefer colors blended	68%
Prefer colors kept separate	18
(Depends)	11
(Not Sure)	2

56. Every color has a wide range of shades. Take the color blue, for example. An artist can use a bright, vibrant shade of blue, like royal blue; a pale, muted shade of blue, like light blue; or a darker tone of blue, like dark or midnight blue. In general, which would you say that you prefer: when the artist uses <u>more vibrant shades</u>, <u>paler shades</u>, or <u>darker shades</u> of color?

Prefer more vibrant shades	36%
Prefer paler shades	32
Prefer darker shades	22
(Depends)	9
(Not Sure)	1

57. In general, do you enjoy paintings that have a <u>more serious</u> or a <u>more festive</u> mood?

Serious	37%
Festive	49
(Depends)	12
(Not Sure)	3

58. And how about the painting itself—do you like it to be <u>busy and contain a lot of people or objects</u>, or do you like it to be <u>as simple as possible</u>?

Busy	17%
Simple	71
(Depends)	11
(Not Sure)	1

59. How about the size of paintings: do you prefer <u>larger paintings</u> or <u>smaller paintings</u>?

Larger	41%
Smaller	34
(Depends)	23
(Not Sure)	2

(IF LARGE)
60. Would that be the size of a <u>dishwasher</u>, a <u>full-size refrigerator</u>, or a <u>full wall</u>?

Dishwasher	67%
Full-size refrigerator	17
Full wall	11
(Depends)	2
(Not Sure)	2

Farinas, Ithaca, student). Rrose Sélavy—a cherry and a carrot on a plate (Tim Merrick, Ithaca, artist). Something with clear lines, bright colors—yellows and reds—something that would show a

(IF SMALL IN QUESTION 59)
61. Would that be the size of a <u>nineteen-inch television set</u>, a <u>magazine</u>, or a <u>paperback book</u>?

Nineteen-inch television	69%
A magazine	24
A paperback book	4
(Depends)	2
(Not Sure)	1

(ALL)
62. Some paintings are of famous historical figures and others are of more ordinary people. Do you generally prefer paintings of <u>famous people</u>, or ones of more <u>ordinary people</u>, or does it make <u>no difference</u> to you at all?

Famous people	6%
Ordinary people	41
Makes no difference	50
(Not Sure)	3

(IF FAMOUS PEOPLE)
63. Do you prefer <u>figures from a long time ago</u>, like Lincoln or Jesus, or <u>more recent figures</u>, like John F. Kennedy or Elvis Presley?

Historical figures	56%
More recent figures	14
(Depends)	22
(Not Sure)	8

(IF ORDINARY OR NO DIFFERENCE IN Q62)
64. Do you prefer paintings which are predominantly <u>of children</u>, <u>of women</u>, or <u>of men</u>, or <u>doesn't it matter</u>?

Children	11%
Women	6
Men	2
Doesn't matter	77
(Not Sure)	4

(ALL)
65. Thinking back to the paintings of people that you have liked in the past, for the most part were the figures <u>working</u>, <u>at leisure</u>, or were they <u>posed portraits</u>?

Working	23%
At leisure	43
Portraits	27
(Not Sure)	7

This is the crisis of modernism. Modern art used to reflect a radical way of thinking. It did this until World War II and then it gradually became more and more established. Eventually, the radical thinking was totally removed from this. People adapted to this, said, Okay, let there be, say, triangles. But in the beginning painting triangles was a huge statement, a daredevil act—for good or for worse that's a different story, but that's how it was. But now it's totally changed its meaning because it's just a bourgeois business. You produce pictures and you sell them. You keep the form—you can play with triangles endlessly—but the meaning is lost, so it's a perversion of the intention of modernism. And nobody cares. The same thing happened with academic painting and ancient history, before modernism. Nobody believed in it anymore, nobody cared, but still they went on depicting these beautiful women, these mythological figures. But it was totally obsolete. It lost the common sense; it lost touch with the people. Modernism was the idea to get back to some sense. Now it is senseless, so we have to revise again. And even the idea that art irritates or angers the people, it's very nice because it captures the people. You have some communication; even negative communication is better than no communication at all.

distortion of the human form in an almost grotesque way, and that would have some erotic aspect (Fred, Upper Darby, Penn.). Modigliani to paint his most favorite woman and give it to me to

Q: After we published the poll in *The Nation*, we probably received more negative letters from readers than at any time in our 130-year history.

AM: See, that's very good.

11

66. Next, which do you think you like better, a painting of <u>one person</u> or of a <u>group of people</u>?

One person	34%
Group	48
(Depends)	15
(Not Sure)	3

67. And from what you've seen, would you say that you prefer paintings in which the person or people are <u>nude</u>, <u>partially clothed</u>, or <u>fully clothed</u>?

Nude	3%
Partially clothed	13
Fully clothed	68
(Depends)	13
(Not Sure)	1

Now I'm going to read several statements. Please tell me whether you generally <u>agree</u> or <u>disagree</u> with each one.

	Agree	Disagree	(Not Sure)
68. I only like to look at art that makes me happy.	60%	39	1
69. A work of art can be beautiful even if it doesn't look like anything you see in the real world.	82%	17	2
70. Art should be relaxing to look at, not all jumbled up and confusing.	77%	22	1
71. I generally prefer paintings and drawings that are predominantly black and white.	11%	87	2

72. If you were given the choice of a gift—<u>a sum of money</u> or <u>a piece of art that you genuinely liked</u> and which was of equal value to the money,—which would you choose?

Art	35%
Money	57
(Not Sure)	7

hang in my house and come over and tell me why he painted her the way he did (S. G. Criswell, Ithaca, educator/artist/writer). Horses in a stable (Rachel Strohman, Lansing, N.Y., kindergarten

73. Please tell me <u>which one of the following would be most important</u> to you in deciding how much money you would spend on a painting. **(READ LIST. DO NOT ROTATE.)**

The size of the piece	3%
The fame of the artist	7
The medium, such as oil paints, watercolors, or charcoal drawings	5
The degree to which you like the painting	62
Whether or not you think it will increase in value	16
(Depends)	4
(Not Sure)	3

74. What is the <u>most amount of money</u> you would consider spending on a piece of art you really like? **(READ LIST.)**

$25–$50	20%
$50–$100	27
$200–$500	28
$500–$1,000	9
$1,000–$3,000	3
Over $3,000	5
(Not Sure)	8

Now I'm going to read the names of some prominent artists of the past and present. For each name I mention, please tell me if your impressions of that artist's work are <u>very favorable</u>, <u>favorable</u>, <u>unfavorable</u>, or <u>very unfavorable</u>. Some of these artists are not very well known, so if you have <u>never heard of someone</u>, or <u>don't know enough</u> about his work to have an opinion, just say so.

		<u>Vry fav</u>	<u>Fav</u>	<u>Unfav</u>	Very <u>unfav</u>	Never <u>heard</u>	Don't <u>know</u>
75.	Pablo Picasso	20%	45	14	5	5	11
76.	Norman Rockwell	43%	38	5	2	6	6
77.	Jackson Pollock	4%	11	6	1	49	28
78.	Salvador Dali	9%	23	12	5	31	20
79.	Leroy Neiman	5%	20	7	3	40	26
80.	Claude Monet	24%	33	4	1	21	16
81.	Rembrandt	32%	46	5	1	6	8
82.	Andy Warhol	9%	24	21	12	18	16
83.	Georgia O'Keeffe	11%	19	3	2	39	26

Q: Also, it has to be said, more enthusiastic response than ever. But what struck me about the opponents was their vehemence: "The editor of this issue should be fired!" "You should be disgraced!" That kind of thing—people absolutely incensed that artists (a) should ask people what they want; and (b) should use the tool of capitalist market research to ask people what they want. They weren't interested in ideas; you'd simply committed some kind of sacrilege, and these are people who I'd suspect are largely atheistic——

AM: Oh, even more reason! Because they want to compensate for their atheism by believing in art. That's very important. Belief in art, faith in art, starts with atheism. They worship art as something sacred, a separate church. Atheists believe in art adamantly; I know it from Russia. It's a last refuge of spirituality, because in Russia artists are the most sacred of the sacred people.

VK: You know, many followers of our work have expressed disappointment in the paintings we based on results of poll. Same thing happened to the Russian President: for first time ever, head of Russian government was elected democratically—and everyone is disappointed. The ideal is by definition a dream, but when a dream becomes reality it ceases to be ideal. Our poll results indicate that most people are dissatisfied with 90 percent of paintings currently hanging in museums, reproduced on posters, and sent on postcards. After all, majority of these images are not blue landscapes. Still, it is my hope that people who come to see our *Most Wanted* paintings will become so horrified that their tastes will gradually change, and another poll would gather different results for creation of paintings that do not resemble blue landscapes.

student). Various colors of horses pounding wildly through the surf on the coastline of Rhode Island (Mary Ellen Mullija, Trumansburg, N.Y., speech pathologist/horse trainer). Marilyn Monroe

Q: Horrified? So you think the blue landscape is a bad thing?

VK: I didn't say it's a bad thing. What I mean is that anything which becomes visual cliché will later become a barrier for development.

AM: I'm sorry, what is not visual cliché?

VK: Sure, but for me throughout this project the absence of surprises has been the biggest surprise. Maybe our method was flawed. Maybe we have to work with people one by one. Maybe a better question would have been "Do you expect to see the unexpected when you look at art?"

Q: But if you expect it, can anything be unexpected?

VK: That's a paradoxical situation. Maybe it's better to say, "Do you want the painting to surprise you?" In town hall meeting in the church in Ithaca, New York, I asked this question and only one person said she wanted a total surprise.

84. If you could pick one type of person you'd most enjoy having dinner with, would you choose an <u>artist</u>, a <u>television or movie actor</u>, an <u>author</u>, or a <u>sports star</u>?

Artist	14%
Television or movie actor	25
Author	29
Sports star	24
Other	1
(None)	3
(Not Sure)	4

85. How often, on average, would you say that you go to art museums—<u>more than two times a year</u>, either <u>one or two times a year</u>, <u>less than once a year</u>, or <u>not at all</u>?

More than two times a year	19%
Either one or two times a year	30
Less than once a year	24
Not at all	24
(Depends)	2
(Not Sure)	1

(IF LESS THAN ONCE A YEAR OR NOT AT ALL)
The following are some reasons people have given in the past as to why they do not go to art museums. For each, please tell me whether it is a <u>major reason</u> why you do not go to museums more often, <u>a minor reason</u>, or <u>not a reason at all</u>.

		Major	Minor	Not a reasn	(Not Sure)
86.	There is not an art museum in my area.	34%	15	49	2
87.	I don't have enough spare time.	44%	19	36	1
88.	I don't feel comfortable in art museums because I don't know a lot about art.	24%	21	54	1
89.	The cost of admission is too expensive.	11%	22	62	5
90.	I simply don't enjoy looking at art.	12%	21	65	1

(ALL)
91. Would you <u>favor</u> or <u>oppose</u> spending more money in federal taxes than we do on the arts?

Favor	30%
Oppose	57
(Not Sure)	13

and Elvis romping in the Ithaca falls in the style of Bouguereau (Melanie-Claire Mallison, Ithaca, humor and my son). The style is impressionist, more specifically Manet, comments by Zola, by

(IF FAVOR)

92. The ordinary taxpayer now spends roughly $420 in federal taxes for defense and $38 in federal taxes for education each year. Would you be willing to pay an extra $25 a year in taxes to support the arts? **(IF NO)** An extra $15? **(IF NO)** An extra $10? **(IF NO)** An extra $5?

$25 more in taxes per year	66%
$15 more in taxes per year	10
$10 more in taxes per year	6
$5 more in taxes per year	3
None of the above	11
(Not Sure)	4

(ALL)

93. Some works of art are displayed in public places. Do you think that average citizens should or should not have a say in determining which works of art are appropriate to be displayed in public?

Should have a say	67%
Shouldn't have a say	27
(Not Sure)	6

94. If you had unlimited resources and could commission your favorite artist to paint anything you wanted, what would it be?

My family	14%	Sunsets/Sunsets in water/In trees	1
Self-portrait/Myself	5	Old farmhouse/Barn	1
Mountain scene	5	Parents/Mother/Father	1
Wildlife/Wild animals	5	Women/Ladies/Nude women	1
Landscape	4	Abstract art	1
Nature/Nature scene	4	Athlete/Sports hero	1
Ocean scene/View	4	Christ/Crucifixion	1
My children	3	The sky/Sky with cloud	1
Anything/Artist's choice	3	Waterfall scene	1
Outdoor scene	3	Religious painting/Angels/Heaven	1
Grandchildren	2	Western scene	1
Seascape	2	Lake/River/Stream	1
Garden flowers/Wild flowers/		Norman Rockwell painting	*
A garden	2	Indian art/Tribe	*
Forest scene	2	Motorcycle/Harley	*
Country scene	2	Mona Lisa	*
Everyday people	2	Scene from book I read	*
An innocent child	2	Homeless	*
The city/Tall buildings	1	A bar/Barroom	*
My wife/Girlfriend/Fiancée	1	Church/Chapel	*
Winter scene	1	Mother holding baby	*
My house/The house I grew up in	1	Elephant/Herd	*
A deer/A doe or deer in the		Other	3
woods	1	Nothing/Wouldn't commission artist	*
My dog/A dog	1	Don't know	11
Horses/Horses running	1		

Q: A great British journalist, and communist actually, Claud Cockburn, once observed that nothing is so satisfying as coming to a place and having it turn out to be exactly as you expected it.

VK: Well, maybe when we see our desires turned into reality it always surprises. Of course, now that we know people like landscapes, we could conduct a new poll. If blue, how much blue? How many trees? how many rocks? how many animals? on the left or on the right? Do you like landscape viewed straight on? or from point of view of mountain? or from below? or aerial view? And what shape? horizontal? vertical? plain square? That way we could get down to smallest particle of their desires.

AM: You know, the point is maybe the poll is not the best way. Maybe we could try some different approach. Maybe we have to buy a van and go around the country working on art among people—van art. From Vanguard to Van Art. But society now depends on polls, so we just pick the tool which is here. And this is scientifically accurate poll, so if this poll is wrong, then all polls are wrong. Still, there are some things unknown to me, like it had to be 1,001 persons asked. It needs to be one more than 1,000. I don't know why, but supposedly science tells the pollsters this. But is it real science, or is it kind of science lite? Since I was always a very bad student in science, I cannot judge this. But that's another story: if you need to have a real truth, or if you just align yourself with what is considered to be truth here, in this given moment, in this place. So we have this truth—science, medicine, polls—and we say, Okay, that's truth. We trust it. If we won't trust in polls, the whole world will collapse. So what to believe? We don't believe in God, and we don't believe in science, so what is left?

sporadic reference to the Hellenistic style. The subject, the celebrations after the Ithaca, N.Y., workers' struggle for power (Alan Mitchell, Reading, England, youth community worker). Our large

Q: And what did you think of the responses you got from people in the focus groups and at the town meetings?

AM: They were very enthusiastic, but it seemed to me that they were looking for words to express themselves—like me sometimes in English, it was foreign territory. You know, the upper classes treat the lower classes like children: "It's too early"; like, it's too early for sex. Talking to these people I understood that they were very passionate. They had hidden desires. But they don't have the words; they don't have very much field to experiment. There needs to be written, maybe, a book, a manual, like *Joy of Sex*—*Joy of Art*, and then *More Joy of Art*.

95. These last questions are strictly for tabulation purposes. First, in which of these categories does your age fall? (READ LIST.)

Under 25	14%
25 to 29	11
30 to 34	14
35 to 39	12
40 to 44	11
45 to 49	8
50 to 54	6
55 to 59	5
60 to 64	4
65 and over	13
(Refused)	1

96. What was the last grade of school you completed?

Grade school or less (1–8)	3%
Some high school (9–11)	8
High school grad	31
Vocational/Technical	4
Some college/2-yr college	24
Four-year college grad	19
Postgraduate work	10
(Refused)	1

97. Do you have children?

Yes	67%
No	33

(IF YES)
98. If one of your children wanted to be an artist, would you encourage your child, discourage your child, or wouldn't it matter to you?

Encourage	79%
Discourage	2
Would not matter	18
(Depends)	1
(Not Sure)	1

99. If one of your children wanted to marry an artist, would you encourage your child, discourage your child, or wouldn't it matter to you?

Encourage	26%
Discourage	3
Would not matter	65
(Depends)	5
(Not Sure)	2

ocean waves crashing onto sunlit rocks—with seals playing—so the viewer feels inside [the] picture (Anonymous, Kipond, Me.). I would commission Hieronymus Bosch to do a current morality piece

16

(ALL)

100. Are you from a <u>Spanish-speaking background</u>? **(IF NO, ASK:)** Are you <u>white</u>, <u>black/African-American</u>, <u>Asian/Oriental</u>, <u>Middle Eastern/Arabic</u>, or <u>something else</u>?

Hispanic	7%
White	78
Black/African-American	10
Asian/Oriental	1
Middle Eastern/Arabic	1
Something else	3
(Refused)	1

101. When it comes to most political issues, do you think of yourself as a <u>liberal</u>, a <u>conservative</u>, or a <u>moderate</u>? **(IF MODERATE)** Do you think of yourself as <u>closer to being liberal</u> or <u>being conservative</u>?

Liberal	23%
Moderate-Liberal	8
Moderate	14
Moderate-Conservative	11
Conservative	36
Other	2
(Not Sure)	5

102. For tabulation purposes only, please tell me which of the following income categories includes your total family income in 1992 before taxes—just stop me when I read the correct category: <u>Less than $20,000</u>; <u>$20,000 to $29,999</u>; <u>$30,000 to $39,999</u>; <u>$40,000 to $49,999</u>; <u>$50,000 to $74,999</u>, or <u>over $75,000</u>?

Less than $20,000	15%
$20,000–$29,999	19
$30,000–$39,999	15
$40,000–$49,999	13
$50,000–$74,999	15
Over $75,000	9
(Refused)	13

103. **GENDER, BY OBSERVATION**

Male	47%
Female	53

"THANK YOU FOR YOUR COOPERATION"

Q: Had any of the people at the meetings actually seen the pictures made from the results of the poll?

AM: In Ukraine this guy came up and said, "By the way, you know this picture doesn't express the soul of the Ukrainian people." The soul of the whole Ukrainian people!

Q: Some of whom, old-timers, went at the task of killing Jews with more lusty energy than the Nazis.

AM: Yeah, it must represent the whole society, people demand no less. You see this enormous task we have, an enormous burden to express the soul of the people.

with politicians and bureaucrats playing the part of the damned (Garth Hobie, Freeville, N.Y., photographer). A painting of Komar and Melamid sitting inside a horse-drawn carriage, with

VK: This is connected with another deep feeling that I believe everybody has. As long as we are mortal, the number of our days, the number of moments of our life, are limited—like money in our account. We pay our moments, our days, for everything, and we understand that our account is limited. Someday it will be zero, and we will die. It's the only real money that we have. For example, Mark Rothko. He painted all his life more or less similar painting, but why they're so valuable? Because he paid for that with his life. If I were to make every day one point in the middle of canvas, people would say, "Eh, that's bullshit." But if I will do it all my life every day and I pay for that with my life—because the most expensive thing people have are their moments—then it would be most valuable. So when we make paintings, we pay with our life. But in case of town hall meetings and answering poll questions, the people pay their lives, their moments, for us. We are like vampires: these hundreds, thousands of people who come to these meetings, who talk to pollsters, we suck their blood, their moments. So naturally they are demanding.

Seattle as backdrop. They would be in conversation with two other artists, probably about Hegel and his philosophy of absolute spirit (Anonymous, Lansing, N.Y., writer). The home where I grew

Q: Yet you have based every country's "most wanted painting" on *America's Most Wanted.* Was it the idea to create the artistic equivalent of Burger King—the same basic model but "have it your way"?

AM: Well, American poll was first poll, and all others are based on this, so in a way we are like exporters—not of revolution, unfortunately, since we are just humble artists. But, you know, when we started doing polls in other countries, we never thought they would all result in the blue landscape. So at first we started doing different paintings for each country, but then we realized, no, what people everywhere have in their mind is ideal landscape. They all see the same pictures, the same magazines; this world culture of reproductions, CNN, is very strong.

And what do they want? In every country the favorite color is blue, and almost everywhere green is second. In Denmark it was red. In Turkey—really amazing—white was second; and there was also the biggest vote for abstract painting, but still landscape came first. Everywhere the people want outdoor scenes, with wild animals, water, trees, and some people—whether ordinary people or famous it depends. Except for China, of course, which is a really special case. But in general the people all hate gold, universally, and orange. They all hate the sharp angles and geometric patterns. The third favorite color is almost always red or something closely related—brown in Finland, purple in Kenya. So we decided to use American painting—which people here say, "Oh, Hudson River landscape," but is actually ideal landscape based on Domenichino—as a kind of template, and from there we make adjustments depending on each country's results.

VK: And now we use computer to make sketches, which follows our artistic experiment. Ideally the percentage of canvas covered by blue would correspond exactly to percentage of public that picked blue as their favorite color. The same with green and so on.

AM: The point is, what is the logic of this project? It's funny that all this machinery, all of these sophisticated methods and numbers and digitally coded results—plus or minus 3.2 margin of error—all lead to one humble oil painting. All this hi-tech blah-blah-blah and in the end we are working as artists have worked for hundreds of years. So now with computer there is more coherence from beginning to end, which is still, by the way, a simple oil painting.

Q: Just to go back, you said China is a special case. How?

AM: It is only country where majority is not sure about almost everything. Size? Not sure. Abstract or realistic? Not sure. Nudity? Not sure. Famous people or common people? Not sure. In group or alone? Not sure. Sometimes they say "Depends," but for me as an instruction it is the same thing. It is a real society in transition. Even color: on this question "What is the second-favorite color?"—42 percent, not sure. Can you believe it? And this is a really professional poll, by the way; the Chinese took it really seriously—this huge report, detailed explanations of how they asked the people, what the numbers mean, and so on—because polling is so new to them, of course. It is interesting as sociology—were people scared that they say the wrong thing and they're in trouble? or that they say the wrong thing and it means they're behind American culture (because this culture is very important for the youth)? I don't know, but it is very hard for making a painting. We have no instructions. At first I thought, So they are not sure, so there can be no painting. If they're not sure, they're not sure. But then I thought about how this American system works. In America, maybe half the people don't vote, sometimes more, but still no one ever says, "So there can be no President." Those who are sure decide, and all the rest don't count. This is American democracy: there can be landslide, mandate-schmandate, even if majority stays home. So we will do painting for those Chinese who are sure; and these people want a blue landscape, of course—large-size, "modern" style (by

31

up in Fairbanks, Alaska, with my ex-seeing-eye dog, Lance, playing off-leash in the front yard in autumn (Kris Brown, New York City, attorney). I'd like a picture that helps, through its beauty

which they mean nineteenth-century), with domestic animals. This is the breakthrough: Chinese alone clearly prefer the domestic animals. They also are only people we have polled who want portraits.

Q: You said earlier, Vitaly, that maybe the blue landscape makes people hermits for a second. Let's say you don't mean a literal second and these blue landscapes speak to people's desire for freedom—in a psychological sense, for a space for meditation. Yet they are generated by the same technology that's brought us cultural saturation bombing (computer networks, instant polls, MTV) and the death of contemplative solitude, the constriction of any space for private thought. Isn't it a dialectical problem: the wish to satisfy popular yearnings, and the impossibility of doing that in the conventional terms of elite or popular culture?

VK: I don't believe in death of contemplative solitude. Under bombs of pop culture it develops new immune system and is reborn in new guise. A person can become as accustomed to explosions as to the beat of his own heart. When I look at people sitting for hours in a Paris café, I am convinced they are watching the flow of people and cars in same way that hermit watches the flow of a river. When in New York I see people wearing Rollerblades and earphones glide by as if in dream, I feel this is their paradoxically hermetic meditation, their solitude. "The legend continues . . ." Do you recall hero of popular TV show *Kung Fu*, who attained status of "monk among people"? The vanity and vexation of this world didn't disturb him. His was more complex solution than that of the hippie who moves away from cities to a commune. I love Nam June Paik's Buddha in front of the television. It's a grotesque but also a serious vision of future. I believe that we can satisfy popular yearnings by creating a three-dimensional grotesque of Garden of Eden. We hope to be able to execute the blue landscape not only in painting but in nature. It is possible to plant trees similar to ones in our painting, create the same lake, same hill, and so on. This locale will be called Poll-Art Park, a place where people can spend time as hermits. An ideal vacation getaway.

Q: And how would you rank your blue landscapes in terms of the history of art?

AM: I am not in charge of this. I'm a follower of this tradition of Chekhov, Anton Chekhov, just to show. Chekhov said, I cannot judge; I can show. The artist, the writer, can only do one thing, to show their things, and let the people judge whether it's good, bad, negative or positive, and I totally agree with this.

But, you know, you cannot separate the painting from the work. You cannot say that's a good idea but a bad landscape; if the idea is good, the work is good. If not, okay. The point is, the work belongs in this line of modernism, late modernism, and in this line it is the only blue landscape. So if you accept it as modern—and we are modernist artists—you can say this is some crooked, deformed thing, but you cannot say whether it's good or bad in quality. That's why it's more or less accepted by the establishment—whether they like it or not that's a different story but they cannot say it's a bad landscape, because it's the only one landscape. There is nothing to compare to. It doesn't belong to the world of classical landscapes or to the world of Korean landscapes in stores in Bayonne, New Jersey. It belongs to the world of Pollock, and that is how it has to be judged.

That's the weakness of modernism, actually. Everything exists in this line, and if you don't keep in mind the whole line, then you cannot understand, cannot comprehend any particular work; it doesn't exist. Of course, it exists as a dirty canvas, or if it falls on your head it exists as an object, but it doesn't exist as art. Unlike in physics, where you may not know the scientists or their different discoveries, but the H-bomb exists regardless, because physically it can harm you. But this blue landscape, it exists only in the line of Pollock. That's the uniqueness of this work; it's the only one such landscape in the whole history of a huge movement.

and horror, the process of getting to know ourselves. If, in addition, it can be deeply spiritually revealing, better. Thanks for asking (Eduardo, Ithaca, economist). Mitchell Magee, completely nude,

Q: Although this is not quite your first foray into the blue landscape; I remember an earlier dreamy one with a factory that made blue smoke.

VK: Yes, but that not ideal landscape. The idea there was how to make real nature beautiful, how to transform pollution into the blue color. This blue smoke could transform all pollution and clouds into blue. We wrote to several people—the Prime Minister of Greece, Giovanni Agnelli of Fiat, and Sheik Yamani of Saudi Arabia—suggesting that they might want to build such a factory. Sheik Yamani told us he might consider it, but unfortunately we never heard from him again. So in that case we were less interested in landscape than in actual production of something ephemeral—blue clouds, blue rain, blue water. I remember my most striking experience was my first encounter with Western civilization. I was in a Boeing airplane when I emigrated, and I visited the toilet room. When I flush water, the water was a dark blue. I thought something was wrong; this whole world was new. It was something I never expected, this dark blue color. It was a big shock, a color shock. Of course, children when they paint landscapes they paint water blue, but this was literally blue water—dark blue water.

Q: Well, as I think Ruskin said, "Blue color is everlastingly appointed by the Deity to be a source of delight."

VK: And now we know he was right.

The Renowned Artists
of the End of the 2 Millennium A.D.
Komar/Melamid
Moscow

The Prime Minister of Greece
Mr. Karamanlis
Athens

Honorable Mr. Karamanlis!

You are the head of the government of a country which, being the cradle of European civilization, has always evoked the deepest feelings in the heart of every civilized man.

In our century, the problem of preserving harmony between man and the environment is attracting the anxious attention of worldwide public opinion. Who, if not you and your country, could become the pioneers in the matter, resurrecting the idyllic landscape of the long-gone Golden Age?

We do not suggest the elimination of colossal machinery of modern industrial production. However, it is within our power to direct this machinery along the path of eternal and ideal aesthetics. Therefore, we appeal to you, Mr. Prime Minister, and also, in other letters, to the large-scale capitalists of our time, with the request to support the construction of the Factory for the Production of Blue Smoke. We ask you to offer the land of ancient Hellas as an honored site for this factory.

Clean, unpolluted with the ideas of utilitarianism, blue smoke, constantly diffused, will produce monuments to the genuine beauty of human sensibility and intelligence.

We are attaching to this letter a photograph of the design for the Factory of Blue Smoke.

We hope to receive your reply as soon as possible. Would you please send your reply to our home address: Leninsky Prospect 70/II, Apt. 404, Moscow, USSR, or to the Ronald Feldman Gallery, 33 East 74th Street, New York, New York 10021.

The coordination of organizations which are financing the project, and the purchase of the land, is to be handled through the Ronald Feldman Gallery.

plate no. 1

in a graceful swan dive from McGraw tower; bright sun, blue sky, Mitch has a smile on his face, as do Komar and Melamid, barely visible in the upper reaches of the belfry (Georges Ruella, Ithaca,

MALE FEMALE

plate no. 2

independent consultant). Large seascape around the time of the early 1900s, with the waves breaking over the rocks (Anonymous, Ithaca, microbiologist). Love and compassion (Gunther,

Q: A lot of people, though, find all of this puzzling. Where, they ask, does the poll stop and artistic creativity begin?

AM: That's another question, very general, about freedom. What is freedom? Are we free? Are we worked by order, unconsciously to serve this market, to serve these people who like some pictures and don't like some other pictures? Of course we all work by orders. We're all commissioned. The old Marxist education of mine still tells me that there is no freedom in capitalist society. Communism was a desperate attempt to achieve this freedom. Marx said that we're going from the realm of necessity to the realm of freedom—a breakthrough vision, from a totally unfree society to a real free society. It failed, of course; it hasn't been achieved. But still I understand these quests for freedom. That was the quest of the Revolution, the Russian Revolution. Not only the Russian Revolution but any revolution.

VK: You know, even if it fails to please (or displease) we hope this project will at least provoke some thought about the old religious and philosophic quandary of free will versus predetermination. In our early work, we arrived at definition of freedom that entailed being free from individual clichés, being free to change intonations and styles. Individuality lost its stability and its uniqueness. Now we are searching for a new freedom. We have been traveling to different countries, engaging in dull negotiations with representatives of polling companies, raising money for further polls, receiving more or less same results, and painting more or less same blue landscape. Looking for freedom, we found slavery. Sometimes I feel like a masochist who, having found himself in paradise, longs for the lost inferno—some kind of new Miltonian protagonist.

Q: Then how much do you think the answers themselves in the poll are the result of a kind of unfreedom? The result of what people think they should say as opposed to what they really truly——

AM: Right, maybe the people are not exposed to art, of course, and they know very little—and what they know, they tell us. And maybe they're scared. But that's what is art, what's alive about it. What we're scared of, our fears, are a legitimate part of our life. That's real truth. We shouldn't be ashamed of our shame. Our shame is us.

Of course, this poll is not the final truth. All polls are big lies. According to Churchill, Winston Churchill, a statistic is the biggest lie, and it's true. But how else to find out? Of course, the best way is to make a revolution. That's ideal. I'm dreaming to organize a good, bloody revolution here in the United States. But that's much more difficult. It's much easier to raise $40,000 and make a poll.

VK: If I might add something about polls and manipulation: this is never so clear as during political campaigns. Recently we included a ballot box in exhibition of our paintings. Rather than voting for leaders, visitors voted for representations of leaders. All were based on famous photograph of Churchill, Stalin, and Roosevelt at Yalta, but each one was different. Of fifty images, No. 1 received the most votes, followed by No. 2, No. 4, No. 3. All images were numbered 1 to 50 and fairly small in size, but 1, 2, 3, and 4 were reproduced on the opposite wall in form of huge paintings. So I think people were influenced not only by order of pictures but also by how much they thought we invested in them. Presidential candidates are created through the same process, as are enormous contributions to their campaigns.

Trumansburg, N.Y., craftsman). *Happiness or love, so that I could have some (Margaret Ayala, Bronx, student).* *Me, by Renoir, at an outdoor French peasant feast, surrounded by burly, ruddy,*

Q: On this subject of manipulation, let's talk about who determines what's up and down in the art world. You said at one point that in the Soviet Union one of the frustrations was that you could paint only what the commissars would let you paint——

AM: No, no, we could paint whatever we wanted. If we wanted to make a living, that's another story. But the commissars—in a way, the commissars painted something which at least officially got some response from the people. But me and Vitaly, being a part of the dissident life, we lived very strange lives, because we were totally remote from reality. Everything was happening indoors, small rooms; outdoors didn't exist at that time. I waited for people walking by. People—who are these people? And, as I said, we were brought up believing art belongs to the people, so we were in a type of exile.

VK: I remember such an expression "Sunday artist"—the artist who works for himself. This blue landscape may be "Sunday landscape," as people imagine their celebration, their holiday. In Russia, "Sunday painter" had a very pure, simple dissident flavor, because to paint on Sunday meant to paint for yourself, not for government. I knew a few very professional artists who made a living painting socialist realism for money all week and painted abstract art on Sunday, just for their heart.

Q: So did you paint on Sunday?

VK: Yes, I was teacher in art school, and Alex also was teacher for a few years, and we made a living as book designers or private tutors preparing students. And most of our works, of course, we created on Sunday. Now we paint differently. You know the propaganda cliché: we emigrate and become free, and now we can paint all week, without interruption, without weekends. Every day became Sunday, but you're working every day. No free time; that's because you're free.

Q: The antithesis of progress: more work, less leisure.

VK: But I can imagine someday a new totalitarian government will press people into vacation. You'll have to go enjoy yourself under fear of arrest.

Q: Back to the original question, though, do you think America is not that dissimilar from the Soviet Union, only here the commissars are the collectors and curators?

VK: Yes, sure. We were at New York School of Visual Arts to discuss poll and the question was raised, "Who are the tastemakers?" And I said there that I came to United States not in search of answers but looking for new questions. The creation of new questions is what makes our life more exciting. And "Who are the tastemakers?" I don't think is the right question. What interests me is "Who are the starmakers?" Because art world has become world of big names. If someone tried to tell me that stars are created by art critics, I wouldn't believe them. Have you ever seen an article about an artist who's never had a show? This means that gallery plays role of censor between

healthy men (farmers, sailors, etc.), one of whom I am dancing with. He gazes at me adoringly and I arch my swan-like neck and am looking at something off-camera that no one but me can see

plate no. 3

(Loretta Buckley, Ithaca, teenager). My lover and me after great sex, saturated with love (Anonymous, Bellingham, Wash., mother). I want to see animals in a nature setting. Animals such as

art and public. If gallery plays role of tastemaker, then you can compare artist to cook, and gallery owner to restaurant owner, and art critic to food critic. But we have to remember that concept of taste has to do with our tongue, with our ability to taste.

AM: And that's another important question. What is taste? What is good taste? Is it something that just exists, objectively speaking, among some special people? I am part of this modernist movement, so I cannot afford to like this blue landscape—that's just by definition, because regardless of how blue or how landscapey it is, it's bad, you know, it's a bad taste, it's kitsch, by definition. So there's real taste and acquired taste, but either way it has nothing to do with quality, because taste is a matter of love, not a matter of art. You can fall in love with a very bad picture, by some standards, just like you can fall in love with a very ugly woman. But that's your love, it's something inside you. You do not love this woman because she is better or worse than all other women, objectively speaking. You love her and then you like what you love, or else maybe sometimes you're ashamed—maybe something's too small, something else is too big; but what is "too small"? why? who defines this?

You know, every time I come back from Europe, I'm stunned by the difference between the European culture and the American culture. In America, the best which has been produced in culture came from the bottom of society. Like music—the greatest musicians of the twentieth century were illiterate; they couldn't read music. Just the opposite of what the good European art is. In Europe, basically the aristocrats—by blood before and now by spirit or by education—invent the culture, and then they impose this culture on the people. Here it always worked differently, except in fine arts, which is working the same way as it is in Europe. Still these aristocrats of spirit impose their ideas on people. That's why fine art is the least important cultural thing in America.

Q: What's the role of the collector?

AM: That's another part of why we started this project. I met many big collectors. Ninety-nine percent of them were either really stupid, illiterate people or just vicious people. There were some exceptions, but really very few. And I was wondering, why do you need to be vicious and stupid to buy art? What?—it's one of the requirements of the whole business? Or can you be smart and buy it? Because the smart people are true exceptions in this field. I know this quite well, because I've been quite many years in this system. I read about one of the greatest collectors of Russia, who collected first all these Impressionists, and early Picasso, Matisse, and he assembled the greatest collection ever. And he was an idiot! So maybe it is a requirement.

But as far as I understand it, here in America there are several types of collectors. Some are just Collectors; they can collect watches or books or pipes, smoking pipes, or collect art. There's no difference; it's a passion and it has nothing to do with art. And the other big group who collects does it because it gives them a certain entrance to the big social events, museums. All of the museums in the United States exist only to serve these people. There's a secret life of the museums. These people, the rich people, the people in power, they build their castles, which are called museums. And the real life of the museum is not the time when the visitors are there; no, the real life starts when the museum closes its doors. Then these great people come in and they have their bar mitzvahs or wedding parties. It's just like the aristocrats and their castles. They let people in for a couple of hours, but it's not why the place exists. They pay money supporting the museum not to serve the people but for their own pleasure—to have this great building, chandeliers, nice company, good food . . .

rabbits or sea mammals in water . . . OR a picture of the three crosses at Calvary (Christine Lui, Staten Island, student). No landscapes. No abstract art. Dark colors. People—a family—at the

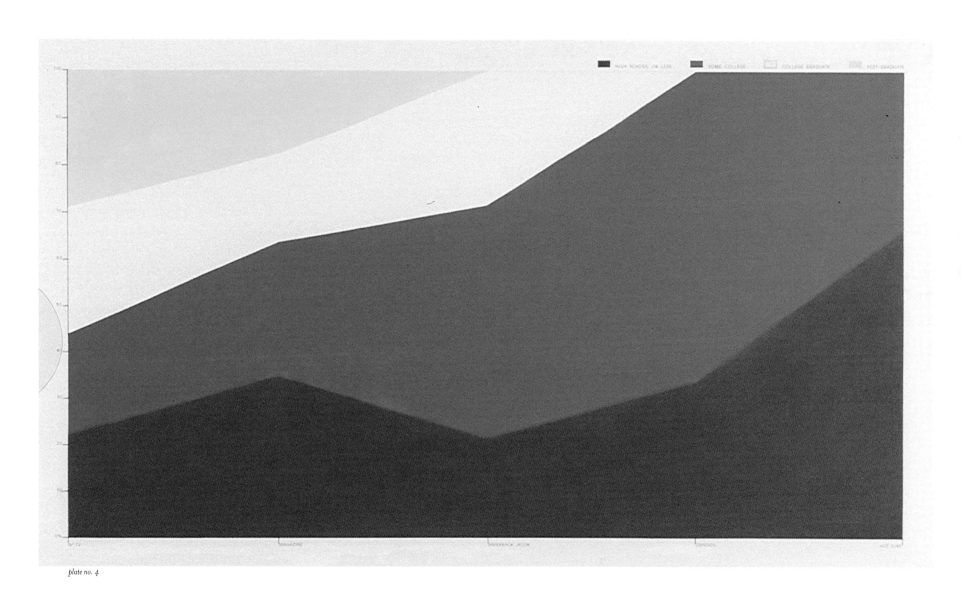

The legend text and axis labels are too faint/illegible to read reliably.

plate no. 4

dinner table. Odd lighting. Ominous. Realistic family life. Kids playing with their food, one parent laughing, one angry . . . events twistedly humorous in themselves yet painted so the overall

Q: Was this a surprise to you when you came from Russia?

AM: Yeah, because, you know, we had this image in Russia of America as a country of freedom, of course, where the majority rules—which in a way is true, because in the election you can win by sheer majority. So if 20,000 more people voted for you, it means that you are the President. That's why we mimic this in the poll. We trust—it's interesting—we trust this people, we believe that this system, among existing systems, is the best political and social system. We trust these people to vote for the President. But we never trust them in their tastes, in their aesthetic judgment. And nobody can prove to me that the painting made from this American poll is worse than Ross Bleckner's piece, for instance. There's no proof in the whole world of this. And I think that it's a better picture, because there was more effort put into it. So many people worked—I don't know, more than 1,001. We spent $40,000! For the size of this picture it's quite expensive, I think.

Q: But how do you think people who aren't part of this system express their aesthetic judgment?

AM: They do all the time. Americans are very down-to-earth people, very concrete, and they know precisely what they like—the design of their apartment, the color of the sink—they think about art. And that's a very legitimate way to think about that. I am a modernist artist, and I think even polishing your car, cutting the hedges, is a totally legitimate modernist action. But how to get people to talk about this? In the poll we didn't start out asking about museums. We asked about color, size—real questions. We start with a common object and go into objects as art. The car as an art object. People like the car not because of its real ability but because it has a particular form. Maybe they don't understand that a car is art, but they buy on their aesthetic urge. They need to buy beauty. And, you know, it's mesmerizing, the shininess. Just visit the showrooms and see this incredible beauty—incredible!

We live in a consumer society, so art and money go together. You cannot separate them. But, on another hand, this relation with money is not absolute. Poor people, they spend much more money for decoration purposes, percentwise. People in ghettos, these young people, they spend an enormous amount of money for their dress. They care about the beauty of the thing, much more than people with a bigger income. At one point in making this poll somebody said he thought there was this hierarchy of importance, that for rich people art came right after food, and for everyone else came first food, shelter, etc., etc. But it doesn't go like that. You cannot say simply first shelter, because people living in shelters decorate their walls. And I don't have any pictures on the walls of my house.

Q: In the course of this project you were on NPR's "Talk of the Nation" asking people what they want in art, and this one guy called in pretty derisively asking you whether what you were talking about was really art or something more like furniture—something "to match the couch."

AM: The problem is that we define art as something really ideal, beyond and above the couch. But in real world, art lives in the environment, and it can be environment in the museum with white walls, so in this case it has to match the white walls—it cannot be bigger than the walls, for example—or the paintings it's surrounded by. And that's the same with every interior. If you happen to have small walls, you buy small paintings.

So art lives a real life. It is not better, purer, or more exciting than anything else in our life. And I don't see why people want to see art as something excluded from our daily lives, because our daily lives are very noble and very good.

painting would be written by Edgar Allan Poe. Kitchen hinted at in the background (Rebecca Woodhouse, Swannanoa, N.C., student). Adult vs. child—showing how much innocence and creativity

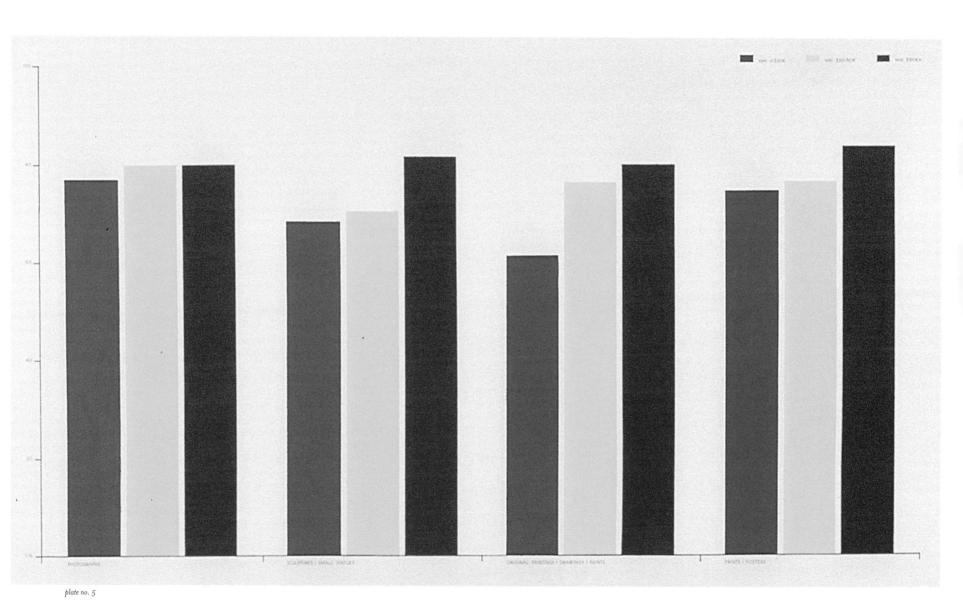

we humans lose as we grow up. It would be a part of history, as art once was: true to the world . . . a true representation (Anonymous). I would commission a really good artist to paint lots of ugly

That's another point, very important, about why we did this project. What is the position of art at this given moment, in this capitalist society? We want to say, Listen, whether better or worse, sacred, not sacred, it doesn't matter; art is a production of things for sale. So let's define it this way; let's try to understand it in the context of our lives.

Q: That obviously was a preoccupation of pop art——

AM: Yeah, but, you know, pop art kind of romanticized these objects of capitalist society, because everything was so beautiful, so bright—giant Brillo boxes—capitalism as it ought to be, not as it is. In a way, pop art in America was like socialist realism in Russia, because the real pop art of America is not Andy Warhol but Sears, and this is quite different: dark brown color, off-white, wood grain, the hum—mmmmmmmmm—of a Kenmore refrigerator. "Searstyle," as we called it when we did a show on this a number of years ago.

VK: And in that case, in Searstyle, I think behind the banal colors—almond, avocado, java—there is tragedy and the deepest fears of America, the fear of unemployment, the fear of death.

plate no. 6

Q: I remember right about the time you did the Sears show, Sears announced it was shutting down its catalogue business and cutting loose 43,000 people. But what I started to say earlier was that when you talk about art living a real life, living in the environment—one doesn't hear painters talking about that so much these days. Mostly that seems to be a debate limited to architects, and even among them it's a controversy.

VK: This raises an interesting point. Our "People's Choice" installations include graphs in form of very large paintings and sculptures representing some findings of poll. When we were in France, our assistant, a young architect, said that in his view these graphs are the most aesthetic part of the show, that behind beauty and design of these abstract works, we see some truth, some actual fact of life. One could call these works social abstractionism.

The main point is we always try to see the truth behind abstractionism, something bigger than a game. In beginning of seventies we created a conceptual work called *Color Code*. Different colors meant different letters of alphabet, so behind the color strokes there was a conceptual text.

Now I think stylistic similarity between our graphs and postmodern architecture is a real surprise. Neo-expressionism has no similarity to postmodern architecture, yet it appears at same time. Our dream is to work with an architect to put our bar chart and graph sculptures and murals in the public view. These three-dimensional and two-dimensional graphs could be public memorial to the city, state, or community life, and could be designed according to statistical data about our local lives or common human interest.

people in a city (Ben Stafford, Ithaca, art student). Anything original as long as it's happy. I'm tired of being assaulted by dark and dreary artwork (Eliot Marchant, Ithaca, student). Something I

plate no. 7

plate no. 9

plate no. 8

cannot imagine and have never seen before (Nan Smith, Ithaca, architecture student). Geometric configurations of saturated, pure colors in complementary relationships (Leigh George, Atlanta,

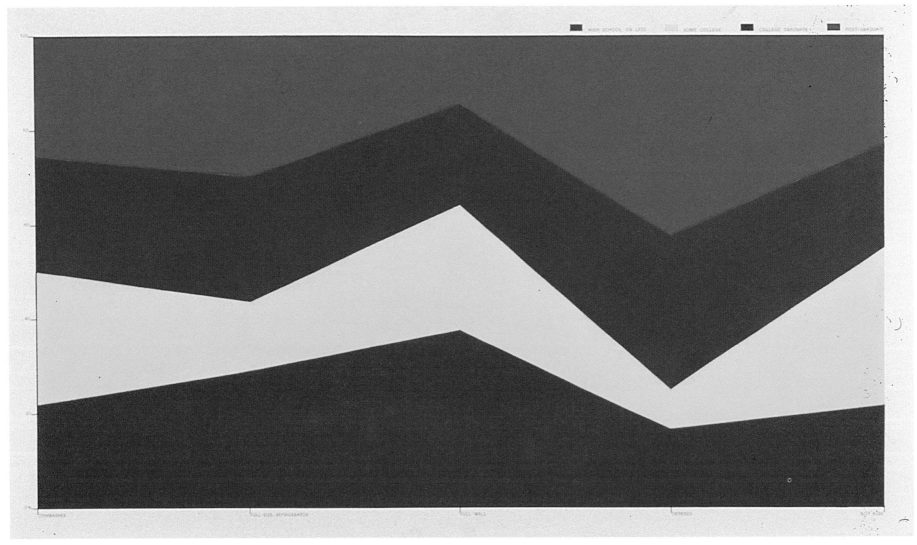

plate no. 10

writer). A Picture of Me (Cheryl Cism, Ithaca, student). Given unlimited resources I would commission the artists to paint my house. That is, I would use my money to have my dream home built

Q: In another vein, on this subject of art and real life, there is one question in the poll in which people are asked what they would commission from their favorite artist if money were no object, and there the biggest single vote is for portraits of their families.

AM: People want private relevance, not only historical relevance. Because art is so far away—in museums, in galleries—how can they get close to it? Maybe if they see their girlfriend in it, their families, their dog. The portrait is a search for personal identity in big art. It's not only big art, great art, but it's my art.

VK: I would say in this case we're talking about collaboration instinct, not instinct to art. Because collaboration is always about joining individualities. And it's important that people think "favorite artist," great artist—not just any artist—because they like to be personally involved in collaboration with something really great. And portrait is only form of representation of this collaboration with greatness.

But I believe even in that question, if you add up all responses, most people want blue landscape. And this is a different, purer form of collaboration. For us, the poll is a form of collaboration with the people, a furthering of concept of collective creativity. The old romantic maxim that it is not genius who must understand the people but rather people who must understand the genius brings to mind the notion of God's inscrutability. But if people were not granted ability to understand God, then God has no compassion for their curiosity. As much as contemporary artists resist the idea, most still think of themselves as mediums for revelation. But will of majority brings divine will into existence; people believe, so God exists, just as statistical averages determine the ideal. If what people love is "kitsch," then kitsch becomes taste of the gods, and everything in the world is either kitsch or a grotesque of it.

Q: In the focus groups, people were mixed as to whether they thought the artist was a genius or whether it's just a matter of having some extra talent.

AM: It's part of the disillusionment of our society, believe me. Hitler came as the last romantic; he came at the end of German romanticism, and he symbolized, he was, *the* German genius. But he didn't invent this. Since the eighteenth century, Germany lived in this belief that the real genius can exist in this world—so either it's Wagner or Goethe or Hitler. And Hitler killed this idea of real genius, because we don't believe in it anymore. So for art in the twentieth century it was Picasso, supposedly: a sheer genius, god, something which can be above every-

and then have the artists paint frescoes on the interior walls, floors, ceilings, to suit the various moods I might be in when I asked for each room. There could be unified themes in certain ones, clashes

thing. But getting older, he made these ridiculous paintings, so we are disillusioned. We say, Okay, so it's genius, but in the first part, not in the second part of life. If you divide your life in two parts, you are not genius anymore. Either you're genius or you're not.

Q: Don't you think, though, there's still something of a cult of personality around artists that eclipses their work? This funny thing happened during the focus groups, where you took part, Alex. At the end the people who knew something about art all asked for an autograph, and the ones that didn't know much about art didn't ask for an autograph.

AM: As I say, it's like remnants of this cult, this romantic cult of genius, which is fading.

Q: How do you respond to those who say this work—the poll, the pictures—is a way of patronizing the public?

AM: That is their projection. You know, almost everyone from art world who comments on this poll sees it as a way of being derogatory to the masses. Isn't it funny?—a blue landscape. Why? We are now planning to do a big show of all these polls by computer. And now talking to the museum about a room full of computers there seems nothing funny. But why should a landscape of computers seem like normal elite art but a landscape of nature seems something funny, lowbrow? There is no sense to this.

Q: Of course, your work is famously satirical; what people sometimes miss is that jokes can be a way of getting to something serious. Throughout this project we've encountered people—readers of *The Nation*, trustees of the Whitney Museum, etc.—who were confused: "Is this serious or is it a put-on, an elaborate, expensive joke?"

VK: This gets back to question of art and life. No one would ask of life, "Is it all serious or all a joke?" because tragedy and comedy coexist in one life. You cannot separate and say it is all one or all the other. It is same with this work, with all our work: it is serious and humorous at the same time, like our life.

AM: And don't forget, there is a truth in every joke. But you mention *Nation*. This is a problem. The left throughout history is notorious for having no sense of humor. Jesus Christ never smiled. Do you know this? And Lenin—no jokes. You can't find any. Even Marx in all his great literary brilliance, there is no humor. Or there is a special kind of humor toward enemies—I call it derisionism. But that's it. That's as far as they could go. That was the problem: there was never cheerfulness in communism.

from wall to wall for others. Grotesque satires like Graceland decor or Billy Joel's "Deep pile carpets and a couple of paintings from Sears." This way I could have a room with bodacious naked

Q: And in capitalism?

AM: I'll tell you this story. We did this huge commission for the lobby of the tallest building in L.A. And it was commissioned by the owner of this building, who owns a lot of skyscrapers—he's a very, very rich man. And in the process for winning this commission, I told him a joke which we said once in Jersey City when we made pictures there for this small Catholic church: "Listen, we are not Michelangelo, but Jersey City is not Rome." I repeated this joke to this guy and he liked it. So at the opening of this wall in L.A., a huge event, he said, Oh, these funny Russian guys, they said a really funny thing, and he repeated this, and of course the audience laughed. So in answer to him, I said, "We're not Michelangelo, that's for sure, and L.A. not Rome, but you're not Medici."

You know, Medici, he was an aristocrat, a very vicious man. But still he was brought up in a certain culture, surrounded by certain pictures. I understand that, as Marx said, the rule of aristocracy had a good side to it. Even if you're idiot-stupid, born stupid, still the culture in which you're surrounded for generations gives you some ability to judge. There was some method of inheriting the culture from generation to generation. And culture in a way made these people more genteel. Plus there were more channels for communication between the classes. This is romanticized in a way, but still there was less of a separation—all people had the same fleas, of course. But with the coming of the bourgeoisie, people who made their money yesterday, people of no culture, judge about everything. There is no cultural chain. Of course, that is capitalism.

Q: So now you have found your Medici with the poll?

AM: This poll just revealed what we're always working on. We'll always serve some people, or someone, maybe unconsciously. So let's do it consciously. Let's serve the people. Stop playing this game that we're freewheeling artists. We're not! We're slaves of the society. We have to find—we have to choose the masters. Unlike in Russia, we have this choice. Because Russian serfs didn't have any choice; the masters were given to them. But here we live in a free society; we can choose our masters. Maybe that's what freedom is—this is a new definition of freedom.

The old romantic notion had this idea of a free spirit, the artist with a capital A; he's free, free of everything, and he imposes his will on the society. If we imagine the society as a pyramid, the only one on top is Stalin, or the Artist; and only one, because these are some special souls, geniuses, the most brilliant people who can achieve—who just jump from the realm of necessity to the realm of freedom. The rest are slaves.

women everywhere, others with more formal still life, others with humorous trompe l'oeil embellishment, rooms that challenged with abstracts and large-format statements, and others that reflect the

Q: I was thinking about the populist aspect of this project and about the landscape —in art and in life—as something that is not the province, physically or intellectually, of any one class. And I wanted to read you a bit from Emerson's "Nature":

> "The charming landscape which I saw this morning is indubitably made up of some twenty or thirty farms. Miller owns this field, Locke that, and Manning the woodland beyond. But none of them owns the landscape. There is a property in the horizon which no man has but he whose eye can integrate all the parts, that is, the poet. This is the best part of these men's farms, yet to this their warranty-deeds give no title. . . . Every rational creature has all nature for his dowry and estate. It is his if he will. He may divest himself of it; he may creep in a corner, and abdicate his kingdom as most men do, but he is entitled to the world by his constitution."

What do you think of that?

VK: It's a nice idea, but I don't know if it applies in real life.

AM: And even Emerson, you see, he cannot help himself; he has to bring in the poet, the special soul.

Q: Well, you're right; that was Emerson's problem.

VK: What I mean is that in real life, in our socialistic experience, if people consider something belongs to everybody, that means it doesn't belong to any one person, so it doesn't belong to them. It belongs to state or something. People always identify public property with someone else. That's why in Soviet Union the parks became so dirty, so people must clean them on Saturdays as part of *subbotnik*—the voluntary (in quotation marks) work program by which everyone did some public works.

On the other hand, now I'm thinking that some of my friends who have a big depression, their private apartment looks like public park—very dirty, very disordered. So maybe something else makes people make graffiti and make dirty public places. Maybe they just try to put it in visual harmony with their internal soul. If they have a disorder in personality, maybe only way to make order is to reflect this personality on reality around them. And then most graffiti is kind of signature. They mark and then they own the building: "It's my property."

serene, uplifting, meditational, or religious styles I have liked, etc. Oh, and one more thing, I might leave a place or two where the artists could do their own bidding with no interference or advice

Q: In relation to American society, though, it seems fair to say that the poll project anticipated the popular revulsion toward the rule of experts, of distant authority. If so many people see government, the established order, as something alien to their lives, maybe it makes sense that they see elite culture in the same way?

AM: Of course, the point is, this culture is totally uninterested in them. You know, we did this picture, *The Jesus Christ of New Jersey*, for the Holy Rosary Church in Jersey City, but it went almost unnoticed outside that Jersey City parish, because art world doesn't believe that something can be done outside of SoHo, or this gallery environment, or something. People do it, but everything which belongs to the gallery or museum is art; that which is outside is not art. It's kitsch, whatever. You know, I am interested in this guy John Noble. He was not the greatest artist in the world, but he was quite a nice realist. He painted marine life, made etchings, and drank in the bars of Bayonne. The biggest collector of his work was, still is, a bartender. He, Noble, was a drunk actually, but for me really interesting. Very romantic of course. He died in 1982, and until his death he lived serving the people of Bayonne and Staten Island, selling and bartering his work. So there's still hope that somewhere there are some people, and some places, that real art is possible. Maybe big art, great art.

Q: In the same way that when you were in the Soviet Union you were painting pictures that countered the official art, do you think that the poll and the pictures that came out of it are a kind of parallel to that in the United States?

AM: Definitely. This is a totally dissident art. Mostly, of course, because of the question, Who are the viewers? Who is the audience? Nobody asks this question.

from me (Lars Washburn, Ithaca, electrician). A huge lizard walking across the Sahara saddled by this guy Phil I know (Jesse N. Hive, Ithaca, emblem of my generation). Katy Sulyman

p a r

painting Katy Sulyman (Katy Sulyman, Marston Mills, Mass., artist). Me driving a Ferrari through the "Octopus" by Caravaggio (Sam S., Cortland, N.Y., social worker). Me playing a

t 2

concert grand piano on a ship on a French lagoon by Dégas (Mike Stevens, Cortland, N.Y., technician). Bierstadt painting Lake Bow, N.H., at sunset with loons (S. Gozzara, Stafford, N.H.,

VOX POP: NOTES ON A PUBLIC CONVERSATION

JoANN WYPIJEWSKI

Mr Escot. *I presume, sir, you are one of those who value an* authority *more than a reason.*

Mr Panscope. *The* authority, *sir, of all these great men, whose works, as well as the whole of the Encyclopaedia Britannica, the entire series of the Monthly Review, the complete set of the Variorum Classics, and the Memoirs of the Academy of Inscriptions, I have read through from beginning to end, deposes, with irrefragable refutation, against your ratiocinative speculations, wherein you seem desirous, by the futile process of analytical dialectics, to subvert the pyramidal structure of synthetically deduced opinions, which have withstood the secular revolutions of physiological disquisition, and which I maintain to be transcendentally self-evident, categorically certain, and syllogistically demonstrable.*

Squire Headlong. *Bravo! Pass the bottle. The very best speech that ever was made.*

Mr Escot. *It has only the slight disadvantage of being unintelligible.*

Mr Panscope. *I am not obliged, sir, as Dr Johnson observed on a similar occasion, to furnish you with an understanding.*

Mr Escot. *I fear, sir, you would have some difficulty in furnishing me with such an article from your own stock.*

Mr Panscope. *'Sdeath, sir, do you question my understanding?*

Mr Escot. *I only question, sir, where I expect a reply; which, from things that have no existence, I am not visionary enough to anticipate.*

Mr Panscope. *I beg leave to observe, sir, that my language was perfectly perspicuous, and etymologically correct; and, I conceive, I have demonstrated what I shall now take the liberty to say in plain terms, that all your opinions are extremely absurd.*

Mr Escot. *I should be sorry, sir, to advance any opinion that you would not find absurd.*

—Thomas Love Peacock, Headlong Hall

retired nurse). A pyramid of cultural contribution with artists, i.e., Hopper, Shahn, etc., at the top and politicians at the bottom looking up (C. N. Gozzara, Stafford, N.H., retired physicist).

Poor Panscope. Not even an honest foolishness can rescue him from the prison of his runic tongue. And poor Squire Headlong, with nothing *but* foolishness. So it was in the nineteenth century; so it is today. But most people faced with Panscopianism are not so slavish as the Squire nor so self-possessed as Mr. Escot. Most of us are just embarrassed.

At least at first. Embarrassment is the point around which the entire public conversation of Komar and Melamid's art poll project has revolved. It is that delicate emotion by which the "out" group—in this case, most of society—attempts to address itself to a subject, art, that is in one sense so close it is part of the air-conditioning system of the culture, and in another sense so remote it seems knowable only through the mastery of a mysterious, often impenetrable language. Embarrassment—how to ask in such a way that people would answer openly—was on the table as Komar and Melamid, the pollsters from Marttila & Kiley, and members of The Nation Institute and *The Nation* magazine constructed the poll questionnaire. It occupied a seat in the Manhattan Opinion Center as the focus groups met to test that questionnaire. It was present, though in something other than its pure, artless form, in the comments of certain knowing writers, critics, connoisseurs, and Internet chatterers after the results had been made public. And, in a kind of reprise of a 1960s practice by which blacks, gays, women, anyone on the outside, would talk about the value of *getting into their oppression*, it was the thing that Komar and Melamid urged audiences at their public meetings to get into, get beyond, flaunt, understand, accept as a part of life, so as to convey to the artists their dreams of the perfect picture.

Those meetings, part carnival, part consciousness-raising, part psychic communion, were as integral to the art work as the poll, the focus groups, the pictures rendered from the results; and if the idea of asking people to tell artists what they want in art seems absurd, one ought ponder the question, Why?

Shift, for a moment, to politics. Back in the summer of 1965 the Student Non-violent Coordinating Committee's major project in the South was a series of conferences titled "Let the People Speak." John Lewis, now a congressman from Georgia, then chairman of SNCC, said, "We want the people to tell us what we can do. We'll do anything they tell us." To all but sworn enemies, Lewis and the rest of the SNCC kids were visionaries. And while I was too young to bear witness, I doubt any of the poor, often unschooled people who gathered in those churches and community halls prefaced their remarks by saying, "I don't know anything about politics, but . . ." Likewise, even in today's degraded form of the town meeting, in which audiences are mustered simply to validate the candidates' claim to the "popular touch," it would be bizarre to hear a participant say: "I don't know anything about macroeconomics, but it's clear that Wall Street calls the shots in everything from Mexico's future to whether I'm going to have a job in a year, with the result that a lot of us feel insecure." In fact, it's probably safe to say that most people would lose their way trying to decipher the special language of economists, macro or micro, but their daily acquaintance with money, goods, labor, and power emboldens them to express their views of the general case with ease.

Where art is the subject, it's just the reverse. In the focus groups the conversation began with color, design, beauty as divined in everyday things. On such matters the participants—a diverse lot drawn from the New York metropolitan area—spoke with confident animation. But as emphasis shifted from those building blocks of art to what Alex Melamid calls "art with a capital A," embarrassment cleared its throat, announced its presence:

> *"How important is art in my life? Not being very knowledgeable in art, I don't place too much importance in it. My art is a nice car or a nice pair of gym shoes . . ."*

> *"I'm not too knowledgeable in art; I mean, I like looking at art . . ."*

Right-fielder Jim Eisenreich (Tom Skyler, Philadelphia, student). A series of portraits of my closest friends, in perfect representational detail, making use of symbolic objects reflecting their lives

"I don't know that much about art. I know what I like, and I know what I appreciate. There are many forms of art that I don't understand, but I enjoy the things I do understand—some of the things that even I don't understand . . ."

"It's important—is that bad?"

"I wish it were [important], but it's not . . ."

"I think the perception is that that's [fine art's] not something the average man can avail himself of . . ."

"For us, the adult, it's too late, but for children . . ."

"I know as a social worker we try to get kids to express themselves artistically and they won't. They don't know how, or they get embarrassed——"

"I was just going to say, you get embarrassed."

Yet embarrassment plays a double game: at once inhibiting speech and granting to the reluctant speaker a plainness of address that often eludes more confident speakers, and is in any case more intriguing because of its unlikely source. Observed from behind the one-way mirror at the Manhattan Opinion Center, the two focus groups had a carousel excitement, as round and round the table voices surprised even their owners with wonder ("Now that I think about it, my whole childhood was bathed in blue") and wit ("He should be nude; he should be six foot four"); irritation ("The entire concept of going to an artist and saying 'I want a painting that will look like this' is ludicrous to me"); the rational calculus of the everyday ("I at first said cash [if given a choice between art and money], but I think I would have to think about it, because if I really, really loved it, I might consider the art. It depends on what bills I need to pay, really"); and fantastic

imagining ("It should be mural-size . . . smooth . . . jewel-like colors . . . a sort of family tree, with those members of my family going as far back as I can remember sort of very large in the background, coming toward the front of the painting with those of us who are now: sort of like a line coming down, and in the front, my children, my children's children").

At one point, flush with exertion, John Marttila, who led the focus groups, stepped behind the glass into the observers' room. "They're in over their heads," he said, quickly gulping some water. The pollster had worried about this project from the beginning—worried that Komar and Melamid were romantic to think everyday people had any interest whatsoever in art, that crafting a poll to plumb such interest, even if it existed, would be immensely, maybe impossibly, complicated ("I appreciate the concept, but it's really *not* like testing a brand of soap"). Ultimately, the curiousness of the project overwhelmed his misgivings. Still, on the afternoon before the focus group session, Marttila had warned Alex Melamid not to expect too much: "It's sort of like watching sausage being made. It's very long and dull."

"There's nothing wrong with watching sausage being made," Alex replied. "I would love to."

Alex was to sit in on the groups, first as a participant of few words ("My name is Alex. I live in Jersey City, and I'm a painter"), then, halfway through, revealing himself as the project's instigator for more direct discussion of what the people desired in terms of style, content, form, size, color intensity. As it turned out, they were not in over their heads; they were just answering questions no one had ever asked them before. It was the first time—awkward, in some ways thrilling, an exercise of unknown capacities. And when they learned Alex was a *real artist*, and that he and Vitaly intended to make of the entire polling process an art work that, by dint of its authorship, would be similarly *real*, there was in the room something of the air of a

and interests—deep, vivid jewel tones preferred and smooth oils, when there is a choice, and natural light—indoors or outdoors depending on the individual (Sara Hivey, Ithaca, writer). It would

Happening, late-style. All of the players, even those who thought the exercise ridiculous, inclined increasingly forward, as if the center of the blank, brown table had become the canvas of their conversation.

Of course, a closed room with coffee, sandwiches, sweets, and a group of responsibly dressed and behaved adults, paid for their time to answer a series of standardized questions more or less in turn, seems the very opposite of the image one would likely conjure from the word "Happening." Blame history. We have exited the time, in America at least, when artists might coax a crowd to extroversion in a public square for a collaborative creative event. But if one intention of the Happening always was to connect art to the currents of real life, its messiness and contradiction, the grand, the vulgar, the briskly mundane, then these focus groups—and to a greater extent the public goings-on Komar and Melamid presided over in Ithaca (of which more later)—surely fit the description.

Back in the high days of Happenings, John Cage said, "For too long art obscured the difference between life and art. Now let life obscure the difference between art and life." What follows, then, are some notes from a life study of this project.

be abstract, modern, and colorful—more like America's Most Unwanted *than* America's Most Wanted *(Ellen Cleckley, Ithaca, student). Van Gogh—with bright, brilliant, dark,*

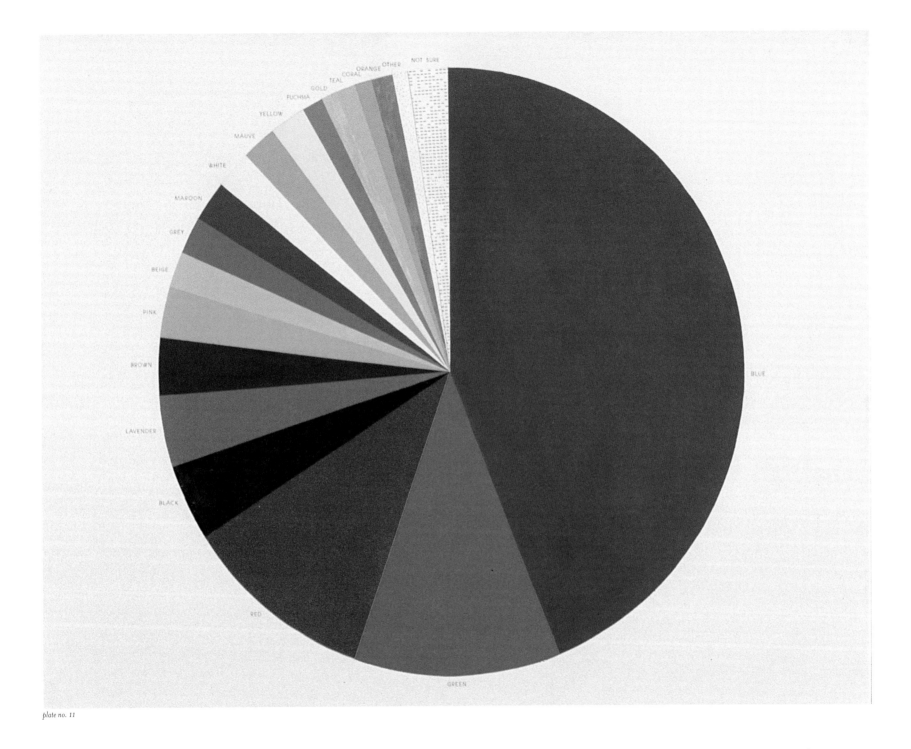

NOT SURE OTHER ORANGE CORAL TEAL GOLD FUCHSIA YELLOW MAUVE WHITE MAROON GREY BEIGE PINK BROWN LAVENDER BLACK RED GREEN BLUE

powerful, imaginative strokes—painting Mount Washington, N.H., at any time of day . . . or do a series of four: dawn, midday, dusk, midnight . . . or me at a stairway at the Met (Suzanne

I.

Start with color, as intimately familiar to humans as our own names. How do we know this? Science can plot the perceptual development of babies as their eyes adjust focus from hazy grays to full spectrum, but as far as determining how that *special* color lodges in the brain, the one the sight of which makes our breath come just a little faster or soothes the aggravated soul, there are no final quantitative guides. It is humanity's little sadness that memory denies to us recapture of that ecstasy of babyhood when color first burst upon the scene.

Forced to navigate without quantitative data, the pollster was naturally skeptical about whether people could answer questions about color with any assurance at all. So it was for him a matter of some relief and not a little surprise when in both focus groups people were able to fire off their favorite colors as effortlessly as entries on a calling card:

> Lorraine, Manhattan, real estate, *green*
> Jackie, Brooklyn, politics, *orange*
> Anthony, Yonkers, computers, *blue*
> Mark, Queens, the post office, *blue*
> David, Manhattan, business, *black*
> Louis, the Bronx, investments, *blue*
> Andrew, Queens, car dealer, *red*
> Tilda, Long Island, receptionist, *pink and red*
> John, Long Island, deckhand, *blue*
> Christine, Queens, secretary, *black and blue*
> Edna, Brooklyn, bookkeeper, *black*

Later, when the poll authoritatively determined that 44 percent of Americans prefer blue, 12 percent green, and so on, and that 82 percent either strongly agree or somewhat agree that "color affects people's moods," John Marttila could finally relax. He hadn't been lured along on some wild-goose chase, after all. Science had come through.

Being artists, as well as members of the public themselves, of course, Komar and Melamid had no such anxieties. Theirs was the certainty of the color professional combined with the generalizing bluster of the amateur. Like most people, they understood that, as a means of communication, color can be far more precise than language. For years, homosexual men have recognized colored bandanas worn in the left or right back pocket as a means of announcing one's desires without all the cumbersome explanation: light blue for oral, navy for anal, black for s/m, red for fisting, yellow for water sports, and so on. Some aficionados of s/m have raised such color coding to a higher plane, developing a totally unambiguous vocabulary: "Yellow, yellow, yellow!" to mean "I'm not sure I like this; maybe we ought to reconsider." "Red, red!" to mean "I'm going to punch you if you continue this one more minute." According to one practitioner of the dialect, "Yes," "No," "I don't think so," are just too prone to misinterpretation in a sexual milieu in which, famously, one thing can mean another—in fact, its opposite. A similarly unambiguous system has been devised by members of the Jesus Seminar, a group of Catholic and Protestant theologians who are assessing passages from the New Testament and various Gnostic gospels for their authenticity. The scholars vote on sections under consideration using colored beads: red for "yes," pink for "probably," gray for "unlikely," and black for "no."

But if color represents a kind of plainspeaking, does it have its own grammar? Is it the long-craved universal language? If a majority out of almost two billion of the world's people prefer blue, do they all read it in the same way as Americans, who typically associate the blue color with such words as

Sallalia, Landaff, N.H., student). A painting of the atomic nucleus (W. Stafford, Andover, Mass., molecular biophysicist). A very flattering portrait of myself, perhaps as a Greek god or

"calm," "tranquil," "peaceful"? And does that mean humanity's aspiration is serenity? What, then, of our idioms? Blue funk. Blue Monday. Got the blues. Tangled up in blue. Is man's fate melancholy, instead—on the assumption that peace is impossible?

Nineteenth-century people took the language of color very seriously. Goethe spent years of painstaking experimentation trying to disprove Newton's wave theory and to isolate the intrinsic qualities of each hue. Far from the essence of calm, he characterized blue as "a stimulating negation," desirable but elusive, exciting but always leaving the viewer empty, wanting more: "As we readily follow an agreeable object that flies from us, so we love to contemplate blue, not because it advances to us, but because it draws us after it." Blue, the color of coquetry.

Goethe invoked science as his authority, but how much, too, was he engaging the vestige of superstition? Some two and a half centuries earlier, indigo was seen as something of a temptation. In 1577, the German crown banned "the newly invented pernicious and deceitful, eating and corrosive dye called the Devil's Dye." This quoted in Derek Jarman's wonderful book *Chroma*, which also instructs us that at the same time in France dyers had to renounce the use of indigo by formal oath; that for two centuries the dye was encumbered by legislative writ; and that it was the Russians who first synthesized the color in the eighteenth century, which puts them in the vanguard of blue liberation.

Komar and Melamid like red—whether out of nostalgia or for its beauty it's difficult to know. The two may be inseparable. Vitaly is fond of speculating that the success of the Bolshevik Revolution may have had something to do with the red flag registering in people's minds as a symbol of beauty, since in Russian *prekrasno* means both "beautiful" and "very red." "'Red Square,'" he points out, "is mistranslation of the West. It should really be 'Beautiful Square.'" I had fully expected that, when polled, Russians would prefer red.

My reasoning was rather crude, the product of visions of red regiments on May Day, red ink staining the globe in cold-war fright maps, red banquettes at the old Russian Tea Room. I had not known then of Russia's role in the early ascendance of blue. This would have been no more valid as an explanation for people's tastes, but, since 31 percent of Russians favor blue, with red a distant third at 10 percent, it would have had the advantage of being right as a predictor.

And where color is concerned, the predictive element—*What will this red dress say?*—is everything. Back when the Romans murdered the mollusks *Purpura* and *Murex* by the millions to extract the ink that would make the imperial purple, they must have had more in mind than simply doing something special for the emperor. Any number of insects, plants, and sea creatures could have been boiled up with as much exertion to deliver a rare hue at a time when white was the universal dress code. But purple—believed to be closer to crimson then—somehow declared regality, godliness. It was a *statement.*

Scratch the public across time and it is the odd individual who insists that color is nothing more than a phenomenon of light. Like folk of the Middle Ages discerning mystical significance behind all of the natural world, we search for color's meaning, shop for associations, and trust in its transcendent power.

> Toni: *"My favorite color is green. . . . It definitely affects people's mood. I'm a social worker and on rainy days I try to wear brighter colors for the benefit of the people coming in. Because when it's dreary, more people tend to be down, so if you wear something that's brighter, people tend to be more aware and awake."*

> Ficino: *"We might ask why the color green is a sight that helps us more than any other, and why it delights us. Green is the middle step in coloring and the most temperate."*

something (Anonymous). A really delicious cheesecake (Eli Browber, Tarrytown, N.Y., student). A painting made out of leaves (Will Nixon, New York City, environmentalist). The woodlands

Gale: *"When I said blue and green, I feel comfortable with these colors. I'm in the car most of the day; it becomes my house. And that's very important to me, the color of a car. I would feel, like, really not comfortable in a car that was—yellow, although when I was younger that was my color, yellow."*

Goethe: *"The eye experiences a distinctly grateful impression from this color [green]. . . . Hence, for rooms to live in constantly, the green color is most generally selected.*

". . . [Yellow] which inclines to green has a something unpleasant in it. . . . By a slight and scarcely perceptible change, the beautiful impression of fire and gold is transformed into one not undeserving the epithet foul; and the color of honor and joy reversed to that of ignominy and aversion. To this impression the yellow hats of bankrupts and the yellow circles on the mantles of Jews may have owed their origin."

Lorraine: *"Green's my favorite color—and I'm wearing green. It reminds me of forests, trees, nature, nice things like that—everything opposite of New York City. It's sort of the getaway color."*

Kandinsky: *"Absolute green is represented by the placid middle notes of a violin."*

If they diverge in elegance of expression, there is nothing very different in the assumptions exhibited by the focus group participants and the famed theorists of color quoted above. (Though I doubt any of the former could duplicate Goethe's observation re Jews.) Nor, for that matter, is it much of a walk from their assumptions to those of fashion entrepreneurs who charge American women substantial sums to "do their colors," thereby determining whether the client is a "Winter," "Spring," "Summer," or "Autumn"—the corresponding spectrums relating to the client's skin tone and psychology, and promising a new and better life.

COLORS

Blue, by far America's favorite color (44%), is most appealing to people in the Central states (50%) between 40 and 49 years of age (49%), conservative (47%), white (46%), male (45%), making $30,000–$39,999 (50%), who are not sure if they'd take the art or the money (51%) and who don't go to museums at all (50%).

The appeal of blue decreases as the level of education increases: 48% of people with high school education or less like blue, as against 34% of postgraduates.

The appeal of red—favored by 11% of Americans—increases with education level: 9% of those with high school or less like red, as against 14% of postgraduates.

Red does best among people in the Northeast (15%). It does better among liberals than conservatives (14% vs. 9%).

Conservatives prefer pink/rose a bit more than liberals (4% vs. 2%), and moderates prefer gray a bit more than either liberals or conservatives (3% vs. 1%).

and pink rocks along the St. Lawrence River (Margaret B. Loe, Watertown, N.Y., retired). My life so far (James J. Gallagher, Sayre, Penn., physician). A cube (J. Showan, New York City,

Much fun has been made of this fad for colors—remember the frantic woman in Michael Moore's *Roger & Me* who spent a small fortune to transform her wardrobe to "Autumn" only to learn later that her color analyst had been a charlatan and she was really a "Spring"? But there is a cultural chain, obscured by class and form and taste, between this pop faith in the spiritual essence of color and highbrow faith of the same order. Wasn't it one of the most *avant* of the avant-garde painters, Malevich, who maintained that color had an intrinsically purifying, beneficent effect? Long before personal color consultants made their entrance in America, Komar and Melamid, then still in the Soviet Union, blurred the difference between the sacred and the mundane with their *Color Therapeutics*. Parodying both Malevich's misty modernist concept and socialist realism's insistence on art-for-improvement's-sake, they lined up twenty-five tiny colored tiles and appended an instruction sheet that declared:

→

COLOR IS A MIGHTY POWER

Free Yourself of All Your Ailments through Colored Plaques

BY GAZING INTENTLY FOR A CERTAIN TIME AT ONE OF OUR PLAQUES
YOUR AILMENT WILL BE OVERCOME BY
A CORRESPONDING COLOR

Our Plaques help in cases of:

DRINKING PROBLEMS—3 min. 7 sec., *dark green*
IMPOTENCE—6 min. 2 sec., *orange*
INFERIORITY COMPLEXES—4 min. 5 sec., *turquoise*
A SWEET TOOTH—2 min. 9 sec., *bright green*
OBESITY—5 min. 5 sec., *mustard*
EMACIATION—5 min. 4 sec., *light brown*
INSOMNIA—4 min. 8 sec., *reddish brown*
NEUROSES—5 min. 9 sec., *olive green*
PREGNANCY—3 min. 8 sec., *blue green*
LAZINESS—1 min. 6 sec., *dark brown*
COLD—2 min. 4 sec., *gold*
ALIENATION—5 min. 9 sec., *rust*

architect). Oh, if Kandinsky were available! . . . something large that would take the eye on a progression over the canvas . . . something to explore . . . Oh, and very little orange at all (April

Today "art therapy" is a real discipline. And psychologists regularly use color and design as interpretive tools. At a mass level, poll results have become *the* means of reading the collective pulse, so after Komar and Melamid made public the findings of the "People's Choice" poll, there was no shortage of media commentary on what it all means in terms of the national character. After registering surprise that three-quarters of Americans have any kind of art in their homes, and skepticism about whether "respondents understood the implications of the term 'original,'" *The Philadelphia Inquirer*'s art critic, Edward J. Sozanski, sniffed:

> *It's true enough, as Melamid observes, that much contemporary art has little to say to ordinary people—but not because art has run out of ideas. Rather, it's because, as the poll indicates, people generally aren't willing to stretch beyond the most conventional, familiar and, let's face it, most banal art. . . .*
>
> *Americans want to be soothed and reassured, not stimulated. They want decoration, not intellectual challenge. Sixty percent of the respondents agreed with this statement: "I only like to look at art that makes me happy."*
>
> *Art hasn't run out of ideas. If anything, contemporary artists have too many ideas. There just isn't much of an audience for any kind of art . . . that traffics in ideas.*

It seems a flawed logic to insist that the poll and the "most wanted" picture have a lot to say about Americans—that they are dull, pedestrian, anti-intellectual—but nothing to say about art. This is what Sozanski implies and what others have said in more dismissive terms. ("I don't think the painting is a statement. . . . The painting doesn't exist to me," declared the director of the Sonnabend Gallery, Antonio Homem. Hilton Kramer was too aghast to say anything at all when casually asked his opinion.)

plate no. 12

Paffrath, Ithaca, student). I'd like to see a representation of regular people being productive and earning a living. Not downtrodden masses, not poets or ballerinas (Kirk Bart, Chatham, N.J.,

It also seems that if an argument is unworthy in its second proposition, it is perhaps unworthy in its first as well. But assuming there *is* a correlation between what people say and how they feel, what does the poll tell us about the national psyche? Language having misled, might color offer some clues?

Browsing through a bookstore, I glanced upon a title, *The Lüscher Color Test*, "the remarkable test that reveals your personality through color." This is the popularized "Quick" version of a more expansive test that first came into use by psychologists in 1947 and that advertises its seriousness via a twelve-page list of scholarly papers, most in German, concerning it. The book warns that "It is NOT a parlor game," but let's pretend that America, as represented by the favorite and second-favorite color preferences indicated in the poll, is taking the Quick Test. The object is to rank eight colored cards in descending order of desirability, and to do this twice in succession. The resulting choices are meant to indicate the chooser's wishes, worries, conflicts, at a particular moment in time.

By this standard, America is an anxious wreck.

It loves blue and green, meaning its greatest hope is for a tranquil environment in which things proceed in orderly fashion, along more or less traditional lines, and in which it has a measure of control over events. It seeks excitement and exhilaration but feels somehow obstructed in its desires, prevented from obtaining those things deemed most essential, and obliged to forgo some pleasures. It can feel satisfaction, but at its back there is a whisper that all might be fleeting. Its choice of yellow in last place or second-to-last place is bad news, indeed, since yellow is the color of the future, of change and hope. "Rejected yellow," according to the test's interpretation tables, suggests alienation and profound insecurity, a sense of hopes disappointed, ground lost, and fear that there may be "no way out." When yellow is in last place, the calm of blue is a distant dream, that "agreeable object that flies from us." And rather than symbolize serenity, it suggests an urgent clinging—to tradition as a hedge against insecurity rather than as simple continuity—and a dis-ease or outright intolerance toward that which is unfamiliar.

All this does sound a bit like astrology, but *what if it were true?* Insecurity? According to the American poll, the lower a person's income the greater the love of blue, and the higher the income the greater the love of the color of money (people who make more than $75,000 a year are three times as likely to favor green as those who make less than $20,000). But all are equal in their distaste of yellow. Now turn to some statistics that are regularly cited as legitimate indicators of national life. For the past two decades the great mass of Americans—80 percent—have seen their futures fade as their wages have fallen or stagnated. Only the top 20 percent have seen their fortunes rise, and of these only the top 1 percent have done extremely well. Since 1979 forty-three million Americans—working class and mid-managerial alike—have seen their jobs be erased. In the private sector, temp agencies are now the biggest employers in the country. Families crack up under the strain, and are offered a Save the Marriage rally for comfort. Meanwhile, great slabs of nature have been sold off to the lords of industry, rivers run foul with mine tailings and timber debris, capital is ruthless, and government remote or actively complicit. Waco. Oklahoma City. Cries for the death penalty, and for the losers' revenge upon the losers. Fear is in the air, and that funny blue landscape is looking a lot more macabre.

Or, metaphorically, a lot more black. Call this vulgar science? Unashamedly. Might there be a truth in it? Undoubtedly. This is America. But just as color is taking a bow for its little exercise in revelation, modern readers might pipe up, *What's that you said about black?*

Ah, black, adamantine and ambiguous, the color of paradox. Dr. Max Lüscher, the Swiss psychologist who devised the Color Test, did so before "the little black dress" made its way into the closets of all classes of women;

retired). A mural that creates a distinction between work that is beneficial for mankind and for the persons themselves and work that is regulated by fear and insecurity and scarcity. You'd have

before Black Power, Black Is Beautiful, Sing It Loud, I'm Black and I'm Proud; before black had become the color of Style. He saw only the color of negation. The poll shines a tiny light onto the split nature of black. Those with incomes under $20,000 are twice as likely to prefer black as those with incomes over $75,000. But those who go to museums most are also about twice as likely to prefer black as those who don't go at all. And blacks, Hispanics, and other minorities are far more partial to black than whites. Although blacks say black is their *favorite* color at the same rate as the entire poll population (4 percent), when it comes to a *second-favorite* color, 19 percent choose black, as against only 5 percent of whites who do. Among Hispanics, black is tied with red in the favorite-color category at 11 percent.

Growing up in the 1960s, I took black to be the color of strength and a beautiful defiance—also of beautiful economy, since for thrift's sake my mother mostly wore two black dresses, one for winter, one for summer, and always looked stunning. So I immediately identified with something I heard from Regina Martino, an African-American who participated in the focus groups. A collector of African art and an exuberant lover of black history and heritage, she works a regular job for a realtor in order to travel the world and pursue African dance without starving. She has gone to Africa every year for the past fifteen years, and has also seen China, Japan, and other Asian countries. She has performed with the company Malaki Ma Kongo in such forward settings as the Brooklyn Academy of Music, but the first word that comes to mind when she hears the word "art," she says, is "underpaid."

"Unless you become Great, and that's very few people, art is always something like second class. You have to love the art, because no matter how long you're at it—and I've been dancing twenty-five years—no matter how good you are, you'll almost never make enough at it even just to *live*."

Black is her favorite color. "I think it's rich. I think it's ready. I think it's elegant. I think it's finished. And I like to always be rich, elegant, ready—though not finished."

But history and physics still bind us to black and doom, black and nothingness. Black clouds. Black Death. The Black Hundreds. The SS perfectly tailored in black. Black Monday. Black Holes. A friend of mine named Greg Beals told me a story from down in Georgia during the '96 Republican primary. He was covering the Buchanan campaign for *Newsweek* and got to talking with one Buchanan supporter, a white man who used to be a service-station mechanic and now works in a furniture factory. Greg asked if he had a Confederate bandana. "No," the man said. "My bandana is black. My T-shirt is black. I wear black for the underprivileged people, for the poor people, for the people who's got their own beliefs. That's just my color. I've got a black car, a black truck, my living-room furniture is black, my kitchen is black. It's the truth."

So black it's blue.

the heavens contrasted with the underworld, and in the middle you'd have a little child doing something in the nature of finger-painting. And that child is moving in two possible directions: one is

What do YOU want...

Photo ©Teri Slotkin, 1990

...to see in a painting?
Tell artists Komar & Melamid — they'll paint it.

The People's Choice
Town Meeting
Thursday, Oct. 27, 7:15 p.m.

St. John's Episcopal Church, 210 Cayuga St., Ithaca

Come to the meeting and you could win...$250 cash...dinner for two
at OldPort Harbour...or a signed lithograph by the Artists!

The People's Choice exhibit and town meetings are sponsored by the Herbert F. Johnson Museum of Art,
The Goldsen Fund: Images and Society, the NY State Council for the Humanities, *The Ithaca Times*,
The Nation Institute, the Alternative Museum, and the Cornell Art Department.

Ithaca Pennysaver

A professional advertising service distributed free to over 32,000 homes in the Ithaca area. October 19 - 25, 1994

Car Care
Section
Coming Next
Week - Ad
Deadline Fri.,
Oct. 21st

INDEX

SPECIAL GUIDES
Auctions & Family Sales 12
Automotive 24-27
Daycare 8
Electronics/Computers 8
Employment 7-8
Family Health, Beauty ,
 Fitness 13
Farm, Livestock, Pets 11
FCPNY 20
For the Community 14-15
Furniture & Appliances 6-7
Lawn, Garden & Snow 7
Professional Connection .10-11
Real Estate 17
Recreation & Sports 24
Services 8-9
Travel & Leisure 16
Wining, Dining, Entertainment
..................................... 16

SPECIAL COUPONS
Reader Ad Forms 20-21
Eagle Hotel 16
Agway Energy 8
Kost Tire 4
Cayuga Chrysler 22
Phone Exchanges 9
Zip Codes 20
Rock River Model Hobbies ..24

INSERTS
P&C (P)
Shursave (P)
Render's Choice (P)
P - Partial Distribution; F - Full

SPECIAL FEATURES
Big Buck Contest 22-23
Manufactured Housing 18-19

Ithaca Pennysaver

Published by:
Tri-Village Pennysaver, Inc.
Offices located at:
Clinton West Plaza
Ithaca, NY 14850
and 15 Geneva St.
P. O. Box 416
Interlaken, NY 14847
TO PLACE ADVERTISING
Classified Ads 607-273-1611
............. 607-532-4320, 387-6885
Business Ads
Ithaca Area 607-273-1611
Tri-Village Area 387-6885
................................ 532-4320
Printing 607-532-4320
FAX - Tri-Village 607-532-9557
FAX - Ithaca 607-273-6248
TOTAL CIRCULATION 31,590
Mailed and carrier delivered to
homes in Tompkins, Seneca, Tioga,
Schuyler and Chemung counties.
NOTICE: The Tri-Village Pennysaver, Inc.
reserves the right to edit or reject any mate-
rial. The Tri-Village Pennysaver does not
assume financial responsibility for typo-
graphical errors in advertisements. How-
ever, when notified promptly of an error we
will furnish the advertiser a letter to be
shown to customers, acknowledging such
error, and will reprint in its next edition that
portion of the advertisement in which the ty-
pographical error occurred.

Used Cars & Trucks Sale

Only At CUTTING MOTORS

Best Selection
Best Quality
Best Backed

TOP DOLLAR FOR TRADES • HURRY IN!

WISE BUYS

90 Honda Accord Coupe DX
#8376, 5spd., air & more, 1 owner
$7,900 or $196/Mo.

91 Honda Civic CRX
#8399, 1 owner local, excellent
condition, 29,000 miles
$6,995 or $155/Mo.

90 Buick LeSabre LTD
#8499, leather seat, se seat on both
sides, loaded, like new
$8,900 or $209/Mo.

91 Geo Metro
#8457, high gas mileage, low
insurance, reliable
$4,900 or $108/Mo.

92 Pontiac Transport
#8566, 7 pass., V6, loaded
$13,400 or $274/Mo.

92 Buick LeSabre Custom
#8467, 1 owner, loaded, 35K
$13,500 or $276/Mo.

93 Chevy 4x4 Pickup
#8542, V8, like new
$16,995 or $348/Mo.

90 Chevy Conversion Van #8474,
V8, must be seen, loaded, spotless
$11,925 or $296/Mo.

HERE'S JUST A FEW OF OUR QUALITY USED VEHICLES AVAILABLE!

84 Mercury Cougar
#8578, absolutely spotless,
leather seat, 1 owner 40K mi.
$3,900

87 Pontiac Bonneville
#8550, bucket seat, p. seat,
1 owner, 56K, spotless
$7,900

88 Ford Crown Victoria
#8386, 1 owner, loaded,
V8, 67K
$4,995

89 Buick Skylark LTD
#8564, V6, p. seat, loaded,
1 owner, 62K
$6,500

89 Olds Delta 88
Brougham #8548, 1
owner, 3.8L MPFI, loaded
$7,900

88 Nissan Sentra XE
#8529, 4 dr., auto., air, very
nice, excellent condition
$4,900

88 Nissan Sentra XE
Hatchback, #8535, 5 spd.,
4 dr., air & more
$4,900

88 Honda Prelude SI
#8529, fully loaded, 1
owner, only 33K
$8,995

93 Pontiac Grand Prix
SE Coupe #8491, bucket
seat, p. seat, 1 owner, 12K
$14,400

93 Buick Park Ave
#6406, fully loaded, low
miles
$18,995

94 Buick Park Ave
#8451, leather seat, dual
p.seat, dual climate control
$20,900

94 Buick Park Ave
#6452, cloth seat, loaded
$20,500

91 Chrysler New
Yorker 5th Ave #8560, 1
owner, loaded, just like new
$11,900

91 Olds Cutlass Su-
preme S #8547, 4 dr.,
auto., V6, air, 40K, more!
$9,900

91 Buick Regal Custom
#8496, 1 owner, 4 dr., auto.,
air, cass., cruise, etc.
$7,900

91 Chevy Lumina
#8575, V6, auto., air,
cruise, loaded, 1 owner
$10,900

92 Olds Cutlass Su-
preme S #8582, 4 dr.,
V6, air, p. windows
$10,900

92 Chevy Cavalier
#8540, 4 dr., auto., air,
cass., & more, 36K
$8,400

92 Chevy Lumina
Eurosport #8553, V6,
bucket seat
$9,900

94 Buick Skylark
#6471, V6, auto., air, cruise
$11,995

92 Olds Delta 88
Royal #8504, 1 owner,
loaded
$13,500

93 Ford Taurus GL
#6396, 4 dr., V6, loaded
$12,900

91 Buick Park Ave
#8568, like brand new, leather
seat, dual p. seat, 22K
$15,500

93 Chevy Lumina Euro
#8524, V6, bucket seat,
fully loaded
$11,900

TRUCKS & MINIVANS

94 Safari XT AWD
#6474, loaded, family
minivan, almost new
$20,500

88 Nissan Pickup
#8571, auto., p. steering &
brakes
$3,995

91 Olds Bravada
AWD 4x4 #8580, leather
seat, security system, loaded
$17,995

93 Chevy Blazer 4x4
LT Tahoe, 4.3L CPI V6,
leather seat, remote entry, CD
$19,995

93 Chevy S-10 Tahoe
#8539, V6, loaded, only 30K
$8,900

93 Safari XT
#5384, 4.3L, V6, 8 pass.,
loaded
$13,995

90 Mazda MPV
Minivan 4x4 (AWD)
#8565, 7 pass., 1 owner, local
$12,900

92 Chevy 1/2 Ton
Work Truck #8456, V6,
air & more
$9,900

91 Ford Ranger XLT
#8362, V6, loaded
$7,900

90 Chevy Silverado
#8537, V8, fully loaded
$10,945

89 GMC Sierra
#8433, V6, work truck,
bedliner, new tires, nice truck
$7,995

85 Chevy 4x4
#8506, auto., nice truck,
great condition
$5,900

*All prices plus tax, title &
registration. Payments are
based on tax down. Please
see us for further detail

CUTTING MOTORS

BUICK • PONTIAC • GMC

315 Elmira Rd.
Ithaca
607-273-5080

plate no. 13

toward a kind of underworld and very dark-colored area until they wind up as an adult and they're a prison guard; and in the other direction, as they mature they become, in luminescent colors, a

2.

The sky in Ithaca, New York, already had something of winter in it when Komar and Melamid arrived there in late October of 1994: silver and gray with slashes of blue—"so much like watercolor," Vitaly would remark. They were late, and at Cornell University's Herbert F. Johnson Museum of Art about eighty people were waiting for them in the lobby, amid a striking display of *America's Most Wanted* and *Unwanted*, several giant paintings that look a little like Color Field works but are actually graphic representations of statistics from the poll, and a pair of charts blown up in three dimensions. Matthew Armstrong, then a curator at the museum and the man who had persuaded the artists to come to Ithaca, hastened them to a balcony overlooking the crowd.

"Hey guys," Alex began, a little staggered by the tight mass of students and professors, museum workers, journalists, and camera crews below. "I am Alex Melamid. I feel like Lenin standing on the steps at St. Petersburg. But I am not Lenin, and Ithaca is not St. Petersburg." The crowd laughed, and he went on to discuss the ideas behind the "People's Choice" project. Aware that the assembled included folk from Cornell's art history, American history, Russian studies, statistics, and anthropology departments, Vitaly interjected, "We need a new art history, from bottom up, with new names, new faces."

If they could not be Lenin expounding revolution from the steps of Madame Kashinskaya's house, the allusion was nevertheless a bit more than a good opening line. They were, after all, talking about the cultural poverty of elite art from the bower of an elite institution, one that makes all the right liberal gestures to "the community" but finally speaks a totally separate language

and is happy to keep it that way. By the end of their three-day stay, Komar and Melamid would upend a lot of notions about how art is talked about and by whom.

Ithaca, in the state's Finger Lakes region, lies in a valley at the head of Cayuga Lake and stretches up onto the slopes of the surrounding hills. It is known chiefly for Cornell and the three creeks, Fall, Cascadilla, and Six Mile, that cut deep gorges into the hills and tumble dramatically down and through the town. The countryside beyond presents leafy groves, rolling farms, waterfalls higher than any other this side of the Rockies, and big skies well attended to by God's lighting crew. It is, in other words, a good place to shop for landscape. Also a good place, a diverse place, to talk about art. Komar and Melamid went there because, like politicians just starting out, they wanted to test their message on a small market. It was their Louisiana straw poll, their Iowa caucus. And Matthew Armstrong was their campaign manager.

Armstrong is a disarming guy, puckish but with icy blue eyes capable of expressing as much bitter judgment as mirth. A few years earlier in New York, he'd worked on the Museum of Modern Art's "High & Low" show; when it came to organizing "The People's Choice" in Ithaca, he went at it with a rolled-up-sleeve kind of media savvy common to politics but utterly unknown in the art world. He brought the show to the Johnson from New York's Alternative Museum, but the exhibition was to be only background scenery for another show—the public conversation the artists planned to conduct at two "town meetings," one on the Cornell campus and the other at an Episcopal church downtown. For that show, Armstrong had to build a crowd.

He'd convinced *The Ithaca Times*, a local weekly, to sponsor the event, and its first story, splashed across the cover, appeared in May of 1994. By October and in the weeks after Komar and Melamid's visit, every town and gown

boat builder and sail away (Michael, Seattle). Naked women. Lots of them (Anonymous). A massive painting (120' x 14') that would be like a cave painting but of modern imagery. Showing

paper was talking about it. The story was the top of page one—next to news of Burt Lancaster's death and above Princess Di's visit to D.C. and "Chemical seeping from CU radioactive waste site"—in *The Ithaca Journal* for October 22. "Russians to offer art taste test," the city's only daily paper announced; then directed readers to four stories inside with coverage ranging from Cornell art-censorship controversies to Ithacans' view on public art and architecture to "Russian artists' schedule."

For radio, Armstrong and his intern, Joel Jablonski, built a sixty-second spot:

> "I *could have painted* that*!" [PAUSE]*
>
> *Have* you *ever seen something at an art museum, and said, "I could have painted that!"? . . . Yeah? . . . Then what do* you *think should be in a painting? Cayuga Lake? a still life with cookies? a* really *good-lookin' . . . no, wait,* you *tell* us*!*

and arranged for it to run 142 times over seven days on six stations. He got his "candidates" on the number-one radio talk show in town, and he arranged for Bob Harris, at Ithaca College's TV production department, to assign a video crew to follow the artists everywhere. Even if there had been no tape in the cameras, Armstrong thought, "just their presence, and the lights, the big microphones, lends an overblown theatrical imperative to everything." Meanwhile, Professor John Bunge's statistics students at Cornell's School of Industrial and Labor Relations had polled Ithaca residents, using a shortened form of the Marttila & Kiley questionnaire. Those townsfolk may have later opened the *Ithaca Pennysaver* ("distributed to over 32,000 homes") to see the full-page ad on the back beckoning them to the downtown meeting. Or perhaps they glanced through *The Shopper*, where the same ad appeared opposite notices for Jepson Power Tools, Grisamore Farms apple picking and pumpkin painting, Draperies by Judy, Lew Farkas (Decks, Porches, "and everything in between"), Agway, and Coal FOR SALE: $120 Ton.

Over at St. John's Episcopal, where the October 27 meeting would be held, Rector Philip Snyder (whose motto appears to be "Not everyone is your cup of tea, but there will be a cup of tea for everyone!") ran an announcement in the church bulletin with a graphic counterposing the onion dome of St. Basil's in Moscow and the steeple of St. John's. And on the grounds of Cornell, fliers for the October 26 on-campus meeting began sprouting, customized with hand-lettered exhortations: "All Tastes Are Created Equal" and "You Have Nothing to Lose but Your Voice."

Armstrong ran the campaign with the exuberance of a flatbed traveling show, and it all worked. For a few days art lived a real life. It circulated in the commercial ether with every other commodity people need or don't need, want or don't want, sample or decide to pass up. It was background noise or an alluring attraction, but either way it spoke in a familiar voice. *Retail, honey!*—only it was all free. Komar and Melamid's idea, the conceptual work, became appealing as advertising in the same way that Andy Warhol's reproduced ads for storm doors and cooking pots and drills had become appealing as art, with the difference that in humbling art to the everyday, it romanticized neither one, and so made a common conversation possible. And unlike Bill Clinton, whose techniques of salesmanship they mimicked, the artists were not actually selling anything: the three hundred people who came to participate in the town meetings would not be required to pay for their participation later. So you might say Komar and Melamid undercut the essential function of "the sell" even as they embraced the form.

In the process, they were also hitting close to home. Like Big Politics, Big Art never commences anymore without advertising, and it is almost always crass. Not cheap. In fact, it's quite expensive: think of the Picasso T-shirts, the Matisse tote bags, the corporate logos attached to each blockbuster show, and everyone's secret reason for visiting the palaces of art, the museum shop. Cheapness has a pure pride in its low estate. It says, I may be a whore, but I know what I am. Crassness is a rich kid gone slumming; something is

Ithaca's natural beauty and its changing population. The painting should be grand in scale and placed in a public area (K. MacGeraughty, Ithaca, graphic designer). A three-mile-long scrap-

always off. This is Big Art's embarrassment: it needs the crowds and the bucks but is so distant from the culture of homely hucksterism that the best it can do is mimic Disney. And no one thinks the language of Disney is the language of life, however much they might patronize it. In real life, surface and depth are more intimate.

About midway through the first public meeting, at the Hollis E. Cornell Auditorium, a man stood up to give his vision of the perfect painting:

> I would put some history of Ithaca into the picture. NCR was big here for a long time. Ithaca Gun was here for a long time. I worked there almost twenty-five years; it's gone. And all you see there is a smokestack, and I think that should be involved in it. Elijah Cornell had a pottery factory at the bottom of Fall Creek, with the falls behind it. In the fall, you know, with the leaves coming down—real pretty colors. And Cornell in the background. You can see all of that from downtown. I see it because I live there. So, like, if you have Cornell in the background and maybe somehow blend Cayuga Lake into it, or Buttermilk Falls or something like that, with the Fall Creek and maybe an old rusted building with a little waterwheel on it. And maybe a smoke-stack, you know, back of that. There's a lot of history that people in this town would relate to. . . . The Indians paint more pictures; [they have] a truck that goes to all these truck shows, car shows, and if you look at this picture you'll see about five thou-sand faces all in this picture. And you can add that in, you can take a picture of a wolf and blend it into rocks—you know what I mean? You got to give it depth but history also, because back in the sixties, you know, we used to drive up State Street—State Street's gone—with my Corvette and all this and that. It was a red Corvette; I had two, two red ones. But I used to drive around Cornell and there was a guy that graduated from Cornell, he had a Cobra AC 427. We'd go down to Stewart Park, and we'd look up and see all of this—it was beautiful in the fall. So that's what I'd like to see, some kind of history. Maybe an airplane in there, because we used to build airplanes here too.

Alex and Vitaly were in the well of the auditorium, looking up at the audience. Behind them, a woman noted people's visions on a blackboard. They were a sequence of dreams or memories, things lost, things to be preserved against loss. "Nature with an edge, nature with danger." Beguiling nature, disclosing its details only slowly. Lizards, and then "the animals that eat the lizards." Ithaca as it is. "Water, just water, in a breeze." Abstract blues and greens—"Anselm Kiefer without the depression." A game of Ultimate Frisbee in a panorama in which a moment (the game itself), common time (the Cornell campus), and the timeless (the heavens) are all captured in their essence. A street in Troy, New York, where some of the stairs lead to nowhere because the places have been torn down. A perky boat on a clear blue lake.

As people spoke, Alex fired questions: how big? huge? can you show me in this room? what do you mean "emotion," "communication"? how blue? as blue as my jacket? what kind of nature? wilderness or like a park? I am sorry, what is this Ultimate Frisbee? is there a book? And as kinetic as Alex was, so Vitaly was still—like some pure Freudian, listening, weighing the words and images as they tumbled forth.

From time to time someone spoke with a striking clarity:

> It's very realistic. It's a picture in either late fall or early spring of an old-fashioned hillside farm. And the viewer is looking down on it, and when you look down on it you see a nice, realistic picture of an old-fashioned hillside farm. But the more you look at it you realize that it's very imperfect, in the same way that everybody is imperfect. And the more you look at it, the more you'll see the unfinished business of life: the clothing hanging on the washline, half of which was taken down and the rest never quite got taken down. Or the car in the driveway that has a flat tire. Lots of little details of all the things that we screw up, but you have to look at it over and over again in order to see them all. . . . The painting would be textured, but the more textured it is the less detail you'd be able to see, so it can't be too much. I guess it would be like small crumbs. . . . And if it's late fall or early spring the colors would be browns and grays. The earth will be brown and most of the old buildings would prob-ably be very gray—unpainted wood tends to be very gray.

metal wall with images of the world's greatest graffiti in black and white (Alex, Ithaca, student). I would like to have Michelangelo create a painting in three stages: (1) the capture of slaves in

Toward the end, one man gave an extremely detailed description of an ice-scape, very bleak, on which reclined a nude woman, "like Manet's Olympia." This prompted a woman to say she'd like to see "a small grouping of trees, and sitting on a picnic blanket there are two nude males serving wine to two women who are dressed."

"I like this painting," Alex said. "And these women, what kind of dress are they dressed in?"

"Just, like, a white shirt with black pants."

"So they are both dressed the same way. And men are just athletic, or ugly, old, you know, with huge bellies, or nice, athletic young males—what do you prefer? What age?"

"About thirty-five, getting a little soft; but they haven't lost all their definition yet."

"So two women dressed the same way, approximately the same age. And two men, naked the same way and approximately the same age. All right, I understand . . . So, is that it? Are we finished?"

After one man said he hoped Komar and Melamid could combine all of the images offered that night into one painting that would nevertheless not be disjointed, Alex said, "I feel like a sultan in a harem; I am sure that there will be people who will not be satisfied fully," and that was the end of the evening.

At the Johnson Museum the next day we looked through the comments of visitors to the show. Armstrong had made books of blank sheets with the question "If you had unlimited resources and could commission your favorite artist to paint anything you wanted, what would it be?" These were now covered with handwriting and fingerprints, and were, to me, mesmerizing. Like pages from someone else's diary they seemed exposed, and I turned from one to the next with a snooper's excitement. "Of course, it is the form," Alex noted. "If we were now standing in front of a computer, content would be totally changed."

He was talking about the physical reality of the thing, and anyone who has ever tried to write a love letter on a computer can surely understand the truth in that. But from the beginning of this project and throughout the events in Ithaca the mutability of perception had been a constant theme. At a Cornell art class that morning, Alex related how as a boy he had loved Rembrandt's *Man with the Golden Helmet*. When he learned it was the work of someone other than Rembrandt, he was disappointed in it. Why? The picture had not changed; his love had changed, but it was irrational. In a different way, when he went to Rome and finally saw the ceiling of the Sistine Chapel, he was also disappointed. Since childhood, his only knowledge of the work had been from a poor black-and-white reproduction. It was the photograph that he had fallen in love with, that had influenced him, that he carried around in his head; the original could never unseat childhood's wondrous first encounter. He might also have told them the story of Hans van Meergeren, one of the most illuminating parables on the vagaries of quality and "meaningful aesthetic experience," a phrase that would be bandied about later that night at the church. Earlier in the century, as recounted by Glenn Gould, van Meergeren decided to paint some pictures in the style of his countryman Vermeer, which he successfully passed off as the real thing, to public hosannas and his own substantial enrichment. He was hailed as a national success for having discovered this cache of masterpieces, until he began selling them to the Gestapo, who were building the collection of Hermann Goering. After the war he was tried as a collaborator, but argued in his own defense that the pictures were fakes, therefore worthless, therefore he had actually cheated the Nazis, therefore he should go free. He nearly became a hero all over again until the art historians who'd

West Africa; (2) the Middle Passage with a large cross-section of a ship and a surrealistic sky with the body count of on-ship mortalities represented by body bags and souls; and (3) the selling of

first certified the pictures as originals began to realize the extent of their own humiliation and declared that van Meergeren was guilty of a crime against art and the artistic life of the Dutch nation, and demanded that he be returned to jail at once. As Gould concluded, "He was, and he died there."

As it happened, the art students seemed indifferent to the issues of quality, perception, the role of the public, and the purpose of art, so it was a relief to leave there and go on to John Bunge's statistics class. One felt on firm ground with numbers, even if the equations scrawled across the blackboard were mysteries. Alex and Vitaly had wanted to thank the students for con-ducting the poll in Ithaca, which found the locals generally in sync with the nation except on the question of serious or festive (they are serious), relax-ing or confusing (they don't mind confusion), art or money (they'd take the art), and whether they "only like to look at art that makes [them] happy" (they disagree). In Cornell's statistics circles the art poll was already on its way to legendary status, partly because of its oddity and partly because stu-dents almost never have an opportunity to apply their theoretical work in a way that then presents a visible result. There in the class, as the ubiquitous video crew jostled for space and strove to maneuver microphones, the stu-dents tried to answer questions about sample size and confidence levels; Bunge covered the blackboard with more obscure formulae; and Komar and Melamid, delighted to see Science at work, passed out signed handmade charts measuring "Nudity by Political Self-Identification."

At one point Vitaly turned to Bunge and said, "Please to explain to me: as I understand, if I ate one chicken and Alex ate no chicken, you'd say that I ate half-chicken and Alex ate half-chicken even as Alex goes hungry." To which the professor replied authoritatively, "Well, it depends on what you're measuring. In this case, what's important is the global consumption of chickens, not how any individual consumes. So the statistic tells you some-thing; it doesn't tell you everything."

On the road again in the blue Ford Windstar van, headed for lunch with the mayor, Vitaly ruminated on the irresolvability of this partial way of knowing. "Maybe we have to work as psychiatrists—one on one. Maybe there is no other way to know." The contradiction of those half-chickens was vexing. Fortunately, we ate Italian with Mayor Ben Nichols, a socialist, who regaled the table with tales of his experience with the New Deal's National Youth Administration in the thirties. Also present was Reverend Snyder. "Here we have the Church and the State," Armstrong said merrily, and, picking up the check, "the Market."

Later, as if that morning's discussion had continued running on some silent tape in his head, Alex said: "If you look at individuals, even individuals in small group, you will never find the answer. Behavior of the masses is differ-ent from behavior of individuals. But still the nation behaves *in some way*. Why the country as a whole acts in this way when each person alone would act another way? It's a totally unresolved problem. Coming from Russia, I think: Stalin? Was I responsible for Stalin? No, that's ridiculous. Were my parents responsible? Maybe so, but logic tells you they cannot be. These things are not the work of individuals. And so when we talk about what the people want, we mean the People and not individual people. Of course, individual people want this and that, but the People—the masses—want some-thing too, and it can be totally different. That's what makes the result of this poll interesting. The *nation* wants it. It doesn't matter what individuals want. It's about the masses."

So why the town meetings? Why the interrogations dredging up individual dreams and desires when the numbers are so cool, so adamant in their sin-gular ability to represent the mass? The analogy to a technocrat's political campaign goes only so far. Back of "The People's Choice" is also a utopian notion—the perfect painting for the perfect public. And back of all utopian notions is a problem—the necessity of perfection fantasies as against their futility. Without them, action is impossible, revolution unthinkable, and the

blacks in the South set on an aerial map of the U.S.A. (Sheila Goldfarb, Ithaca, housewife). A football scene showing the Bills win the Super Bowl (Andrew Alexander, Ithaca, elementary school

status quo supreme. But perfection attained means revolution denied, permanently; in other words, the exchange of one intolerable situation for another. Nobody really chooses Heaven over Earth, even if they believe they'll be happy once they get there. Happiness itself is conceivable only because we know sadness. And the revolutionary imagination can sustain the idea of "the masses," the faith in their transformative power for good, only so long as it recognizes their capacity for creative messiness, for danger and contradiction. Jesus knew this and established an imperfect church. I'm not sure any such thinking went into the choice of a church for Komar and Melamid's October 27 public meeting, but the more questions they asked, the further they got from any possible ideal.

"How to talk to the people?" Vitaly and Alex had asked from the very beginning, and the question took on practical dimension at St. John's parish hall, where the art poll entourage, by then grown to seven people, ate dinner the night of the meeting. Reverend Snyder had invited us to the weekly Loaves and Fishes supper, which the church provides free to anyone in Ithaca who wants a meal. "You can meet some people there," he'd said. In some abstract sense one always believes that a neutral language, indifferent to race and class and position, exists. But, like most everyone else in the room that night, we sat shyly among dinner companions for whom this meal was a necessity. I remember thinking back to a moment in the focus groups when John Marttila asked the participants whether, from among various types of persons, they'd pick the artist as one they'd most enjoy having dinner with. A woman named Tilda, a receptionist, had answered: "Well, I don't know what we would have in common. How would we communicate? I know nothing about art."

"But would you like to know about an artist?" Alex asked her.

"Well, would you like to know about what I do in my life?" she replied.

Alex smiled with recognition, as one suddenly reminded that people learn to speak to each other across gulfs only awkwardly, and there is no derision in self-consciousness about differences; in fact, it may be the only honest approach.

At dinner a young man from Ecuador responded to Alex and Vitaly's accent, immigrant to immigrant. He had been in the merchant marine, then came to Ithaca on a job tip that failed, and now, landlocked and broke, was trying to plot his next move. He'd once met a Russian sailor, he said, who'd taught him some curses and something from Shakespeare he couldn't quite remember.

Byt' ili ne byt'? Vot v chyom vopros, Alex offered.

"To be or not to be? That is the question." He wrote it down on a napkin, and the Ecuadorean and I practiced our delivery.

opposite: plate no. 14

student). Bob Marley (Isaiah Rossiter, Ithaca, age eight). Crocodiles devouring people gorily (Vinnie, Trumansburg, N.Y., kid). My bedroom ceiling like the Sistine Chapel by Michelangelo

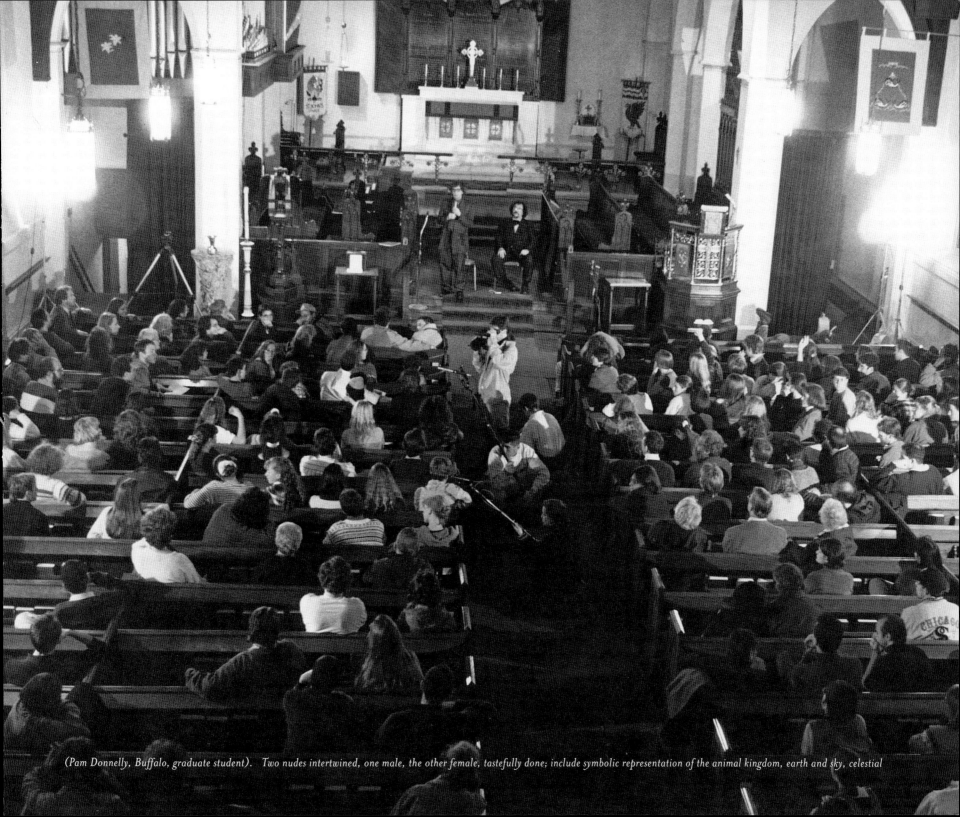

(Pam Donnelly, Buffalo, graduate student). Two nudes intertwined, one male, the other female, tastefully done; include symbolic representation of the animal kingdom, earth and sky, celestial

Inside the church, Gothic Revival with a Protestant disdain for ornamentation, the pews were filling up. By the time Armstrong began the proceedings, two hundred people were seated the length of the nave. There were more children and old people than had been at Cornell, and the social mix appeared more varied. Komar and Melamid started off by saying they came "as technical workers—as plumbers, house painters" to do the people's bidding, but positioned as they were in front of the chancel, they could not dispel the image of themselves as priests. And whether because of the solemnity of the setting or because of Vitaly's suggestion that the audience consult its night dreams, there was a misty quality to people's speech, one which, before long, shifted Alex into an inquisitorial mode.

> Woman: *"Very often when I think of things that are beautiful, I see things that are in Ithaca . . . and sometimes I think it would be nice to see a painting which represented the four seasons, different aspects of all those seasons at one time. . . . and maybe [it would have] even the aspect of allowing the person to be* in *the painting so that you could really have the virtual reality of smelling the flowers, or being able to pick the apple or something like that, possibly even see the sprites that are living in the trees and the other beings that are around."*

> Melamid: *"But it's interesting: you started out saying you see Ithaca, right? But you live already in this painting. You already can smell the flowers——"*

> Woman: *"But not in the other seasons—the snow and the flowers at the same time."*

> Melamid: *"Wow. You want us to bring all seasons into Ithaca at once? I mean . . . But if we're talking about smaller goals, imagine it's on a painting. Would you believe that painting can depict what you see without actually smelling like reality or bearing fruits? Would you think art has a power to fool you? to make an illusion of something which you want to see?"*

> Woman: *"Yes."*

> Melamid: *"So in that case there will be no real fruits and no real flowers, and the smell will be bad, because paints smell bad. But regardless of that, you somehow think you could see real fruits and real flowers. Do you agree that it is possible in principle? Do you believe in the power of art to such a degree that it can make this illusion out of reality? Because I'm not sure that art can be as good as you describe."*

I couldn't see if Reverend Snyder was fidgeting as others spoke of doors that open onto real landscapes, moonlight that obscures the silhouette of a flying cat, "scars . . . cuts, lacerations" each of which has a story, or—this last the vision of a young boy—"a deep red curtain, and then coming closer there would be a lake and surrounding the lake there would be black candles with flames jumping right up from them." But to my Catholic heart time seemed suddenly to hurtle backward, to a period before Reformationist severity was even conceivable, when the floors and vaults and niches of cathedrals were rich with allegory, and a community's artists and artisans patched together the things of their life, their faith, their fears, and the natural world into a monument of mystery and disclosure. Armstrong had welcomed the people with a bow to the Church's historic role as a patron of art. Who could blame them now if their words began to tint the whitewashed walls of St. John's Episcopal with the gaudy, mystical colors of the medieval Church of Rome?

There were descriptions enough of common landscapes—with common cathedrals, and monkeys, boats, bald eagles, and familiar buildings—to content the secular soul. And enough public art—murals, for courtyards or museum walls—to satisfy the civic-minded. But some people couldn't help seeing the artist as spiritual medium. "I'd like you to look at me and know what I want," said one man. "I've got to get a feeling, *any* feeling," a woman insisted. "It could be emotional conflict; it could be awe. . . . what you wish to convey is up to you. I want just to look at it and feel something."

bodies, plant kingdom, balance, water; colors are earthy tones emphasizing blue, specks of gold (Joanne Lyson, Manchester, N.H., physical therapist). A human form entwined with a wild bird-

"Yeah, but you know," Alex replied, "I don't think it works this way. You know, the great German philosopher Immanuel Kant said that art doesn't work this way. Emotions are inside of us. And a painting is an object. And we put into the painting *our* emotions. Emotions don't exist in a painting. You demand from art too much. You think [we] can put something in it, and then you will get emotional. I understand your thing, but I don't think art exists as a reason for emotion. It's something different. I'm not sure what, but it's something different."

Another woman, an art student, suggested that irony seemed to be contemporary art's purpose. Alex asked her to explain. She floundered. He goaded her: "You know, you can define 'ironic' if you believe that something is really absolutely serious. To understand irony you have to have really deep beliefs—in something, which is not ironic. And if you say that you think art is ironic these days, what kind of belief do you have? What is not ironic? What is really great art?" She floundered some more, and some more.

"You are an art major," he said, "and I am talking now as almost a professor. The point is, what really bothered us for years, especially among people who just started working as artists, is the lack of clear thinking. Because we know a lot of words about art, and we are immersed in these words— 'dichotomy,' whatever. And we presume these words have meanings. And they do have meanings, but when we build a phrase of these words it has no meaning at all. We were very disciplined because our English is very poor and was even worse when we first came here. And for us it was very important to speak up, to say something. We knew very few words, so we needed to say it in few words. And now I understand, if you cannot say something in simple terms, this something doesn't exist. It has no meaning. Only simple things are vital; difficult things don't exist. Even in science, everywhere, if you cannot say something simple—and *you* cannot, because you're saying these words which were not getting into any clear, sensitive idea—so better

not to talk . . . Or learn Russian, you know, and after two months of studying Russian, think and speak about art in Russian."

The evening returned to a lighthearted note, and in the end there were door prizes and clowning. The grand prize was a choice of art or money; the winner chose art, after consulting his wife. Komar and Melamid held up two silkscreen angels on rusted metal—a diptych they'd made a few years earlier, based on their work for the lobby of the First Interstate Bancorp building in Los Angeles. Now these *Urban Angels* floated in the chancel, with only the legs of the artists visible below. The camera lights flashed; the sound people pivoted their microphone extensions like miniature cranes away from the crowd, finally left to its own musings. The mayor, the reverend, Armstrong, were all well pleased. Outside, the cool night carried aloft sentenceless phrases, fragments of images—might it be true that the best work of art is the work that we believe in?

animal—the species is not important. The forms should begin to meld into one another to represent an ideal state of life where all creatures live harmoniously. The background also begins to merge

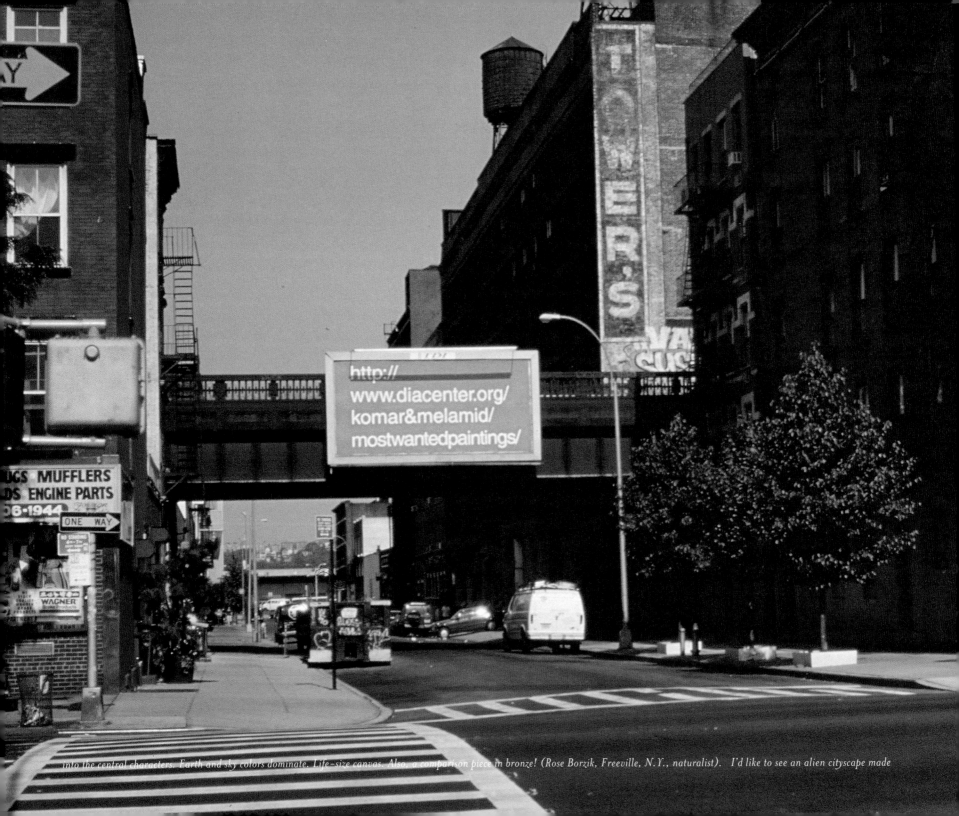

into the central characters. Earth and sky colors dominate. Life-size canvas. Also, a comparison piece in bronze! (Rose Borzik, Freeville, N.Y., naturalist). I'd like to see an alien cityscape made

3.

Noam Chomsky once asked an artist friend to paint him a picture. It would be a beachscape, he explained, not unlike those of the North Atlantic so familiar to him—kind of moody, unpeopled, with an old boat pulled up on the sand. She told him he was hopelessly provincial, an illiterate artistically; but, being his friend, agreed to indulge his simple desires.

He was not surprised at all by the way people answered Komar and Melamid's polls. Landscapes, he mused, seem a natural point of return once humanity has reached the end of its creative capacity with paint and brush. He said this matter-of-factly. As I remember it: since humans have mastered the problems of color, perspective, and representation and, that done, have pushed to the limits of color, form, and abstraction, maybe we've gone as far forward on this particular road as our internal wiring will allow. It's nothing tragic; technically speaking, Homo sapiens can do only so much. Besides, landscapes can be quite pleasant.

Pleasure . . . Roll the word gently across your tongue; it didn't see much service in the cognoscenti's discussion of this project.

Not long after *The Nation* published the results of the poll and a chat with Alex Melamid (Vitaly had been out of town), some far-flung artists got together on the Internet to talk about it. There was enthusiasm and disapproval, mixed, but mostly the participants seemed preoccupied with the question of whether artists should care about producing work that people will like; and mostly they agreed that what people "like" (always in quotation marks) is simplistic, illegitimate, even cynical as a line of inquiry. As one concluded, "Komar & Melamid's survey is about 'pictures' not about 'art.' Art takes a little more work."

Flash forward to a panel discussion at the New York School of Visual Arts in December of 1994. David Ross, director of the Whitney Museum and an avowed fan of the poll as a concept, said:

> Perhaps the reason why it's so unlikely that we're all sitting here talking about American taste, or about public taste and its role in relationship to art, is that in fact it's irrelevant. And it's an invention, and if this exhibition and this project in its elaborate use of scientific methodology and a kind of vocabulary of scientism proves anything to us, it's that we can construct a very elaborate set of arguments to allow us to believe that taste not only exists but exists as a defining character of culture both here in the U.S. and anywhere else in the world. In fact, as we know, taste is the last resort of those who are seeking to define or impose their will in a situation where aesthetic decision-making must be done. It essentially is meaningless on a broad public level because it is a series of questions that function in a private sphere in an arena of low consequence but are almost impossible to transfer to a public sphere of high consequence with any serious precision. Therefore, when you ask questions about preference in color, preference in form, preference of the compositional content of works of art, what we're doing is we're playing with people's predispositions and presumptions about what something we can talk about as art—but in fact has nothing to do with art—is.

A little later came Dore Ashton, who observed:

> I think that talking about what the people want is absurd, and I think that they [Komar and Melamid] know it is absurd. I hope they do, anyway. But it's interesting that so many of us are here to talk about what the people want.

> My father was a person of the Depression, and there was a lot of talk about what the people wanted and, of course, they never got it—whoever the people were. As a historian, I'd like to remind you that this is not new. And these things have been met head on by intellectuals for many centuries. . . .

from a combination of rare metals and rocks. The rocks could be used to display the run-down areas and the metals to accentuate the ritzy areas; gems could be used for "neon areas" (Sheridan

In the Bauhaus, the problems that they had with the burghers, especially in Weimar, had to do with taste, if that's what you're going to call it. It turned out that it was not a problem of taste but that that was a cover-up for their problem with the state. Not the state but one of the divisions of the state which was supporting the Weimar bauhaus. It turned out that they didn't want any of these "alien elements" in the Bauhaus, and sometimes I think that the capitulation of Gropius to those people was a mistake. He didn't come to terms with the real threat to artists. He thought he could set up an enclave of wonderful-looking individualism—which the town hated, by the way, and that same town today I'm sure is using every kind of utilitarian utensil designed in the Bauhaus. There is no reason to pander to the state, and this is what— if you give the people what they want, which, of course, is absurd—then that would just pander to the state. . . .

When you heard Senator Helms telling people, "This is what your taxes paid for," and if you're aware of history and you happened to see, for instance, the "Entartete Kunst"—the art exhibition which was in California and Washington and I forget where else—all of the exhibits in the original show in Germany in 1938 had little signs next to them saying, "This is what your taxes paid for." I think we have to bear that in mind. The people is what these senators think that they are patrolling, and we really have to not fall into that.

It's always bracing to bring Hitler into a discussion; on the same panel an artist named Luis Cavnitzer seconded Ashton in comparing the poll project to the Führer's famous "Degenerate Art" exhibition and then went further, concluding that *America's Most Wanted* is "anti-art." But from my seat in the auditorium I thought how far away Ithaca seemed.

Certainly, those New York panelists all made a lunge in the direction of something they called democracy and the responsibility of the artist to an audience. But I couldn't help hearing the scold of Authority in the one's declaration of "the idiocy of these blue landscapes," in the other's insistence that "in any truly democratic society . . . there is never 'a society,'" in the

third's analogy between the poll's questions and "asking illiterate people to judge poetry."

Illiterate people judged Shakespeare all the time in his day. They had little patience for *Troilus and Cressida* (one of my favorites), just like so many critics and producers today. They loved *Lear*, which has lost none of its honor over the centuries. Why should painting be so different? Why the assumption that public taste must be base, possibly evil, perhaps even irrelevant? If "literate people" could love landscapes without fear of ridicule a hundred years ago, why should a preference for "outdoor scenes," for "realistic-looking" pictures, for representations of "lakes, rivers, oceans, and seas," now be, as one cybercritic put it, a sign of "how dismal this country's view of art is"? And why did the audience at the School of Visual Arts titter as soon as Komar and Melamid told them, without irony, that people the world over seem to have a blue landscape in their head? Why did so many readers of *The Nation* and visitors to the Dia Center's World Wide Website on the art poll—in both cases disproportionately well-educated, liberal, and museum-loving—see in the poll results a mandate for missionary work among the backward masses? In this, then, how different are their impulses from those of Jesse Helms himself?

Polls may not end up getting people what they want in the best of all possible worlds (if one candidate leads another in opinion surveys, does that mean Americans cannot imagine *any better choice*?); but, judging by the enthusiasm with which they are greeted, polls do offer something. And that something may be as simple as the satisfaction of having been counted.

The operators hired by Marttila & Kiley to conduct the art poll reported a spirited response on the other end of the phone lines. People may have been skeptical about whether it was all for real, they said, but in the main they took the journey through the questions with curiosity and even a sense of delight. This, actually, is how most people I encounter respond

Rawlins, Boston, software designer). Residential interior, sunset, lots of plants . . . nothing political, easy to match furniture to (Jennifer Chun, Ithaca, student). Leonardo da Vinci painting

to any poll. They know the choices are never complete; they know the results will not fully represent their individual opinion; they distrust pollsters in particular and the statistical method of knowing in general—yet they answer. And in another place and time they won't hesitate to repeat statistics gathered in exactly the same way to bolster their side of an argument.

The vulgar explanation for this is that the masses have become a programmed, unthinking herd; polls have replaced the polity and imprisoned the best to the benefit of the worst, etc., etc. More charitably, it is said that answering polls has simply become a kind of national fad. Between December 1, 1993, and March 31, 1994—the period in which the Komar and Melamid/Nation Institute poll was conducted and reported publicly—the American press and electronic media discussed polls at least 31,589 times. That works out to about 263 times a day, which means that a lot of people had to consent to answer an awful lot of questions—on matters as various as belief in heaven and hell (only 5 percent of believers expect the fiery pit for themselves), attitude toward the CIA (52 percent, unfavorable), sympathy for wife beater/penis amputee John Wayne Bobbitt (52 percent, none), biggest national anxieties (26 percent, the economy/jobs), and American pizza consumption (100 acres a day).

Clearly, people like polls or they wouldn't participate. Americans, Komar and Melamid often remark, are unusual in their eagerness to tell strangers what they think about almost anything. The problem with the pure-fad theory and the unthinking-herd theory is that neither one accounts for the fact that, consciously or unconsciously, people often take a more dialectical approach to these things.

About a year after the findings of the art poll were reported, Harvard's Joan Shorenstein Center at the Kennedy School of Government issued a paper (unrelated) called "Painting-by-Numbers Journalism: How Reader Surveys and Focus Groups Subvert a Democratic Press." Its author, Alison Carper, bemoaned the newspaper business's reliance on poll data to determine its coverage of the day's events, and by way of contrast constructed a picture of the pre-polling past in which the press was fearlessly independent, bold in its discussion of unpopular subjects, a guardian of democracy against the buffets of powerful interests all round. In the same way, every election season some liberal pundit makes sentimental whimperings about American politics in the days before it was "hijacked" by the calculations of pollsters. And, indeed, on the World Wide Web, commentators presumed a purer time in taking Komar and Melamid to task for debasing art and "buying into" market supremacy. From where most people stand, though, it's pretty clear that all of those Golden Ages are fictions: by and large the press has always been power's concubine, the political process has always been manipulated and exclusionary, high art has always had an intimate relationship with money and the whims of a very specialized market. People know this. But society being a collaborative enterprise—however constrained or corrupted—they still look for their openings, strive to be heard, suspend disbelief in a way, so as to feel part of some embracing culture. Polling may be a charade of democracy, but consider the alternatives to hand.

Japanese art—samurai warriors, swords, etc. (David Sireenian, Ridgewood, N.J., stock boy). A big bonfire with people sitting around it having fun in a wood (Amanda Finch, Horseheads,

The art world itself has not particularly encouraged what Vitaly Komar calls this "instinct to collaboration." It wasn't that long ago that an upswell of popular protest succeeded in evicting Richard Serra's *Tilted Arc* from New York City's Federal Plaza. To so many in the art world, none of the popular complaints mattered—not the fact that Serra's sculptural wall of rusted steel impeded people walking across the plaza, not the fact that it plunged half the square in shadow and destroyed the view across open space for people allowed an hour's lunchtime freedom from the confines of their offices, certainly not the fact that the public that had to live with it in that particular location did not find it pleasurable. The public was simply ignorant, and the city's removal of the sculpture an act of censorship. It's just a statistic, but according to Komar and Melamid's American poll, a belief in the public's right to participate in decisions about public art declines as one moves up the social ladder. About 74 percent of those who make less than $30,000 a year and those in the smallest minority groups think citizens should have a say; whereas a slim majority (54 percent) of those who make more than $75,000 a year think the same, and 42 percent of respondents in that category think citizens should have no say at all. Similarly, barely half (51 percent) of those who go to museums twice a year think people should have a say, compared with almost three-quarters (72 percent) of those who go less than once a year. So who is the philistine?

But let's not think about collaboration so narrowly. Cast back to that woman in the Ithaca church who wanted a painting that would make her feel the snow's cold and smell the fragrance of spring flowers at the same time. On one level, she was simply participating in a public meeting. On another, to the extent that her vision of seasonal dissonance corresponded to the combination icescape-and-picnic-scene-with-nudes that eventually made it into *Ithaca's Most Wanted*, she was participating in the construction of an actual painting. But on a further level, one more oblique to the process by which art is created and enjoyed, she was imagining herself physically within the art work.

I thought this bizarre until, attending more closely to what people say, I realized it is landscape's special power to invite the viewer in—and perhaps its special pleasure as well.

By coincidence, Chicago University Press published a book called *Inside Culture* at exactly the same time that Komar and Melamid's "People's Choice" opened in New York. David Halle, a sociologist, documented the artistic content of people's homes from New York's Upper East Side (the golden 10021 zip code, which alone fills more political treasure chests than each of twenty-four states) to Brooklyn's working-class and immigrant Greenpoint section to upper-middle-class and working-class neighborhoods of Long Island. What he found by personal interview and investigation animates the poll's plain numbers: across class and race and profession, people like landscapes best. Traditional scenes of mountains, meadows, oceans, skies, whether executed by masters or by homeowners' grown children, are displayed in greater number, in more homes, and with more prominence than any other art works. Beyond that, "landscapes" tend to be what people say they "see" when they look at their abstract pictures.

But unlike abstractions, whose exclusively higher-class and well-educated owners seem most to appreciate for "decorative" effect, conventional landscapes provoke in people an imaginative leap into another dimension. One after another, Halle's subjects told him: "I like it because it's tranquil. No one bothers you"; or because looking at a sandy horizon was like "being there, lying on the beach"; or because one could experience the sensation of "walking through the meadow or having a picnic there."

I have known squatters in parts of New York City most alien to nature who'd covered whole walls with photographs or murals of field and stream. I have seen the same on the walls of cramped trailer homes in the South. In one of the focus groups a Long Island woman named Gale told Alex, "I just saw on TV the other day *A River Runs Through It*, and I was in awe at the scenery of this

N.Y.). Scenes of Acadia National Park—along the coastline preferably with a lighthouse on a sunny day with cumulus clouds, by Monet or da Vinci (Maria Satko, Cheltenham, Penn., R.N.). A

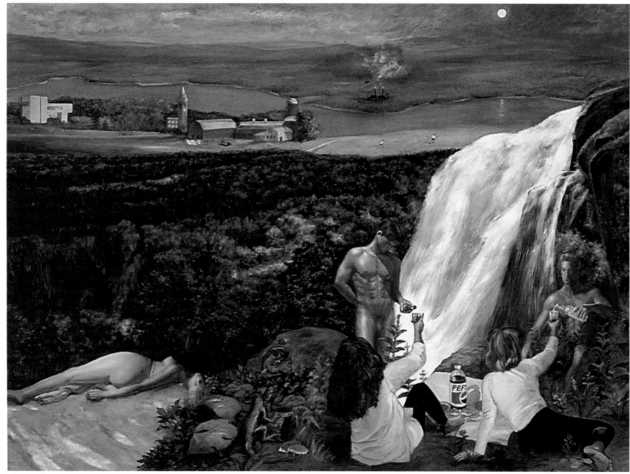

plate no. 16

portrait of a black female Labrador retriever in a hunting, woodland, or marsh scene! (Larry Saulsgiver, Ithaca, electrical technician). I would have the artist paint a huge mural the size of the

country. See, I would like to have something like that in my house—any one of those scenes." The impulse to lasso nature, subtract its danger, and bring it inside only to enter it again is not a contemporary phenomenon. In the late nineteenth century a German aesthete named Jakob von Falke, so worried by the popularity of illusion in home decor, warned against "attempting to make a room appear something quite other than it is, by decorative means." Such a "violation of truth and unity," he wrote, would exact a heavy penalty:

> *Having sinned against the ideal, we should soon find that the outraged ideal would avenge itself. If we painted a wood or a grove upon our walls, however skillfully, successfully, and deceptively, the sight of the real forest, with its play of air and light, and of the real flower-garden, which we can freely enjoy, would soon render our artificial wood and garden tedious, wearisome, and vexatious.*

Von Falke, who intended his *Art in the House* as a bible on the harmonious deployment of color, drapery, furnishing, and art work, despised white walls, photographs, lithographs, murals of any kind ("The wall has its own rights, which must be respected"). He felt defeated by the rise of "easel-painting," which, once let into the house, would refuse to play the subordinate role of decoration but would instead "exercise complete control over the wall." What might he make of contemporary aesthetic choices? It's amusing to think that von Falke—whose taste for dark walls, decorative borders, a couple of seventeenth-century portraits, a nice coat of arms, a knight's shield with spears, was repudiated by modernism—might today be less distressed by minimalist rooms adorned with abstract pictures than by walls bearing landscapes which their viewers regard as a dreamy, even anarchic escape from his idealized room.

Such rigidity aside, what are nonbelievers to make of people's vivid relationships to nature painting? Like one who reads into the photograph of a distant lover a private narrative that the picture alone offers nothing to sup-

port, the active admirer of landscape seems a fantasist or a fool to anyone not so inclined. Rivers actually flow, lizards actually creep, and the moment seemingly frozen is not immune to disruption. Halle reports that the landscapes his subjects preferred were almost totally depopulated. Why?

> *"You don't want people there to pollute nature; they'll throw around their garbage."*

> *"It's good no one is there. Otherwise, they'd probably have built a condominium by now!"*

> *"It's more peaceful, and people would spoil it. Yesterday we went to Cedar Island; people had thrown broken bottles and babies' diapers all around."*

In the focus groups most people who liked landscapes also tended to imagine them empty.

> *"I work with people all day; I don't want to deal with them when I get home."*

> *"Maybe there's too much thinking involved in looking at a painting with people. Because then maybe, depending on your mood, you're wondering, 'Well, how would that person feel? What would this person say?' Whereas, if you're looking at something without people, you can just put yourself in there and go with it."*

America's Most Wanted features people because, when polled, the majority did not reject the idea of people. Whether those same respondents also wanted landscapes we can't be sure, but in taking a postcard of the painting around to shops and malls and housing complexes in various cities, I was intrigued by how many strangers almost reflexively placed their thumbs over the images of George Washington and the family group, and echoed the sentiment of a New York man who said, "To tell you the truth, if it were like this it would be perfect." At the Newport Centre Mall in New Jersey the manager of Art Expo—surrounded by angels and Elvis, Victorian bouquets and black

Hoover Dam—maybe on the Hoover Dam—incorporating objects from the world, almost like a mosaic of the world, the car parts, mirrors, logs, etc. With deep, vibrant colors on the picture—they

musicians, patios in primary colors, abstract reliefs in black with metallic and muddy pink projectiles, desert landscapes with gigantic textured moons—told me he could certainly sell *America's Most Wanted* but, "I'll be honest, George Washington will be a problem for our immigrant customers; they'll have a hard time seeing themselves in there with him."

Absurd? Not if one thinks harder about this instinct to collaboration. In 1994, Umberto Eco gave the Norton Lectures at Harvard and took as his subject the role of the reader. These have been published under the title *Six Walks in the Fictional Woods*. At one point, illustrating the phenomenon whereby the reader of fiction must "suspend disbelief about some things but not about others"—that is, he must accept that imaginary events are really happening without completely abandoning what he knows of lived reality—Eco tells a story about King Vittorio Emanuele III, the last king of Italy. It seems that the king, a man not given to cultural pursuits, was to open a painting exhibition. He arrived, found himself before a beautiful landscape showing a hillside village, which he regarded for a long time. Finally he turned to the exhibition's director and asked, "How many inhabitants does it have?" Left just like that, the story is a marvelous joke, but Eco, extracting it from the frame in which visual art is usually perceived, writes:

> Given that the boundaries between what we have to believe in and what we don't are pretty ambiguous . . . how can we condemn poor old Vittorio Emanuele? If he was merely supposed to admire the aesthetic elements of the picture (its colors, the quality of the perspective), he was quite wrong to ask how many inhabitants the village had. But if he entered it as one enters a fictional world and imagined himself wandering through those hills, why shouldn't he have asked himself whom he would meet there and whether he might find a quiet little inn? Given that the picture was probably a realistic one, why should he have thought that the village was uninhabited, or plagued by nightmares à la Lovecraft? This is really the attraction in every fiction, whether verbal or visual. Such a work encloses us within the boundaries of its world and leads us, one way or another, to take it seriously.

Like Vittorio Emanuele, that woman in the Ithaca church begins to make an odd kind of sense. What is assumed, naturally, is that the artist, the author, the critic, takes his audience seriously as well, that collaboration moves in two directions. The art poll and associated events were not designed to test that proposition, so it is left to others to determine. But having observed the audience side of this exchange, I've been occasionally stunned by just how seriously, how generously, uncredentialed citizens seem to take art and artists, regardless of whether they like the work.

Long after the focus groups met, I asked one of the participants, Thelma Armstrong (no relation to Matthew), how she judged art. "In life, in any given situation, I can tell you the difference between good and bad immediately," she said, "no matter what the question; but in art, who can say?" We batted this around a bit, and I said I thought anything that was pretentious, that was fraudulent, dishonest, was bad art. She thought about this, then said, "Well, I have to deal with pretentious and fraudulent people every day, and so I think that is part of life. So maybe art that is pretentious just expresses that part of life."

I had gone to visit Thelma with Alex Melamid and Katya Arnold, Alex's wife, also an artist. The three of us were struck by the Zen-like nature of her answer, particularly as it was delivered in the same high-spirited, easy manner in which she described recipes from her native Guyana or told the stories behind the pictures and objects that cover almost every surface of her house in the East Flatbush section of Brooklyn. None of the enemies of the blue landscape whom we had encountered over the years talked like this.

As it happens, Thelma herself is not a particular partisan of the blue landscape. In her home such landscapes as one sees are dominated by people— women at work in an African village, an old man hauling water on a Korean street, Japanese women in a traditional setting, a Taino warrior, original

can be abstract—showing love, goodness, beauty, and suffering—as much of the panoply of creation as can conceivably fit on the Hoover Dam. The best way to paint this would be to hire thousands

inhabitant of the Caribbean, in the brush, an American Indian on horseback, a black jazzman on the trumpet, a black child among some flowers—"my daughter," she said, with wistful facetiousness—photographs of her two sons, her husband, her extended family members. Hanging in a hallway was the oddest construction we had ever seen: a group of "panels" of successively smaller size linked together by string, the panels themselves made of tongue depressors pieced together and brightly painted, with the portrait of a woman in the center of a flower. Thelma explained that it had been a gift from an Indian student with whom she had worked at the New School for Social Research in Manhattan. His father is a doctor, she said, which accounts for the tongue depressors. "And do you recognize the woman?" We didn't. "It's an homage to Georgia O'Keeffe—but, since he is Indian, Georgia O'Keeffe resembles Indira Gandhi."

Like Regina Martino, whom I visited earlier, Thelma seems to work to travel. She has seen so many countries, on so many continents, that she has forgotten all their names. It is tempting to regard the masks and pipes and statues and paintings around her house as a collection of souvenirs, and certainly that is part of the story, but between trinketry and timelessness the line is not so absolute. From Venice she'd brought some glass candies with lovely striated colors and delicately turned "wrappers." In Venetian shops, bowls brim with these samples of the commercial glassblower's art. From China, she'd brought a lady's traveling writing box from the last century. Its cover is etched and inlaid with mother of pearl; sloped for maximum comfort when open and in use. Inside, there is a little inkwell—its leather cover bears a faded miniature of a dog's head—as well as compartments of graduated size for writing papers, seals, an ivory-and-gold pen encased in leather fastened with metal hooks. On the palimpsest, a rosy velvet now frayed and faded to orange at the crease, one can begin to construct a narrative. Who made this? Who used it? What was the contour of her life? How did she sit as she wrote, and did the ink ever splash onto the page when the carriage hit

a bump? What was the content of her messages—her accounts, her loves, her agitations, her thoughts? For the same reason that people in museums puzzle over letters or bracelets or bits of pottery from ancient times, Thelma looks upon the art in her house—high, low, it makes no difference—and is linked to the past and present real life of the world. Like the palimpsest, the pieces themselves are blank, neutral; upon their surfaces she is free to write her associations.

In the focus group Thelma had been more precise than most about her ideal painting, an ancestral portrait, mural-size, containing the faces of family members as far back as she can trace. One of twelve children, she remembers the walls of her mother's house in Guyana painted pale pink and bare of anything but a few family photos. "Even as a child I collected things that I loved, that I thought were beautiful—my mother called it clutter. Oh, and I always wanted to sing, I wanted to dance! But that was never encouraged. Not only was it not encouraged, it was actively suppressed." Thelma came to Brooklyn with her husband, Bill, in 1969, "and I still dreamed of dancing, but assimilation takes so much time, you put those more frivolous dreams aside." Bill worked in computers for Manufacturers Hanover Bank until the mid-1980s, when he was laid off—"this was the beginning of 'downsizing' in America, and he was on the cutting edge." Now he works as a lineman for NYNEX and, off the job, applies himself to cooking and gardening, talents he discovered while out of work.

Katya, Alex, Thelma, and I were having lunch in a Guyanese restaurant, chatting back and forth about families, Caribbean spices, Russia, the O.J. trial, when this cheerful, vivacious woman confided, "As a citizen and a woman I just feel completely defenseless, completely unprotected, as if I have no recourse, no recourse whatsoever. That's the most difficult thing about this society, to know that no one really has any recourse." She was speaking of an existential rather than physical insecurity, and of the appar-

of out-of-work people to represent the world as best they can on some specified square footage of space. That way, more people would get to represent the world as they experience it and thus share

ent lack of answers. "New York—who can solve the problems? Whoever is in office, whatever they try, they fail." Earlier, I had asked her what she thought of *America's Most Wanted* and, like so many before her, she'd said, "Well, it's very safe. And the whole world wants this? Naturally, the whole world wants peace."

I must confess a real fondness for *America's Most Wanted*, but I have never been able to see it in terms of peace or serenity or even painting per se. To me it exists mostly as the postcard I've been carrying around, and in its colors and forms are all these contradictions, all these jangly conversations, all these faceted personalities, all the logistics of the poll, all the comments of furniture-department salesmen and fake-tapestry hawkers and print-shop owners who supply art to people every day. ("Twenty years ago, this would have been pure gold," a guy in SoHo who sells mostly 3-D pictures to tourists told me.) It is discordant like the focus groups, like the town meetings, like anything that is collectively created. It looks nothing like motel paintings, or like the landscapes the late Bob Ross would teach his public-TV audience to paint in twenty-six minutes, or like the pictures on sale at places like Penney's or Stern's (where the culture of potpourri and Victoriana is firmly in control). It looks nothing like a Hudson River School painting or even like a Finger Lakes School painting either, though somehow people I've spoken with have seen it contain all of these things. When Komar and Melamid unveiled *Ithaca's Most Wanted* in the spring following the public meetings in that town, the man who had hoped that the picture would reflect Ithaca's history asked if Alex would pose for a photo with his children, and said, "Thank you. You have given us exactly what we wanted." I'm not sure how many people in Ithaca would agree, and I don't know anyone who's said that about the national picture. Maybe it doesn't matter. After all, no one has ever, will ever, could ever actually hear the *Vox populi*, but still it exists.

their experience with others (Lisa Rivera, Ithaca, student). A picture of aliens in a spaceship, or a lot of Pulsars Chargers, Drig Trackers, and a few Sonar Securities (Tim Karplus, Ithaca, age

p a r

seven). I would want Jackson Pollock to paint me a copy of his Lavender Mist. *Actually, anything by Jackson Pollock would be fine (Dan Hirschman, Ithaca, student).* Something

t 3

shimmering, vivid, brilliant colors, play with light, activity and stillness, touching, breathtaking, nudes, children, musical instruments, fruit, angels, small or enormous, tangible. Make it real

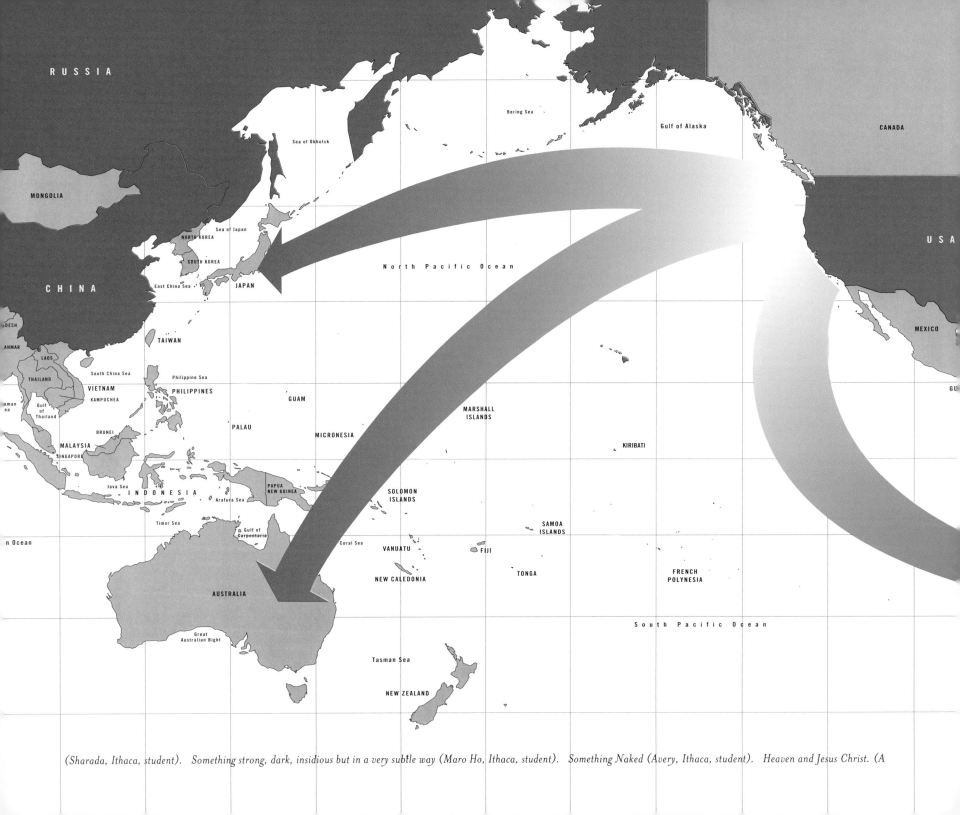

(Sharada, Ithaca, student). *Something strong, dark, insidious but in a very subtle way (Maro Ho, Ithaca, student). Something Naked (Avery, Ithaca, student). Heaven and Jesus Christ. (A*

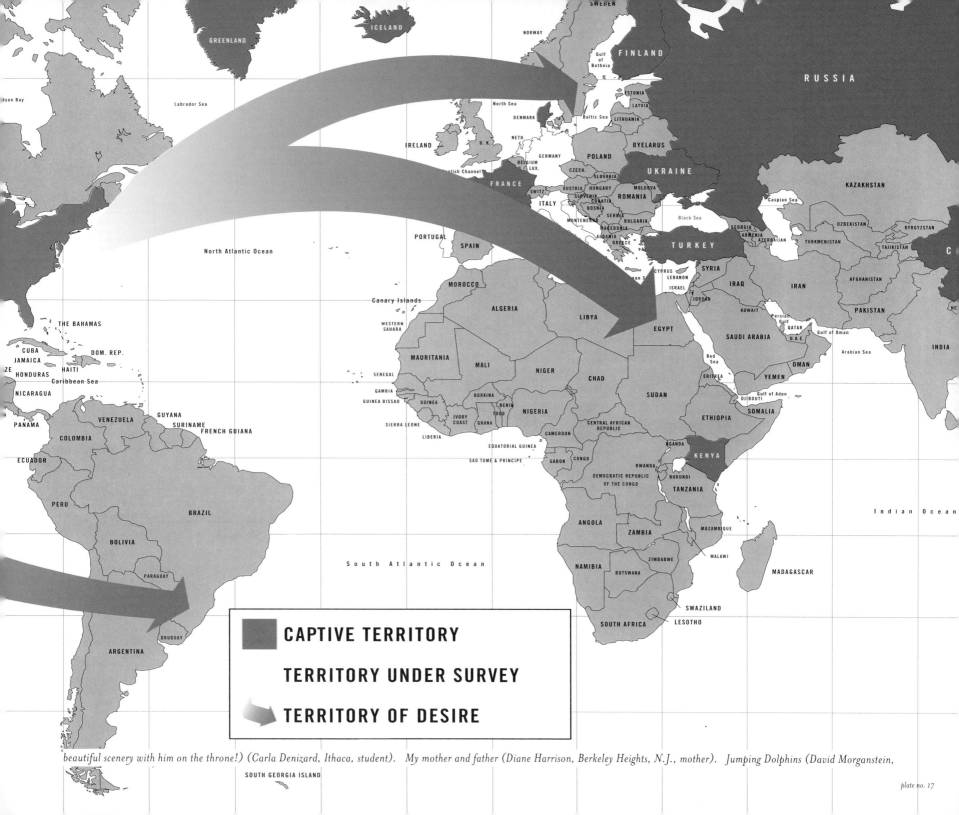

CAPTIVE TERRITORY

TERRITORY UNDER SURVEY

TERRITORY OF DESIRE

beautiful scenery with him on the throne!) (Carla Denizard, Ithaca, student). My mother and father (Diane Harrison, Berkeley Heights, N.J., mother). Jumping Dolphins (David Morganstein,

plate no. 17

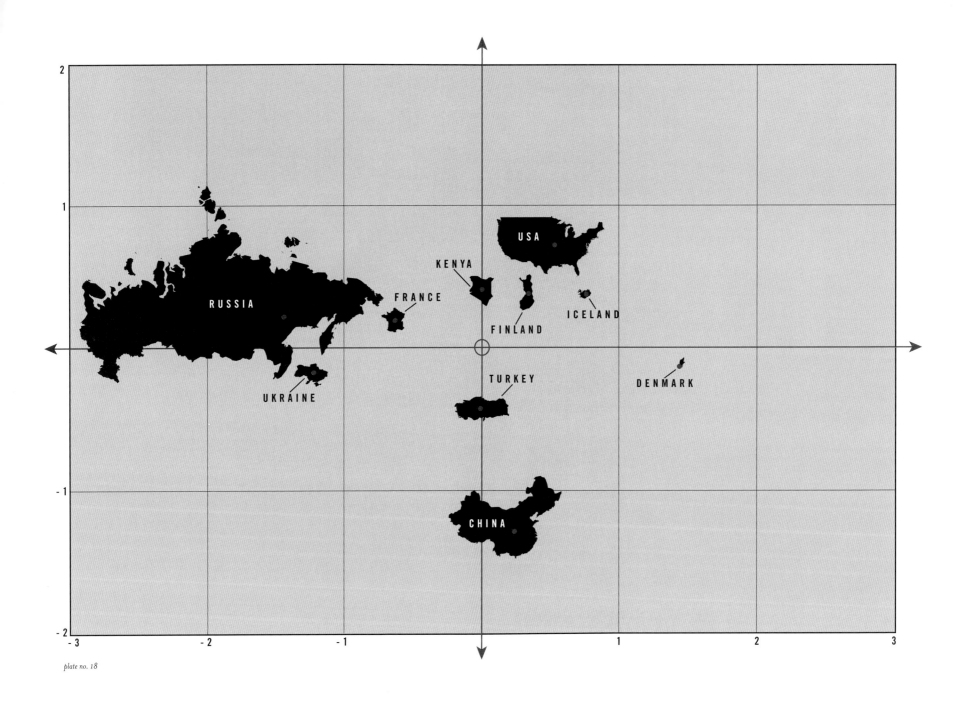

2

1

-1

-2

-3 -2 -1 1 2 3

RUSSIA

KENYA

FRANCE

USA

FINLAND

ICELAND

UKRAINE

TURKEY

DENMARK

CHINA

plate no. 18

Potomac, N.Y., student). Lake Cayuga on the first day of spring—the dawning of spring (presence of the first robin) (K. Blackman, Del Mar, Calif., freelance). A statue of a king (Erik Rossen,

BLUE WORLD ORDER?: A *POST HOC* STATISTICAL ANALYSIS OF ART PREFERENCE SURVEYS FROM TEN COUNTRIES

JOHN BUNGE
ADRIENNE FREEMAN-GALLANT
STATISTICS CENTER,
CORNELL UNIVERSITY

At the time of this analysis, Komar and Melamid had had comparable surveys conducted in China, Denmark, Finland, France, Iceland, Kenya, Russia, Turkey, Ukraine, and the United States. Those ten countries represent more than 32 percent of the world's population—or 1,824,690,000 people, by the United Nations' most recent figures. If you were to plot those countries on a map not using longitude and latitude but rather calculating the mathematical "survey distance" between them based on the similarity or dissimilarity of their answers to a set of questions from the poll, the result would be something like the diagram to the left.

Every map is an approximation—great political rows have erupted over the Mercator projection, yet it is still used in American schools—and this one is no exception. It is not possible to situate the country "icons" in a way that preserves the exact survey distances. But that they are where they are is not a matter of whimsy. We plotted the points on this grid using a statistical procedure called multidimensional scaling, or MDS. This is a standard method for representing complex data in a "readable" form; basically, for squeezing information that has a great number of possible dimensions into only two dimensions.

To do this, we first selected ten questions that were comparable in all ten countries' surveys. Those questions measured preferences that can be abbreviated as follows: favorite color, modern/traditional, large/small, realistic/different-looking, textured/smooth, sharp angles/soft curves, outdoor/indoor, wild/domestic animals, men/women/children, nude/clothed. We then did a series of mathematical calculations to define the spatial relationship between countries based on those questions. Essentially, the distance between two countries is large if their survey results are quite different for those questions, and small if the results are similar. So, for instance, the people of the United States and Finland are closer in their preferences than the

people of the United States and Kenya; but all of them are closer to one another (indeed, the points lie along a more or less straight line—the survey "latitude," so to speak) than they are to the people of China, who are off on another axis entirely.

How accurate is this? Mathematically we can determine the "stress" involved in representing the original survey data in two dimensions; that is, the degree of distortion that occurred in plotting the distances using points on a map. Our MDS map has a stress of 7.7 percent, which, on a scale where 0 percent means the distances are exactly right and 100 percent means they are completely wrong, shows that distortion is low and the map does a very good job of representing the actual survey distances. Moreover, for comparative purposes we did seven other MDS maps using different combinations of questions, and in every case the general relationships held. Finland was always near the U.S.; Russia was always near Ukraine; China was always off on its own, and so on.

One other point is worth noting. Statistics is not an absolute science, and the integrity of polls is subject to all kinds of variability. But it was interesting to us that most countries' positions on the map appear reasonable from a cultural perspective. Turkey, for instance, falls a significant distance from the U.S. This is even more interesting because the American and Turkish questionnaires were identical. So it seems that the questionnaire does measure preferences in art, rather than simply producing results that were predetermined by the formulation of the questions.

Of course, there is more than one way to read the international data. The map considers each country as an equal unit, much as in the UN General Assembly. Following that analogy, dead center on the map is like those countries' composite ideal ambassador—in other words, the ordinary average of their responses. Such an average is fine as a device for plotting survey distances, but not so fine for revealing the collective artistic preferences of the international sample. After all, countries are not equal units; they have populations that differ greatly in size. Still, one is curious to know what this sample of almost one-third of the world's population wants in art. How can we arrive at an aggregate portrait of its preferences?

Imagine that there were no borders between these ten countries, that they composed one big population, and that Komar and Melamid had polled a random sample of that big population in a single survey. That is the conceptualization behind the numbers that appear on the following pages. We call them combined population estimates, or pooled estimates, and we derived them using a standard statistical method called stratified sampling. In this set-up we regard all the data from a select number of questions as resulting from a survey of a single (combined) population with ten "strata" (the countries). The combined population estimate for a particular question—say, favorite color—is an average of the individual countries' results weighted by population. This gives statistically correct estimates for the combined population while taking into account differences between countries, since, for example, 19 per-

after crossing the Delaware. You always see him just standing up in the boat; I'd like to see the beginning of the story, or the end of it (Ted Wypijewski, Buffalo, N.Y., tool-and-die-maker,

On the basis of this sampling, and considering only those questions that all ten countries answered, it *appears* that a person chosen at random from this third of the world's population is most likely to prefer paintings that are large, that are predominantly blue, of traditional style, realistic, with domestic animals and ordinary people (fully clothed and rarely men) outdoors in the spring, with soft curves and a flat, smooth application of paint. Whether that "representative" person would want all of those features *in one painting*, however, is an entirely different matter. To determine that, we would have to study the dependences, or interactions, between questions. This would mean re-analyzing all of the original questionnaire data from each country—a big job, but it could be done.

cent of Chinese favoring blue is far different from 18 percent of Ukrainians favoring blue. For some questions, combined estimates could be made for only a subset of countries, owing to differences in the questionnaires. The combined population estimates have a conservative margin of error of +/-2.9 percent, at a confidence level of 95 percent.

retired). Roy Lichtenstein, America's Most Unwanted *(Jan C. Goetze, Heidelberg, Germany).* Cows *(Laura Phillips, Guelph, Ontario, Canada, police dispatcher).* The American

PAINTING WITHOUT BORDERS

FAVORITE COLOR	POPULATION ESTIMATE
Beige/Tan	4%
Black	6
Blue	24
Brown	3
Fuchsia	0
Gold	1
Gray	3
Green	15
Maroon/Burgundy	1
Mauve	2
Orange	2
Peach/Coral	2
Pink/Rose	5
Purple/Lavender/Violet	5
Red	7
Teal/Turqoise	4
White	10
Yellow	3
Other	1
(Not Sure)	1

Population: China, Denmark, Finland, France, Iceland, Kenya, Russia, Turkey, Ukraine, U.S.
(represents 32.4% of world population)

SECOND-FAVORITE COLOR	POPULATION ESTIMATE
Beige/Tan	5%
Black	7
Blue	18
Brown	2
Fuchsia	0
Gold	1
Gray	3
Green	11
Maroon/Burgundy	1
Mauve	1
Orange	1
Peach/Coral	2
Pink/Rose	3
Purple/Lavender/Violet	2
Red	6
Teal/Turqoise	1
White	4
Yellow	1
Other	2
(Not Sure)	29

Population: China, Denmark, Finland, Iceland, Kenya, Russia, Turkey, Ukraine, U.S.
(represents 31.4% of world population)

Dream destroyed. It would have a poor man and woman waiting outside the unemployment office while rich people decide their fate and legislation (Kathy Ny, Ithaca, student). Van Gogh

MODERN OR TRADITIONAL STYLES?

	POPULATION ESTIMATE
Modern	32%
Traditional	34
(Mixed)	21
(Didn't select)	6
(Not Sure)	8

Population: China, Denmark, Finland, France, Iceland, Kenya, Russia, Turkey, Ukraine, U.S.
(represents 32.4% of world population)

OLD OR NEW?

	POPULATION ESTIMATE
Older objects	23%
Newer objects	38
(Mixed)	24
(Not Sure)	15

Population: China, Denmark, Finland, Iceland, Kenya, Russia, Turkey, Ukraine, U.S.
(represents 31.4% of world population)

WILD OR DOMESTIC ANIMALS?

	POPULATION ESTIMATE
Wild animals	26%
Domestic animals	30
Both	23
Neither	10
(Not Sure)	11

Population: China, Denmark, Finland, France, Iceland, Kenya, Russia, Turkey, Ukraine, U.S.
(represents 32.4% of world population)

NATURAL SETTING OR PORTRAIT?

	POPULATION ESTIMATE
Natural setting	66%
Portrait	7
Both	15
Neither	3
(Not Sure)	10

Population: China, Denmark, Finland, Iceland, Kenya, Turkey, U.S.
(represents 27.9% of world population)

painting an iceberg (Helen Pfann, Hamilton, N.Y., student). Landscape of winter into spring. There would be snow in some areas yet up front you would be able to see small budding flowers. The

OUTDOOR OR INDOOR SCENES?

	POPULATION ESTIMATE
Outdoor scenes	66%
Indoor scenes	6
Both	19
Neither	2
(Not Sure)	7

Population: China, Denmark, Finland, France, Iceland, Kenya, Russia, Turkey, Ukraine, U.S.

(represents 32.4% of world population)

SEASON

	POPULATION ESTIMATE
Winter	10%
Spring	35
Summer	13
Fall	22
(All equal/Depends)	17
(Not Sure)	3

Population: China, Finland, France, Iceland, Russia, Turkey, Ukraine, U.S.

(represents 31.8% of world population)

PAINTINGS RELATED TO RELIGION?

	POPULATION ESTIMATE
Related to religion	17%
Not related to religion	38
(Both/Depends)	12
(Not Sure)	33

Population: China, Finland, France, Iceland, Kenya, Russia, Turkey, Ukraine, U.S.

(represents 32.3% of world population)

PAINTINGS SHOULD TEACH A LESSON?

	POPULATION ESTIMATE
Yes	42%
No	44
(Both/Depends)	13
(Not Sure)	1

Population: China, Denmark, Finland, Iceland, Kenya, Russia, Turkey, Ukraine, U.S.

(represents 31.4% of world population)

trees would be barely budding. The painting at first would look cold and desperate, while the hints of spring would give hope (Hunt Doering, Ithaca, student). I like the color blue. Go with it!

REALISTIC OR DIFFERENT-LOOKING?

	POPULATION ESTIMATE
Realistic	44%
Different-looking	25
(Both/Depends)	24
(Not Sure)	7

Population: China, Denmark, Finland, France, Iceland, Kenya, Russia, Turkey, Ukraine, U.S.
(represents 32.4% of world population)

(IF DIFFERENT) EXAGGERATIONS OF REAL OBJECTS OR IMAGINARY OBJECTS?

	POPULATION ESTIMATE
Exaggerations of objects	39%
Imaginary objects	36
(Depends)	20
(Not Sure)	5

Population: China, Denmark, Finland, France, Iceland, Kenya, Russia, Turkey, U.S.
(represents 31.5% of world population)

BOLD OR PLAYFUL DESIGN?

	POPULATION ESTIMATE
Bold, stark designs	33%
Playful, whimsical designs	52
(Depends)	11
(Not Sure)	4

Population: China, Finland, Iceland, Kenya, Turkey, U.S.
(represents 27.8% of world population)

SHARP ANGLES OR SOFT CURVES?

	POPULATION ESTIMATE
Sharp angles	22%
Soft curves	61
(Depends)	13
(Not Sure)	4

Population: China, Denmark, Finland, France, Iceland, Kenya, Russia, Turkey, Ukraine, U.S.
(represents 32.4% of world population)

(Annie Du, Ithaca, student). Black anguish and strength *(Lisa Summers, Ithaca, student).* Van Gogh to paint a picture of Fall Creek Gorge on an October day *(Joshua Habib, Ithaca, student).*

GEOMETRIC OR RANDOM PATTERNS?

	POPULATION ESTIMATE
Geometric	22%
More random	53
(Depends)	19
(Not Sure)	6

Population: China, Denmark, Finland, France, Iceland, Kenya, Turkey, U.S.

(represents 28.9% of world population)

BRUSH STROKES OR SMOOTH?

	POPULATION ESTIMATE
Brush strokes	33%
Smooth	32
(Depends)	25
(Not Sure)	10

Population: China, Finland, Iceland, Kenya, Russia, Turkey, Ukraine, U.S.

(represents 31.3% of world population)

TEXTURED OR FLAT?

	POPULATION ESTIMATE
Thick, textured	26%
Flat, smooth	37
(Depends)	27
(Not Sure/No Answer)	11

Population: China, Denmark, Finland, France, Iceland, Kenya, Russia, Turkey, Ukraine, U.S.

(represents 32.4% of world population)

COLORS BLENDED OR SEPARATE?

	POPULATION ESTIMATE
Colors blended	45%
Colors separate	20
(Depends)	24
(Not Sure)	10

Population: China, Finland, Iceland, Kenya, Turkey, U.S.

(represents 27.8% of world population)

The sunrise over the Texas coast (Archana Prakash, Ithaca, student). Van Gogh to paint a landscape with color and bright sun with me in the picture as a feature (Michael Frankel, Short Hills,

SHADES OF COLOR

	POPULATION ESTIMATE
Vibrant shades	37%
Paler shades	38
Darker shades	9
(Depends)	12
(Not Sure)	5

Population: China, Denmark, Finland, France, Iceland, Kenya, Turkey, U.S.
(represents 28.9% of world population)

BUSY OR SIMPLE?

	POPULATION ESTIMATE
Busy	24%
Simple	43
(Depends)	25
(Not Sure)	8

Population: China, Denmark, Finland, Iceland, Kenya, Russia, Turkey, U.S.
(represents 30.5% of world population)

SERIOUS OR FESTIVE?

	POPULATION ESTIMATE
Serious	17%
Festive	57
(Depends)	18
(Not Sure)	7

Population: China, Denmark, Finland, France, Iceland, Kenya, Turkey, U.S.
(represents 28.9% of world population)

LARGE OR SMALL?

	POPULATION ESTIMATE
Larger	34%
Smaller	23
(Depends)	37
(Not Sure)	6

Population: China, Denmark, Finland, France, Iceland, Kenya, Russia, Turkey, Ukraine, U.S.
(represents 32.4% of world population)

N.J., attorney). Van Gogh, but tulips instead of irises (F. D. Slater, Scottsdale, N.Y., professor). Robert Williams painting the U.S. taken over by a race of buxom female Martians (Chris Bors,

FAMOUS OR ORDINARY PEOPLE?

	POPULATION ESTIMATE
Famous people	25%
Ordinary people	28
(No difference/Depends)	28
(Not Sure)	20

Population: China, Denmark, Finland, Iceland, Kenya, Russia, Turkey, Ukraine, U.S.

(represents 31.4% of world population)

ORDINARY PEOPLE

	POPULATION ESTIMATE
Children	29%
Women	17
Men	4
Doesn't matter	35
(Not Sure)	15

Population: China, Denmark, Finland, France, Iceland, Kenya, Russia, Turkey, Ukraine, U.S.

(represents 32.4% of world population)

HISTORICAL OR RECENT FIGURES?

	POPULATION ESTIMATE
Historical figures	42%
More recent figures	40
(Depends/Other)	12
(Not Sure)	7

Population: China, Finland, Iceland, Kenya, Russia, Turkey, Ukraine, U.S.

(represents 31.3% of world population)

WORKING OR AT LEISURE?

	POPULATION ESTIMATE
Working	28%
At leisure	54
(Depends)	0
(Not Sure)	17

Population: China, Denmark, Finland, Iceland, Kenya, Russia, Turkey, Ukraine, U.S.

(represents 31.4% of world population)

Liberty, N.Y., high school art teacher). Abstract of scared cats (Moz Taylor, Ithaca, hack drawer). A lake with a sunset with a family having a picnic and a bright rose in a glass jar on the table

ONE PERSON OR A GROUP?

	POPULATION ESTIMATE
One person	30%
Group	26
(Depends)	17
(Not Sure)	26

Population: China, Denmark, Finland, France, Iceland,
Kenya, Turkey, U.S.
(represents 28.9% of world population)

NUDE OR CLOTHED?

	POPULATION ESTIMATE
Nude	6%
Partially clothed	15
Fully clothed	40
(Depends)	16
(Not Sure)	23

Population: China, Denmark, Finland, France, Iceland, Kenya,
Russia, Turkey, Ukraine, U.S.
(represents 32.4% of world population)

I ONLY LIKE ART THAT MAKES ME HAPPY

	POPULATION ESTIMATE
Agree	60%
Disagree	24
(Not Sure)	15

Population: China, Finland, Kenya, Turkey, U.S.
(represents 27.8% of world population)

ART CAN BE BEAUTIFUL EVEN IF IT IS NOT REALISTIC

	POPULATION ESTIMATE
Agree	58%
Disagree	20
(Not Sure)	22

Population: China, Finland, Kenya, Turkey, U.S.
(represents 27.8% of world population)

(Beth Riggs, Candor, N.Y., age ten and a half). Our house, orchard, view and, mostly, our daughter (Joe Bartholomew, Homer, N.Y., teacher). A view of Trafalgar Square from the Sainsbury

ART SHOULD BE RELAXING
TO LOOK AT

	POPULATION ESTIMATE
Agree	66%
Disagree	15
(Not Sure)	19

Population: China, Finland, Kenya, Turkey, U.S.
(represents 27.8% of world population)

I PREFER PAINTINGS THAT ARE
PREDOMINANTLY BLACK AND WHITE

	POPULATION ESTIMATE
Agree	30%
Disagree	38
(Not Sure)	31

Population: China, Finland, Kenya, Turkey, U.S.
(represents 27.8% of world population)

OPINION OF PABLO PICASSO

	POPULATION ESTIMATE
Very favorable	18%
Favorable	29
Unfavorable	9
Very unfavorable	2
Never heard	38
Don't know	5

Population: China, Denmark, Finland, France, Iceland,
Kenya, Russia, Turkey, Ukraine, U.S.
(represents 32.4% of world population)

JACKSON POLLOCK

	POPULATION ESTIMATE
Very favorable	3%
Favorable	11
Unfavorable	5
Very unfavorable	1
Never heard	58
Don't know	22

Population: France, Iceland, Kenya, Turkey, U.S.
(represents 7.2% of world population)

wing of the National Gallery, London (Ron Law, London, family doctor). A representation of the declining graffiti art movement on both coasts of the U.S. (Marlin Watson, Ithaca, student).

SALVADOR DALÍ

	POPULATION ESTIMATE
Very favorable	9%
Favorable	24
Unfavorable	12
Very unfavorable	4
Never heard	31
Don't know	20

Population: Finland, France, Iceland, Kenya, Russia, Turkey, Ukraine, U.S. (represents 10.8% of world population)

REMBRANDT

	POPULATION ESTIMATE
Very favorable	10%
Favorable	18
Unfavorable	3
Very unfavorable	1
Never heard	66
Don't know	2

Population: China, Finland, France, Iceland, Kenya, Turkey, U.S. (represents 28.8% of world population)

CLAUDE MONET

	POPULATION ESTIMATE
Very favorable	8%
Favorable	17
Unfavorable	3
Very unfavorable	1
Never heard	64
Don't know	6

Population: China, Denmark, France, Iceland, Kenya, Russia, Turkey, Ukraine, U.S. (represents 32.3% of world population)

ANDY WARHOL

	POPULATION ESTIMATE
Very favorable	4%
Favorable	13
Unfavorable	10
Very unfavorable	6
Never heard	57
Don't know	11

Population: Finland, France, Kenya, Russia, Turkey, Ukraine, U.S. (represents 10.8% of world population)

My dogs in tones of gray, brown, and yellow (Barbara Block, Syracuse, N.Y., writer). CITY (Allony, Ithaca, first-grader, age six). A 3-D outline of New York City (Amir Brann, Ithaca,

sixth-grader, age eleven). Lichtenstein, a family portrait (Casey Btash, Deerfield, Ill., sixth-grader). Just SEX (Omar Silwany, Ithaca, student). My dream matter—that which connects me to

The Paintings

the previous voters and all others out there. Somehow, it doesn't seem real . . . Perhaps a painting would affirm the shared brain stem. It would be my own icon (Dianne Elasiak, Rochester, N.Y.,

plate no. 19

photo student and potter). The dying Republican (Alesc Papas, Sydney, Australia, nomad). A broken vacuum (Bob MaGill, Troy, N.Y., road painter). Cascading waterfalls with rapids below

plate no. 20

in a river and lush green forest surrounding, blue sky and bright sun shining on waterfalls, or a star-filled night with a bright moon and angels among the stars (Angela Jaromin, Ithaca,

plate no. 21

consultant). Something fauvist—a representational painting that used color like sticks of dynamite (Anonymous). Heavenly-looking angels surrounding a little child within a forest (Teresa

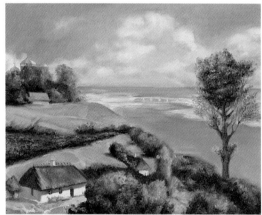

plate no. 22

LeClaire, Ithaca, teacher). A picture at sunset of a cloud in the shape of a horse with its mane and tail flowing in the wind (Elisabeth Sokol, Concord, N.H., fourth-grader). Sorrow (Kayt

plate no. 23

Brown, Ithaca, student). Nature (David Williams, Ithaca, child). My lover, John (Tom, Philadelphia, musician). I want a painting about life. It would be of an abortion and other hard

FRANCE'S MOST WANTED

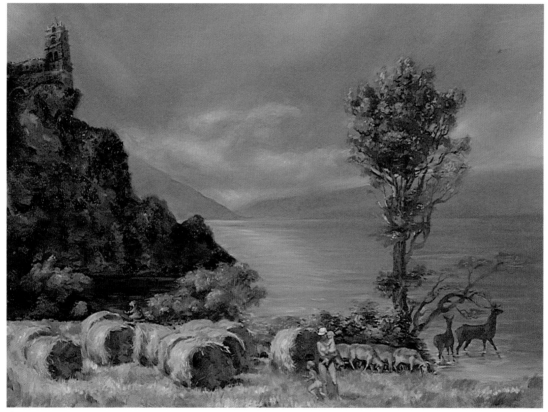

plate no. 24

things in life all in one painting. I don't know any artists, but it would have to be a creative one who knew how people felt about life (Lauren Bennet, Syracuse, N.Y., eighth-grader). Steam

plate no. 25

trains and rugged mountain scenery (James Satho, Cheltland, Penn., elevator mechanic). An atomic blast (Jason Coles, Ithaca, student). The interaction of an electron beam and phosphorus

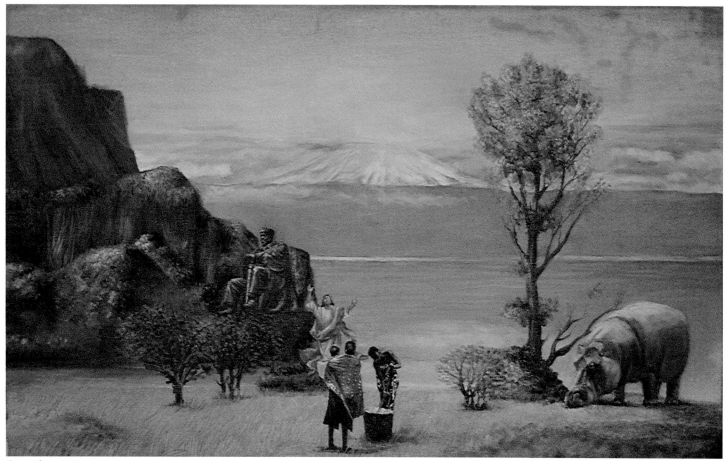

plate no. 26

(M. Garon, Silver Spring, Md., engineer). The center of the earth, from the inside turned out, stretched forth like braided roots of flame, Gaia's hair emerging in ribbons, a tree of life,

plate no. 27

connecting us to the origin of love in the cosmos (*Jeff Hayward, Bellingham, Wash., permaculturist*). A Rhino Alien (*Justin Zoll, Newfield, N.Y., first-grader*). "Rhapsody in Blue"/Matisse or

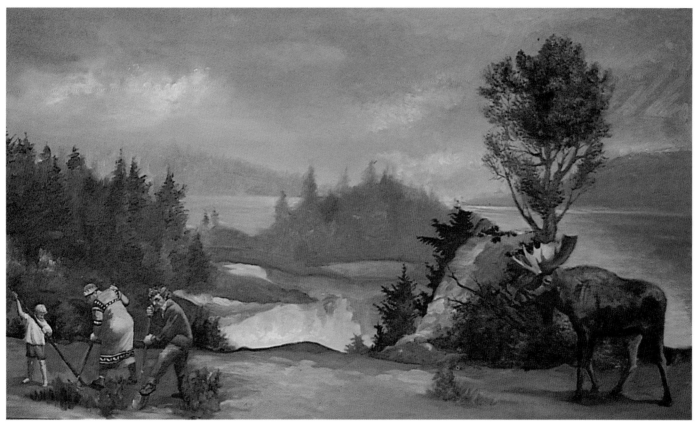

plate no. 28

"Bolero"/Kandinsky or "Saber Dance"/Félix Vallotton (Sheila Bonamarte, Ross Maples, Minn., customer rep). A portrait of me and my sweetie dressed up in Renaissance wardrobe (Slick Pet,

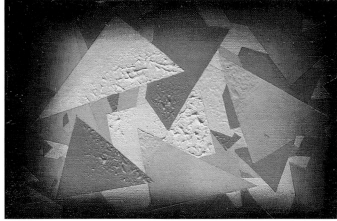

plate no. 29

Ithaca, student). A portrait of Marilyn Monroe by anyone who could capture the "real" Marilyn (Colleen Sherwood, Binghamton, N.Y., student). A portrait of myself with a background

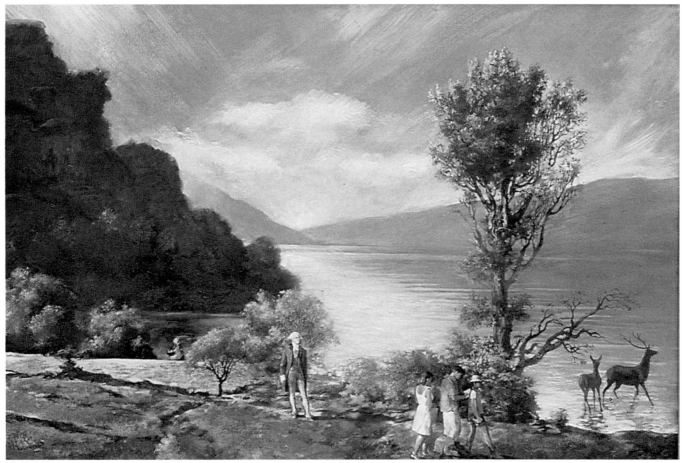

plate no. 30

depicting a happy life (Scott Smith, Binghamton, N.Y., courier). Any of the Hudson River School paintings. I really like them (Keith Wales, Endicott, N.Y., cook/waiter/student). A dining room

ICELAND'S MOST UNWANTED

plate no. 31

painted in very precise socialist realist style, and around the table, talking, are Trotsky, Lenin, Cromwell, and Robespierre. I am sitting under the table taking notes (Tariq Ali, London,

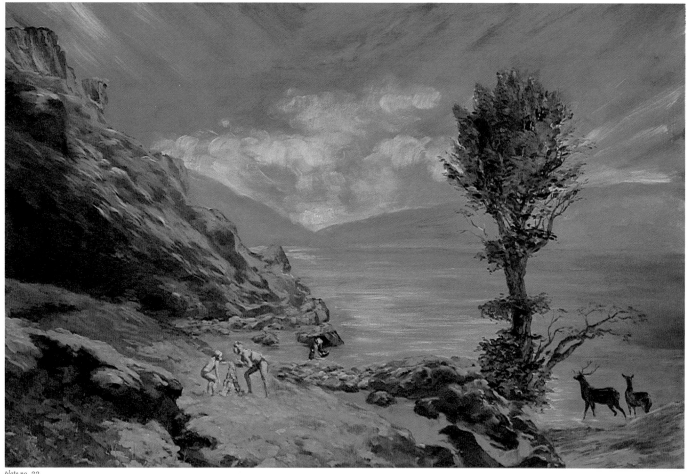

plate no. 32

writer/television producer). It would be a watercolor scene in the mountains during fall, with a pond and a creek. I would want the brightness of the foliage reflected in great detail and animals as

plate no. 33

they would be seen in their natural setting. I would also include a person and dogs observing this wonderful time (Jerry Regan, Ithaca, business manager). Something joyous and colorful,

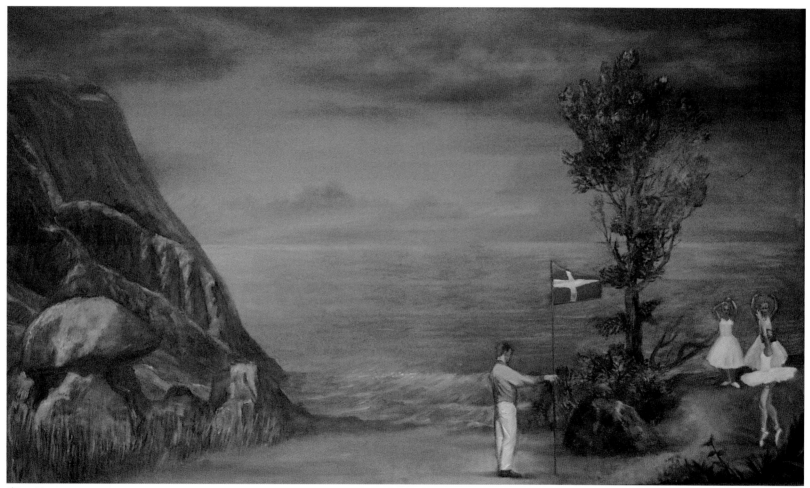

plate no. 34

something that includes all ages, all humans, all times, it would include nature and space and structure and aliens, children, old, young, in-between, it would make me feel loved and safe and

plate no. 35

beautiful and part of something wonderful and all-inclusive. I would feel happy, peaceful, and inspired by it (Jo, Ithaca). Yankee Stadium, night game in progress, 30,000 fans there—Mickey

plate no. 36

Mantle at bat (Bob Lynk, Delmar, N.Y., veterinarian). A painting of me and Diana playing on the big field with flowers, the sun, grass, and a couple of trees (Maya Fathing-Kohl, Ithaca, first-

plate no. 37

opposite: plate no. 38

grader). Me and my partner—my girlfriend—and our cat and our dog. (I wear glasses.) And some frogs in the background, green frogs (Pam, Seattle). Jeff Koons, full-size, gold, of my

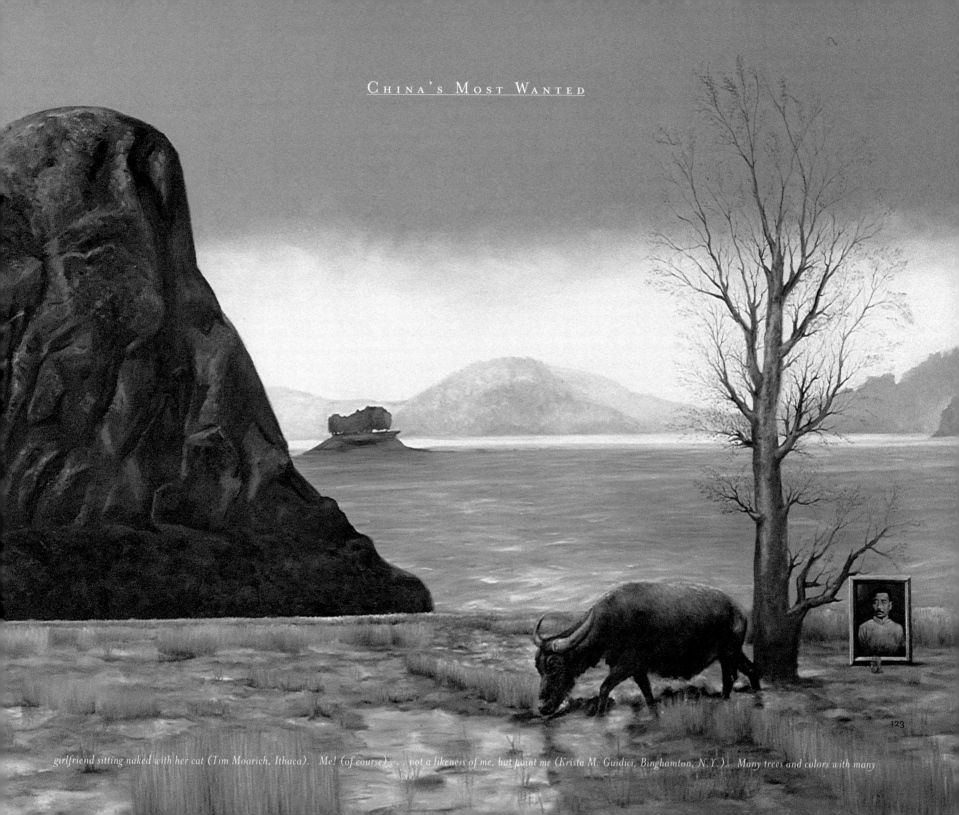

CHINA'S MOST WANTED

123

girlfriend sitting naked with her cat (Tim Moorich, Ithaca). Me! (of course) . . . not a likeness of me, but paint me (Krista M. Guidici, Binghamton, N.Y.). Many trees and colors with many

CAN IT BE THE "MOST WANTED PAINTING" EVEN IF NOBODY WANTS IT?

ARTHUR C. DANTO

At first glance, *America's Most Wanted*, along with its international peers, seems a common thing—no more difficult to understand than the landscapes annually bestowed with calendars and Christmas greetings upon a company's customers. And though few of us have very clear ideas of when works of art are to be classed as "postmodern"—the term having as many permutations as the attitude it is meant to describe—these "most wanted paintings" seem hardly daring enough visually to qualify for that label. So much for what the eye alone will tell us about art! Actually, these are works with a complex aesthetic and an intricate relationship to the history of art. It is accordingly appropriate, I think, to defer analysis of them a bit, and first take something of a tour across the history and conceptual landscape of their creators, Vitaly Komar and Alexander Melamid.

I confess to having had my own problems in learning how to perceive these artists' work. It first made an impression on me not long after Komar and Melamid arrived in New York as political émigrés from the Soviet Union. I had been invited to meet them at a party in some well-wisher's apartment, where a few of their pictures were on display for the guests to look at as we wandered around with our wineglasses. This must have been some time in late 1978, before the first of their openings at the Ronald Feldman gallery

people kissing (Nathalie Lounge, Ithaca, student). Picture of Native Americans in traditional outfits, family, dancing (Shirelle Jacobs, Akwesasne Nation, student). Something abstract,

that they were actually able to attend; and its purpose was to introduce these artists to an American art world that had almost no knowledge of them or of their art. It is interesting, I think, to recall that event, for in certain ways Komar and Melamid were greatly ahead of the New York art world, which imagined itself to be at the very edge of advanced art when in truth that edge was to be found elsewhere—in Germany and, astonishingly enough, in Moscow. New Yorkers, especially in matters of artistic judgment, can be complacent and patronizing, and it now seems to me that the sophisticates who were gathered there that evening, thinking they were welcoming some politically courageous but aesthetically marginal and possibly retrograde figures, had in fact much to learn from these new guests.

Even before that party I had already seen something of Komar and Melamid's work, which I now realize I had been utterly unprepared for at the time. Ronald Feldman's gallery, in those years a kind of graduate school for me in advanced art, was itself ahead of its time in many ways. It was in that space that I first encountered the work of Arakawa and Madeline Gins, of Joseph Beuys, of Hannah Wilke, of Helen and Newton Harrison, and of a great many others who did not fit what would have been regarded as the mainstream art of the time—though by the 1970s the reality if not the idea of a mainstream was beginning to dissolve. In any case, Feldman once showed me, with great pride and enthusiasm, some paintings by Komar and Melamid that had been smuggled out of the Soviet Union. My memory of them is indistinct, other than that they were quite small and on bits of cardboard. It occurred to me then that the scale of the images might have been determined by clandestinity, and that what I saw was the artistic equivalent of *samizdat* literature, as if the little pictures would be handed round from person to person for private, dangerous séances of artistic experience. That, doubtless, would have given the work the kind of heroic status one associates with dissidence in a totalitarian state—I thought of the minute watercolors Emil Nolde had painted after being forbidden by the Nazis (in whose odious philosophy he actually believed) to make any further pictures—for in truth

there was nothing particularly heroic about these paintings by Komar and Melamid in either their content or their style. In terms of content, they were perhaps counter-heroic, given the heroizing demands of official academic painting in the Soviet Union in the Stalin era, with muscled proletarian man and kerchiefed proletarian woman, flourishing their hammers and sickles, standing firm and unshakable beneath a red sky. What Feldman showed me, tiny oil landscapes sheathed in plastic, made no immediate direct impression. The New York aesthetic was not suited to littleness, and whatever allusions there may have been were lost on me. My only response was that the pictures did not especially look like Soviet art, whatever that may have meant. But neither, of course, did they resemble art of the sort one was accustomed to looking at in the galleries of the time. I now recognize that I radically misperceived the work, which was, as I later appreciated, altogether brilliant. But the brilliance was not something that could be established by looking at the work itself. Indeed, what met the eye, together with the sentimentalization of the dissident artist, was almost guaranteed to misdirect perception.

The modest analogy to Nolde's truant watercolors was also misleading. I had thought that making these frankly minor landscapes was an act of refuge from, and protest against, the bombast of socialist realism. The puddled little landscapes called for compassion and, however undistinguished, were moving because of the myth that vested them with moral meaning. Nothing could have been further from the truth. The paintings, I subsequently learned, were "executed" by a one-eyed Russian artist whom Komar and Melamid had invented, Nikolai Buchumov. Buchumov and his similarly imagined colleague, Apelles Ziablov, were artistic personalities of the pre-revolutionary era in Russia; and for a time in the early seventies, Komar and Melamid composed biographical documents about the two, fragments of whose works they also created. The tiny landscapes were themselves fragments, and testified to their romantic maker's rather moony feeling toward nature. In one sense my initial interpretation of the works might not have

something Asian, something larger than six feet wide and eight feet high (Adam Silver, Astoria, N.Y., educator). My dog (Chris Carreiro, graphic designer). My dear sister, Ruth (Estelle Bloom,

plate no. 39

been altogether beside the point. It is quite possible that living under the harsh artistic realities of late Soviet communism, Komar and Melamid found solace in imagining the free, romantic artistic lives of an earlier art world, and even in vicariously living the lives of Buchumov and Ziablov. But at the same time they were having a lot of fun in the creation of an alternate identity, rather like the female identity Duchamp gave himself in the personage of Rrose Sélavy. These paintings, meanwhile, of lakes with trees washed wetly in, are the true ancestors of *America's Most Wanted*. And like the latter, I think, they convey a certain conflict. I am convinced that, deep in their hearts, Komar and Melamid themselves believe in *America's Most Wanted*. It is what they think art really is—beautiful, quiet, retinal. Had they only lived in times when artists and art were in harmony with each other! But they came of artistic age after the end of art. The Buchumov landscapes, like the "most wanted painting," have nothing or little to do with what gives joy to the eye and pleasure to the soul. And the work is witty, sardonic, and philosophical—all qualities that elude the unaided eye.

My blank encounter, almost Nabokovian in its incomprehending or miscomprehending obtuseness, took place a full decade before I entered upon my career of writing about art, and I had not yet thought deeply enough about art criticism to realize that virtually everything that was being written as such had been rendered obsolete by the work of the fictive artist Buchumov, itself more subversive than the work of Duchamp's fictive R. Mutt. Back in 1917 criticism fell mute before R. Mutt's celebrated urinal, or sought refuge in honorifics like "gleaming" or "sculptural." But criticism felt itself on firm ground with Buchumov's landscapes, which it could pronounce "deeply felt," or whatever, when what had begun to be plain for anyone with the sense to see it was that the "good eye"—the critic's sine qua non—had no particular relevance in judging art of this sort. What was important was what did not meet the eye at all. The little pictures were part of a large conceptual work, a performance in fact, and one had to reconstitute this work in order to respond appropriately to the paintings. The

South Orange, N.J., computer operator). Phoebe, Bonnie's dog (Antonio, San Juan, Puerto Rico, student). Paint me a fixed point (Ignacio Barandiaran, New York City, architect). A blond,

plate no. 40

skinny girl reading a book under a tree, during a fall thunderstorm; the sky is lighted up with many sparks of lightning (Italo Barros, Ithaca, student). I'm dead, lying in a casket in a funeral

qualities to which the good critical eye responded were a kind of bait, and everything the trapped critic might say had been anticipated: the critic was part of the spoof. (There is even an internal reference to the eye in these works—a wavy edge along the left side which one might interpret as a sort of art nouveau mannerism but happens to be the outline of the one-eyed artist's nose. There is thus the idea, at once powerful and comical, that in rendering the landscape *as he really saw it,* Buchumov was in fact painting himself!) So these works marked a new era in art criticism as well as in art, an era in which critics had to learn *not* to use their eyes, and certainly not to regard the visual as definitive. The grounds for their erstwhile expertise had been vaporized away.

When I say that Komar and Melamid were ahead of us when they came to New York, I mean that they were living in an era that most of their audience had not yet entered. And a telltale sign that a later art-historical period has already, surreptitiously, made its entrance in an earlier one is the critical perturbation that arises from trying to judge "later" work by a set of criteria whose very irrelevance is what will ultimately come to define that later period. One of the things that impressed me in looking at the work displayed in the apartment was its heterogeneity. There was no single style that each of the works embodied, which at that time one standardly expected of an artist's work. When Warhol, for example, showed his *Hammer and Sickle* paintings in 1977 (a year after Komar and Melamid's first New York exhibition), the paintings varied in size and composition, but quite apart from the fact that they were variations on a theme, each was unmistakably recognizable stylistically as coming from Warhol's artistic personality. And that was the general expectation, taken for granted until fairly recent times when, with artists like Gerhard Richter or Sigmar Polke, there really is no visual unity among the works, and one must, as it were, turn at right angles to the visual to find their unifying style. In the case of Richter and Polke, the unity is more conceptual than perceptual—more a style of thought than a style of touch. In this, it now occurs to me, Komar and Melamid were precocious. "They have

mastered most styles of painting," observed Gary Sangster at the Cleveland Center for Contemporary Art. "Their work is very postmodern, very humorous and very iconic." In effect, there is no painterly style that is identifiably Komar and Melamid. Their style is disjunctiveness: they take what they require as they need it, their academic training in the Soviet Union having given them a virtuosity that until postmodern times was alien to the concept of artistic sincerity. That nearly total discontinuity in visual terms would account for what remained puzzling to me in the apartment show of twenty or so years ago. As a viewer I was put on edge by what I sensed as a visual cacophony. Naturally, I explained it by supposing that these artists had not really found themselves, when in truth I did not quite know at that time how to find these artists. I did not know how to make the conceptual ascent needed for doing so, or even that such an ascent was needed.

I think there is room for some interesting art-historical speculation on the fact that the heterogeneity in the work of Komar and Melamid is also found in the work of Polke and of Richter in Germany. It is a historical fact that pop art was deeply influential on both sets of artists. Polke and Richter developed what they called Capitalist Realism on the basis of pop, which they adapted to the context of German consumerism and their own political agenda. Komar and Melamid invented what they called Sots Art, again based on pop art but adapted to the socialist aesthetic environment. Both sets of artists read about pop in the American magazines that came their way, and it is remarkable evidence of the way that art magazines have been the vehicles of artistic transformation in our times. But neither set of artists merely emulated pop. Rather, both found pop extraordinarily liberating, as indeed it was. It is, after all, an art of liberation. In my own case it was philosophically liberating to experience pop in 1964, when I encountered Warhol's *Brillo Boxes* in the Stable Gallery that April. Nineteen sixty-four was the great year for liberation: it was the year of Freedom Summer, when blacks and whites together cracked the American system of apartheid; and it was the year in which feminism exploded into a political movement whose repercussions

parlor—many religious people in the room praying and weeping, etc. Strangely, I can read everyone's minds. Some are happy that I'm deceased. I'm smiling inside because I can look into their

have not yet died down. Pop was a liberation from the tyrannies of abstraction here and in Germany, and from the tyrannies of realism in Russia. It is utterly striking to consider the way in which, before pop, there was an ideological battle between abstraction and realism, and how, after pop, the differences between them became negligible. With pop, indeed, the tyranny—if one chooses to see it that way—of painting came to an end. Capitalist Realism, like Sots Art and pop art, remained an art of painting, but painting was only part of it. So was sculpture. The new art was art beyond painting and sculpture, as we can see in the variety of Oldenburg and Warhol and even Lichtenstein. Komar and Melamid have remained painters, but the way they paint is a function of the larger conceptual structures within which their work must be understood.

In any case, the pop references were perhaps the only ones I was able to grasp in the apartment exhibit I began this essay by describing. And the work of which I had the most vivid memory—indeed, the only memory, the rest having faded from mind—was a piece of canvas on which the artists had painted, in the intense hues pop art had borrowed from the comic strip, an energized word like "POW!" or "BLAM!" in the kind of jagged balloon that is the graphic symbol of an explosion of some sort, and that one might have seen in a painting by Roy Lichtenstein. I have recently done a bit of research and can say with confidence that the word was "BRAT" (a fragment of "BRATATATAT") and that in fact it had been altogether appropriated from Lichtenstein, putting it two steps removed from the original comic panel that Lichtenstein had made his own. But the canvas had been charred along the edges and its surface was soiled, so it had the look of a brash logo that had been salvaged from the ashes. This was not something one would have found in pop painting, which always had sharp, snappy edges and always looked new. Here the contrast between the brashness of the logo and the physical degradation of the canvas conveyed a feeling of melancholy and even tragedy, like a child's toy in a burnt room. Two interpretations occurred to me. One was that the work was like an artifact future archaeologists might

come upon, a remnant of a civilization that had destroyed itself, so the contrast between the word and the way it was painted—the object and the way it projected desolation—was fairly overpowering. If it was a political work, the politics was that of war and peace. The other interpretation, more difficult to validate, was that the graphic explosion had somehow become a real one, setting fire to the very surface that bore it. This could be a metaphor for the power of symbols and, less immediately, the power of art, for it would be a *pop* art "explosion" that caused the canvas to go up in smoke. The work might then finally convey an idea about the power of art: how it could change the world, or, as a dissident artist might, after all, hope, destroy the framework of the society inhospitable to it. Either interpretation would go considerably beyond what pop art in its own right at that time—or ever—was capable of or even interested in conveying. As I came to realize, the second interpretation would not hold water. The painting in question was part of a series Komar and Melamid called *Post-Art*, which also included a handsome charred and degraded "Warhol"—a red-and-green Campbell's Soup can, tattered and torn like something resurrected from an excavation in the desert, as if a piece of Coptic textile.

There is a further feature, not in the least commonplace in the art of those years, that I was taken with, namely its comedy. As ideas, a painting so "hot" it goes up in smoke or the prospect that our civilization would leave pop canvases for archaeological delectation, the way the Minoans left behind their gold and their labyrinths, or the Mayas their pyramids and serpents, were both pretty funny. The charred painting was a kind of artistic joke—one knew that it was funny even if one could not quite be sure how—and its humor was a function of the concept of art itself. These were novel features of artistic experience, for, in America at least, we had come through (and in a way are still in) a period of almost puritanical seriousness about art, in which attitudes toward the abstract expressionist canvas were every bit as austere and intolerant as those insisted upon in the Soviet Union toward the socialist realist canvas. Komar and Melamid were original in the art worlds

hearts and minds (Trudy Coughlin, Ithaca). A modern scene of horses—with or without riders (Nancy Johnston, Champaign, Ill., veterinarian). Peaceful setting, nudes, male and female,

plate no. 41

relaxing by a pool. Traditional setting in Greece—geometric stone slabs on which figures are relaxing. Water is blue and reflecting clouds, background is a natural setting, gold and oranges reflected

plate no. 42

off trees and shrubs in the distance (Micah Kaplan, Ithaca, student). A twenty-foot-tall picture of a clitoris, ray traced in violet (Anonymous). Anything homoerotic! (L. Hoxsic, New York

of both Moscow and New York in the spirit of play they made central to their collaboration. But there is a deeper point as well. It was only, I believe, in and through the internal development of art in the sixties and seventies that the *concept* of art itself had been sufficiently brought to consciousness that one could make *conceptual* fun of art, could make art its own subject. *The New Yorker,* for example, had as a standing motif cartoons about artists, especially involving abstract painting and sculpture. There must have been hundreds of these cartoons making fun of contemporary painting. But it is one thing to draw pictures about painting and painterly practices that a cartoonist finds funny; it is quite another to draw pictures about the concept of art that rise to a certain philosophical distance from the subject and put it, through humor, in an amusing light. Hogarth once did a brilliant painting in which, with great skill, he made all the mistakes in perspective an inept painter might make. That painting was about perspective, which it slyly subverted in order to make its point. The American trompe l'oeil artists did paintings of the backs of paintings so realistically rendered that one thought one was *looking* at the back. These were paintings in which the concept of illusion, as old as Pliny, became the subject of a visual joke. But again a painting about painting was not a painting about the concept of art. In my view, it became possible to make the concept of art a subject for art only after Duchamp and Warhol had achieved their singular breakthroughs; hence, at a certain moment in history. For the ascent to consciousness of a concept like art could not have been the work of one or two artists; it was the product of a long and complex historical development that culminated in our time.

Komar and Melamid were part of this development. And though I lacked the wit to perceive it at the time, the charred pop painting was the key to their entire achievement. In a nutshell, their art consists in conceptual analyses of art through the medium of humorous objects: to see the humor of their work is to grasp at the same time a conceptual critique of art. Wittgenstein once said that a philosophical work can be imagined that is composed exclu-

sively of jokes. It is actually easier to imagine such a work than to imagine a serious body of art that consists only of jokes. But the aggregate art of Komar and Melamid comes close to that ideal. I saw one of their latest efforts at a studio visit I made in preparation for this essay. It was an immense canvas that looked like an abstract expressionist painting done by someone who had been impressed with the work of Morris Louis—that is, there were furious expressionist brush strokes on both sides of the canvas, with a largely empty middle, a bit like Louis's *Delta* series. The painting was the result of a collaboration between the two artists and the elephant Renee, of the Toledo Zoo. "Abstract expressionism wasn't invented by animals, but Renee is better at it than we are," Komar said. And the artists were made especially merry by the thought that the culmination of the history of art in abstract expressionist gesture is in fact a reversion to what animals were capable of all the time, had anyone the idea of giving them access to brush and pigment. A photograph in Toledo's daily newspaper *The Blade* shows the three artists working side by side, Renee in the middle. The painting—by two humans and an elephant—is certainly not a joke in visual terms (though the footprint placed near the bottom in the middle as a kind of signature would alert the observant viewer to the presence of a spoof). It is a joke in terms of what the theorists and aestheticians of abstract expressionist painting have said about the latter. The work is the painting together with the conceptual and historical references, and the impish spirit of sabotage.

One final point before turning to *America's Most Wanted*. I'd like to linger for a moment on the title of their series *Post-Art*. A bit earlier I insidiously referred to my own concept of the end of art, and I ought to clarify that I think it was with pop, and especially with the work of Warhol, that the history of art came to an end. I'm not sure that Komar and Melamid had quite the same idea, but it is worth stressing that it is pop art that is presented as charred, and that it has a special melancholy that does not arise simply from the sight of burned canvas. I remember when one of Monet's *Water Lilies* was destroyed in a fire at the Museum of Modern Art. I can imagine someone

City, textile designer). Myself, naked, with a bellowing hippo (A. Hathiday, Meadville, Penn., professor). Group of naked women with bellowing cats (Kate Halliday, Ithaca, therapist). A

plate no. 43

133

picture of Paul Hill's electrical field after execution (Tom Gould, Ocean Beach, Calif., biotech associate). I would like a painting depicting class warfare in the painterly strokes of Seurat, using

making a copy of a fragment of the Monet—how hard would that be to do?—and then charring its edges. It could be called *In Memory of a Masterpiece* or some such. It could even be called *The Death of Art*. There is, after all, a history of incinerated art, from the destroyed icons of Byzantium to the bonfire of the vanities ignited by Savonarola to the iconoclastic flames of the Dutch Reformation to various individual aesthetic tragedies. I could imagine someone painting something in the manner of Botticelli and burning it, and displaying the result under the title *After Savonarola*. But "post-art" means, paradoxically, art after the end of art. There is nothing left but appropriation and wit—and the sense of loss that the finally pretty vapid paintings of Nikolai Buchumov poignantly exemplify, the sense that art like that is really no longer available save in the spirit of pastiche and prank. Komar and Melamid are postmodern artists who yearn, as in a way we all do, for the sweet innocence of premodern art, when one could paint damp landscapes, cows in sunny pastures, girls in windows, the Seine at Pontoise, bathers at Cabourg, Madame Renoir nursing baby Pierre.

It is against this background that the marvelous exercise of determining what is the "most wanted painting" must ultimately be appreciated. The more immediate background is the singular success Komar and Melamid had in the art world of the 1980s, which had, in a sense, caught up with them. It was an art world as permissive conceptually as any in history—as any in what one might think of as possible history, in the sense that there were no longer any defining imperatives as to what is art: not the New York imperatives of pure painting, which was intolerant of what did not fit into a narrowly prescribed structure; and not the Moscow imperatives of historical materialism, which defined what art must be in a socialist society and swept aside as counterrevolutionary whatever did not celebrate the victory of the working class. This radical permissiveness I credit pop art with having achieved. It was an art world made to order for Komar and Melamid, with their academic powers and their satirical impulses; and they flourished in the eighties by exploiting the remarkable comic potential of socialist realist art, mocking

the representations of Lenin and Stalin from the relative safety of the New York art scene, where they were appreciated for their wit as much as for their predicament. And, in a way that had been pioneered by Andy Warhol, they became, simultaneously, celebrities and critical successes. Their work was accessible as well as esteemed. I can think of few more delicious comic achievements than their masterpiece *The Origin of Socialist Realism* of 1982–83, which illustrates the legendary episode in which a Corinthian girl is said to have invented the art of drawing by outlining the shadow of her lover's head on the wall behind him—except that the lover in this case is Joseph Stalin, whose profile is being inscribed by a young woman lightly clad in classical drapery. The painting itself is in the high socialist realist manner, and the malice comes only in part from using socialist realism to satirize itself and its scary inspirer and frequent subject. The project of cannibalizing Soviet art culminated in their spectacular May Day installation at the Palladium nightclub in New York in 1986—an elaborate set hung with red banners and featuring a replica of Lenin in his tomb. But with the persistence of glasnost and perestroika, and then with the breakup of the Soviet Union, they all at once lost their best and, in a sense, their defining subject. Such are the ironies of history that the collapse of communism coincided with the collapse of the art world in the West, and the question even for the most successful artists of the eighties was, to use the title that they borrowed in 1988 from a major text of Lenin, "What is to be done?"

The true genius of Komar and Melamid revealed itself when, finding themselves at a historical moment fulsome with declarations of the "triumph of capitalism," they took as their subject the concept of the market—now hailed with equal vigor in America and Russia, where former apparatchiks suddenly accepted the tenets of free-market economics with the unquestioning conviction with which their ancestors had accepted the dogmas of Greek Orthodoxy. With the support of The Nation Institute, the artists decided to use market research to find what the cover of *The Nation*'s March 14, 1994, issue termed "a people's art"—namely, the kind of art people really want.

lots of reds and dots—and the poor are winning (Warren, Pittstown, Penn.). The inside of a shell that has just washed up, or the inside of a camelia that has just burst open with some morning dew

Once this was known, supply could be adjusted to demand according to the harmonious rhythms laid out by classical economics: society (or, since linguistic habit dies hard, "the people") would get the art it wants; and artists who knew what the people wanted should be able to make a decent living. From the beginning, I could not quite imagine that this knowledge could be put into industrial practice, since part of what the people want could be art produced by artists in the old-fashioned one-at-a-time way, brush-to-canvas, by an artist in a beret standing before an easel. But who knew? No one had ever tried to find out. Meanwhile, painting to the American market must have seemed the way for Komar and Melamid to achieve their own transformation from Russian to American artists.

The statistical science used was state of the art (accurate "within a margin of error of +/-3.2 percent, at a 95 percent confidence level"), and the answers themselves constitute a singularly interesting piece of aesthetic sociology. Blue, for example—by far America's favorite color (44 percent) is most appealing to people in the Central states who are between forty and forty-nine years of age, conservative, white, male, making $30,000 to $40,000, and who don't go to museums at all. In a comparable poll, but with what I think must be incomparably higher monetary stakes, the manufacturers of M&M's undertook to expand the spectrum of colored coating on their candy by finding out which was the most highly preferred color. I suppose to no one's great surprise, it turned out to be blue. By Komar and Melamid's poll, the appeal of blue falls off as the level of education and income rises. People making less than $20,000 are almost twice as likely to prefer blue as those with incomes over $75,000. The biggest consumers of M&M's are not likely to be in the $40,000-a-year class, though all of their income, from baby-sitting and the like, is probably discretionary. On the basis of this copious amount of data, Komar and Melamid produced what they title *America's Most Wanted*, a painting that reflects as many of the preferred qualities as the artists could incorporate onto a single canvas.

plate no. 44

on it, in the pearlescent colors of nature. But it's not a postcard or still life; it's more surrealistic, where the painting itself is an escape (Jackie, Melbourne Beach, Fla.). A Marcel Duchamp

As luck would have it, the Book Review section of *The New York Times* for January 15, 1995, advertised "the new bestseller" by Doris Mortman, *True Colors*, with "everything you want in a novel," itemized as "Family. Love. Betrayal. Rivalry. Talent. Triumph." It is clearly about an artist—the full-page ad shows us a vase with brushes, and some twisted tubes laid out on a piece of exotic fabric. "*True Colors* sweeps you into the international art scene, where the intense pressures of success compete with the deeper dictates of the heart." It is worth speculating whether anyone conducted a poll to find out what the people most want in a novel, but I tend to think that most people want novels to come from sources other than scientifically impeccable opinion polls. They want a novel to come from the heart, from the guts, or at least the experience of the novelist; and my own sense—to be sure, based on intuition rather than science—is that the moment you learned that "everything you want in a novel" is in the novel only because you want it there, you would lose interest in the novel. Whatever the case, I have never seen *True Colors* on the *New York Times* bestseller list. Nevertheless, I infer that something can be a "bestselling novel" without actually being a bestseller. A "bestselling novel" must be a kind of novel, defined by what it has in it. And with at least two sorts of novels—romances and pornography—it is probably the case that readers place a higher premium on compliance with a formula than on creativity or inspiration. The interesting question is to what degree that is true of paintings. The artist whose brushes and paint tubes appear on the jacket of the "most wanted novel" could not really be an artist whose paintings are as they are because the people want them to be that way. It should be the other way around: the people want them to be that way because the artist is such a great success in the "international art scene." It could not be the "most wanted novel" whose artist hero or heroine traded inspiration in for opinion polls: artistic inspiration, after all, goes hand in hand with the panting romanticism, the finding of true love, the fear of betrayal—in other words, the very qualities in which "most wanted novels" must trade. It would have been interesting, therefore, if Komar and Melamid had included a set of questions that asked if people preferred paintings that resulted from

finding out what they most wanted in a painting, or paintings in which the artist painted from inspiration. People—I continue to speak without the backing of any scientific evidence—want artists to be like Buchumov! My sense, then, is that the "most wanted painting" is incompatible with what most people want of a painting. But that may be different from what most people want *in* a painting. Following the same line of reasoning applied above to a "bestselling novel" and a bestseller, my parallel intuition here is that something can be the "most wanted painting" even if nobody wants it.

This brings me to the last of my relevant personal encounters with the work of Komar and Melamid: the marvelous, carnivalesque inaugural exhibition of *America's Most Wanted* at the Alternative Museum on Broadway in New York. I had been somewhat privy to the processes by which the artists had arrived at this work, inasmuch as it was The Nation Institute that organized the funding for the poll itself and I was kept pretty well informed by the institute's executive director, Peter Meyer. But there are few secrets in the art world, and the crowds were significant. Everyone went to see what we all most deeply want in our heart of aesthetic hearts, though it would have been exceedingly difficult, given the questions asked, to imagine that works like Barnett Newman's *Who's Afraid of Red, Yellow and Blue* series—or one of Robert Motherwell's *Elegies for the Spanish Republic*, or Mark Rothko's *Number 16*—would have emerged as exemplifying what America most wanted in a painting. A different kind of survey would have been needed to see what the art world would favor as its "most wanted painting." Much of the audience that evening, drinking blue vodka (to emblemize the triumph of blue in the chromatic sweepstakes), exchanging gossip and wisecracks, was too skewed a population to feel anything but superiority to the implied aesthetics of the common man and woman supposedly objectified in the "genuine oil painting" in the gilded frame. But would Mister or Ms. Whoever cry out "That's it!" when presented with the way in which Komar and Melamid had realized their presumed dream painting?

chess set (Richard Rapoport, New York City, unemployed). A rainy summer day, with pillows and a small dog and a soft sweater (and a human and a couch), very blue, moody (Richard Hartz,

I think that in terms of its painterly style it almost certainly must represent what people like who "don't know much about art but know what they like." *America's Most Wanted* is executed in what one might term a modified Hudson River Biedermeier style—with perhaps something more than 44 percent blue—and shows figures "at leisure" in a landscape. What is somewhat surprising is the result of polls later conducted in a variety of countries, from Russia and Scandinavia to France to Kenya and finally to China (where poll takers conducted a statistically mapped door-to-door canvass, as the distribution of telephones in China would have badly distorted the results from phone interviews). There is a more saturated blue, but less of it, in *Russia's Most Wanted*, and the figures are depicted "at work." But throughout the world the results have been strikingly congruent, in the sense that each country's *Most Wanted* looks like, give or take a few details, every other *Most Wanted*. Each of the paintings, that is, looks stylistically alike. And it is at the very least cause for reflection that what randomly selected populations the world round "most want" are paintings in the generic, all-purpose realist style the artists invented for *America's Most Wanted*. When I suggested to them that the paintings all look pretty much alike, Komar and Melamid granted as much, pointing out that national differences emerge more in the "most unwanted painting," invariably abstract, featuring sharp angles and such colors as gold, orange, mauve, fuchsia, and teal (to scrape the bottom of Kenya's chromatic scale), but often variant in size and pattern. *America's Most Unwanted* is small and mean; *France's Most Unwanted* is large and vapid. The point remains that the style is invariant, national differences showing up in the details. The "most wanted painting," speaking transnationally, is a nineteenth-century landscape—the kind of painting Buchumov cut his teeth on, the kind of painting whose degenerate descendants embellish calendars from Kalamazoo to Kenya. The 44-percent-blue landscape with water and trees must be the a priori aesthetic universal, what everyone who thinks of art first thinks of, as if modernism had never happened.

It is possible, of course, that everyone's concept of art *was* formed by calendars (even in Kenya), which now constitutes a sort of paradigm of what everyone first thinks of when they think of art. The psychologist Eleanor Rosch and her associates have developed a branch of psychology known as paradigm theory, based on the way in which information is stored. Most people will answer "robin" when asked to name a bird, or "dog" when asked to name an animal. Few will answer "coot" to the first, or "aardvark" to the second. Asked to name a kind of dog, people will preponderately mention "police dog" rather than "Lhasa apso." Americans, but no Chinese, will answer "George Washington" when asked the name of a famous historical person. Nobody is likely to answer "hippopotamus" to "wild animal"; the usual answers are "elephant," "lion," and "tiger." It is altogether likely that what Komar and Melamid have unearthed is less what people prefer than what they are most familiar with in paintings. I would wager that the unrepresentative population at the museum opening shares the same paradigms. That would be why, when throughout history anything has deviated significantly from the predominately blue landscape, the spontaneous response has been that it is not art. Why else would the Kenyans, for example, come out with the same kind of painting as everyone else even though 70 percent of them answered "African" to question 37—"If you had to choose from the following list, which type of art would you say you prefer?"—when the other choices were Asian, American, and European? There is nothing in the least African about the Hudson River Biedermeier style of landscape with water. But it may be exactly with reference to such images that the Kenyans learned the meaning of art. It is no accident that in the Kenya questionnaire, in response to the question on what type of art people have in their homes, 91 percent mentioned prints from calendars (though, in fairness, 72 percent mentioned "prints or posters").

New York City, student). A nude portrait of Winona Ryder before the Jefferson Memorial at sunset, with strawberries and an ermine (James Cox, Pittsburgh, student). I would like a painting

Where the differences emerge is in the figures with which these landscapes are populated, and it is here that Komar and Melamid get mischievous. Since people prefer landscapes to nonlandscapes, and paintings with people (famous or otherwise) to paintings without people, Komar and Melamid give them landscapes with people—often famous people—in them. People also cite a preference for paintings with animals, and indeed—in almost every case—wild animals, but it would hardly have occurred to them that what they wanted was a landscape with a famous person and wild animal, unless there were some internal connection between the famous person and the animal, as between Sampson and the lion, or Europa and the bull, or Jonah and the whale. There is no way in which George Washington and the hippopotamus can be connected up that way—no way really that George Washington and a hippopotamus would share a pictorial environment if it is meant to be a realistic picture. And neither do they co-occur on the same level in one of Rosch's schematisms, since Washington is a paradigm famous person but the hippopotamus is far from the paradigm wild animal (though unquestionably a wild animal). Yet they are together in *America's Most Wanted.* Putting Washington together with a typical American family in camping clothes violates another law of consistency, since it violates the unity of time.

What is striking about *America's Most Wanted* is that I cannot imagine anyone really wanting it as a painting, least of all anyone in the population whose taste it is supposed to reflect. No one who wants a painting of wild animals *or* who wants a painting of George Washington wants a painting of George Washington *and* of wild animals. Komar and Melamid have transformed disjunctions into conjunctions, and the conjunction can be displeasing even if the conjuncts are pleasing, taken one by one. Everyone, to use a contemporary political parallel, might like tax cuts, the elimination of the federal deficit, efficient government services with few government regulations, but it is not clear that you can have all of those things at once: Newt Gingrich's Contract with America is perhaps the political counterpart to *America's Most Wanted.* There may or may not be a parable of political philosophy in this,

but the painting that is supposed to reflect the integrated aesthetic utility curves of Everyone in fact reflects the aesthetic utility curve of no one at all. The painting has the seeming structure of a rebus puzzle, with disjoint components thrust into the same conjoining frame. But unlike a rebus, there is no solution. There is no explanation of why anything is there other than the fact that it came up first in response to a question in a questionnaire. Nothing has anything to do with anything else in terms of meaning or causality. Like the Contract with America, it may basically be incoherent, and my overall view is that once everyone registers the fact that the style is what they like, the painting would rapidly be despised because of its incoherence. Had there been a question to the effect "Do you prefer coherence to incoherence in a painting?" these *Most Wanted* paintings could never have been painted.

"Most Wanted," as an expression, has a use in American English connected with the list of criminals to whose apprehension the FBI assigns the highest priority, not with the wish list of the National Gallery. Nevertheless, the "second most wanted painting" would not be, say, Gainsborough's *Blue Boy* or the Mona Lisa but a painting by Komar and Melamid incorporating the second most highly prized aesthetic qualities according to their poll. In fact, *America's Most Wanted* can belong nowhere but on a list that includes paintings by Komar and Melamid based on the same data from which it came. As a painting it has no place in the art world at all. What does have a place in the art world is the performance piece by Komar and Melamid that consists in the opinion poll, the painting, the publicity, etc. *That* work is probably a masterpiece. *That* work is about people's art without itself being people's art. *That* work is "postmodern, humorous, and iconic," as is, derivatively, the *Most Wanted* painting itself. The fact that it looks unmistakably Hudson River Biedermeier shows, in point of expression, the nostalgia of these marvelous artists; but in point of identity it shows the truth that we are forever exiled from the aesthetic motherland where painting pretty pictures was the defin-

by the artist whose work commands the highest price on the market so that I could sell it, buy a country house, and use the rest of the money to buy lots of cheaper pictures (Katha Pollitt, New York

ing artistic imperative. It also shows how little distance our eyes will carry us in finding our way in the art world of postmodern times. But finally it shows how great the distance is between where art is today and where the population is so far as, until the mischief began, its taste is captured in *America's Most Wanted*.

City, writer). A glowing waitress. Your average woman, but idealized, bigger, kind of hearty-looking (Page, Minneapolis, waitress).

You can re-create this picture in your own home by following this simple key:

1. dark blue; 2. medium blue; 3. light blue;

4. dark sky blue; 5. medium sky blue;

6. light sky blue; 7. dark gray-green;

8. medium gray-green; 9. light gray-green;

10. dark yellow-green; 11. medium yellow-green;

12. light yellow-green; 13. very light yellow-green;

14. beige; 15. red; 16. pale green; 17. light gray;

18. light flesh; 19. dark flesh; 20. medium gray;

21. brown; 22. dark brown.

Illustration: Paul Chudy

CROSS TABULATIONS OF THE AMERICAN POLL

Q1. How carefully do you consider most of your spending decisions?

	TOTAL	EXTRME /VERY CAREFL	Extrme Carefl	Very Carefl	Somewt Carefl	Not Very Carefl	TOTAL SOMWT/ NT VRY CAREFL	Not Sure
All Voters.........	1001	79%	30%	49%	18%	3%	21%	*
Northeast..........	216	76%	28%	48%	19%	5%	24%	*
South..............	335	79%	33%	46%	20%	1%	21%	*
Central............	241	81%	29%	52%	16%	2%	19%	*
West...............	209	79%	27%	52%	18%	3%	21%	-
Male...............	475	77%	32%	45%	19%	3%	22%	*
Female.............	526	80%	28%	52%	17%	2%	20%	*
Under 30...........	247	70%	26%	44%	27%	2%	30%	-
30 to 39...........	263	79%	30%	49%	17%	3%	21%	1%
40 to 49...........	191	82%	27%	54%	14%	4%	18%	1%
50 to 64...........	154	84%	36%	48%	15%	1%	16%	-
65 And Over........	131	83%	27%	56%	14%	3%	17%	-
High School/Less...	421	77%	31%	46%	20%	3%	23%	-
Some College.......	281	79%	31%	48%	17%	3%	20%	1%
College Graduate...	293	81%	26%	55%	17%	2%	19%	*
Post-Graduate....	103	73%	22%	50%	23%	4%	27%	-
Liberal............	319	74%	24%	50%	23%	3%	25%	*
Moderate/Other.....	207	81%	33%	47%	15%	3%	19%	*
Conservative.......	475	81%	32%	49%	16%	3%	19%	*
Under $30K.........	343	78%	31%	46%	19%	3%	22%	-
Under $20K......	155	81%	32%	48%	16%	3%	19%	-
$20K to $30K.......	188	76%	31%	45%	22%	3%	24%	-
$30K to $40K.......	155	76%	28%	48%	21%	3%	24%	-
$40K to $50K.......	133	81%	26%	56%	17%	2%	19%	-
Over $50K..........	244	76%	25%	50%	21%	3%	24%	*
Over $75K.......	95	69%	19%	51%	26%	4%	31%	*
White..............	779	80%	29%	50%	18%	2%	20%	*
Black..............	100	74%	30%	44%	21%	5%	26%	-
Hispanic...........	66	79%	32%	47%	20%	2%	21%	-
All Other..........	56	75%	32%	43%	21%	4%	25%	-
Have Children......	666	81%	29%	52%	17%	3%	19%	*
Encourage/Artist	523	80%	29%	51%	17%	3%	20%	*
Don't Have Children	335	75%	32%	43%	22%	3%	24%	1%
Willing To Pay More	393	76%	27%	49%	20%	4%	24%	1%
Only Sometimes.....	382	79%	26%	53%	19%	2%	21%	-
Hardly Ever Pay Mre	211	83%	39%	44%	14%	2%	17%	*
Have Art In Home...	768	79%	29%	50%	18%	3%	21%	*
Don't Have Art.....	233	79%	32%	46%	19%	2%	21%	*
Choice - Choose Art	352	76%	26%	51%	20%	3%	23%	*
Would Choose Money.	574	79%	33%	47%	17%	3%	20%	*
Not Sure...........	75	85%	27%	59%	15%	-	15%	-
Spend $25-100/Art..	472	80%	35%	45%	17%	2%	20%	*
Wld Spend Over $200	451	76%	24%	52%	21%	3%	24%	*
Museum >2 Times Yr.	188	79%	26%	53%	16%	5%	21%	-
1 or 2 Times A Yr..	301	79%	26%	53%	18%	2%	20%	1%
Less Than Once A Yr	236	78%	28%	50%	19%	3%	21%	*
Don't Go To Museums	240	79%	39%	40%	20%	2%	21%	-
Favor Mre Fed Taxes	300	79%	26%	53%	18%	3%	21%	*
Wld Pay $25 More	197	79%	23%	56%	17%	3%	20%	1%
Pay $5-$15 More.	57	72%	26%	46%	26%	2%	28%	-
None Of Above...	33	88%	39%	48%	9%	3%	12%	-
Oppose Mre Fed Taxs	571	79%	32%	47%	19%	2%	21%	*
Not Sure...........	130	79%	30%	49%	17%	4%	21%	-

Q2. When you have a choice between two products of equal quality, how often are you willing to pay a little extra for a design or style you prefer?

	TOTAL	ALL/ MOST OF THE TIME	All The Time	Most Of The Time	Only Smtmes	Hardly Ever	ONLY SMTME/ HARDLY EVER	Not Sure
All Voters.........	1001	39%	9%	30%	38%	21%	59%	1%
Northeast..........	216	34%	7%	26%	42%	23%	65%	1%
South..............	335	39%	11%	28%	38%	22%	60%	2%
Central............	241	40%	10%	30%	39%	20%	59%	1%
West...............	209	45%	8%	37%	34%	19%	53%	2%
Male...............	475	44%	11%	33%	34%	20%	54%	2%
Female.............	526	35%	8%	27%	42%	22%	64%	1%
Under 30...........	247	43%	10%	34%	42%	13%	55%	1%
30 to 39...........	263	39%	8%	31%	38%	22%	60%	1%
40 to 49...........	191	43%	11%	32%	37%	19%	55%	1%
50 to 64...........	154	36%	8%	27%	41%	21%	62%	2%
65 And Over........	131	30%	10%	20%	31%	36%	67%	3%
High School/Less...	421	35%	9%	27%	38%	26%	63%	1%
Some College.......	281	38%	6%	32%	43%	18%	60%	1%
College Graduate...	293	46%	13%	33%	35%	17%	52%	2%
Post-Graduate....	103	44%	12%	32%	34%	19%	53%	3%
Liberal............	319	42%	11%	30%	39%	19%	57%	1%
Moderate/Other.....	207	34%	9%	25%	41%	21%	62%	4%
Conservative.......	475	40%	8%	32%	37%	23%	59%	1%
Under $30K.........	343	32%	8%	24%	40%	27%	67%	1%
Under $20K......	155	31%	8%	23%	36%	30%	66%	3%
$20K to $30K.......	188	32%	9%	24%	43%	24%	67%	1%
$30K to $40K.......	155	38%	8%	30%	40%	22%	62%	-
$40K to $50K.......	133	45%	11%	35%	41%	13%	53%	2%
Over $50K..........	244	48%	11%	36%	36%	14%	50%	2%
Over $75K.......	95	54%	12%	42%	32%	14%	45%	1%
White..............	779	40%	10%	30%	38%	21%	59%	1%
Black..............	100	37%	9%	28%	38%	24%	62%	1%
Hispanic...........	66	35%	3%	32%	44%	21%	65%	-
All Other..........	56	45%	9%	36%	36%	18%	54%	2%
Have Children......	666	37%	8%	29%	38%	24%	62%	1%
Encourage/Artist	523	37%	8%	28%	39%	23%	62%	1%
Don't Have Children	335	44%	12%	33%	39%	15%	53%	2%
Willing To Pay More	393	100%	24%	76%	-	-	-	-
Only Sometimes.....	382	-	-	-	100%	-	100%	-
Hardly Ever Pay Mre	211	-	-	-	-	100%	100%	-
Have Art In Home...	768	40%	9%	31%	38%	21%	59%	1%
Don't Have Art.....	233	37%	9%	28%	40%	21%	61%	2%
Choice - Choose Art	352	42%	11%	32%	37%	20%	57%	1%
Would Choose Money.	574	38%	9%	29%	40%	21%	60%	2%
Not Sure...........	75	35%	7%	28%	33%	31%	64%	1%
Spend $25-100/Art..	472	31%	7%	24%	44%	25%	68%	1%
Wld Spend Over $200	451	49%	12%	37%	33%	16%	50%	1%
Museum >2 Times Yr.	188	43%	14%	29%	32%	23%	55%	2%
1 or 2 Times A Yr..	301	42%	9%	33%	41%	16%	57%	1%
Less Than Once A Yr	236	37%	8%	29%	41%	20%	61%	1%
Don't Go To Museums	240	36%	8%	28%	35%	26%	61%	3%
Favor Mre Fed Taxes	300	42%	11%	32%	37%	20%	56%	1%
Wld Pay $25 More	197	44%	12%	32%	35%	20%	54%	2%
Pay $5-$15 More.	57	39%	7%	32%	46%	14%	60%	2%
None Of Above...	33	36%	9%	27%	36%	27%	64%	-
Oppose Mre Fed Taxs	571	38%	9%	29%	39%	21%	61%	1%
Not Sure...........	130	38%	7%	31%	36%	23%	59%	3%

Q3. How important would the appearance or design of the following
be in your decision to buy that product: A new car.

	TOTAL	TOTAL VERY/ SOMEWT IMPRNT	Very Imprnt	Somewt Imprnt	Not Very Imprnt	Not At All Imprnt	TOTAL NOT VERY/ AT ALL	Not Sure
All Voters........	1001	87%	59%	28%	8%	5%	12%	1%
Northeast..........	216	87%	55%	31%	10%	3%	13%	*
South..............	335	87%	62%	24%	7%	5%	12%	1%
Central............	241	86%	57%	29%	9%	5%	13%	1%
West...............	209	88%	60%	28%	5%	6%	11%	*
Male...............	475	88%	64%	25%	8%	3%	11%	1%
Female.............	526	86%	55%	31%	7%	6%	13%	1%
Under 30...........	247	94%	67%	27%	4%	1%	6%	–
30 to 39...........	263	90%	61%	29%	7%	3%	10%	1%
40 to 49...........	191	86%	56%	30%	7%	6%	14%	1%
50 to 64...........	154	81%	56%	25%	12%	6%	18%	1%
65 And Over........	131	75%	47%	28%	11%	12%	23%	2%
High School/Less...	421	81%	58%	24%	10%	7%	17%	1%
Some College.......	281	89%	58%	30%	7%	4%	11%	*
College Graduate...	293	93%	61%	32%	4%	2%	6%	1%
Post-Graduate....	103	94%	60%	34%	5%	–	5%	1%
Liberal............	319	88%	57%	31%	6%	6%	12%	*
Moderate/Other.....	207	82%	57%	25%	10%	6%	16%	1%
Conservative.......	475	88%	61%	27%	8%	4%	11%	1%
Under $30K.........	343	83%	57%	26%	8%	9%	17%	*
Under $20K......	155	79%	53%	26%	10%	10%	21%	1%
$20K to $30K.......	188	86%	61%	26%	6%	7%	14%	–
$30K to $40K.......	155	87%	58%	29%	10%	1%	11%	2%
$40K to $50K.......	133	91%	60%	31%	5%	3%	8%	1%
Over $50K..........	244	93%	65%	28%	5%	2%	7%	*
Over $75K.......	95	92%	63%	28%	5%	2%	7%	1%
White..............	779	88%	60%	27%	7%	4%	12%	1%
Black..............	100	82%	56%	26%	9%	8%	17%	1%
Hispanic...........	66	85%	48%	36%	8%	8%	15%	–
All Other..........	56	84%	59%	25%	7%	5%	13%	4%
Have Children......	666	85%	56%	29%	9%	6%	14%	1%
Encourage/Artist	523	86%	57%	29%	8%	5%	13%	1%
Don't Have Children	335	91%	66%	25%	6%	3%	9%	1%
Willing To Pay More	393	92%	71%	21%	5%	3%	7%	1%
Only Sometimes.....	382	87%	54%	34%	9%	3%	12%	1%
Hardly Ever Pay Mre	211	76%	45%	30%	10%	13%	23%	1%
Have Art In Home...	768	88%	61%	28%	7%	4%	11%	1%
Don't Have Art.....	233	82%	54%	28%	9%	8%	17%	1%
Choice - Choose Art	352	87%	57%	30%	8%	5%	13%	*
Would Choose Money.	574	87%	60%	26%	8%	4%	12%	1%
Not Sure...........	75	87%	60%	27%	5%	5%	11%	3%
Spend $25-100/Art..	472	86%	59%	27%	9%	5%	14%	1%
Wld Spend Over $200	451	90%	60%	30%	6%	4%	9%	1%
Museum >2 Times Yr.	188	89%	57%	32%	4%	6%	10%	1%
1 or 2 Times A Yr..	301	88%	57%	31%	9%	3%	12%	–
Less Than Once A Yr	236	86%	61%	25%	8%	5%	12%	1%
Don't Go To Museums	240	84%	62%	22%	8%	7%	15%	1%
Favor Mre Fed Taxes	300	89%	58%	31%	6%	5%	11%	*
Wld Pay $25 More	197	91%	57%	34%	5%	4%	9%	–
Pay $5-$15 More.	57	88%	60%	28%	5%	7%	12%	–
None Of Above...	33	82%	64%	18%	12%	6%	18%	–
Oppose Mre Fed Taxs	571	87%	61%	26%	8%	4%	12%	1%
Not Sure...........	130	80%	53%	27%	11%	6%	17%	3%

Q4. How important would the appearance or design of the following
be in your decision to buy that product: A pair of underwear.

	TOTAL	TOTAL VERY/ SOMEWT IMPRNT	Very Imprnt	Somewt Imprnt	Not Very Imprnt	Not At All Imprnt	TOTAL NOT VERY/ AT ALL	Not Sure
All Voters........	1001	48%	19%	28%	31%	21%	52%	*
Northeast..........	216	53%	23%	30%	27%	20%	47%	–
South..............	335	48%	19%	29%	31%	20%	51%	1%
Central............	241	47%	22%	26%	32%	21%	53%	–
West...............	209	42%	14%	28%	33%	24%	57%	*
Male...............	475	41%	14%	27%	33%	25%	58%	*
Female.............	526	53%	24%	29%	28%	18%	46%	1%
Under 30...........	247	49%	17%	33%	34%	16%	51%	–
30 to 39...........	263	46%	14%	31%	32%	22%	54%	1%
40 to 49...........	191	51%	23%	28%	28%	21%	49%	–
50 to 64...........	154	46%	23%	23%	29%	25%	54%	–
65 And Over........	131	46%	24%	22%	27%	24%	52%	2%
High School/Less...	421	51%	23%	29%	28%	20%	48%	1%
Some College.......	281	45%	18%	27%	31%	24%	55%	*
College Graduate...	293	45%	16%	29%	34%	20%	55%	*
Post-Graduate....	103	36%	17%	18%	39%	25%	64%	–
Liberal............	319	51%	18%	34%	29%	20%	49%	–
Moderate/Other.....	207	47%	24%	23%	29%	23%	52%	1%
Conservative.......	475	45%	18%	27%	32%	22%	54%	*
Under $30K.........	343	53%	23%	30%	27%	19%	47%	*
Under $20K......	155	55%	27%	28%	22%	23%	45%	1%
$20K to $30K.......	188	52%	19%	32%	32%	16%	48%	–
$30K to $40K.......	155	48%	16%	32%	34%	17%	52%	1%
$40K to $50K.......	133	41%	20%	22%	35%	24%	59%	–
Over $50K..........	244	43%	15%	28%	34%	23%	57%	–
Over $75K.......	95	42%	15%	27%	32%	26%	58%	–
White..............	779	47%	18%	30%	32%	21%	52%	*
Black..............	100	61%	32%	29%	20%	18%	38%	1%
Hispanic...........	66	39%	18%	21%	36%	24%	61%	–
All Other..........	56	39%	21%	18%	25%	34%	59%	2%
Have Children......	666	48%	21%	27%	28%	23%	51%	1%
Encourage/Artist	523	48%	21%	27%	30%	22%	52%	*
Don't Have Children	335	47%	16%	31%	35%	18%	53%	–
Willing To Pay More	393	53%	20%	33%	30%	16%	47%	*
Only Sometimes.....	382	48%	21%	27%	31%	20%	52%	1%
Hardly Ever Pay Mre	211	36%	13%	22%	30%	34%	64%	1%
Have Art In Home...	768	48%	19%	29%	31%	21%	51%	1%
Don't Have Art.....	233	46%	19%	27%	30%	23%	53%	*
Choice - Choose Art	352	48%	21%	28%	28%	23%	52%	–
Would Choose Money.	574	47%	18%	29%	32%	20%	52%	1%
Not Sure...........	75	47%	23%	24%	31%	20%	51%	3%
Spend $25-100/Art..	472	48%	21%	27%	29%	23%	52%	*
Wld Spend Over $200	451	47%	18%	30%	33%	20%	52%	*
Museum >2 Times Yr.	188	48%	22%	26%	31%	20%	52%	–
1 or 2 Times A Yr..	301	49%	18%	32%	32%	19%	51%	–
Less Than Once A Yr	236	46%	18%	28%	32%	22%	54%	–
Don't Go To Museums	240	47%	21%	26%	28%	24%	52%	1%
Favor Mre Fed Taxes	300	45%	17%	28%	31%	23%	54%	1%
Wld Pay $25 More	197	49%	16%	33%	32%	19%	51%	*
Pay $5-$15 More.	57	35%	18%	18%	32%	33%	65%	–
None Of Above...	33	33%	12%	21%	27%	33%	61%	6%
Oppose Mre Fed Taxs	571	48%	19%	29%	30%	22%	51%	*
Not Sure...........	130	51%	25%	25%	32%	17%	49%	–

Q5. How important would the appearance or design of the following
be in your decision to buy that product: A television set.

	TOTAL	TOTAL VERY/ SOMEWT IMPRNT	Very Imprnt	Somewt Imprnt	Not Very Imprnt	Not At All Imprnt	TOTAL NOT VERY/ AT ALL	Not Sure
All Voters........	1001	72%	33%	40%	19%	8%	27%	1%
Northeast..........	216	69%	26%	44%	22%	8%	30%	1%
South..............	335	73%	37%	36%	17%	9%	26%	1%
Central............	241	73%	35%	38%	18%	8%	26%	1%
West...............	209	74%	29%	44%	21%	5%	26%	-
Male...............	475	71%	31%	40%	21%	8%	28%	1%
Female.............	526	74%	34%	40%	18%	8%	26%	1%
Under 30...........	247	75%	31%	44%	20%	4%	24%	*
30 to 39...........	263	74%	27%	47%	18%	8%	25%	1%
40 to 49...........	191	74%	32%	42%	18%	8%	26%	-
50 to 64...........	154	69%	38%	31%	23%	7%	31%	1%
65 And Over.......	131	67%	40%	27%	18%	13%	31%	2%
High School/Less...	421	71%	36%	35%	19%	8%	28%	1%
Some College.......	281	73%	30%	43%	19%	8%	27%	*
College Graduate...	293	73%	29%	44%	20%	6%	26%	*
Post-Graduate....	103	78%	28%	50%	21%	1%	22%	-
Liberal............	319	73%	32%	41%	19%	8%	27%	-
Moderate/Other.....	207	71%	35%	35%	18%	9%	28%	2%
Conservative.......	475	73%	32%	41%	20%	7%	27%	*
Under $30K.........	343	71%	35%	36%	18%	9%	27%	1%
Under $20K......	155	67%	38%	29%	18%	13%	31%	2%
$20K to $30K.......	188	75%	32%	43%	19%	6%	24%	1%
$30K to $40K.......	155	77%	35%	42%	17%	6%	23%	-
$40K to $50K.......	133	71%	27%	44%	20%	9%	29%	-
Over $50K..........	244	73%	29%	44%	20%	7%	27%	*
Over $75K.......	95	65%	22%	43%	27%	6%	34%	1%
White..............	779	72%	32%	39%	20%	8%	28%	1%
Black..............	100	80%	39%	41%	11%	8%	19%	1%
Hispanic...........	66	70%	29%	41%	20%	9%	29%	2%
All Other..........	56	75%	32%	43%	21%	4%	25%	-
Have Children......	666	71%	34%	37%	19%	9%	28%	1%
Encourage/Artist	523	73%	36%	37%	18%	9%	27%	*
Don't Have Children	335	74%	30%	45%	21%	5%	25%	*
Willing To Pay More	393	75%	41%	34%	21%	4%	25%	1%
Only Sometimes.....	382	77%	27%	50%	17%	6%	23%	*
Hardly Ever Pay Mre	211	58%	24%	34%	22%	19%	41%	1%
Have Art In Home...	768	72%	32%	40%	20%	7%	27%	1%
Don't Have Art.....	233	73%	34%	39%	16%	10%	26%	1%
Choice - Choose Art	352	72%	35%	38%	21%	6%	27%	*
Would Choose Money.	574	72%	32%	41%	19%	9%	27%	*
Not Sure...........	75	73%	29%	44%	15%	8%	23%	4%
Spend $25-100/Art..	472	71%	33%	38%	19%	10%	28%	*
Wld Spend Over $200	451	74%	31%	42%	20%	5%	25%	1%
Museum >2 Times Yr.	188	66%	30%	36%	20%	13%	34%	1%
1 or 2 Times A Yr..	301	76%	31%	46%	19%	4%	23%	1%
Less Than Once A Yr	236	74%	34%	40%	19%	6%	26%	-
Don't Go To Museums	240	70%	36%	34%	19%	10%	29%	*
Favor Mre Fed Taxes	300	71%	31%	40%	21%	8%	28%	1%
Wld Pay $25 More	197	72%	32%	40%	22%	6%	28%	-
Pay $5-$15 More.	57	72%	21%	51%	19%	9%	28%	-
None Of Above...	33	61%	36%	24%	18%	15%	33%	6%
Oppose Mre Fed Taxs	571	74%	33%	40%	18%	8%	26%	*
Not Sure...........	130	70%	34%	36%	21%	8%	28%	2%

Q6. How important would the appearance or design of the following
be in your decision to buy that product: A winter coat.

	TOTAL	TOTAL VERY/ SOMEWT IMPRNT	Very Imprnt	Somewt Imprnt	Not Very Imprnt	Not At All Imprnt	TOTAL NOT VERY/ AT ALL	Not Sure
All Voters........	1001	89%	51%	38%	6%	4%	10%	1%
Northeast..........	216	93%	54%	38%	4%	3%	7%	*
South..............	335	87%	52%	35%	6%	5%	11%	2%
Central............	241	89%	49%	40%	7%	4%	11%	-
West...............	209	88%	48%	40%	7%	4%	11%	*
Male...............	475	88%	48%	40%	7%	4%	11%	1%
Female.............	526	90%	54%	36%	5%	4%	9%	1%
Under 30...........	247	94%	52%	43%	4%	2%	6%	-
30 to 39...........	263	90%	49%	41%	7%	2%	9%	1%
40 to 49...........	191	90%	49%	41%	4%	5%	9%	1%
50 to 64...........	154	86%	53%	32%	9%	5%	14%	*
65 And Over.......	131	81%	54%	27%	8%	8%	15%	4%
High School/Less...	421	86%	46%	40%	7%	5%	12%	2%
Some College.......	281	92%	53%	40%	4%	4%	8%	-
College Graduate...	293	90%	56%	34%	6%	3%	10%	-
Post-Graduate....	103	94%	60%	34%	5%	1%	6%	-
Liberal............	319	90%	52%	38%	6%	3%	9%	1%
Moderate/Other.....	207	87%	49%	38%	6%	6%	12%	1%
Conservative.......	475	89%	52%	38%	6%	4%	10%	1%
Under $30K.........	343	89%	49%	39%	6%	4%	10%	1%
Under $20K......	155	86%	50%	35%	6%	6%	12%	3%
$20K to $30K.......	188	91%	48%	43%	7%	2%	9%	-
$30K to $40K.......	155	87%	50%	37%	8%	3%	11%	2%
$40K to $50K.......	133	92%	53%	38%	3%	5%	8%	-
Over $50K..........	244	92%	52%	41%	6%	2%	8%	-
Over $75K.......	95	94%	53%	41%	4%	2%	6%	-
White..............	779	89%	51%	39%	6%	4%	10%	1%
Black..............	100	89%	54%	35%	4%	6%	10%	1%
Hispanic...........	66	85%	45%	39%	11%	5%	15%	-
All Other..........	56	93%	59%	34%	7%	-	7%	-
Have Children......	666	87%	50%	37%	7%	5%	12%	1%
Encourage/Artist	523	88%	50%	37%	7%	4%	11%	1%
Don't Have Children	335	92%	53%	40%	5%	3%	7%	*
Willing To Pay More	393	94%	60%	34%	4%	2%	6%	1%
Only Sometimes.....	382	90%	50%	41%	7%	2%	9%	1%
Hardly Ever Pay Mre	211	77%	35%	43%	9%	12%	21%	1%
Have Art In Home...	768	90%	53%	37%	6%	4%	10%	1%
Don't Have Art.....	233	87%	45%	42%	6%	6%	12%	1%
Choice - Choose Art	352	92%	50%	42%	5%	3%	7%	1%
Would Choose Money.	574	88%	51%	37%	6%	5%	11%	1%
Not Sure...........	75	83%	56%	27%	9%	5%	15%	3%
Spend $25-100/Art..	472	86%	47%	39%	8%	5%	13%	1%
Wld Spend Over $200	451	93%	55%	38%	4%	3%	7%	*
Museum >2 Times Yr.	188	90%	55%	35%	4%	5%	10%	-
1 or 2 Times A Yr..	301	90%	52%	38%	7%	2%	9%	1%
Less Than Once A Yr	236	89%	52%	37%	6%	4%	10%	1%
Don't Go To Museums	240	87%	47%	40%	8%	5%	13%	1%
Favor Mre Fed Taxes	300	91%	53%	38%	5%	4%	8%	1%
Wld Pay $25 More	197	92%	52%	40%	4%	4%	8%	1%
Pay $5-$15 More.	57	96%	58%	39%	2%	2%	4%	-
None Of Above...	33	76%	48%	27%	15%	6%	21%	3%
Oppose Mre Fed Taxs	571	88%	48%	40%	7%	4%	11%	1%
Not Sure...........	130	89%	58%	31%	5%	4%	9%	2%

Q7. How important would the color of the following be in
 your decision to buy that product: A new car.

	TOTAL	TOTAL VERY/ SOMEWT IMPRNT	Very Imprnt	Somewt Imprnt	Not Very Imprnt	Not At All Imprnt	TOTAL NOT VERY/ AT ALL	Not Sure
All Voters.........	1001	81%	49%	32%	13%	6%	19%	*
Northeast..........	216	81%	49%	32%	14%	5%	19%	-
South..............	335	82%	50%	32%	13%	6%	18%	-
Central............	241	80%	47%	33%	11%	8%	20%	*
West...............	209	82%	48%	34%	13%	5%	18%	-
Male...............	475	82%	52%	30%	13%	6%	18%	-
Female.............	526	81%	46%	35%	13%	6%	19%	*
Under 30...........	247	84%	46%	38%	12%	4%	16%	-
30 to 39...........	263	80%	43%	37%	14%	6%	20%	*
40 to 49...........	191	81%	54%	26%	13%	6%	19%	-
50 to 64...........	154	80%	52%	28%	12%	8%	20%	-
65 And Over........	131	82%	53%	28%	11%	8%	18%	-
High School/Less...	421	80%	50%	30%	14%	7%	20%	-
Some College.......	281	82%	47%	35%	11%	6%	18%	*
College Graduate...	293	83%	49%	34%	13%	4%	17%	-
Post-Graduate....	103	89%	50%	40%	9%	2%	11%	-
Liberal............	319	83%	47%	36%	12%	5%	17%	-
Moderate/Other.....	207	76%	47%	29%	15%	9%	24%	-
Conservative.......	475	82%	50%	32%	12%	5%	18%	*
Under $30K.........	343	77%	50%	27%	14%	9%	23%	*
Under $20K......	155	78%	50%	28%	11%	10%	21%	1%
$20K to $30K.......	188	76%	50%	26%	16%	8%	24%	-
$30K to $40K.......	155	83%	45%	38%	12%	6%	17%	-
$40K to $50K.......	133	85%	52%	33%	11%	5%	15%	-
Over $50K..........	244	86%	51%	35%	12%	2%	14%	-
Over $75K.......	95	84%	47%	37%	15%	1%	16%	-
White..............	779	82%	49%	33%	12%	6%	18%	*
Black..............	100	73%	43%	30%	18%	9%	27%	-
Hispanic...........	66	80%	45%	35%	15%	5%	20%	-
All Other..........	56	80%	52%	29%	13%	7%	20%	-
Have Children......	666	80%	48%	32%	13%	7%	20%	*
Encourage/Artist	523	79%	48%	31%	14%	7%	21%	*
Don't Have Children	335	83%	49%	34%	13%	4%	17%	-
Willing To Pay More	393	85%	58%	28%	11%	3%	14%	*
Only Sometimes.....	382	85%	45%	40%	11%	4%	15%	-
Hardly Ever Pay Mre	211	67%	39%	28%	18%	15%	33%	-
Have Art In Home...	768	80%	47%	34%	14%	6%	19%	*
Don't Have Art.....	233	83%	55%	28%	9%	7%	17%	-
Choice - Choose Art	352	81%	49%	32%	12%	8%	19%	-
Would Choose Money.	574	82%	49%	32%	13%	5%	18%	*
Not Sure..........	75	80%	43%	37%	15%	5%	20%	-
Spend $25-100/Art..	472	79%	45%	33%	14%	7%	21%	*
Wld Spend Over $200	451	84%	52%	32%	12%	4%	16%	-
Museum >2 Times Yr.	188	78%	48%	30%	13%	9%	22%	-
1 or 2 Times A Yr..	301	81%	44%	37%	15%	4%	19%	-
Less Than Once A Yr	236	83%	53%	31%	11%	5%	17%	-
Don't Go To Museums	240	82%	50%	32%	11%	7%	18%	*
Favor Mre Fed Taxes	300	83%	49%	34%	10%	7%	17%	-
Wld Pay $25 More	197	87%	49%	38%	8%	5%	13%	-
Pay $5-$15 More.	57	81%	56%	25%	12%	7%	19%	-
None Of Above...	33	61%	33%	27%	21%	18%	39%	-
Oppose Mre Fed Taxs	571	82%	51%	32%	12%	5%	18%	*
Not Sure...........	130	72%	39%	33%	20%	8%	28%	-

Q8. How important would the color of the following be in
 your decision to buy that product: A pair of underwear.

	TOTAL	TOTAL VERY/ SOMEWT IMPRNT	Very Imprnt	Somewt Imprnt	Not Very Imprnt	Not At All Imprnt	TOTAL NOT VERY/ AT ALL	Not Sure
All Voters.........	1001	36%	16%	19%	35%	29%	64%	*
Northeast..........	216	40%	18%	22%	33%	27%	60%	-
South..............	335	34%	17%	16%	37%	30%	66%	-
Central............	241	36%	17%	19%	33%	30%	63%	1%
West...............	209	36%	14%	22%	36%	28%	64%	-
Male...............	475	30%	13%	17%	35%	35%	69%	*
Female.............	526	41%	20%	21%	35%	24%	59%	*
Under 30...........	247	30%	11%	19%	42%	28%	70%	-
30 to 39...........	263	29%	12%	17%	41%	30%	71%	*
40 to 49...........	191	43%	18%	25%	31%	25%	57%	1%
50 to 64...........	154	42%	19%	23%	29%	30%	58%	-
65 And Over........	131	45%	30%	15%	25%	29%	54%	1%
High School/Less...	421	37%	20%	17%	32%	30%	62%	*
Some College.......	281	34%	12%	22%	38%	28%	66%	*
College Graduate...	293	36%	16%	20%	37%	27%	64%	-
Post-Graduate....	103	35%	14%	21%	36%	29%	65%	-
Liberal............	319	40%	17%	24%	31%	28%	60%	*
Moderate/Other.....	207	39%	20%	19%	32%	28%	60%	*
Conservative.......	475	32%	15%	17%	39%	29%	68%	*
Under $30K.........	343	37%	20%	17%	34%	28%	63%	*
Under $20K......	155	44%	27%	17%	26%	29%	55%	1%
$20K to $30K.......	188	31%	14%	18%	41%	28%	69%	-
$30K to $40K.......	155	37%	12%	25%	36%	26%	63%	1%
$40K to $50K.......	133	29%	12%	17%	38%	32%	71%	-
Over $50K..........	244	36%	13%	23%	36%	28%	64%	-
Over $75K.......	95	35%	11%	24%	36%	29%	65%	-
White..............	779	34%	15%	20%	35%	30%	65%	*
Black..............	100	48%	30%	18%	29%	23%	52%	-
Hispanic...........	66	38%	20%	18%	41%	21%	62%	-
All Other..........	56	34%	14%	20%	34%	32%	66%	-
Have Children......	666	37%	19%	19%	33%	29%	62%	*
Encourage/Artist	523	35%	17%	18%	33%	31%	64%	*
Don't Have Children	335	33%	12%	21%	39%	27%	67%	*
Willing To Pay More	393	38%	17%	21%	35%	27%	62%	*
Only Sometimes.....	382	36%	15%	21%	36%	27%	63%	1%
Hardly Ever Pay Mre	211	32%	19%	13%	32%	36%	68%	-
Have Art In Home...	768	36%	15%	21%	35%	29%	64%	*
Don't Have Art.....	233	36%	21%	15%	35%	29%	64%	*
Choice - Choose Art	352	35%	15%	20%	33%	32%	64%	*
Would Choose Money.	574	35%	16%	19%	38%	26%	64%	*
Not Sure..........	75	44%	24%	19%	23%	33%	56%	-
Spend $25-100/Art..	472	35%	15%	19%	35%	30%	65%	*
Wld Spend Over $200	451	36%	17%	19%	36%	28%	64%	-
Museum >2 Times Yr.	188	46%	23%	23%	30%	24%	54%	-
1 or 2 Times A Yr..	301	33%	13%	20%	39%	28%	67%	-
Less Than Once A Yr	236	32%	14%	18%	38%	30%	67%	*
Don't Go To Museums	240	36%	18%	18%	30%	34%	63%	1%
Favor Mre Fed Taxes	300	37%	16%	21%	33%	30%	63%	*
Wld Pay $25 More	197	37%	13%	24%	35%	28%	62%	1%
Pay $5-$15 More.	57	33%	21%	12%	28%	39%	67%	-
None Of Above...	33	39%	21%	18%	36%	24%	61%	-
Oppose Mre Fed Taxs	571	36%	16%	20%	36%	28%	64%	*
Not Sure...........	130	33%	20%	13%	38%	29%	67%	-

Q9. How important would the color of the following be in
 your decision to buy that product: A television set.

	TOTAL	TOTAL VERY/ SOMEWT IMPRNT	Very Imprnt	Somewt Imprnt	Not Very Imprnt	Not At All Imprnt	TOTAL NOT VERY/ AT ALL	Not Sure
All Voters.........	1001	53%	21%	31%	29%	18%	47%	*
Northeast..........	216	52%	22%	31%	29%	19%	47%	*
South..............	335	53%	23%	30%	29%	18%	47%	*
Central............	241	51%	20%	31%	30%	19%	49%	*
West...............	209	56%	20%	35%	29%	15%	44%	-
Male...............	475	49%	18%	30%	32%	19%	51%	*
Female.............	526	56%	24%	32%	27%	17%	43%	*
Under 30...........	247	48%	19%	29%	33%	19%	52%	-
30 to 39...........	263	50%	14%	36%	31%	19%	50%	-
40 to 49...........	191	57%	22%	35%	28%	15%	43%	-
50 to 64...........	154	53%	25%	28%	27%	19%	46%	1%
65 And Over........	131	65%	38%	27%	24%	10%	34%	1%
High School/Less...	421	53%	24%	30%	26%	20%	46%	*
Some College.......	281	51%	19%	32%	34%	15%	49%	-
College Graduate...	293	53%	20%	33%	30%	16%	46%	*
Post-Graduate....	103	53%	24%	29%	32%	14%	46%	1%
Liberal............	319	52%	22%	30%	32%	17%	48%	-
Moderate/Other.....	207	48%	19%	29%	28%	24%	51%	1%
Conservative.......	475	56%	22%	33%	28%	16%	44%	*
Under $30K.........	343	54%	23%	31%	27%	18%	46%	*
Under $20K......	155	58%	30%	28%	24%	17%	41%	1%
$20K to $30K.......	188	51%	18%	32%	30%	19%	49%	-
$30K to $40K.......	155	52%	23%	30%	34%	14%	48%	-
$40K to $50K.......	133	53%	16%	38%	27%	20%	47%	-
Over $50K..........	244	51%	20%	31%	31%	18%	49%	-
Over $75K.......	95	55%	19%	36%	29%	16%	45%	-
White..............	779	52%	20%	32%	30%	17%	48%	*
Black..............	100	62%	29%	33%	21%	17%	38%	-
Hispanic...........	66	48%	20%	29%	32%	20%	52%	-
All Other..........	56	54%	25%	29%	25%	21%	46%	-
Have Children......	666	54%	23%	31%	29%	17%	46%	*
Encourage/Artist	523	53%	22%	31%	29%	18%	47%	*
Don't Have Children	335	51%	18%	33%	29%	20%	49%	1%
Willing To Pay More	393	57%	27%	30%	27%	16%	43%	-
Only Sometimes.....	382	51%	16%	35%	32%	16%	49%	*
Hardly Ever Pay Mre	211	47%	20%	27%	27%	25%	53%	*
Have Art In Home...	768	52%	20%	32%	30%	17%	48%	*
Don't Have Art.....	233	55%	25%	30%	25%	20%	45%	*
Choice - Choose Art	352	54%	25%	29%	26%	19%	45%	1%
Would Choose Money.	574	52%	20%	33%	31%	17%	47%	*
Not Sure...........	75	48%	17%	31%	32%	20%	52%	-
Spend $25-100/Art..	472	51%	19%	32%	29%	19%	49%	*
Wld Spend Over $200	451	54%	24%	30%	29%	17%	46%	*
Museum >2 Times Yr.	188	54%	24%	30%	26%	20%	46%	-
1 or 2 Times A Yr..	301	49%	20%	29%	34%	17%	51%	*
Less Than Once A Yr	236	55%	21%	34%	31%	13%	44%	*
Don't Go To Museums	240	54%	22%	32%	23%	22%	45%	*
Favor Mre Fed Taxes	300	48%	18%	30%	30%	22%	52%	-
Wld Pay $25 More	197	47%	18%	29%	30%	23%	53%	-
Pay $5-$15 More.	57	46%	19%	26%	35%	19%	54%	-
None Of Above...	33	45%	18%	27%	24%	30%	55%	-
Oppose Mre Fed Taxs	571	54%	22%	32%	30%	16%	45%	*
Not Sure...........	130	57%	26%	31%	26%	16%	42%	1%

Q10. How important would the color of the following be in
 your decision to buy that product: A winter coat.

	TOTAL	TOTAL VERY/ SOMEWT IMPRNT	Very Imprnt	Somewt Imprnt	Not Very Imprnt	Not At All Imprnt	TOTAL NOT VERY/ AT ALL	Not Sure
All Voters.........	1001	88%	56%	32%	7%	5%	12%	*
Northeast..........	216	92%	62%	30%	5%	3%	8%	*
South..............	335	87%	58%	30%	7%	6%	13%	-
Central............	241	84%	54%	30%	10%	6%	16%	*
West...............	209	89%	49%	40%	8%	3%	11%	-
Male...............	475	87%	52%	35%	7%	6%	13%	-
Female.............	526	88%	59%	29%	8%	4%	12%	*
Under 30...........	247	90%	53%	38%	5%	4%	10%	-
30 to 39...........	263	88%	49%	39%	9%	3%	12%	-
40 to 49...........	191	90%	57%	33%	7%	4%	10%	-
50 to 64...........	154	84%	62%	22%	9%	6%	16%	-
65 And Over........	131	85%	67%	18%	8%	6%	14%	1%
High School/Less...	421	84%	51%	33%	10%	7%	16%	*
Some College.......	281	88%	56%	32%	8%	4%	12%	*
College Graduate...	293	93%	62%	31%	4%	3%	7%	-
Post-Graduate....	103	93%	63%	30%	6%	1%	7%	-
Liberal............	319	89%	57%	32%	6%	5%	11%	-
Moderate/Other.....	207	85%	55%	30%	10%	6%	15%	-
Conservative.......	475	88%	56%	33%	7%	4%	11%	*
Under $30K.........	343	86%	56%	31%	7%	6%	13%	*
Under $20K......	155	85%	55%	30%	6%	8%	14%	1%
$20K to $30K.......	188	87%	56%	31%	9%	4%	13%	-
$30K to $40K.......	155	83%	50%	34%	14%	3%	17%	-
$40K to $50K.......	133	92%	50%	41%	5%	4%	8%	-
Over $50K..........	244	93%	60%	33%	6%	2%	7%	-
Over $75K.......	95	91%	62%	28%	6%	3%	9%	-
White..............	779	89%	56%	33%	7%	5%	11%	*
Black..............	100	83%	56%	27%	11%	6%	17%	-
Hispanic...........	66	82%	45%	36%	12%	6%	18%	-
All Other..........	56	91%	66%	25%	7%	2%	9%	-
Have Children......	666	85%	56%	29%	9%	5%	15%	*
Encourage/Artist	523	85%	57%	28%	10%	5%	15%	*
Don't Have Children	335	93%	55%	38%	4%	3%	7%	-
Willing To Pay More	393	92%	64%	28%	5%	3%	8%	-
Only Sometimes.....	382	88%	54%	34%	7%	4%	12%	*
Hardly Ever Pay Mre	211	80%	44%	36%	11%	9%	20%	*
Have Art In Home...	768	90%	57%	33%	7%	4%	10%	-
Don't Have Art.....	233	82%	53%	29%	10%	8%	18%	1%
Choice - Choose Art	352	90%	57%	34%	6%	4%	10%	-
Would Choose Money.	574	87%	56%	31%	8%	5%	13%	*
Not Sure...........	75	80%	52%	28%	12%	8%	20%	-
Spend $25-100/Art..	472	85%	53%	32%	9%	6%	15%	*
Wld Spend Over $200	451	91%	59%	33%	5%	3%	8%	*
Museum >2 Times Yr.	188	90%	60%	30%	6%	4%	10%	-
1 or 2 Times A Yr..	301	91%	58%	33%	6%	3%	9%	-
Less Than Once A Yr	236	88%	57%	31%	8%	3%	11%	1%
Don't Go To Museums	240	82%	49%	33%	8%	10%	18%	-
Favor Mre Fed Taxes	300	89%	55%	34%	6%	5%	11%	-
Wld Pay $25 More	197	90%	54%	37%	7%	3%	10%	-
Pay $5-$15 More.	57	91%	61%	30%	4%	5%	9%	-
None Of Above...	33	79%	45%	33%	6%	15%	21%	-
Oppose Mre Fed Taxs	571	88%	56%	32%	8%	4%	12%	*
Not Sure...........	130	85%	57%	28%	9%	5%	15%	1%

Q11. Some people feel that color can affect people's moods.
Would you say that you agree or disagree with this idea?

	TOTAL	TOTAL AGREE	Strong Agree	Somewt Agree	Somewt Dsagre	Strong Dsagre	TOTAL DSAGRE	Not Sure
All Voters.........	1001	82%	40%	42%	11%	6%	17%	1%
Northeast..........	216	84%	43%	42%	9%	5%	14%	2%
South..............	335	80%	42%	37%	12%	7%	20%	1%
Central............	241	80%	37%	43%	12%	7%	19%	1%
West...............	209	86%	39%	46%	10%	4%	14%	*
Male...............	475	80%	39%	41%	11%	8%	19%	1%
Female.............	526	84%	42%	42%	11%	4%	16%	1%
Under 30...........	247	82%	35%	47%	12%	5%	17%	1%
30 to 39...........	263	85%	39%	46%	10%	5%	15%	-
40 to 49...........	191	86%	40%	46%	12%	2%	13%	1%
50 to 64...........	154	81%	49%	32%	10%	7%	18%	1%
65 And Over........	131	72%	44%	28%	13%	14%	27%	2%
High School/Less...	421	75%	34%	41%	14%	10%	24%	1%
Some College.......	281	84%	44%	40%	10%	5%	15%	1%
College Graduate...	293	90%	46%	45%	8%	2%	10%	-
Post-Graduate....	103	91%	43%	49%	8%	1%	9%	-
Liberal............	319	82%	41%	41%	12%	5%	17%	*
Moderate/Other.....	207	80%	38%	42%	11%	8%	19%	*
Conservative.......	475	83%	41%	42%	10%	6%	16%	1%
Under $30K.........	343	79%	42%	37%	12%	8%	20%	1%
Under $20K......	155	74%	43%	31%	14%	11%	25%	1%
$20K to $30K.......	188	83%	41%	42%	11%	6%	16%	1%
$30K to $40K.......	155	78%	35%	43%	14%	6%	20%	2%
$40K to $50K.......	133	83%	40%	44%	10%	6%	16%	1%
Over $50K..........	244	88%	41%	47%	9%	3%	12%	-
Over $75K.......	95	88%	43%	45%	9%	2%	12%	-
White..............	779	83%	42%	41%	10%	6%	16%	1%
Black..............	100	74%	34%	40%	17%	8%	25%	1%
Hispanic...........	66	79%	33%	45%	11%	9%	20%	2%
All Other..........	56	80%	32%	48%	14%	5%	20%	-
Have Children......	666	81%	41%	40%	11%	7%	18%	1%
Encourage/Artist	523	82%	42%	40%	11%	6%	17%	1%
Don't Have Children	335	83%	39%	44%	11%	5%	16%	1%
Willing To Pay More	393	81%	40%	41%	11%	6%	18%	1%
Only Sometimes.....	382	87%	41%	45%	9%	4%	13%	1%
Hardly Ever Pay Mre	211	76%	38%	37%	14%	9%	23%	1%
Have Art In Home...	768	85%	43%	42%	10%	4%	14%	*
Don't Have Art.....	233	71%	32%	39%	15%	12%	27%	3%
Choice - Choose Art	352	85%	47%	38%	10%	5%	15%	*
Would Choose Money.	574	81%	37%	45%	11%	6%	18%	1%
Not Sure..........	75	73%	41%	32%	12%	12%	24%	3%
Spend $25-100/Art..	472	79%	36%	43%	13%	7%	20%	1%
Wld Spend Over $200	451	86%	44%	42%	9%	4%	14%	*
Museum >2 Times Yr.	188	87%	49%	38%	6%	6%	13%	1%
1 or 2 Times A Yr..	301	83%	39%	44%	12%	5%	17%	*
Less Than Once A Yr	236	86%	43%	43%	10%	4%	14%	1%
Don't Go To Museums	240	75%	34%	41%	13%	10%	23%	2%
Favor Mre Fed Taxes	300	90%	44%	46%	7%	3%	10%	*
Wld Pay $25 More	197	90%	43%	47%	8%	2%	10%	-
Pay $5-$15 More.	57	95%	51%	44%	5%	-	5%	-
None Of Above...	33	85%	33%	52%	6%	6%	12%	3%
Oppose Mre Fed Taxs	571	79%	40%	39%	12%	7%	20%	1%
Not Sure...........	130	77%	35%	42%	14%	8%	22%	2%

Q12a. If you had to name one color as your favorite color,
which color would it be?

	TOTAL	Beige/ Tan	Black	Blue	Brown	Grey	Green	Maroon /Brgnd	Orange	Pink/ Rose
All Voters.........	1001	2%	4%	44%	3%	2%	12%	2%	1%	3%
Northeast..........	216	2%	4%	40%	1%	*	13%	1%	2%	3%
South..............	335	1%	4%	43%	4%	2%	14%	1%	1%	3%
Central............	241	2%	6%	50%	3%	2%	8%	2%	1%	2%
West...............	209	2%	5%	40%	3%	2%	15%	3%	1%	4%
Male...............	475	2%	5%	45%	4%	2%	13%	2%	1%	1%
Female.............	526	2%	4%	42%	2%	2%	12%	2%	1%	5%
Under 30...........	247	1%	8%	35%	1%	1%	15%	4%	2%	4%
30 to 39...........	263	1%	4%	48%	3%	3%	12%	2%	1%	2%
40 to 49...........	191	3%	5%	49%	1%	2%	13%	2%	1%	-
50 to 64...........	154	3%	2%	43%	6%	1%	11%	1%	2%	3%
65 And Over........	131	2%	1%	44%	5%	2%	9%	-	1%	8%
High School/Less...	421	2%	5%	48%	3%	3%	11%	1%	1%	2%
Some College.......	281	2%	5%	41%	5%	1%	14%	3%	*	3%
College Graduate...	293	1%	3%	41%	2%	1%	14%	2%	3%	4%
Post-Graduate....	103	1%	4%	34%	1%	1%	16%	3%	5%	5%
Liberal............	319	2%	4%	43%	2%	1%	14%	2%	2%	2%
Moderate/Other.....	207	2%	7%	38%	2%	3%	13%	2%	2%	1%
Conservative.......	475	2%	4%	47%	4%	1%	11%	2%	1%	4%
Under $30K.........	343	1%	7%	43%	4%	2%	10%	1%	2%	2%
Under $20K......	155	2%	8%	48%	6%	2%	8%	1%	1%	3%
$20K to $30K.......	188	1%	6%	39%	3%	2%	12%	2%	3%	1%
$30K to $40K.......	155	1%	2%	50%	3%	-	13%	1%	1%	1%
$40K to $50K.......	133	2%	2%	41%	3%	2%	15%	-	1%	7%
Over $50K..........	244	3%	5%	38%	2%	2%	14%	3%	2%	3%
Over $75K.......	95	3%	3%	28%	3%	2%	24%	2%	1%	3%
White..............	779	1%	4%	46%	3%	1%	12%	2%	1%	3%
Black..............	100	5%	4%	33%	4%	4%	12%	1%	2%	4%
Hispanic...........	66	3%	11%	30%	2%	2%	14%	2%	2%	3%
All Other..........	56	2%	5%	45%	2%	4%	14%	-	2%	-
Have Children......	666	2%	4%	45%	4%	2%	11%	1%	1%	3%
Encourage/Artist	523	2%	4%	46%	4%	2%	10%	1%	1%	3%
Don't Have Children	335	1%	6%	41%	1%	1%	16%	3%	2%	4%
Willing To Pay More	393	2%	5%	40%	3%	2%	11%	2%	2%	5%
Only Sometimes.....	382	2%	4%	46%	2%	2%	13%	2%	*	2%
Hardly Ever Pay Mre	211	2%	4%	46%	5%	1%	13%	*	1%	1%
Have Art In Home...	768	2%	5%	43%	3%	1%	12%	2%	1%	3%
Don't Have Art.....	233	3%	4%	45%	4%	3%	14%	2%	1%	2%
Choice - Choose Art	352	2%	5%	41%	3%	2%	13%	1%	1%	3%
Would Choose Money.	574	2%	4%	44%	3%	2%	13%	2%	2%	3%
Not Sure...........	75	1%	4%	51%	4%	3%	8%	4%	-	4%
Spend $25-100/Art..	472	2%	4%	46%	3%	2%	11%	2%	1%	3%
Wld Spend Over $200	451	2%	5%	41%	2%	2%	14%	2%	1%	3%
Museum >2 Times Yr.	188	1%	7%	32%	2%	3%	15%	2%	3%	3%
1 or 2 Times A Yr..	301	3%	3%	45%	3%	1%	12%	2%	1%	3%
Less Than Once A Yr	236	2%	3%	46%	2%	1%	11%	1%	1%	5%
Don't Go To Museums	240	2%	4%	50%	4%	3%	13%	2%	1%	1%
Favor Mre Fed Taxes	300	1%	4%	45%	3%	2%	13%	2%	2%	2%
Wld Pay $25 More	197	2%	5%	43%	3%	3%	14%	1%	3%	2%
Pay $5-$15 More.	57	-	-	53%	4%	-	14%	2%	-	2%
None Of Above...	33	-	9%	45%	3%	3%	9%	6%	3%	6%
Oppose Mre Fed Taxs	571	2%	4%	44%	4%	1%	13%	2%	1%	3%
Not Sure...........	130	3%	7%	37%	2%	2%	9%	2%	2%	4%

Q12b. If you had to name one color as your favorite color,
which color would it be?

	TOTAL	Purple /Lvndr /Violt	Red	White	Yellow	Mauve	Turqse /Teal	Peach/ Coral	Fushia	Gold	Other	Not Sure
All Voters.........	1001	4%	11%	2%	2%	2%	1%	1%	1%	1%	1%	2%
Northeast..........	216	5%	15%	2%	2%	2%	1%	1%	1%	-	-	2%
South..............	335	4%	9%	4%	2%	2%	2%	1%	*	-	1%	2%
Central............	241	4%	10%	*	2%	2%	*	*	1%	1%	1%	1%
West...............	209	5%	11%	*	*	1%	*	1%	*	1%	*	1%
Male...............	475	2%	12%	2%	1%	1%	1%	1%	*	1%	1%	2%
Female.............	526	7%	9%	2%	3%	3%	1%	2%	1%	1%	*	1%
Under 30...........	247	7%	14%	1%	1%	2%	1%	1%	1%	-	*	*
30 to 39...........	263	2%	10%	2%	2%	2%	1%	1%	1%	1%	*	2%
40 to 49...........	191	6%	12%	2%	2%	2%	1%	-	1%	1%	1%	1%
50 to 64...........	154	4%	8%	1%	3%	2%	2%	2%	-	1%	-	4%
65 And Over........	131	2%	9%	8%	2%	1%	1%	2%	-	-	2%	3%
High School/Less...	421	4%	9%	3%	2%	3%	1%	1%	-	1%	1%	1%
Some College.......	281	4%	12%	2%	1%	1%	2%	1%	1%	-	-	1%
College Graduate...	293	5%	12%	2%	2%	2%	1%	1%	1%	1%	1%	2%
Post-Graduate....	103	5%	14%	1%	1%	3%	-	-	1%	2%	2%	3%
Liberal............	319	4%	14%	2%	3%	2%	1%	1%	1%	1%	*	2%
Moderate/Other.....	207	6%	10%	3%	*	1%	1%	2%	1%	*	1%	3%
Conservative.......	475	4%	9%	2%	2%	3%	1%	1%	*	1%	1%	1%
Under $30K.........	343	6%	9%	3%	2%	2%	1%	1%	1%	*	1%	1%
Under $20K......	155	3%	6%	3%	3%	2%	1%	1%	1%	-	1%	1%
$20K to $30K.......	188	8%	12%	3%	2%	3%	1%	-	1%	1%	1%	2%
$30K to $40K.......	155	3%	15%	1%	1%	3%	1%	3%	1%	-	-	2%
$40K to $50K.......	133	2%	12%	3%	2%	2%	2%	-	-	2%	1%	2%
Over $50K..........	244	5%	12%	1%	2%	2%	1%	2%	*	1%	-	2%
Over $75K.......	95	5%	15%	2%	3%	2%	-	1%	1%	-	-	-
White..............	779	4%	11%	2%	2%	2%	1%	1%	1%	*	1%	1%
Black..............	100	4%	14%	3%	2%	2%	1%	2%	1%	2%	-	-
Hispanic...........	66	3%	11%	5%	3%	3%	2%	-	-	2%	-	6%
All Other..........	56	7%	9%	5%	-	-	2%	-	-	-	-	4%
Have Children......	666	5%	9%	3%	2%	2%	2%	1%	1%	1%	1%	2%
Encourage/Artist	523	4%	8%	3%	2%	2%	2%	1%	*	1%	*	2%
Don't Have Children	335	4%	14%	1%	1%	2%	*	1%	1%	*	1%	1%
Willing To Pay More	393	6%	12%	2%	1%	2%	1%	1%	-	1%	*	1%
Only Sometimes.....	382	4%	11%	1%	2%	2%	1%	1%	1%	*	1%	2%
Hardly Ever Pay Mre	211	2%	8%	3%	3%	2%	1%	1%	*	*	1%	2%
Have Art In Home...	768	4%	12%	2%	2%	2%	1%	1%	1%	1%	1%	2%
Don't Have Art.....	233	5%	8%	4%	1%	2%	-	*	*	1%	-	1%
Choice - Choose Art	352	5%	11%	2%	3%	3%	1%	1%	1%	1%	1%	2%
Would Choose Money.	574	4%	11%	2%	1%	2%	1%	1%	1%	1%	*	1%
Not Sure...........	75	3%	8%	3%	-	1%	-	1%	-	-	1%	4%
Spend $25-100/Art..	472	5%	9%	2%	2%	2%	1%	1%	1%	*	1%	1%
Wld Spend Over $200	451	4%	11%	2%	2%	2%	1%	2%	*	1%	1%	2%
Museum >2 Times Yr.	188	5%	14%	3%	2%	1%	1%	1%	1%	1%	1%	2%
1 or 2 Times A Yr..	301	5%	11%	2%	3%	1%	1%	1%	1%	1%	1%	1%
Less Than Once A Yr	236	5%	9%	2%	1%	5%	1%	2%	*	*	*	3%
Don't Go To Museums	240	3%	11%	2%	1%	2%	*	*	-	-	*	1%
Favor Mre Fed Taxes	300	4%	12%	2%	1%	1%	1%	1%	*	1%	1%	2%
Wld Pay $25 More	197	5%	13%	2%	1%	1%	1%	1%	1%	1%	1%	2%
Pay $5-$15 More.	57	7%	16%	2%	2%	-	-	-	-	-	-	-
None Of Above...	33	-	3%	6%	3%	-	-	-	-	-	-	3%
Oppose Mre Fed Taxs	571	4%	10%	2%	2%	3%	1%	1%	*	1%	*	1%
Not Sure...........	130	5%	9%	3%	3%	-	2%	2%	2%	1%	2%	2%

	TOTAL	Beige/ Tan	Black	Blue	Brown	Grey	Green	Maroon /Brgnd	Orange	Rose
All Voters.........	1001	3%	7%	19%	4%	3%	17%	1%	1%	6%
Northeast..........	216	3%	6%	20%	3%	2%	20%	*	*	5%
South..............	335	3%	6%	18%	3%	2%	18%	2%	1%	9%
Central............	241	2%	7%	17%	5%	4%	12%	2%	*	6%
West...............	209	3%	11%	22%	5%	2%	16%	*	*	3%
Male...............	475	3%	10%	18%	5%	3%	17%	2%	1%	3%
Female.............	526	2%	5%	20%	3%	2%	16%	1%	1%	9%
Under 30...........	247	*	16%	20%	1%	1%	17%	1%	-	1%
30 to 39...........	263	1%	6%	19%	5%	3%	19%	1%	2%	6%
40 to 49...........	191	3%	5%	20%	6%	4%	15%	2%	-	8%
50 to 64...........	154	3%	5%	16%	6%	1%	18%	2%	1%	8%
65 And Over........	131	10%	2%	18%	3%	2%	14%	3%	1%	10%
High School/Less...	421	3%	9%	18%	4%	2%	14%	2%	*	6%
Some College.......	281	3%	7%	20%	3%	4%	19%	1%	1%	7%
College Graduate...	293	3%	6%	20%	5%	3%	19%	1%	1%	5%
Post-Graduate....	103	5%	10%	23%	6%	3%	18%	1%	-	3%
Liberal............	319	2%	9%	21%	5%	3%	18%	1%	1%	6%
Moderate/Other.....	207	3%	7%	19%	4%	3%	13%	2%	*	5%
Conservative.......	475	3%	7%	17%	3%	2%	17%	1%	1%	7%
Under $30K.........	343	4%	10%	17%	3%	2%	13%	1%	1%	6%
Under $20K......	155	5%	7%	16%	3%	1%	14%	1%	1%	8%
$20K to $30K.......	188	4%	13%	19%	3%	2%	13%	1%	-	5%
$30K to $40K.......	155	1%	6%	21%	2%	4%	19%	3%	1%	8%
$40K to $50K.......	133	2%	7%	19%	8%	2%	15%	-	2%	5%
Over $50K..........	244	1%	7%	20%	4%	2%	22%	2%	1%	5%
Over $75K.......	95	1%	4%	26%	5%	1%	23%	2%	2%	6%
White..............	779	2%	5%	19%	4%	3%	19%	2%	1%	6%
Black..............	100	3%	19%	21%	7%	2%	10%	2%	-	5%
Hispanic...........	66	3%	12%	21%	3%	-	11%	-	-	3%
All Other..........	56	5%	9%	18%	2%	5%	5%	-	2%	11%
Have Children......	666	3%	6%	20%	4%	3%	16%	2%	1%	8%
Encourage/Artist	523	3%	7%	19%	4%	3%	17%	1%	1%	8%
Don't Have Children	335	3%	10%	18%	4%	2%	18%	1%	1%	3%
Willing To Pay More	393	2%	9%	20%	5%	4%	16%	1%	1%	6%
Only Sometimes.....	382	3%	7%	17%	4%	2%	18%	2%	1%	7%
Hardly Ever Pay Mre	211	5%	6%	19%	2%	2%	17%	1%	*	5%
Have Art In Home...	768	3%	8%	19%	4%	2%	18%	2%	1%	6%
Don't Have Art.....	233	3%	7%	18%	4%	3%	13%	1%	1%	7%
Choice - Choose Art	352	4%	9%	20%	5%	3%	18%	1%	*	6%
Would Choose Money.	574	2%	7%	19%	3%	2%	15%	2%	1%	6%
Not Sure...........	75	3%	3%	12%	7%	3%	25%	3%	-	9%
Spend $25-100/Art..	472	2%	7%	21%	3%	1%	17%	2%	*	7%
Wld Spend Over $200	451	3%	8%	18%	6%	4%	16%	1%	1%	5%
Museum >2 Times Yr.	188	4%	10%	14%	5%	3%	21%	1%	1%	7%
1 or 2 Times A Yr..	301	3%	8%	20%	4%	4%	17%	1%	*	5%
Less Than Once A Yr	236	3%	7%	20%	5%	3%	19%	1%	-	6%
Don't Go To Museums	240	2%	5%	20%	3%	1%	12%	2%	1%	7%
Favor Mre Fed Taxes	300	3%	9%	17%	5%	3%	17%	2%	1%	6%
Wld Pay $25 More	197	3%	8%	17%	4%	4%	17%	3%	2%	7%
Pay $5-$15 More.	57	5%	14%	19%	9%	-	14%	2%	-	-
None Of Above...	33	-	12%	9%	6%	6%	18%	-	-	12%
Oppose Mre Fed Taxs	571	3%	7%	20%	4%	3%	16%	1%	1%	6%
Not Sure...........	130	3%	5%	21%	2%	1%	20%	2%	-	5%

Q13b. (All Except NS In Q12) And what color would you say
is you second favorite color?

	TOTAL	Purple /Lvndr /Violt	Red	White	Yellow	Mauve	Turqse /Teal	Peach/ Coral	Fushia	Gold	Other	Not Sure
All Voters.........	1001	5%	16%	4%	3%	2%	1%	1%	*	1%	*	2%
Northeast..........	216	6%	12%	5%	4%	3%	1%	1%	*	1%	*	2%
South..............	335	4%	19%	4%	2%	3%	1%	2%	*	1%	-	1%
Central............	241	4%	20%	5%	4%	2%	3%	2%	*	-	-	3%
West..............	209	7%	13%	4%	4%	1%	1%	*	-	1%	*	2%
Male..............	475	3%	21%	3%	3%	*	1%	*	*	1%	*	3%
Female............	526	7%	12%	5%	4%	4%	2%	2%	*	1%	*	2%
Under 30...........	247	9%	19%	4%	3%	2%	2%	-	1%	-	*	2%
30 to 39...........	263	4%	16%	3%	3%	3%	2%	3%	-	*	-	2%
40 to 49...........	191	5%	18%	3%	3%	3%	-	2%	-	2%	-	2%
50 to 64...........	154	1%	13%	5%	5%	3%	2%	2%	1%	1%	1%	3%
65 And Over........	131	4%	13%	8%	2%	-	1%	-	-	2%	-	5%
High School/Less...	421	5%	20%	4%	4%	2%	1%	2%	*	*	*	2%
Some College.......	281	6%	15%	4%	4%	2%	1%	1%	*	1%	*	1%
College Graduate...	293	4%	11%	4%	3%	2%	2%	2%	-	2%	-	3%
Post-Graduate....	103	3%	6%	3%	1%	1%	2%	4%	-	2%	-	7%
Liberal............	319	6%	14%	4%	3%	3%	1%	1%	1%	*	*	1%
Moderate/Other.....	207	6%	18%	4%	2%	1%	3%	2%	-	*	-	3%
Conservative.......	475	4%	17%	4%	4%	3%	1%	2%	*	1%	*	2%
Under $30K.........	343	7%	17%	6%	4%	2%	2%	1%	-	1%	*	2%
Under $20K......	155	8%	17%	8%	5%	2%	1%	1%	-	1%	-	1%
$20K to $30K.......	188	5%	18%	3%	4%	3%	3%	1%	-	1%	1%	2%
$30K to $40K.......	155	3%	17%	1%	3%	2%	-	1%	1%	1%	-	5%
$40K to $50K.......	133	5%	20%	5%	2%	2%	2%	1%	1%	1%	1%	2%
Over $50K..........	244	5%	13%	4%	3%	3%	1%	4%	*	1%	-	1%
Over $75K.......	95	5%	8%	2%	2%	2%	2%	3%	1%	-	-	2%
White..............	779	5%	16%	4%	4%	2%	2%	2%	*	1%	*	2%
Black..............	100	7%	12%	5%	2%	2%	-	-	-	1%	-	2%
Hispanic...........	66	5%	20%	6%	3%	3%	-	3%	-	-	-	2%
All Other..........	56	-	21%	2%	2%	7%	-	2%	-	2%	-	4%
Have Children......	666	4%	15%	4%	4%	3%	1%	2%	-	1%	*	2%
Encourage/Artist	523	4%	15%	4%	4%	3%	1%	2%	-	1%	*	2%
Don't Have Children	335	7%	18%	4%	2%	1%	2%	*	1%	*	*	3%
Willing To Pay More	393	6%	14%	4%	3%	3%	2%	1%	-	2%	-	2%
Only Sometimes.....	382	5%	18%	3%	4%	2%	1%	2%	1%	*	1%	2%
Hardly Ever Pay Mre	211	4%	18%	6%	3%	2%	1%	2%	-	*	-	4%
Have Art In Home...	768	5%	15%	4%	4%	2%	1%	1%	*	1%	*	2%
Don't Have Art.....	233	5%	21%	5%	3%	2%	1%	2%	1%	-	-	3%
Choice - Choose Art	352	4%	15%	4%	2%	1%	1%	1%	-	*	-	2%
Would Choose Money.	574	6%	17%	4%	4%	3%	1%	2%	1%	1%	*	2%
Not Sure...........	75	5%	13%	3%	1%	-	3%	-	-	1%	-	5%
Spend $25-100/Art..	472	4%	18%	4%	3%	3%	1%	1%	*	1%	*	2%
Wld Spend Over $200	451	6%	15%	4%	4%	2%	2%	2%	-	1%	*	2%
Museum >2 Times Yr.	188	5%	17%	2%	2%	2%	1%	1%	-	1%	-	3%
1 or 2 Times A Yr..	301	5%	14%	5%	4%	2%	3%	3%	*	2%	*	1%
Less Than Once A Yr	236	4%	13%	5%	3%	4%	1%	1%	-	-	-	3%
Don't Go To Museums	240	6%	23%	5%	5%	3%	*	1%	1%	-	*	3%
Favor Mre Fed Taxes	300	3%	17%	5%	3%	2%	2%	1%	*	*	*	2%
Wld Pay $25 More	197	4%	14%	4%	4%	2%	3%	1%	1%	1%	-	2%
Pay $5-$15 More.	57	2%	25%	5%	2%	2%	-	2%	-	-	-	-
None Of Above...	33	-	18%	9%	-	3%	-	-	-	-	3%	-
Oppose Mre Fed Taxs	571	6%	16%	4%	4%	3%	1%	2%	*	1%	*	2%
Not Sure...........	130	8%	16%	5%	2%	2%	1%	-	-	2%	-	5%

Q14. How often do you do the following:
Attend an amateur or professional sports event.

	TOTAL	TOTAL FRQNT/ OCNSLY	Frequ- ently	Occas- ionaly	Seldom	Not At All	TOTAL SELDOM /NOT AT ALL	Not Sure
All Voters........	1001	41%	17%	24%	28%	31%	59%	*
Northeast..........	216	35%	16%	19%	31%	33%	65%	-
South..............	335	44%	18%	26%	24%	32%	56%	-
Central............	241	43%	15%	28%	25%	32%	56%	*
West...............	209	39%	19%	20%	34%	26%	61%	-
Male...............	475	48%	21%	27%	31%	21%	52%	-
Female.............	526	35%	14%	21%	25%	40%	65%	*
Under 30...........	247	48%	21%	27%	28%	23%	52%	-
30 to 39...........	263	50%	21%	30%	26%	24%	49%	*
40 to 49...........	191	42%	20%	22%	29%	29%	58%	-
50 to 64...........	154	31%	10%	21%	31%	39%	69%	-
65 And Over.......	131	21%	8%	14%	27%	51%	79%	-
High School/Less...	421	34%	14%	19%	26%	40%	66%	*
Some College.......	281	47%	17%	31%	27%	25%	53%	-
College Graduate...	293	46%	22%	24%	31%	23%	54%	-
Post-Graduate....	103	54%	28%	26%	26%	19%	46%	-
Liberal............	319	48%	21%	27%	27%	25%	52%	-
Moderate/Other.....	207	37%	12%	25%	28%	35%	63%	-
Conservative.......	475	38%	17%	21%	28%	33%	61%	*
Under $30K.........	343	32%	12%	20%	27%	41%	68%	-
Under $20K......	155	28%	10%	18%	21%	51%	72%	-
$20K to $30K......	188	36%	14%	22%	31%	34%	64%	-
$30K to $40K......	155	45%	21%	23%	30%	25%	55%	-
$40K to $50K......	133	44%	14%	31%	27%	28%	55%	1%
Over $50K..........	244	53%	23%	30%	30%	17%	47%	-
Over $75K.......	95	54%	31%	23%	29%	17%	46%	-
White..............	779	40%	17%	22%	29%	31%	60%	*
Black..............	100	50%	20%	30%	17%	33%	50%	-
Hispanic...........	66	50%	12%	38%	27%	23%	50%	-
All Other..........	56	36%	16%	20%	27%	38%	64%	-
Have Children......	666	39%	15%	23%	28%	33%	61%	*
Encourage/Artist	523	39%	15%	24%	28%	32%	61%	-
Don't Have Children	335	46%	21%	25%	27%	27%	54%	-
Willing To Pay More	393	47%	20%	26%	28%	25%	53%	-
Only Sometimes.....	382	40%	15%	25%	31%	29%	60%	-
Hardly Ever Pay Mre	211	34%	17%	18%	22%	44%	65%	*
Have Art In Home...	768	42%	17%	25%	30%	28%	58%	-
Don't Have Art.....	233	37%	16%	21%	21%	41%	62%	*
Choice - Choose Art	352	50%	21%	29%	24%	26%	50%	-
Would Choose Money.	574	38%	16%	22%	30%	32%	62%	*
Not Sure..........	75	25%	12%	13%	33%	41%	75%	-
Spend $25-100/Art..	472	35%	14%	21%	29%	36%	65%	-
Wld Spend Over $200	451	50%	21%	29%	27%	23%	50%	*
Museum >2 Times Yr.	188	48%	23%	24%	28%	24%	52%	-
1 or 2 Times A Yr..	301	46%	18%	28%	28%	26%	54%	-
Less Than Once A Yr	236	38%	16%	22%	33%	28%	62%	-
Don't Go To Museums	240	35%	12%	23%	23%	42%	65%	*
Favor Mre Fed Taxes	300	40%	17%	23%	31%	29%	60%	-
Wld Pay $25 More	197	41%	16%	25%	35%	24%	59%	-
Pay $5-$15 More.	57	42%	19%	23%	16%	42%	58%	-
None Of Above...	33	42%	18%	24%	24%	33%	58%	-
Oppose Mre Fed Taxs	571	42%	17%	25%	27%	31%	58%	*
Not Sure..........	130	38%	17%	22%	26%	35%	62%	-

Q15. How often do you do the following:
Go camping, hiking or canoeing.

	TOTAL	TOTAL FRQNT/ OCNSLY	Frequ- ently	Occas- ionaly	Seldom	Not At All	TOTAL SELDOM /NOT AT ALL	Not Sure
All Voters........	1001	38%	17%	22%	22%	40%	62%	-
Northeast..........	216	33%	14%	19%	23%	44%	67%	-
South..............	335	33%	13%	20%	21%	47%	67%	-
Central............	241	41%	15%	26%	24%	35%	59%	-
West...............	209	50%	28%	22%	19%	31%	50%	-
Male...............	475	40%	17%	24%	25%	35%	60%	-
Female.............	526	37%	17%	20%	19%	45%	63%	-
Under 30...........	247	42%	17%	25%	25%	34%	58%	-
30 to 39...........	263	45%	19%	25%	23%	32%	55%	-
40 to 49...........	191	40%	18%	21%	27%	34%	60%	-
50 to 64...........	154	38%	16%	22%	16%	47%	62%	-
65 And Over.......	131	19%	10%	9%	15%	66%	81%	-
High School/Less...	421	37%	17%	20%	19%	44%	63%	-
Some College.......	281	41%	16%	25%	21%	38%	59%	-
College Graduate...	293	38%	16%	22%	26%	36%	62%	-
Post-Graduate....	103	39%	20%	18%	32%	29%	61%	-
Liberal............	319	39%	16%	24%	25%	36%	61%	-
Moderate/Other.....	207	40%	18%	22%	18%	42%	60%	-
Conservative.......	475	37%	17%	20%	21%	42%	63%	-
Under $30K.........	343	37%	13%	24%	19%	44%	63%	-
Under $20K......	155	33%	12%	21%	19%	48%	67%	-
$20K to $30K......	188	40%	15%	26%	19%	41%	60%	-
$30K to $40K......	155	34%	13%	21%	24%	42%	66%	-
$40K to $50K......	133	47%	23%	23%	23%	30%	53%	-
Over $50K..........	244	40%	20%	20%	25%	35%	60%	-
Over $75K.......	95	40%	19%	21%	24%	36%	60%	-
White..............	779	42%	18%	24%	23%	35%	58%	-
Black..............	100	8%	4%	4%	15%	77%	92%	-
Hispanic...........	66	44%	21%	23%	20%	36%	56%	-
All Other..........	56	34%	11%	23%	18%	48%	66%	-
Have Children......	666	36%	16%	20%	21%	43%	64%	-
Encourage/Artist	523	37%	16%	21%	21%	42%	63%	-
Don't Have Children	335	42%	18%	24%	23%	35%	58%	-
Willing To Pay More	393	41%	18%	23%	20%	39%	59%	-
Only Sometimes.....	382	37%	15%	22%	24%	39%	63%	-
Hardly Ever Pay Mre	211	34%	16%	18%	22%	44%	66%	-
Have Art In Home...	768	40%	17%	23%	23%	37%	60%	-
Don't Have Art.....	233	33%	15%	18%	16%	51%	67%	-
Choice - Choose Art	352	44%	19%	26%	21%	35%	56%	-
Would Choose Money.	574	35%	15%	20%	22%	42%	65%	-
Not Sure..........	75	35%	17%	17%	19%	47%	65%	-
Spend $25-100/Art..	472	35%	16%	19%	23%	42%	65%	-
Wld Spend Over $200	451	42%	18%	25%	21%	37%	58%	-
Museum >2 Times Yr.	188	46%	22%	23%	24%	30%	54%	-
1 or 2 Times A Yr..	301	38%	15%	23%	21%	41%	62%	-
Less Than Once A Yr	236	40%	17%	23%	22%	38%	60%	-
Don't Go To Museums	240	32%	15%	17%	20%	48%	68%	-
Favor Mre Fed Taxes	300	44%	16%	28%	22%	34%	56%	-
Wld Pay $25 More	197	50%	19%	31%	20%	29%	50%	-
Pay $5-$15 More.	57	32%	14%	18%	26%	42%	68%	-
None Of Above...	33	36%	9%	27%	18%	45%	64%	-
Oppose Mre Fed Taxs	571	37%	18%	20%	21%	41%	63%	-
Not Sure..........	130	30%	14%	16%	22%	48%	70%	-

Q16. How often do you do the following:
Grow vegetables, flowers or shrubs in the garden.

	TOTAL	FRQNT/ OCNSLY	Frequ- ently	Occas- ionaly	Seldom	Not At All	TOTAL SELDOM /NOT AT ALL	Not Sure
All Voters.........	1001	54%	34%	20%	11%	35%	46%	-
Northeast..........	216	49%	31%	18%	11%	40%	51%	-
South..............	335	51%	31%	20%	14%	35%	49%	-
Central............	241	60%	40%	20%	9%	31%	40%	-
West...............	209	56%	35%	20%	10%	34%	44%	-
Male...............	475	50%	29%	21%	11%	40%	50%	-
Female.............	526	57%	39%	19%	12%	31%	43%	-
Under 30...........	247	29%	13%	16%	13%	57%	71%	-
30 to 39...........	263	54%	33%	21%	13%	33%	46%	-
40 to 49...........	191	64%	42%	22%	12%	24%	36%	-
50 to 64...........	154	71%	47%	24%	8%	21%	29%	-
65 And Over........	131	65%	50%	15%	7%	28%	35%	-
High School/Less...	421	54%	33%	21%	10%	36%	46%	-
Some College.......	281	54%	32%	21%	12%	34%	46%	-
College Graduate...	293	53%	37%	16%	13%	35%	47%	-
Post-Graduate....	103	57%	35%	22%	10%	33%	43%	-
Liberal............	319	49%	29%	19%	14%	38%	51%	-
Moderate/Other.....	207	57%	37%	20%	10%	33%	43%	-
Conservative.......	475	56%	36%	20%	10%	34%	44%	-
Under $30K.........	343	49%	30%	19%	9%	42%	51%	-
Under $20K......	155	50%	33%	17%	8%	42%	50%	-
$20K to $30K.......	188	48%	28%	20%	11%	41%	52%	-
$30K to $40K.......	155	51%	28%	23%	14%	35%	49%	-
$40K to $50K.......	133	56%	38%	18%	12%	32%	44%	-
Over $50K..........	244	55%	35%	20%	14%	31%	45%	-
Over $75K.......	95	49%	36%	14%	12%	39%	51%	-
White..............	779	55%	36%	19%	13%	32%	45%	-
Black..............	100	45%	23%	22%	3%	52%	55%	-
Hispanic...........	66	47%	20%	27%	12%	41%	53%	-
All Other..........	56	59%	46%	13%	5%	36%	41%	-
Have Children......	666	61%	39%	22%	10%	29%	39%	-
Encourage/Artist	523	60%	38%	22%	10%	30%	40%	-
Don't Have Children	335	40%	25%	16%	13%	47%	60%	-
Willing To Pay More	393	50%	32%	19%	11%	39%	50%	-
Only Sometimes.....	382	54%	32%	21%	12%	35%	46%	-
Hardly Ever Pay Mre	211	60%	40%	19%	12%	28%	40%	-
Have Art In Home...	768	55%	34%	21%	12%	33%	45%	-
Don't Have Art.....	233	50%	33%	17%	9%	40%	50%	-
Choice - Choose Art	352	55%	35%	20%	13%	32%	45%	-
Would Choose Money.	574	51%	33%	18%	11%	38%	49%	-
Not Sure..........	75	69%	39%	31%	3%	28%	31%	-
Spend $25-100/Art..	472	52%	33%	19%	11%	37%	48%	-
Wld Spend Over $200	451	54%	34%	20%	12%	34%	46%	-
Museum >2 Times Yr.	188	54%	31%	23%	13%	33%	46%	-
1 or 2 Times A Yr..	301	56%	34%	22%	10%	34%	44%	-
Less Than Once A Yr	236	57%	39%	18%	13%	30%	43%	-
Don't Go To Museums	240	48%	31%	17%	9%	43%	52%	-
Favor Mre Fed Taxes	300	53%	32%	21%	13%	34%	47%	-
Wld Pay $25 More	197	54%	33%	21%	13%	33%	46%	-
Pay $5-$15 More.	57	53%	35%	18%	11%	37%	47%	-
None Of Above...	33	55%	24%	30%	15%	30%	45%	-
Oppose Mre Fed Taxs	571	53%	36%	18%	11%	36%	47%	-
Not Sure..........	130	57%	32%	25%	8%	35%	43%	-

Q17. How often do you do the following:
Go out to see a movie in a theater.

	TOTAL	FRQNT/ OCNSLY	Frequ- ently	Occas- ionaly	Seldom	Not At All	TOTAL SELDOM /NOT AT ALL	Not Sure
All Voters.........	1001	61%	26%	35%	21%	18%	39%	*
Northeast..........	216	63%	26%	37%	19%	19%	37%	*
South..............	335	64%	30%	33%	19%	17%	36%	-
Central............	241	55%	20%	34%	24%	20%	45%	*
West...............	209	62%	25%	36%	23%	15%	38%	-
Male...............	475	61%	27%	34%	22%	17%	39%	-
Female.............	526	61%	25%	36%	21%	18%	39%	*
Under 30...........	247	78%	41%	37%	14%	7%	21%	1%
30 to 39...........	263	62%	24%	38%	22%	17%	38%	-
40 to 49...........	191	64%	28%	36%	25%	11%	36%	-
50 to 64...........	154	51%	14%	37%	24%	25%	49%	-
65 And Over........	131	37%	13%	24%	25%	38%	63%	-
High School/Less...	421	51%	18%	33%	23%	26%	49%	-
Some College.......	281	65%	30%	35%	21%	13%	35%	1%
College Graduate...	293	72%	34%	38%	18%	10%	28%	-
Post-Graduate....	103	74%	32%	42%	18%	8%	26%	-
Liberal............	319	66%	30%	36%	21%	13%	34%	*
Moderate/Other.....	207	55%	26%	29%	24%	21%	44%	*
Conservative.......	475	60%	23%	37%	20%	20%	40%	-
Under $30K.........	343	57%	25%	32%	22%	21%	43%	-
Under $20K......	155	50%	21%	29%	24%	26%	50%	-
$20K to $30K.......	188	63%	29%	35%	20%	17%	37%	-
$30K to $40K.......	155	66%	26%	40%	19%	15%	34%	-
$40K to $50K.......	133	61%	26%	35%	26%	13%	38%	1%
Over $50K..........	244	71%	30%	42%	16%	12%	28%	*
Over $75K.......	95	74%	38%	36%	20%	5%	25%	1%
White..............	779	58%	24%	34%	24%	18%	42%	*
Black..............	100	72%	34%	38%	8%	20%	28%	-
Hispanic...........	66	70%	33%	36%	12%	17%	29%	2%
All Other..........	56	70%	29%	41%	20%	11%	30%	-
Have Children......	666	56%	20%	37%	23%	21%	44%	-
Encourage/Artist	523	59%	21%	38%	22%	20%	41%	-
Don't Have Children	335	70%	38%	31%	19%	11%	30%	1%
Willing To Pay More	393	67%	33%	35%	17%	15%	32%	*
Only Sometimes.....	382	64%	25%	39%	24%	12%	36%	-
Hardly Ever Pay Mre	211	44%	14%	29%	25%	31%	56%	*
Have Art In Home...	768	62%	27%	35%	21%	17%	38%	*
Don't Have Art.....	233	58%	23%	34%	21%	21%	42%	-
Choice - Choose Art	352	68%	29%	39%	18%	14%	32%	*
Would Choose Money.	574	58%	25%	33%	23%	19%	42%	*
Not Sure..........	75	48%	19%	29%	24%	28%	52%	-
Spend $25-100/Art..	472	53%	20%	33%	26%	21%	47%	*
Wld Spend Over $200	451	72%	35%	38%	17%	11%	28%	-
Museum >2 Times Yr.	188	76%	43%	33%	15%	9%	24%	-
1 or 2 Times A Yr..	301	70%	31%	39%	19%	11%	30%	*
Less Than Once A Yr	236	55%	17%	38%	28%	17%	45%	-
Don't Go To Museums	240	47%	15%	31%	20%	33%	53%	-
Favor Mre Fed Taxes	300	68%	30%	38%	18%	14%	32%	-
Wld Pay $25 More	197	72%	31%	40%	18%	10%	28%	-
Pay $5-$15 More.	57	63%	26%	37%	19%	18%	37%	-
None Of Above...	33	58%	33%	24%	21%	21%	42%	-
Oppose Mre Fed Taxs	571	58%	24%	35%	23%	18%	41%	*
Not Sure..........	130	55%	25%	31%	21%	23%	44%	1%

Q18. How often do you do the following:
Paint, draw or do graphic arts like etching.

	TOTAL	TOTAL FRQNT/ OCNSLY	Frequ- ently	Occas- ionaly	Seldom	Not At All	TOTAL SELDOM /NOT AT ALL	Not Sure
All Voters.........	1001	25%	12%	13%	16%	59%	75%	-
Northeast..........	216	27%	15%	12%	15%	58%	73%	-
South..............	335	25%	10%	16%	16%	59%	75%	-
Central............	241	24%	10%	14%	15%	61%	76%	-
West...............	209	24%	13%	11%	18%	57%	76%	-
Male...............	475	24%	12%	12%	16%	59%	76%	-
Female.............	526	26%	11%	15%	16%	59%	74%	-
Under 30...........	247	33%	15%	18%	19%	47%	67%	-
30 to 39...........	263	23%	10%	13%	22%	55%	77%	-
40 to 49...........	191	28%	13%	15%	14%	58%	72%	-
50 to 64...........	154	23%	13%	10%	7%	70%	77%	-
65 And Over........	131	15%	5%	9%	11%	74%	85%	-
High School/Less...	421	23%	10%	13%	14%	63%	77%	-
Some College.......	281	28%	14%	15%	17%	54%	72%	-
College Graduate...	293	25%	11%	14%	18%	57%	75%	-
Post-Graduate....	103	23%	9%	15%	24%	52%	77%	-
Liberal............	319	27%	14%	13%	18%	55%	73%	-
Moderate/Other.....	207	23%	10%	14%	17%	60%	77%	-
Conservative.......	475	25%	11%	14%	14%	61%	75%	-
Under $30K.........	343	29%	10%	18%	14%	57%	71%	-
Under $20K......	155	25%	7%	17%	14%	62%	75%	-
$20K to $30K.......	188	32%	13%	19%	15%	53%	68%	-
$30K to $40K.......	155	20%	8%	12%	15%	65%	80%	-
$40K to $50K.......	133	26%	17%	9%	17%	57%	74%	-
Over $50K..........	244	22%	11%	11%	19%	59%	78%	-
Over $75K.......	95	23%	11%	13%	22%	55%	77%	-
White..............	779	23%	11%	12%	17%	60%	77%	-
Black..............	100	26%	6%	20%	17%	57%	74%	-
Hispanic...........	66	44%	24%	20%	9%	47%	56%	-
All Other..........	56	32%	13%	20%	13%	55%	68%	-
Have Children......	666	24%	11%	13%	14%	62%	76%	-
Encourage/Artist	523	27%	13%	15%	13%	59%	73%	-
Don't Have Children	335	27%	13%	14%	21%	53%	73%	-
Willing To Pay More	393	27%	11%	16%	14%	59%	73%	-
Only Sometimes.....	382	25%	12%	13%	16%	59%	75%	-
Hardly Ever Pay Mre	211	23%	12%	11%	18%	59%	77%	-
Have Art In Home...	768	27%	13%	14%	18%	55%	73%	-
Don't Have Art.....	233	17%	6%	11%	9%	73%	83%	-
Choice - Choose Art	352	31%	16%	15%	15%	54%	69%	-
Would Choose Money.	574	22%	10%	12%	17%	61%	78%	-
Not Sure...........	75	21%	7%	15%	11%	68%	79%	-
Spend $25-100/Art..	472	23%	11%	12%	16%	61%	77%	-
Wld Spend Over $200	451	27%	12%	16%	16%	56%	73%	-
Museum >2 Times Yr.	188	39%	25%	14%	15%	46%	61%	-
1 or 2 Times A Yr..	301	27%	9%	17%	18%	55%	73%	-
Less Than Once A Yr	236	21%	9%	11%	19%	61%	79%	-
Don't Go To Museums	240	19%	7%	12%	11%	70%	81%	-
Favor Mre Fed Taxes	300	30%	14%	16%	18%	52%	70%	-
Wld Pay $25 More	197	29%	14%	15%	21%	50%	71%	-
Pay $5-$15 More.	57	32%	16%	16%	12%	56%	68%	-
None Of Above...	33	36%	18%	18%	12%	52%	64%	-
Oppose Mre Fed Taxs	571	23%	11%	12%	16%	61%	77%	-
Not Sure...........	130	25%	10%	15%	10%	65%	75%	-

Q19. How often do you do the following:
Take photographs as a hobby.

	TOTAL	TOTAL FRQNT/ OCNSLY	Frequ- ently	Occas- ionaly	Seldom	Not At All	TOTAL SELDOM /NOT AT ALL	Not Sure
All Voters.........	1001	49%	23%	26%	18%	33%	51%	-
Northeast..........	216	52%	25%	27%	15%	33%	48%	-
South..............	335	47%	21%	26%	19%	35%	53%	-
Central............	241	47%	20%	27%	17%	36%	53%	-
West...............	209	52%	29%	22%	20%	29%	48%	-
Male...............	475	48%	22%	25%	16%	36%	52%	-
Female.............	526	50%	24%	26%	19%	31%	50%	-
Under 30...........	247	45%	23%	22%	20%	35%	55%	-
30 to 39...........	263	50%	18%	32%	19%	31%	50%	-
40 to 49...........	191	52%	26%	27%	16%	32%	48%	-
50 to 64...........	154	49%	26%	23%	17%	34%	51%	-
65 And Over........	131	47%	28%	19%	15%	37%	53%	-
High School/Less...	421	41%	17%	25%	17%	41%	59%	-
Some College.......	281	53%	26%	26%	20%	27%	47%	-
College Graduate...	293	56%	30%	26%	17%	27%	44%	-
Post-Graduate....	103	58%	29%	29%	17%	24%	42%	-
Liberal............	319	50%	25%	25%	18%	33%	50%	-
Moderate/Other.....	207	53%	27%	26%	15%	32%	47%	-
Conservative.......	475	47%	21%	26%	19%	34%	53%	-
Under $30K.........	343	46%	21%	25%	15%	39%	54%	-
Under $20K......	155	41%	19%	21%	12%	47%	59%	-
$20K to $30K.......	188	50%	22%	28%	17%	33%	50%	-
$30K to $40K.......	155	46%	22%	24%	22%	32%	54%	-
$40K to $50K.......	133	44%	25%	20%	26%	30%	56%	-
Over $50K..........	244	59%	28%	31%	16%	25%	41%	-
Over $75K.......	95	56%	27%	28%	17%	27%	44%	-
White..............	779	49%	23%	25%	18%	33%	51%	-
Black..............	100	44%	18%	26%	17%	39%	56%	-
Hispanic...........	66	50%	24%	26%	14%	36%	50%	-
All Other..........	56	57%	29%	29%	16%	27%	43%	-
Have Children......	666	50%	24%	26%	17%	32%	50%	-
Encourage/Artist	523	52%	26%	26%	17%	32%	48%	-
Don't Have Children	335	46%	21%	24%	19%	35%	54%	-
Willing To Pay More	393	49%	24%	25%	18%	33%	51%	-
Only Sometimes.....	382	51%	24%	27%	18%	31%	49%	-
Hardly Ever Pay Mre	211	44%	21%	23%	18%	38%	56%	-
Have Art In Home...	768	53%	26%	27%	18%	29%	47%	-
Don't Have Art.....	233	36%	15%	20%	18%	46%	64%	-
Choice - Choose Art	352	57%	29%	28%	14%	28%	43%	-
Would Choose Money.	574	43%	20%	23%	20%	37%	57%	-
Not Sure...........	75	52%	21%	31%	17%	31%	48%	-
Spend $25-100/Art..	472	44%	19%	24%	18%	38%	56%	-
Wld Spend Over $200	451	55%	28%	27%	17%	27%	45%	-
Museum >2 Times Yr.	188	64%	41%	23%	15%	20%	36%	-
1 or 2 Times A Yr..	301	54%	21%	33%	17%	29%	46%	-
Less Than Once A Yr	236	42%	18%	24%	20%	38%	58%	-
Don't Go To Museums	240	38%	17%	21%	18%	44%	62%	-
Favor Mre Fed Taxes	300	58%	32%	25%	14%	29%	42%	-
Wld Pay $25 More	197	61%	34%	27%	15%	24%	39%	-
Pay $5-$15 More.	57	56%	32%	25%	11%	33%	44%	-
None Of Above...	33	45%	24%	21%	9%	45%	55%	-
Oppose Mre Fed Taxs	571	45%	19%	25%	21%	34%	55%	-
Not Sure...........	130	46%	19%	27%	14%	40%	54%	-

Q20. How often do you do the following:
Go out dancing.

	TOTAL	TOTAL FRQNT/OCNSLY	Frequently	Occasionally	Seldom	Not At All	TOTAL SELDOM /NOT AT ALL	Not Sure
All Voters.........	1001	36%	13%	22%	23%	41%	64%	-
Northeast..........	216	43%	17%	25%	19%	38%	57%	-
South..............	335	36%	14%	21%	22%	42%	64%	-
Central............	241	32%	12%	20%	26%	42%	68%	-
West...............	209	33%	11%	22%	24%	43%	67%	-
Male...............	475	38%	13%	25%	24%	38%	62%	-
Female.............	526	33%	13%	20%	22%	44%	67%	-
Under 30...........	247	55%	24%	31%	19%	26%	45%	-
30 to 39...........	263	35%	12%	23%	29%	37%	65%	-
40 to 49...........	191	31%	12%	19%	29%	40%	69%	-
50 to 64...........	154	29%	8%	21%	18%	53%	71%	-
65 And Over........	131	17%	5%	12%	15%	69%	83%	-
High School/Less...	421	32%	14%	19%	19%	48%	68%	-
Some College.......	281	35%	15%	20%	24%	41%	65%	-
College Graduate...	293	41%	12%	29%	28%	31%	59%	-
Post-Graduate....	103	42%	13%	29%	26%	32%	58%	-
Liberal............	319	42%	17%	25%	24%	34%	58%	-
Moderate/Other.....	207	39%	15%	23%	21%	40%	61%	-
Conservative.......	475	30%	10%	20%	23%	47%	70%	-
Under $30K.........	343	38%	16%	21%	17%	45%	62%	-
Under $20K......	155	35%	17%	18%	16%	49%	65%	-
$20K to $30K.......	188	40%	16%	24%	18%	43%	60%	-
$30K to $40K.......	155	34%	10%	24%	24%	43%	66%	-
$40K to $50K.......	133	33%	13%	20%	32%	35%	67%	-
Over $50K..........	244	38%	14%	24%	26%	36%	62%	-
Over $75K.......	95	35%	16%	19%	31%	35%	65%	-
White..............	779	33%	12%	21%	24%	43%	67%	-
Black..............	100	49%	22%	27%	10%	41%	51%	-
Hispanic...........	66	41%	11%	30%	29%	30%	59%	-
All Other..........	56	41%	25%	16%	27%	32%	59%	-
Have Children......	666	31%	11%	20%	23%	46%	69%	-
Encourage/Artist	523	32%	12%	20%	24%	44%	68%	-
Don't Have Children	335	45%	19%	27%	22%	32%	55%	-
Willing To Pay More	393	38%	17%	22%	22%	40%	62%	-
Only Sometimes.....	382	39%	13%	26%	26%	35%	61%	-
Hardly Ever Pay Mre	211	26%	9%	17%	19%	55%	74%	-
Have Art In Home...	768	37%	14%	24%	24%	39%	63%	-
Don't Have Art.....	233	30%	12%	18%	20%	50%	70%	-
Choice - Choose Art	352	38%	16%	23%	25%	36%	62%	-
Would Choose Money.	574	36%	13%	23%	22%	43%	64%	-
Not Sure...........	75	24%	7%	17%	21%	55%	76%	-
Spend $25-100/Art..	472	33%	15%	18%	21%	46%	67%	-
Wld Spend Over $200	451	40%	13%	27%	26%	34%	60%	-
Museum >2 Times Yr.	188	47%	19%	28%	21%	32%	53%	-
1 or 2 Times A Yr..	301	40%	13%	26%	26%	35%	60%	-
Less Than Once A Yr	236	30%	11%	19%	25%	44%	70%	-
Don't Go To Museums	240	28%	11%	17%	19%	54%	73%	-
Favor Mre Fed Taxes	300	38%	13%	24%	25%	37%	62%	-
Wld Pay $25 More	197	38%	13%	25%	28%	34%	62%	-
Pay $5-$15 More.	57	35%	16%	19%	21%	44%	65%	-
None Of Above...	33	45%	15%	30%	21%	33%	55%	-
Oppose Mre Fed Taxs	571	36%	13%	22%	22%	42%	64%	-
Not Sure...........	130	31%	13%	18%	21%	48%	69%	-

Q21. How often do you do the following:
Play a musical instrument like the piano, guitar or violin.

	TOTAL	TOTAL FRQNT/OCNSLY	Frequently	Occasionally	Seldom	Not At All	TOTAL SELDOM /NOT AT ALL	Not Sure
All Voters.........	1001	20%	11%	9%	9%	70%	80%	*
Northeast..........	216	21%	9%	12%	7%	72%	79%	-
South..............	335	20%	11%	8%	9%	71%	80%	*
Central............	241	20%	12%	8%	10%	71%	80%	-
West...............	209	22%	12%	10%	12%	66%	78%	-
Male...............	475	21%	11%	10%	8%	71%	79%	-
Female.............	526	20%	11%	9%	11%	69%	80%	*
Under 30...........	247	26%	14%	12%	13%	61%	74%	-
30 to 39...........	263	19%	10%	9%	12%	69%	81%	*
40 to 49...........	191	23%	9%	13%	8%	69%	77%	-
50 to 64...........	154	14%	12%	3%	6%	79%	86%	-
65 And Over........	131	18%	10%	8%	2%	81%	82%	-
High School/Less...	421	16%	10%	6%	6%	77%	84%	-
Some College.......	281	24%	13%	11%	11%	65%	75%	*
College Graduate...	293	23%	11%	11%	13%	65%	77%	-
Post-Graduate....	103	20%	8%	13%	12%	68%	80%	-
Liberal............	319	21%	13%	9%	12%	67%	79%	-
Moderate/Other.....	207	21%	12%	9%	9%	71%	79%	-
Conservative.......	475	20%	10%	10%	8%	72%	80%	*
Under $30K.........	343	20%	12%	7%	8%	72%	80%	-
Under $20K......	155	17%	12%	6%	5%	78%	83%	-
$20K to $30K.......	188	21%	13%	9%	11%	68%	79%	-
$30K to $40K.......	155	17%	10%	8%	10%	73%	83%	-
$40K to $50K.......	133	18%	10%	8%	12%	70%	82%	-
Over $50K..........	244	24%	10%	14%	9%	67%	76%	-
Over $75K.......	95	22%	11%	12%	9%	68%	78%	-
White..............	779	21%	11%	10%	9%	70%	79%	-
Black..............	100	16%	9%	7%	7%	77%	84%	-
Hispanic...........	66	20%	14%	6%	14%	67%	80%	-
All Other..........	56	23%	16%	7%	14%	61%	75%	2%
Have Children......	666	18%	10%	8%	8%	74%	82%	*
Encourage/Artist	523	19%	11%	9%	7%	74%	81%	*
Don't Have Children	335	24%	13%	12%	13%	63%	76%	-
Willing To Pay More	393	22%	12%	10%	9%	68%	78%	-
Only Sometimes.....	382	20%	10%	10%	11%	68%	80%	*
Hardly Ever Pay Mre	211	18%	12%	5%	7%	75%	82%	-
Have Art In Home...	768	22%	12%	10%	10%	68%	78%	*
Don't Have Art.....	233	16%	9%	6%	7%	77%	84%	-
Choice - Choose Art	352	19%	9%	10%	10%	71%	81%	-
Would Choose Money.	574	21%	13%	8%	9%	70%	79%	*
Not Sure...........	75	23%	7%	16%	9%	68%	77%	-
Spend $25-100/Art..	472	19%	11%	9%	9%	71%	80%	*
Wld Spend Over $200	451	21%	10%	11%	11%	68%	79%	-
Museum >2 Times Yr.	188	28%	17%	11%	13%	60%	72%	-
1 or 2 Times A Yr..	301	22%	13%	9%	9%	69%	78%	-
Less Than Once A Yr	236	19%	7%	12%	11%	69%	81%	-
Don't Go To Museums	240	16%	9%	7%	5%	79%	84%	-
Favor Mre Fed Taxes	300	22%	15%	7%	12%	66%	78%	*
Wld Pay $25 More	197	19%	11%	8%	14%	68%	81%	-
Pay $5-$15 More.	57	30%	25%	5%	5%	65%	70%	-
None Of Above...	33	24%	21%	3%	15%	58%	73%	3%
Oppose Mre Fed Taxs	571	20%	9%	11%	8%	72%	80%	-
Not Sure...........	130	20%	13%	7%	9%	71%	80%	-

Q22. How often do you do the following:
Read a book.

	TOTAL	TOTAL FRQNT/ OCNSLY	Frequently	Occasionally	Seldom	Not At All	TOTAL SELDOM /NOT AT ALL	Not Sure
All Voters.........	1001	84%	59%	24%	10%	6%	16%	-
Northeast..........	216	86%	62%	24%	7%	7%	14%	-
South..............	335	82%	60%	23%	13%	5%	18%	-
Central............	241	82%	56%	26%	10%	9%	18%	-
West...............	209	87%	61%	26%	10%	4%	13%	-
Male...............	475	81%	53%	28%	12%	7%	19%	-
Female.............	526	86%	65%	21%	8%	6%	14%	-
Under 30...........	247	77%	54%	23%	15%	8%	23%	-
30 to 39...........	263	82%	58%	24%	11%	7%	18%	-
40 to 49...........	191	90%	61%	29%	7%	3%	10%	-
50 to 64...........	154	89%	62%	27%	6%	5%	11%	-
65 And Over........	131	84%	66%	18%	11%	5%	16%	-
High School/Less...	421	76%	48%	28%	13%	10%	24%	-
Some College.......	281	88%	64%	24%	10%	2%	12%	-
College Graduate...	293	90%	70%	20%	6%	3%	10%	-
Post-Graduate....	103	92%	74%	18%	6%	2%	8%	-
Liberal............	319	86%	66%	20%	11%	3%	14%	-
Moderate/Other.....	207	86%	61%	25%	8%	6%	14%	-
Conservative.......	475	81%	55%	27%	11%	8%	19%	-
Under $30K.........	343	81%	57%	24%	11%	8%	19%	-
Under $20K......	155	78%	57%	21%	15%	6%	22%	-
$20K to $30K.......	188	84%	57%	27%	7%	9%	16%	-
$30K to $40K.......	155	81%	61%	21%	12%	7%	19%	-
$40K to $50K.......	133	82%	55%	27%	12%	6%	18%	-
Over $50K..........	244	86%	64%	23%	8%	5%	14%	-
Over $75K.......	95	84%	63%	21%	8%	7%	16%	-
White..............	779	83%	60%	23%	11%	6%	17%	-
Black..............	100	88%	65%	23%	6%	6%	12%	-
Hispanic...........	66	85%	52%	33%	8%	8%	15%	-
All Other..........	56	86%	57%	29%	7%	7%	14%	-
Have Children......	666	85%	60%	25%	9%	6%	15%	-
Encourage/Artist	523	85%	61%	24%	9%	6%	15%	-
Don't Have Children	335	82%	59%	23%	12%	6%	18%	-
Willing To Pay More	393	83%	58%	25%	10%	7%	17%	-
Only Sometimes.....	382	86%	63%	24%	10%	4%	14%	-
Hardly Ever Pay Mre	211	82%	58%	23%	10%	8%	18%	-
Have Art In Home...	768	85%	62%	23%	10%	5%	15%	-
Don't Have Art.....	233	81%	52%	28%	11%	9%	19%	-
Choice - Choose Art	352	89%	66%	23%	7%	3%	11%	-
Would Choose Money.	574	80%	55%	25%	12%	7%	20%	-
Not Sure...........	75	85%	59%	27%	7%	8%	15%	-
Spend $25-100/Art..	472	78%	52%	26%	14%	8%	22%	-
Wld Spend Over $200	451	90%	68%	22%	6%	4%	10%	-
Museum >2 Times Yr.	188	90%	78%	13%	4%	5%	10%	-
1 or 2 Times A Yr..	301	88%	64%	24%	8%	4%	12%	-
Less Than Once A Yr	236	85%	56%	29%	11%	4%	15%	-
Don't Go To Museums	240	75%	44%	31%	14%	11%	25%	-
Favor Mre Fed Taxes	300	86%	63%	23%	10%	4%	14%	-
Wld Pay $25 More	197	90%	65%	25%	9%	2%	10%	-
Pay $5-$15 More.	57	82%	67%	16%	14%	4%	18%	-
None Of Above...	33	79%	55%	24%	12%	9%	21%	-
Oppose Mre Fed Taxes	571	82%	58%	24%	11%	7%	18%	-
Not Sure...........	130	88%	58%	29%	6%	6%	12%	-

Q23. How often do you do the following:
Listen to music on records, CD's or audio tapes.

	TOTAL	TOTAL FRQNT/ OCNSLY	Frequently	Occasionally	Seldom	Not At All	TOTAL SELDOM /NOT AT ALL	Not Sure
All Voters.........	1001	93%	77%	16%	5%	3%	7%	-
Northeast..........	216	92%	77%	14%	5%	3%	8%	-
South..............	335	94%	78%	16%	3%	3%	6%	-
Central............	241	91%	76%	15%	6%	3%	9%	-
West...............	209	93%	76%	18%	5%	1%	7%	-
Male...............	475	92%	76%	17%	6%	2%	8%	-
Female.............	526	93%	78%	15%	4%	4%	7%	-
Under 30...........	247	98%	90%	8%	1%	*	2%	-
30 to 39...........	263	94%	77%	17%	4%	3%	6%	-
40 to 49...........	191	93%	75%	17%	7%	1%	7%	-
50 to 64...........	154	86%	64%	21%	7%	7%	14%	-
65 And Over........	131	86%	69%	17%	7%	7%	14%	-
High School/Less...	421	90%	75%	16%	6%	4%	10%	-
Some College.......	281	94%	74%	21%	2%	3%	6%	-
College Graduate...	293	94%	83%	11%	5%	1%	6%	-
Post-Graduate....	103	91%	77%	15%	7%	2%	9%	-
Liberal............	319	94%	84%	11%	3%	2%	6%	-
Moderate/Other.....	207	91%	71%	20%	6%	3%	9%	-
Conservative.......	475	92%	75%	17%	5%	3%	8%	-
Under $30K.........	343	93%	79%	14%	3%	4%	7%	-
Under $20K......	155	94%	83%	12%	4%	2%	6%	-
$20K to $30K.......	188	92%	76%	16%	3%	5%	8%	-
$30K to $40K.......	155	91%	79%	12%	6%	3%	9%	-
$40K to $50K.......	133	92%	71%	21%	5%	2%	8%	-
Over $50K..........	244	94%	82%	12%	5%	1%	6%	-
Over $75K.......	95	97%	84%	13%	3%	-	3%	-
White..............	779	92%	75%	17%	5%	3%	8%	-
Black..............	100	96%	86%	10%	4%	-	4%	-
Hispanic...........	66	92%	83%	9%	3%	5%	8%	-
All Other..........	56	93%	73%	20%	5%	2%	7%	-
Have Children......	666	91%	73%	18%	5%	4%	9%	-
Encourage/Artist	523	92%	75%	17%	5%	3%	8%	-
Don't Have Children	335	96%	84%	11%	3%	1%	4%	-
Willing To Pay More	393	92%	80%	12%	5%	2%	8%	-
Only Sometimes.....	382	93%	77%	17%	3%	3%	7%	-
Hardly Ever Pay Mre	211	92%	72%	20%	6%	2%	8%	-
Have Art In Home...	768	93%	78%	15%	4%	3%	7%	-
Don't Have Art.....	233	91%	73%	18%	5%	4%	9%	-
Choice - Choose Art	352	93%	80%	14%	4%	3%	7%	-
Would Choose Money.	574	92%	76%	16%	5%	3%	8%	-
Not Sure...........	75	92%	72%	20%	7%	1%	8%	-
Spend $25-100/Art..	472	93%	77%	16%	4%	3%	7%	-
Wld Spend Over $200	451	93%	78%	16%	5%	2%	7%	-
Museum >2 Times Yr.	188	96%	85%	11%	4%	1%	4%	-
1 or 2 Times A Yr..	301	94%	80%	15%	4%	2%	6%	-
Less Than Once A Yr	236	92%	74%	19%	4%	4%	8%	-
Don't Go To Museums	240	89%	70%	20%	6%	5%	11%	-
Favor Mre Fed Taxes	300	94%	81%	13%	3%	3%	6%	-
Wld Pay $25 More	197	94%	82%	12%	4%	3%	6%	-
Pay $5-$15 More.	57	95%	81%	14%	4%	2%	5%	-
None Of Above...	33	100%	79%	21%	-	-	-	-
Oppose Mre Fed Taxes	571	91%	74%	17%	6%	3%	9%	-
Not Sure...........	130	95%	78%	17%	3%	2%	5%	-

Q24. How often do you do the following:
Participate in any sports activity.

	TOTAL	TOTAL FRQNT/ OCNSLY	Frequently	Occasionally	Seldom	Not At All	TOTAL SELDOM /NOT AT ALL	Not Sure
All Voters.........	1001	50%	27%	22%	15%	35%	50%	-
Northeast..........	216	47%	26%	21%	16%	37%	53%	-
South..............	335	51%	27%	24%	13%	36%	49%	-
Central............	241	49%	25%	24%	15%	37%	51%	-
West..............	209	53%	32%	21%	17%	31%	47%	-
Male..............	475	61%	36%	25%	15%	24%	39%	-
Female............	526	40%	20%	20%	15%	45%	60%	-
Under 30...........	247	66%	38%	28%	16%	19%	34%	-
30 to 39...........	263	60%	33%	27%	18%	22%	40%	-
40 to 49...........	191	48%	25%	23%	18%	34%	52%	-
50 to 64...........	154	37%	17%	20%	12%	51%	63%	-
65 And Over.......	131	20%	11%	9%	6%	74%	80%	-
High School/Less...	421	40%	20%	20%	14%	45%	60%	-
Some College.......	281	52%	28%	23%	17%	31%	48%	-
College Graduate...	293	63%	38%	25%	14%	23%	37%	-
Post-Graduate....	103	70%	47%	23%	14%	17%	30%	-
Liberal............	319	51%	29%	23%	18%	31%	49%	-
Moderate/Other.....	207	48%	24%	24%	13%	39%	52%	-
Conservative.......	475	50%	28%	22%	14%	36%	50%	-
Under $30K.........	343	42%	23%	19%	13%	45%	58%	-
Under $20K......	155	36%	20%	16%	11%	53%	64%	-
$20K to $30K.......	188	47%	26%	22%	14%	39%	53%	-
$30K to $40K.......	155	44%	25%	19%	18%	38%	56%	-
$40K to $50K.......	133	57%	32%	26%	17%	26%	43%	-
Over $50K..........	244	64%	35%	29%	16%	19%	36%	-
Over $75K.......	95	74%	40%	34%	17%	9%	26%	-
White..............	779	49%	27%	22%	15%	35%	51%	-
Black..............	100	54%	23%	31%	10%	36%	46%	-
Hispanic...........	66	52%	27%	24%	17%	32%	48%	-
All Other..........	56	50%	45%	5%	16%	34%	50%	-
Have Children......	666	44%	22%	21%	15%	41%	56%	-
Encourage/Artist	523	45%	23%	22%	15%	40%	55%	-
Don't Have Children	335	62%	38%	24%	14%	24%	38%	-
Willing To Pay More	393	56%	34%	22%	15%	29%	44%	-
Only Sometimes.....	382	50%	24%	25%	16%	34%	50%	-
Hardly Ever Pay Mre	211	39%	21%	18%	13%	48%	61%	-
Have Art In Home...	768	53%	30%	23%	15%	32%	47%	-
Don't Have Art.....	233	41%	18%	22%	14%	45%	59%	-
Choice - Choose Art	352	55%	30%	26%	15%	29%	45%	-
Would Choose Money.	574	47%	26%	21%	15%	38%	53%	-
Not Sure..........	75	47%	29%	17%	11%	43%	53%	-
Spend $25-100/Art..	472	43%	23%	20%	16%	41%	57%	-
Wld Spend Over $200	451	59%	34%	25%	14%	26%	41%	-
Museum >2 Times Yr.	188	60%	31%	28%	12%	28%	40%	-
1 or 2 Times A Yr..	301	55%	31%	25%	17%	28%	44%	-
Less Than Once A Yr	236	51%	28%	23%	17%	32%	49%	-
Don't Go To Museums	240	39%	23%	16%	11%	50%	61%	-
Favor Mre Fed Taxes	300	54%	28%	26%	14%	32%	46%	-
Wld Pay $25 More	197	59%	30%	29%	15%	25%	41%	-
Pay $5-$15 More.	57	53%	30%	23%	7%	40%	47%	-
None Of Above...	33	36%	18%	18%	18%	45%	64%	-
Oppose Mre Fed Taxs	571	49%	29%	20%	17%	35%	51%	-
Not Sure..........	130	46%	22%	25%	10%	44%	54%	-

Q25. How often do you do the following: Go to a live musical performance, not including school performances.

	TOTAL	TOTAL FRQNT/ OCNSLY	Frequently	Occasionally	Seldom	Not At All	TOTAL SELDOM /NOT AT ALL	Not Sure
All Voters.........	1001	46%	13%	32%	28%	26%	54%	*
Northeast..........	216	49%	15%	34%	28%	23%	51%	-
South..............	335	45%	14%	31%	27%	27%	55%	-
Central............	241	44%	10%	34%	27%	29%	56%	*
West..............	209	46%	16%	30%	30%	23%	54%	-
Male..............	475	49%	13%	35%	28%	24%	51%	-
Female............	526	43%	13%	30%	28%	28%	56%	*
Under 30...........	247	45%	13%	32%	33%	21%	55%	*
30 to 39...........	263	44%	11%	33%	34%	22%	56%	-
40 to 49...........	191	46%	11%	35%	30%	24%	54%	-
50 to 64...........	154	52%	18%	34%	19%	29%	48%	-
65 And Over.......	131	47%	19%	28%	13%	40%	53%	-
High School/Less...	421	37%	11%	26%	25%	38%	63%	-
Some College.......	281	54%	16%	38%	25%	21%	46%	*
College Graduate...	293	51%	15%	36%	35%	14%	49%	-
Post-Graduate....	103	55%	17%	38%	34%	11%	45%	-
Liberal............	319	53%	15%	38%	28%	20%	47%	-
Moderate/Other.....	207	44%	14%	30%	25%	31%	56%	-
Conservative.......	475	42%	12%	30%	30%	28%	58%	*
Under $30K.........	343	40%	13%	27%	24%	36%	60%	-
Under $20K......	155	39%	9%	30%	22%	39%	61%	-
$20K to $30K.......	188	41%	16%	25%	27%	32%	59%	-
$30K to $40K.......	155	45%	12%	33%	29%	26%	55%	-
$40K to $50K.......	133	50%	14%	36%	30%	20%	50%	1%
Over $50K..........	244	55%	14%	41%	32%	13%	45%	-
Over $75K.......	95	58%	21%	37%	29%	13%	42%	-
White..............	779	45%	14%	32%	30%	25%	55%	-
Black..............	100	57%	15%	42%	18%	24%	42%	1%
Hispanic...........	66	41%	9%	32%	20%	39%	59%	-
All Other..........	56	41%	14%	27%	32%	27%	59%	-
Have Children......	666	43%	13%	30%	27%	29%	57%	*
Encourage/Artist	523	45%	13%	32%	27%	28%	54%	*
Don't Have Children	335	51%	14%	37%	29%	20%	49%	-
Willing To Pay More	393	51%	16%	35%	29%	20%	49%	*
Only Sometimes.....	382	45%	12%	33%	29%	25%	55%	-
Hardly Ever Pay Mre	211	37%	11%	26%	24%	38%	63%	-
Have Art In Home...	768	50%	15%	35%	30%	21%	50%	*
Don't Have Art.....	233	33%	10%	24%	22%	44%	67%	-
Choice - Choose Art	352	54%	17%	38%	24%	22%	46%	-
Would Choose Money.	574	41%	12%	29%	30%	28%	58%	*
Not Sure..........	75	40%	9%	31%	28%	32%	60%	-
Spend $25-100/Art..	472	39%	11%	28%	29%	32%	61%	-
Wld Spend Over $200	451	54%	18%	37%	28%	18%	46%	*
Museum >2 Times Yr.	188	62%	22%	40%	24%	14%	38%	-
1 or 2 Times A Yr..	301	57%	16%	41%	25%	18%	43%	-
Less Than Once A Yr	236	43%	10%	33%	33%	24%	57%	-
Don't Go To Museums	240	26%	7%	19%	29%	45%	74%	-
Favor Mre Fed Taxes	300	53%	18%	35%	26%	21%	47%	-
Wld Pay $25 More	197	54%	17%	38%	27%	18%	46%	-
Pay $5-$15 More.	57	47%	19%	28%	32%	21%	53%	-
None Of Above...	33	58%	21%	36%	12%	30%	42%	-
Oppose Mre Fed Taxs	571	41%	11%	30%	30%	28%	58%	*
Not Sure..........	130	50%	13%	37%	21%	29%	50%	-

Q26. How often do you do the following:
Collect things, like stamps or coins.

	TOTAL	TOTAL FRQNT/ OCNSLY	Frequently	Occasionaly	Seldom	Not At All	TOTAL SELDOM /NOT AT ALL	Not Sure
All Voters.........	1001	30%	18%	12%	12%	57%	69%	*
Northeast..........	216	31%	21%	10%	10%	59%	69%	-
South..............	335	31%	18%	13%	12%	57%	69%	*
Central............	241	32%	20%	12%	11%	56%	67%	1%
West...............	209	27%	14%	12%	17%	56%	73%	-
Male...............	475	29%	17%	12%	14%	56%	70%	*
Female.............	526	31%	19%	12%	11%	57%	68%	*
Under 30...........	247	26%	18%	8%	17%	57%	73%	*
30 to 39...........	263	32%	17%	14%	12%	56%	68%	*
40 to 49...........	191	35%	21%	14%	18%	47%	64%	1%
50 to 64...........	154	33%	21%	12%	7%	60%	67%	-
65 And Over........	131	24%	11%	14%	4%	72%	76%	-
High School/Less...	421	27%	18%	9%	9%	63%	73%	*
Some College.......	281	40%	23%	16%	13%	47%	60%	-
College Graduate...	293	28%	15%	13%	16%	56%	72%	*
Post-Graduate....	103	30%	13%	17%	15%	54%	69%	1%
Liberal............	319	30%	18%	12%	13%	58%	70%	-
Moderate/Other.....	207	31%	18%	13%	12%	57%	69%	-
Conservative.......	475	31%	18%	12%	12%	56%	69%	1%
Under $30K.........	343	31%	20%	12%	10%	59%	68%	*
Under $20K......	155	30%	21%	9%	8%	61%	69%	1%
$20K to $30K.......	188	32%	19%	14%	11%	57%	68%	-
$30K to $40K.......	155	28%	19%	10%	15%	56%	71%	1%
$40K to $50K.......	133	29%	18%	11%	17%	53%	70%	1%
Over $50K..........	244	31%	17%	14%	14%	56%	69%	-
Over $75K.......	95	32%	17%	15%	15%	54%	68%	-
White..............	779	30%	18%	11%	13%	57%	70%	*
Black..............	100	30%	17%	13%	12%	58%	70%	-
Hispanic...........	66	42%	20%	23%	6%	52%	58%	-
All Other..........	56	30%	18%	13%	14%	54%	68%	2%
Have Children......	666	31%	18%	13%	11%	58%	69%	*
Encourage/Artist	523	32%	19%	13%	11%	57%	68%	*
Don't Have Children	335	30%	19%	11%	16%	54%	70%	*
Willing To Pay More	393	32%	21%	11%	13%	55%	68%	*
Only Sometimes.....	382	32%	19%	13%	14%	53%	67%	1%
Hardly Ever Pay Mre	211	24%	12%	12%	8%	68%	76%	-
Have Art In Home...	768	32%	20%	12%	14%	54%	68%	*
Don't Have Art.....	233	25%	14%	11%	9%	66%	75%	*
Choice - Choose Art	352	35%	22%	13%	14%	51%	65%	-
Would Choose Money.	574	27%	15%	12%	12%	60%	72%	1%
Not Sure...........	75	35%	24%	11%	7%	59%	65%	-
Spend $25-100/Art..	472	28%	18%	10%	13%	58%	72%	*
Wld Spend Over $200	451	32%	19%	14%	13%	55%	67%	*
Museum >2 Times Yr.	188	40%	27%	13%	13%	47%	60%	-
1 or 2 Times A Yr..	301	30%	17%	12%	14%	56%	70%	*
Less Than Once A Yr	236	33%	17%	16%	15%	52%	67%	-
Don't Go To Museums	240	23%	15%	8%	9%	67%	76%	1%
Favor Mre Fed Taxes	300	32%	20%	12%	13%	55%	68%	-
Wld Pay $25 More	197	31%	20%	11%	16%	53%	69%	-
Pay $5-$15 More.	57	42%	25%	18%	4%	54%	58%	-
None Of Above...	33	24%	12%	12%	12%	64%	76%	-
Oppose Mre Fed Taxs	571	30%	18%	11%	13%	57%	70%	*
Not Sure...........	130	30%	15%	15%	8%	61%	68%	2%

Q27. How important to you is the way that you dress?

	TOTAL	TOTAL VERY/ SOMEWT IMPRNT	Very Imprnt	Somewt Imprnt	Not Very Imprnt	Not At All Imprnt	TOTAL NOT VERY/ AT ALL	Not Sure
All Voters.........	1001	92%	51%	40%	6%	2%	8%	-
Northeast..........	216	94%	54%	40%	4%	2%	6%	-
South..............	335	94%	59%	36%	4%	2%	6%	-
Central............	241	87%	43%	44%	10%	2%	13%	-
West...............	209	90%	46%	44%	8%	2%	10%	-
Male...............	475	88%	47%	41%	9%	3%	12%	-
Female.............	526	95%	55%	40%	4%	1%	5%	-
Under 30...........	247	94%	50%	44%	5%	1%	6%	-
30 to 39...........	263	90%	51%	39%	9%	2%	10%	-
40 to 49...........	191	91%	52%	39%	6%	3%	9%	-
50 to 64...........	154	91%	48%	43%	6%	3%	9%	-
65 And Over........	131	94%	56%	37%	4%	2%	6%	-
High School/Less...	421	92%	55%	37%	5%	3%	8%	-
Some College.......	281	91%	47%	44%	8%	1%	9%	-
College Graduate...	293	91%	50%	41%	7%	2%	9%	-
Post-Graduate....	103	91%	49%	43%	9%	-	9%	-
Liberal............	319	91%	48%	43%	7%	3%	9%	-
Moderate/Other.....	207	89%	54%	35%	9%	2%	11%	-
Conservative.......	475	93%	53%	41%	5%	1%	7%	-
Under $30K.........	343	92%	54%	38%	6%	2%	8%	-
Under $20K......	155	92%	55%	37%	6%	2%	8%	-
$20K to $30K.......	188	93%	54%	39%	6%	2%	7%	-
$30K to $40K.......	155	89%	39%	50%	8%	3%	11%	-
$40K to $50K.......	133	91%	52%	39%	5%	4%	9%	-
Over $50K..........	244	94%	53%	41%	5%	1%	6%	-
Over $75K.......	95	94%	51%	43%	4%	2%	6%	-
White..............	779	91%	48%	42%	7%	2%	9%	-
Black..............	100	96%	71%	25%	2%	2%	4%	-
Hispanic...........	66	94%	48%	45%	5%	2%	6%	-
All Other..........	56	93%	63%	30%	5%	2%	7%	-
Have Children......	666	91%	51%	40%	7%	2%	9%	-
Encourage/Artist	523	92%	52%	40%	6%	2%	8%	-
Don't Have Children	335	93%	53%	40%	6%	1%	7%	-
Willing To Pay More	393	94%	61%	33%	5%	2%	6%	-
Only Sometimes.....	382	91%	48%	43%	8%	1%	9%	-
Hardly Ever Pay Mre	211	87%	38%	49%	8%	5%	13%	-
Have Art In Home...	768	92%	52%	40%	7%	1%	8%	-
Don't Have Art.....	233	91%	51%	40%	6%	4%	9%	-
Choice - Choose Art	352	93%	54%	39%	6%	1%	7%	-
Would Choose Money.	574	92%	51%	41%	6%	2%	8%	-
Not Sure...........	75	85%	41%	44%	13%	1%	15%	-
Spend $25-100/Art..	472	92%	50%	41%	6%	3%	8%	-
Wld Spend Over $200	451	92%	54%	38%	6%	1%	8%	-
Museum >2 Times Yr.	188	91%	54%	37%	6%	3%	9%	-
1 or 2 Times A Yr..	301	91%	51%	40%	8%	1%	9%	-
Less Than Once A Yr	236	92%	50%	42%	7%	1%	8%	-
Don't Go To Museums	240	92%	49%	43%	5%	3%	8%	-
Favor Mre Fed Taxes	300	93%	53%	40%	5%	1%	7%	-
Wld Pay $25 More	197	92%	49%	44%	6%	2%	8%	-
Pay $5-$15 More.	57	98%	65%	33%	2%	-	2%	-
None Of Above...	33	91%	48%	42%	9%	-	9%	-
Oppose Mre Fed Taxs	571	91%	51%	40%	7%	2%	9%	-
Not Sure...........	130	92%	49%	43%	6%	2%	8%	-

Q28. How important to you is the way that you decorate your home?

	TOTAL	TOTAL VERY/ SOMEWT IMPRNT	Very Imprnt	Somewt Imprnt	Not Very Imprnt	Not At All Imprnt	TOTAL NOT VERY/ AT ALL	Not Sure
All Voters.........	1001	93%	56%	37%	6%	1%	7%	-
Northeast..........	216	95%	61%	34%	4%	1%	5%	-
South..............	335	94%	59%	35%	5%	1%	6%	-
Central............	241	89%	50%	39%	9%	2%	11%	-
West...............	209	93%	51%	43%	4%	2%	7%	-
Male...............	475	91%	53%	39%	8%	1%	9%	-
Female.............	526	94%	58%	36%	4%	2%	6%	-
Under 30...........	247	93%	60%	33%	6%	1%	7%	-
30 to 39...........	263	94%	54%	41%	5%	1%	6%	-
40 to 49...........	191	92%	55%	36%	7%	2%	8%	-
50 to 64...........	154	94%	51%	43%	5%	1%	6%	-
65 And Over........	131	92%	57%	35%	5%	3%	8%	-
High School/Less...	421	94%	58%	35%	5%	1%	6%	-
Some College.......	281	92%	55%	37%	7%	1%	8%	-
College Graduate...	293	92%	53%	40%	5%	2%	8%	-
Post-Graduate....	103	93%	54%	39%	6%	1%	7%	-
Liberal............	319	92%	57%	36%	6%	2%	8%	-
Moderate/Other.....	207	91%	55%	36%	7%	1%	9%	-
Conservative.......	475	94%	55%	39%	5%	1%	6%	-
Under $30K.........	343	91%	57%	34%	8%	1%	9%	-
Under $20K......	155	91%	55%	35%	7%	2%	9%	-
$20K to $30K.......	188	91%	57%	34%	8%	1%	9%	-
$30K to $40K.......	155	94%	46%	47%	5%	1%	6%	-
$40K to $50K.......	133	92%	54%	38%	5%	3%	8%	-
Over $50K..........	244	95%	60%	35%	4%	1%	5%	-
Over $75K.......	95	95%	57%	38%	4%	1%	5%	-
White..............	779	92%	53%	39%	6%	1%	8%	-
Black..............	100	96%	73%	23%	1%	3%	4%	-
Hispanic...........	66	92%	52%	41%	6%	2%	8%	-
All Other..........	56	95%	64%	30%	5%	-	5%	-
Have Children......	666	93%	55%	39%	5%	2%	7%	-
Encourage/Artist	523	94%	57%	37%	5%	1%	6%	-
Don't Have Children	335	92%	57%	34%	7%	1%	8%	-
Willing To Pay More	393	94%	64%	30%	5%	1%	6%	-
Only Sometimes.....	382	95%	54%	41%	3%	1%	5%	-
Hardly Ever Pay Mre	211	86%	42%	45%	11%	2%	14%	-
Have Art In Home...	768	94%	58%	36%	5%	1%	6%	-
Don't Have Art.....	233	89%	48%	41%	8%	3%	11%	-
Choice - Choose Art	352	93%	63%	30%	5%	2%	7%	-
Would Choose Money.	574	93%	52%	41%	6%	1%	7%	-
Not Sure..........	75	93%	52%	41%	5%	1%	7%	-
Spend $25-100/Art..	472	93%	50%	43%	7%	1%	7%	-
Wld Spend Over $200	451	94%	63%	31%	4%	2%	6%	-
Museum >2 Times Yr.	188	93%	63%	30%	6%	1%	7%	-
1 or 2 Times A Yr..	301	95%	58%	37%	4%	1%	5%	-
Less Than Once A Yr	236	92%	55%	37%	7%	1%	8%	-
Don't Go To Museums	240	90%	47%	43%	8%	3%	10%	-
Favor Mre Fed Taxes	300	93%	58%	35%	5%	1%	7%	-
Wld Pay $25 More	197	94%	56%	38%	4%	2%	6%	-
Pay $5-$15 More.	57	93%	65%	28%	5%	2%	7%	-
None Of Above...	33	88%	58%	30%	12%	-	12%	-
Oppose Mre Fed Taxs	571	93%	55%	38%	6%	2%	7%	-
Not Sure..........	130	92%	54%	38%	7%	1%	8%	-

Q29. In you own home, do you have any photographs of family and friends displayed?

	TOTAL	Yes	No	Not Sure
All Voters.........	1001	94%	6%	*
Northeast..........	216	95%	5%	*
South..............	335	94%	6%	-
Central............	241	93%	6%	*
West...............	209	93%	7%	-
Male...............	475	93%	6%	*
Female.............	526	94%	6%	*
Under 30...........	247	96%	4%	-
30 to 39...........	263	90%	9%	*
40 to 49...........	191	95%	5%	-
50 to 64...........	154	96%	4%	-
65 And Over........	131	94%	6%	-
High School/Less...	421	93%	7%	-
Some College.......	281	94%	6%	*
College Graduate...	293	95%	5%	*
Post-Graduate....	103	95%	5%	-
Liberal............	319	95%	5%	-
Moderate/Other.....	207	90%	9%	1%
Conservative.......	475	95%	5%	-
Under $30K.........	343	92%	8%	-
Under $20K......	155	90%	10%	-
$20K to $30K.......	188	93%	7%	-
$30K to $40K.......	155	96%	3%	1%
$40K to $50K.......	133	95%	5%	-
Over $50K..........	244	96%	4%	-
Over $75K.......	95	95%	5%	-
White..............	779	94%	6%	*
Black..............	100	92%	8%	-
Hispanic...........	66	91%	9%	-
All Other..........	56	95%	5%	-
Have Children......	666	95%	5%	*
Encourage/Artist	523	96%	4%	*
Don't Have Children	335	91%	9%	-
Willing To Pay More	393	94%	6%	-
Only Sometimes.....	382	95%	5%	-
Hardly Ever Pay Mre	211	92%	7%	1%
Have Art In Home...	768	95%	5%	*
Don't Have Art.....	233	89%	11%	-
Choice - Choose Art	352	97%	3%	-
Would Choose Money.	574	92%	7%	*
Not Sure..........	75	92%	8%	-
Spend $25-100/Art..	472	93%	7%	*
Wld Spend Over $200	451	96%	4%	-
Museum >2 Times Yr.	188	94%	6%	-
1 or 2 Times A Yr..	301	96%	4%	-
Less Than Once A Yr	236	94%	6%	*
Don't Go To Museums	240	91%	9%	*
Favor Mre Fed Taxes	300	94%	6%	-
Wld Pay $25 More	197	93%	7%	-
Pay $5-$15 More.	57	98%	2%	-
None Of Above...	33	97%	3%	-
Oppose Mre Fed Taxs	571	94%	5%	*
Not Sure..........	130	90%	10%	-

Q30. Do you have any works of art displayed in your home?

Q31. (If Yes In Q30) Do you have at least one item of the following kind of art in your home: Photographs, other than family snapshots.

	TOTAL	Yes	No
All Voters.........	1001	77%	23%
Northeast..........	216	81%	19%
South..............	335	77%	23%
Central............	241	69%	31%
West...............	209	80%	20%
Male...............	475	77%	23%
Female.............	526	76%	24%
Under 30...........	247	81%	19%
30 to 39...........	263	75%	25%
40 to 49...........	191	81%	19%
50 to 64...........	154	74%	26%
65 And Over........	131	71%	29%
High School/Less...	421	66%	34%
Some College.......	281	78%	22%
College Graduate...	293	90%	10%
Post-Graduate....	103	92%	8%
Liberal............	319	82%	18%
Moderate/Other.....	207	73%	27%
Conservative.......	475	75%	25%
Under $30K.........	343	71%	29%
Under $20K......	155	68%	32%
$20K to $30K.......	188	74%	26%
$30K to $40K.......	155	77%	23%
$40K to $50K.......	133	71%	29%
Over $50K..........	244	89%	11%
Over $75K.......	95	92%	8%
White..............	779	78%	22%
Black..............	100	73%	27%
Hispanic...........	66	68%	32%
All Other..........	56	75%	25%
Have Children......	666	76%	24%
Encourage/Artist	523	78%	22%
Don't Have Children	335	78%	22%
Willing To Pay More	393	78%	22%
Only Sometimes.....	382	76%	24%
Hardly Ever Pay Mre	211	77%	23%
Have Art In Home...	768	100%	–
Don't Have Art.....	233	–	100%
Choice - Choose Art	352	83%	17%
Would Choose Money.	574	73%	27%
Not Sure...........	75	77%	23%
Spend $25-100/Art..	472	68%	32%
Wld Spend Over $200	451	87%	13%
Museum >2 Times Yr.	188	87%	13%
1 or 2 Times A Yr..	301	83%	17%
Less Than Once A Yr	236	81%	19%
Don't Go To Museums	240	62%	38%
Favor Mre Fed Taxes	300	85%	15%
Wld Pay $25 More	197	87%	13%
Pay $5-$15 More.	57	81%	19%
None Of Above...	33	79%	21%
Oppose Mre Fed Taxs	571	74%	26%
Not Sure...........	130	71%	29%

	TOTAL	Yes	No	Not Sure
All Voters.........	768	78%	22%	*
Northeast..........	174	83%	16%	1%
South..............	259	80%	20%	–
Central............	167	79%	21%	–
West...............	168	70%	30%	–
Male...............	367	78%	22%	*
Female.............	401	78%	22%	–
Under 30...........	200	83%	16%	1%
30 to 39...........	196	77%	23%	–
40 to 49...........	154	83%	17%	–
50 to 64...........	114	78%	22%	–
65 And Over........	93	62%	38%	–
High School/Less...	279	78%	22%	–
Some College.......	220	80%	20%	*
College Graduate...	265	77%	23%	–
Post-Graduate....	95	68%	32%	–
Liberal............	262	84%	16%	*
Moderate/Other.....	151	79%	21%	–
Conservative.......	355	74%	26%	–
Under $30K.........	245	78%	22%	–
Under $20K......	106	75%	25%	–
$20K to $30K.......	139	80%	20%	–
$30K to $40K.......	120	79%	21%	–
$40K to $50K.......	95	81%	19%	–
Over $50K..........	217	80%	20%	–
Over $75K.......	87	84%	16%	–
White..............	608	78%	22%	–
Black..............	73	86%	12%	1%
Hispanic...........	45	71%	29%	–
All Other..........	42	74%	26%	–
Have Children......	507	75%	25%	–
Encourage/Artist	407	76%	24%	–
Don't Have Children	261	84%	16%	*
Willing To Pay More	306	80%	20%	*
Only Sometimes.....	289	79%	21%	–
Hardly Ever Pay Mre	163	74%	26%	–
Have Art In Home...	768	78%	22%	*
Don't Have Art.....	–	–	–	–
Choice - Choose Art	292	82%	18%	–
Would Choose Money.	418	76%	24%	*
Not Sure...........	58	79%	21%	–
Spend $25-100/Art..	321	76%	24%	*
Wld Spend Over $200	391	81%	19%	–
Museum >2 Times Yr.	163	87%	13%	–
1 or 2 Times A Yr..	250	76%	23%	*
Less Than Once A Yr	190	74%	26%	–
Don't Go To Museums	148	76%	24%	–
Favor Mre Fed Taxes	256	83%	17%	*
Wld Pay $25 More	172	85%	15%	–
Pay $5-$15 More.	46	78%	22%	–
None Of Above...	26	81%	15%	4%
Oppose Mre Fed Taxs	420	76%	24%	–
Not Sure...........	92	73%	27%	–

Q32. (If Yes In Q30) Do you have at least one item of the following
 kind of art in your home: Sculptures or small statues.

	TOTAL	Yes	No	Not Sure
All Voters.........	768	73%	27%	*
Northeast..........	174	77%	23%	-
South..............	259	75%	25%	-
Central............	167	68%	32%	-
West...............	168	71%	29%	1%
Male...............	367	75%	25%	-
Female.............	401	71%	29%	*
Under 30...........	200	71%	29%	-
30 to 39...........	196	71%	29%	-
40 to 49...........	154	78%	21%	1%
50 to 64...........	114	74%	26%	-
65 And Over........	93	71%	29%	-
High School/Less...	279	66%	34%	-
Some College.......	220	75%	25%	-
College Graduate...	265	78%	22%	*
Post-Graduate....	95	76%	23%	1%
Liberal............	262	74%	26%	-
Moderate/Other.....	151	74%	26%	1%
Conservative.......	355	71%	29%	-
Under $30K.........	245	69%	31%	-
Under $20K......	106	70%	30%	-
$20K to $30K.......	139	68%	32%	-
$30K to $40K.......	120	74%	26%	-
$40K to $50K.......	95	68%	32%	-
Over $50K..........	217	82%	18%	-
Over $75K.......	87	80%	20%	-
White..............	608	71%	28%	*
Black..............	73	82%	18%	-
Hispanic...........	45	73%	27%	-
All Other..........	42	76%	24%	-
Have Children......	507	74%	26%	*
Encourage/Artist	407	74%	25%	*
Don't Have Children	261	70%	30%	-
Willing To Pay More	306	75%	25%	-
Only Sometimes.....	289	71%	29%	-
Hardly Ever Pay Mre	163	74%	26%	-
Have Art In Home...	768	73%	27%	*
Don't Have Art.....	-	-	-	-
Choice - Choose Art	292	77%	22%	*
Would Choose Money.	418	70%	30%	-
Not Sure...........	58	67%	33%	-
Spend $25-100/Art..	321	67%	33%	-
Wld Spend Over $200	391	77%	23%	*
Museum >2 Times Yr.	163	85%	15%	1%
1 or 2 Times A Yr..	250	73%	27%	-
Less Than Once A Yr	190	68%	32%	-
Don't Go To Museums	148	69%	31%	-
Favor Mre Fed Taxes	256	79%	21%	-
Wld Pay $25 More	172	83%	17%	-
Pay $5-$15 More.	46	67%	33%	-
None Of Above...	26	65%	35%	-
Oppose Mre Fed Taxs	420	69%	31%	*
Not Sure...........	92	76%	24%	-

Q33. (If Yes In Q30) Do you have at least one item of the following
 kind of art in your home: Original paintings or drawings or prints.

	TOTAL	Yes	No	Not Sure
All Voters.........	768	72%	27%	1%
Northeast..........	174	68%	30%	1%
South..............	259	75%	25%	*
Central............	167	73%	26%	1%
West...............	168	72%	27%	1%
Male...............	367	72%	27%	1%
Female.............	401	72%	27%	1%
Under 30...........	200	68%	31%	1%
30 to 39...........	196	76%	24%	1%
40 to 49...........	154	70%	29%	1%
50 to 64...........	114	73%	27%	-
65 And Over........	93	78%	22%	-
High School/Less...	279	67%	32%	1%
Some College.......	220	72%	27%	1%
College Graduate...	265	78%	22%	*
Post-Graduate....	95	79%	20%	1%
Liberal............	262	76%	24%	*
Moderate/Other.....	151	62%	36%	2%
Conservative.......	355	74%	26%	1%
Under $30K.........	245	62%	37%	1%
Under $20K......	106	58%	42%	1%
$20K to $30K.......	139	66%	33%	1%
$30K to $40K.......	120	70%	28%	2%
$40K to $50K.......	95	83%	17%	-
Over $50K..........	217	80%	20%	*
Over $75K.......	87	83%	17%	-
White..............	608	73%	26%	1%
Black..............	73	60%	40%	-
Hispanic...........	45	89%	11%	-
All Other..........	42	67%	31%	2%
Have Children......	507	72%	28%	*
Encourage/Artist	407	71%	29%	*
Don't Have Children	261	73%	25%	2%
Willing To Pay More	306	75%	24%	*
Only Sometimes.....	289	70%	29%	1%
Hardly Ever Pay Mre	163	71%	29%	1%
Have Art In Home...	768	72%	27%	1%
Don't Have Art.....	-	-	-	-
Choice - Choose Art	292	76%	22%	2%
Would Choose Money.	418	70%	30%	-
Not Sure...........	58	66%	33%	2%
Spend $25-100/Art..	321	64%	35%	1%
Wld Spend Over $200	391	79%	20%	*
Museum >2 Times Yr.	163	80%	19%	1%
1 or 2 Times A Yr..	250	74%	26%	-
Less Than Once A Yr	190	68%	31%	1%
Don't Go To Museums	148	66%	32%	2%
Favor Mre Fed Taxes	256	73%	27%	1%
Wld Pay $25 More	172	76%	23%	1%
Pay $5-$15 More.	46	61%	37%	2%
None Of Above...	26	58%	42%	-
Oppose Mre Fed Taxs	420	72%	27%	*
Not Sure...........	92	71%	27%	2%

Q34. (If Yes In Q30) Do you have at least one item of the following
 kind of art in your home: Prints or posters.

	TOTAL	Yes	No	Not Sure
All Voters.........	768	77%	22%	*
Northeast..........	174	72%	28%	-
South..............	259	79%	21%	*
Central............	167	78%	22%	-
West...............	168	79%	20%	1%
Male...............	367	80%	20%	*
Female.............	401	75%	24%	*
Under 30...........	200	78%	21%	1%
30 to 39...........	196	83%	17%	-
40 to 49...........	154	82%	18%	1%
50 to 64...........	114	76%	23%	1%
65 And Over........	93	58%	42%	-
High School/Less...	279	71%	29%	*
Some College.......	220	80%	20%	*
College Graduate...	265	83%	17%	*
Post-Graduate....	95	82%	17%	1%
Liberal............	262	79%	21%	-
Moderate/Other.....	151	72%	26%	1%
Conservative.......	355	78%	22%	*
Under $30K.........	245	75%	24%	1%
Under $20K......	106	73%	27%	-
$20K to $30K.......	139	76%	22%	1%
$30K to $40K.......	120	78%	23%	-
$40K to $50K.......	95	76%	24%	-
Over $50K..........	217	84%	16%	-
Over $75K.......	87	89%	11%	-
White..............	608	77%	22%	*
Black..............	73	68%	32%	-
Hispanic...........	45	84%	16%	-
All Other..........	42	83%	14%	2%
Have Children......	507	76%	23%	1%
Encourage/Artist	407	76%	23%	*
Don't Have Children	261	80%	20%	-
Willing To Pay More	306	79%	21%	*
Only Sometimes.....	289	79%	21%	-
Hardly Ever Pay Mre	163	73%	26%	1%
Have Art In Home...	768	77%	22%	*
Don't Have Art.....	-	-	-	-
Choice - Choose Art	292	80%	19%	1%
Would Choose Money.	418	75%	25%	*
Not Sure...........	58	78%	22%	-
Spend $25-100/Art..	321	72%	27%	*
Wld Spend Over $200	391	82%	17%	1%
Museum >2 Times Yr.	163	87%	12%	1%
1 or 2 Times A Yr..	250	80%	20%	*
Less Than Once A Yr	190	78%	22%	-
Don't Go To Museums	148	62%	37%	1%
Favor Mre Fed Taxes	256	81%	19%	-
Wld Pay $25 More	172	86%	14%	-
Pay $5-$15 More.	46	76%	24%	-
None Of Above...	26	65%	35%	-
Oppose Mre Fed Taxs	420	76%	24%	*
Not Sure...........	92	75%	24%	1%

Q35. (If Yes In Q30) Do you have at least one item of the following
 kind of art in your home: Reproductions of original paintings.

	TOTAL	Yes	No	Not Sure
All Voters.........	768	45%	54%	1%
Northeast..........	174	49%	51%	-
South..............	259	44%	54%	2%
Central............	167	38%	62%	-
West...............	168	51%	48%	2%
Male...............	367	47%	52%	1%
Female.............	401	44%	55%	1%
Under 30...........	200	45%	53%	2%
30 to 39...........	196	40%	59%	1%
40 to 49...........	154	45%	54%	1%
50 to 64...........	114	54%	46%	-
65 And Over........	93	47%	53%	-
High School/Less...	279	35%	64%	1%
Some College.......	220	50%	49%	2%
College Graduate...	265	53%	47%	*
Post-Graduate....	95	46%	53%	1%
Liberal............	262	47%	53%	*
Moderate/Other.....	151	44%	54%	2%
Conservative.......	355	45%	54%	1%
Under $30K.........	245	37%	62%	1%
Under $20K......	106	32%	67%	1%
$20K to $30K.......	139	41%	58%	1%
$30K to $40K.......	120	49%	48%	3%
$40K to $50K.......	95	49%	51%	-
Over $50K..........	217	56%	43%	*
Over $75K.......	87	56%	44%	-
White..............	608	45%	54%	1%
Black..............	73	42%	58%	-
Hispanic...........	45	47%	51%	2%
All Other..........	42	48%	50%	2%
Have Children......	507	45%	54%	1%
Encourage/Artist	407	45%	54%	1%
Don't Have Children	261	45%	54%	1%
Willing To Pay More	306	48%	51%	1%
Only Sometimes.....	289	47%	52%	1%
Hardly Ever Pay Mre	163	37%	61%	1%
Have Art In Home...	768	45%	54%	1%
Don't Have Art.....	-	-	-	-
Choice - Choose Art	292	55%	43%	2%
Would Choose Money.	418	40%	60%	*
Not Sure...........	58	34%	62%	3%
Spend $25-100/Art..	321	36%	63%	1%
Wld Spend Over $200	391	52%	47%	1%
Museum >2 Times Yr.	163	56%	42%	1%
1 or 2 Times A Yr..	250	51%	48%	1%
Less Than Once A Yr	190	42%	57%	1%
Don't Go To Museums	148	26%	72%	1%
Favor Mre Fed Taxes	256	50%	49%	*
Wld Pay $25 More	172	56%	44%	-
Pay $5-$15 More.	46	39%	59%	2%
None Of Above...	26	35%	65%	-
Oppose Mre Fed Taxs	420	45%	54%	1%
Not Sure...........	92	35%	64%	1%

Q36. (If Yes In Q30) When you select pictures photographs, or other pieces of art for your home, do you lean more toward modern or traditional styles?

	TOTAL	Modern	Trdtnl	Mixed	Don't Select	Not Sure
All Voters.........	768	25%	64%	8%	1%	1%
Northeast..........	174	17%	70%	11%	1%	1%
South..............	259	34%	57%	7%	*	1%
Central............	167	20%	68%	8%	2%	2%
West...............	168	26%	64%	6%	2%	2%
Male...............	367	28%	61%	9%	1%	1%
Female.............	401	23%	66%	7%	1%	2%
Under 30...........	200	43%	47%	9%	-	1%
30 to 39...........	196	24%	64%	7%	2%	3%
40 to 49...........	154	19%	66%	12%	3%	1%
50 to 64...........	114	16%	76%	7%	-	1%
65 And Over........	93	14%	78%	2%	3%	2%
High School/Less...	279	29%	61%	6%	2%	2%
Some College.......	220	20%	68%	9%	1%	2%
College Graduate...	265	27%	62%	9%	1%	1%
Post-Graduate....	95	22%	66%	7%	2%	2%
Liberal............	262	33%	55%	10%	1%	1%
Moderate/Other.....	151	23%	62%	12%	1%	2%
Conservative.......	355	21%	71%	5%	2%	2%
Under $30K.........	245	30%	59%	8%	2%	1%
Under $20K......	106	25%	65%	8%	3%	-
$20K to $30K.......	139	35%	55%	8%	1%	2%
$30K to $40K.......	120	28%	61%	10%	-	2%
$40K to $50K.......	95	19%	69%	7%	2%	2%
Over $50K..........	217	24%	68%	6%	1%	1%
Over $75K.......	87	26%	62%	8%	2%	1%
White..............	608	23%	67%	7%	2%	1%
Black..............	73	52%	33%	14%	-	1%
Hispanic...........	45	22%	62%	16%	-	-
All Other..........	42	24%	64%	10%	-	2%
Have Children......	507	21%	69%	7%	2%	2%
Encourage/Artist	407	21%	69%	7%	1%	2%
Don't Have Children	261	35%	53%	10%	1%	1%
Willing To Pay More	306	25%	66%	7%	*	1%
Only Sometimes.....	289	25%	65%	8%	2%	1%
Hardly Ever Pay Mre	163	28%	57%	10%	3%	2%
Have Art In Home...	768	25%	64%	8%	1%	1%
Don't Have Art.....	-	-	-	-	-	-
Choice - Choose Art	292	26%	62%	9%	1%	1%
Would Choose Money.	418	26%	65%	6%	2%	2%
Not Sure...........	58	17%	64%	17%	-	2%
Spend $25-100/Art..	321	24%	66%	6%	2%	2%
Wld Spend Over $200	391	28%	61%	10%	1%	1%
Museum >2 Times Yr.	163	29%	53%	16%	1%	1%
1 or 2 Times A Yr..	250	26%	66%	7%	1%	*
Less Than Once A Yr	190	21%	69%	7%	2%	1%
Don't Go To Museums	148	26%	64%	3%	2%	5%
Favor Mre Fed Taxes	256	29%	61%	8%	1%	1%
Wld Pay $25 More	172	28%	61%	9%	1%	1%
Pay $5-$15 More.	46	33%	59%	7%	2%	-
None Of Above...	26	38%	54%	4%	-	4%
Oppose Mre Fed Taxs	420	25%	66%	6%	2%	1%
Not Sure...........	92	18%	62%	15%	1%	3%

Q37. (If Yes In Q30) If you had to choose from the following list, which type of art would you say you prefer?

	TOTAL	Asian	Amercn	Africn	Europn	Other	Not Sure
All Voters.........	768	6%	49%	8%	30%	2%	5%
Northeast..........	174	6%	39%	9%	37%	2%	7%
South..............	259	6%	56%	9%	24%	1%	4%
Central............	167	6%	54%	7%	26%	4%	4%
West...............	168	8%	46%	7%	34%	1%	5%
Male...............	367	7%	50%	8%	29%	2%	4%
Female.............	401	6%	49%	7%	30%	2%	6%
Under 30...........	200	9%	34%	17%	36%	1%	4%
30 to 39...........	196	6%	56%	7%	25%	3%	4%
40 to 49...........	154	5%	49%	5%	34%	2%	6%
50 to 64...........	114	4%	68%	4%	18%	2%	4%
65 And Over........	93	10%	51%	2%	27%	2%	9%
High School/Less...	279	5%	56%	11%	22%	2%	5%
Some College.......	220	8%	46%	6%	35%	1%	4%
College Graduate...	265	7%	45%	6%	34%	2%	6%
Post-Graduate....	95	9%	43%	7%	26%	2%	12%
Liberal............	262	8%	45%	10%	29%	2%	5%
Moderate/Other.....	151	3%	48%	9%	27%	3%	9%
Conservative.......	355	6%	53%	6%	31%	1%	3%
Under $30K.........	245	6%	54%	11%	26%	2%	2%
Under $20K......	106	6%	53%	8%	29%	2%	2%
$20K to $30K.......	139	6%	55%	13%	24%	1%	1%
$30K to $40K.......	120	8%	46%	4%	33%	2%	8%
$40K to $50K.......	95	6%	54%	9%	22%	4%	4%
Over $50K..........	217	6%	46%	6%	36%	1%	4%
Over $75K.......	87	7%	46%	5%	37%	1%	5%
White..............	608	6%	54%	2%	31%	2%	5%
Black..............	73	5%	21%	56%	14%	1%	3%
Hispanic...........	45	4%	44%	4%	40%	4%	2%
All Other..........	42	17%	36%	14%	26%	-	7%
Have Children......	507	5%	52%	8%	27%	2%	6%
Encourage/Artist	407	5%	52%	9%	28%	2%	4%
Don't Have Children	261	9%	44%	8%	35%	1%	4%
Willing To Pay More	306	3%	52%	7%	32%	2%	4%
Only Sometimes.....	289	9%	47%	9%	28%	2%	5%
Hardly Ever Pay Mre	163	8%	48%	7%	29%	1%	6%
Have Art In Home...	768	6%	49%	8%	30%	2%	5%
Don't Have Art.....	-	-	-	-	-	-	-
Choice - Choose Art	292	8%	45%	10%	33%	2%	3%
Would Choose Money.	418	6%	53%	7%	28%	2%	5%
Not Sure...........	58	3%	48%	5%	24%	3%	16%
Spend $25-100/Art..	321	5%	50%	9%	28%	2%	5%
Wld Spend Over $200	391	8%	49%	7%	31%	1%	4%
Museum >2 Times Yr.	163	9%	40%	7%	34%	2%	7%
1 or 2 Times A Yr..	250	6%	44%	10%	36%	1%	3%
Less Than Once A Yr	190	5%	54%	7%	25%	3%	5%
Don't Go To Museums	148	5%	61%	6%	20%	1%	7%
Favor Mre Fed Taxes	256	7%	45%	7%	34%	2%	5%
Wld Pay $25 More	172	5%	47%	3%	37%	2%	5%
Pay $5-$15 More.	46	15%	37%	15%	30%	-	2%
None Of Above...	26	8%	42%	15%	23%	-	12%
Oppose Mre Fed Taxs	420	6%	53%	9%	29%	2%	2%
Not Sure...........	92	4%	48%	7%	20%	3%	18%

Q38. (If Yes In Q30) When choosing art, do you select pieces that fit the
decor of your home; OR do you focus on whether or not you like the piece?

	TOTAL	Fit Decor Of My Home	Focus Whethr I Like Piece	Not Sure
All Voters.........	768	34%	60%	6%
Northeast..........	174	35%	59%	6%
South..............	259	30%	64%	6%
Central............	167	42%	52%	6%
West...............	168	30%	64%	6%
Male...............	367	32%	62%	5%
Female.............	401	35%	58%	6%
Under 30...........	200	34%	61%	6%
30 to 39...........	196	40%	54%	6%
40 to 49...........	154	29%	64%	7%
50 to 64...........	114	32%	63%	5%
65 And Over........	93	31%	63%	5%
High School/Less...	279	39%	52%	8%
Some College.......	220	33%	62%	5%
College Graduate...	265	28%	67%	5%
Post-Graduate....	95	25%	71%	4%
Liberal............	262	33%	63%	4%
Moderate/Other.....	151	34%	59%	7%
Conservative.......	355	34%	59%	7%
Under $30K.........	245	35%	62%	4%
Under $20K......	106	35%	60%	5%
$20K to $30K.......	139	35%	63%	3%
$30K to $40K.......	120	40%	53%	7%
$40K to $50K.......	95	38%	54%	8%
Over $50K..........	217	30%	63%	7%
Over $75K.......	87	29%	66%	6%
White..............	608	33%	61%	6%
Black..............	73	52%	44%	4%
Hispanic...........	45	16%	78%	7%
All Other..........	42	26%	64%	10%
Have Children......	507	34%	59%	7%
Encourage/Artist	407	32%	61%	7%
Don't Have Children	261	33%	62%	5%
Willing To Pay More	306	34%	61%	5%
Only Sometimes.....	289	35%	57%	8%
Hardly Ever Pay Mre	163	30%	64%	6%
Have Art In Home...	768	34%	60%	6%
Don't Have Art.....	-	-	-	-
Choice - Choose Art	292	29%	66%	5%
Would Choose Money.	418	37%	58%	5%
Not Sure...........	58	34%	48%	17%
Spend $25-100/Art..	321	36%	60%	4%
Wld Spend Over $200	391	34%	61%	6%
Museum >2 Times Yr.	163	27%	69%	4%
1 or 2 Times A Yr..	250	30%	63%	7%
Less Than Once A Yr	190	42%	51%	7%
Don't Go To Museums	148	36%	58%	5%
Favor Mre Fed Taxes	256	31%	65%	4%
Wld Pay $25 More	172	28%	69%	3%
Pay $5-$15 More.	46	41%	54%	4%
None Of Above...	26	27%	62%	12%
Oppose Mre Fed Taxes	420	36%	57%	7%
Not Sure...........	92	30%	61%	9%

Q39. (If Yes In Q30) Would you say you prefer older objects or
newer objects to collect or decorate you home?

	TOTAL	Older Objcts	Newer Objcts	Mixed	Not Sure
All Voters.........	768	49%	31%	19%	1%
Northeast..........	174	51%	26%	21%	2%
South..............	259	46%	36%	17%	1%
Central............	167	49%	32%	19%	-
West...............	168	49%	27%	21%	2%
Male...............	367	50%	28%	20%	2%
Female.............	401	47%	34%	18%	1%
Under 30...........	200	41%	43%	16%	1%
30 to 39...........	196	54%	32%	13%	1%
40 to 49...........	154	46%	31%	22%	1%
50 to 64...........	114	57%	23%	17%	4%
65 And Over........	93	47%	19%	32%	1%
High School/Less...	279	49%	31%	19%	1%
Some College.......	220	55%	30%	15%	-
College Graduate...	265	42%	33%	22%	3%
Post-Graduate....	95	44%	24%	26%	5%
Liberal............	262	48%	32%	19%	1%
Moderate/Other.....	151	48%	28%	22%	2%
Conservative.......	355	49%	32%	18%	1%
Under $30K.........	245	51%	30%	18%	1%
Under $20K......	106	43%	36%	20%	1%
$20K to $30K.......	139	58%	26%	16%	1%
$30K to $40K.......	120	50%	26%	23%	1%
$40K to $50K.......	95	53%	32%	16%	-
Over $50K..........	217	44%	37%	16%	2%
Over $75K.......	87	47%	37%	13%	3%
White..............	608	51%	30%	17%	2%
Black..............	73	36%	38%	26%	-
Hispanic...........	45	38%	36%	27%	-
All Other..........	42	52%	24%	24%	-
Have Children......	507	50%	27%	21%	1%
Encourage/Artist	407	51%	28%	21%	1%
Don't Have Children	261	46%	39%	14%	2%
Willing To Pay More	306	51%	32%	17%	1%
Only Sometimes.....	289	46%	35%	18%	2%
Hardly Ever Pay Mre	163	50%	24%	25%	1%
Have Art In Home...	768	49%	31%	19%	1%
Don't Have Art.....	-	-	-	-	-
Choice - Choose Art	292	52%	26%	20%	1%
Would Choose Money.	418	46%	42%	18%	*
Not Sure...........	58	50%	19%	24%	7%
Spend $25-100/Art..	321	48%	31%	21%	1%
Wld Spend Over $200	391	48%	33%	18%	1%
Museum >2 Times Yr.	163	47%	27%	24%	2%
1 or 2 Times A Yr..	250	50%	34%	16%	*
Less Than Once A Yr	190	50%	32%	16%	2%
Don't Go To Museums	148	48%	30%	22%	1%
Favor Mre Fed Taxes	256	48%	33%	17%	2%
Wld Pay $25 More	172	49%	30%	19%	2%
Pay $5-$15 More.	46	50%	43%	4%	2%
None Of Above...	26	38%	35%	23%	4%
Oppose Mre Fed Taxes	420	50%	32%	17%	*
Not Sure...........	92	42%	23%	33%	2%

Q40. Would you say that you prefer seeing paintings of
wild animals or domestic animals?

	TOTAL	Wild Anmls	Domstc Anmls	Both	Neithr	Not Sure
All Voters.........	1001	51%	27%	7%	14%	1%
Northeast..........	216	45%	29%	9%	16%	2%
South..............	335	49%	31%	6%	13%	1%
Central............	241	54%	25%	7%	13%	1%
West...............	209	56%	20%	8%	16%	*
Male...............	475	57%	22%	7%	13%	1%
Female.............	526	45%	31%	8%	15%	1%
Under 30...........	247	62%	22%	6%	10%	*
30 to 39...........	263	58%	22%	6%	13%	1%
40 to 49...........	191	54%	25%	5%	13%	2%
50 to 64...........	154	42%	28%	12%	18%	1%
65 And Over........	131	24%	44%	10%	21%	2%
High School/Less...	421	50%	31%	7%	11%	1%
Some College.......	281	51%	26%	9%	14%	1%
College Graduate...	293	52%	22%	5%	19%	2%
Post-Graduate....	103	49%	18%	5%	26%	2%
Liberal............	319	51%	26%	5%	18%	*
Moderate/Other.....	207	54%	21%	10%	15%	*
Conservative.......	475	49%	30%	7%	11%	2%
Under $30K.........	343	56%	29%	7%	8%	1%
Under $20K......	155	53%	28%	9%	10%	-
$20K to $30K.......	188	58%	29%	5%	7%	1%
$30K to $40K.......	155	48%	25%	7%	18%	2%
$40K to $50K.......	133	56%	23%	9%	10%	2%
Over $50K..........	244	48%	26%	7%	18%	1%
Over $75K.......	95	47%	22%	7%	23%	-
White..............	779	50%	28%	8%	12%	1%
Black..............	100	45%	29%	5%	21%	-
Hispanic...........	66	59%	18%	3%	20%	-
All Other..........	56	57%	18%	4%	18%	4%
Have Children......	666	49%	27%	8%	15%	1%
Encourage/Artist	523	51%	26%	8%	15%	1%
Don't Have Children	335	55%	27%	6%	11%	1%
Willing To Pay More	393	53%	26%	7%	12%	2%
Only Sometimes.....	382	50%	26%	8%	15%	1%
Hardly Ever Pay Mre	211	48%	29%	7%	14%	1%
Have Art In Home...	768	51%	26%	8%	15%	1%
Don't Have Art.....	233	49%	30%	6%	12%	2%
Choice - Choose Art	352	55%	22%	7%	16%	*
Would Choose Money.	574	50%	30%	6%	12%	2%
Not Sure...........	75	39%	27%	13%	20%	1%
Spend $25-100/Art..	472	51%	30%	8%	10%	1%
Wld Spend Over $200	451	53%	25%	5%	15%	1%
Museum >2 Times Yr.	188	54%	18%	7%	21%	1%
1 or 2 Times A Yr..	301	50%	28%	7%	14%	1%
Less Than Once A Yr	236	50%	28%	7%	13%	2%
Don't Go To Museums	240	50%	32%	7%	10%	2%
Favor Mre Fed Taxes	300	57%	23%	7%	13%	*
Wld Pay $25 More	197	57%	20%	8%	14%	1%
Pay $5-$15 More.	57	58%	25%	7%	11%	-
None Of Above...	33	61%	27%	6%	6%	-
Oppose Mre Fed Taxs	571	50%	29%	6%	14%	2%
Not Sure...........	130	42%	28%	11%	18%	1%

Q41. Would you say that you like it best when the painting shows them
in their natural setting, or when it looks like they are in a studio?

	TOTAL	Naturl Settng	Portrt	Both	Not Sure
All Voters.........	1001	89%	4%	2%	5%
Northeast..........	216	88%	4%	4%	4%
South..............	335	90%	5%	2%	3%
Central............	241	90%	2%	1%	7%
West...............	209	90%	3%	2%	5%
Male...............	475	90%	3%	2%	5%
Female.............	526	89%	4%	2%	4%
Under 30...........	247	90%	6%	2%	2%
30 to 39...........	263	90%	3%	3%	4%
40 to 49...........	191	91%	3%	2%	4%
50 to 64...........	154	90%	3%	1%	5%
65 And Over........	131	84%	5%	2%	10%
High School/Less...	421	89%	5%	2%	5%
Some College.......	281	91%	4%	2%	3%
College Graduate...	293	88%	2%	3%	6%
Post-Graduate....	103	83%	2%	4%	11%
Liberal............	319	89%	3%	2%	6%
Moderate/Other.....	207	87%	3%	4%	5%
Conservative.......	475	91%	4%	2%	3%
Under $30K.........	343	90%	4%	2%	3%
Under $20K......	155	94%	2%	1%	4%
$20K to $30K.......	188	88%	6%	3%	3%
$30K to $40K.......	155	87%	5%	1%	6%
$40K to $50K.......	133	93%	2%	4%	1%
Over $50K..........	244	91%	2%	2%	4%
Over $75K.......	95	91%	4%	1%	4%
White..............	779	91%	3%	2%	4%
Black..............	100	82%	11%	-	7%
Hispanic...........	66	82%	9%	6%	3%
All Other..........	56	95%	-	-	5%
Have Children......	666	90%	3%	2%	5%
Encourage/Artist	523	90%	3%	2%	4%
Don't Have Children	335	89%	4%	2%	4%
Willing To Pay More	393	91%	4%	2%	3%
Only Sometimes.....	382	90%	3%	3%	4%
Hardly Ever Pay Mre	211	86%	5%	1%	7%
Have Art In Home...	768	91%	3%	2%	5%
Don't Have Art.....	233	85%	7%	4%	5%
Choice - Choose Art	352	92%	4%	1%	3%
Would Choose Money.	574	89%	4%	3%	5%
Not Sure...........	75	85%	4%	1%	9%
Spend $25-100/Art..	472	89%	5%	2%	4%
Wld Spend Over $200	451	91%	3%	3%	3%
Museum >2 Times Yr.	188	80%	5%	6%	9%
1 or 2 Times A Yr..	301	94%	3%	2%	2%
Less Than Once A Yr	236	91%	3%	1%	5%
Don't Go To Museums	240	91%	4%	1%	4%
Favor Mre Fed Taxes	300	90%	4%	2%	4%
Wld Pay $25 More	197	88%	4%	3%	5%
Pay $5-$15 More.	57	96%	2%	-	2%
None Of Above...	33	88%	6%	3%	3%
Oppose Mre Fed Taxs	571	90%	4%	2%	4%
Not Sure...........	130	86%	3%	3%	8%

Q42. Would you rather see paintings of outdoor scenes or indoor scenes?

	TOTAL	Outdr Scenes	Indoor Scenes	Both	Neithr	Not Sure
All Voters.........	1001	88%	5%	5%	1%	1%
Northeast..........	216	84%	5%	9%	*	2%
South..............	335	90%	5%	4%	1%	*
Central............	241	90%	5%	4%	*	*
West...............	209	89%	4%	4%	1%	1%
Male...............	475	89%	5%	5%	1%	1%
Female.............	526	88%	5%	5%	1%	1%
Under 30...........	247	88%	7%	4%	*	*
30 to 39...........	263	89%	4%	6%	1%	-
40 to 49...........	191	87%	6%	5%	1%	2%
50 to 64...........	154	91%	1%	6%	-	1%
65 And Over........	131	89%	3%	5%	2%	2%
High School/Less...	421	91%	4%	4%	*	*
Some College.......	281	89%	4%	5%	1%	*
College Graduate...	293	83%	7%	7%	*	2%
Post-Graduate....	103	83%	5%	11%	-	2%
Liberal............	319	86%	6%	6%	1%	1%
Moderate/Other.....	207	85%	3%	8%	*	3%
Conservative.......	475	92%	4%	3%	1%	-
Under $30K.........	343	92%	4%	3%	*	1%
Under $20K......	155	94%	3%	2%	1%	1%
$20K to $30K.......	188	90%	5%	3%	-	1%
$30K to $40K.......	155	88%	6%	5%	1%	-
$40K to $50K.......	133	86%	5%	8%	-	1%
Over $50K..........	244	85%	5%	7%	2%	2%
Over $75K.......	95	82%	8%	4%	2%	3%
White..............	779	89%	5%	5%	1%	1%
Black..............	100	87%	6%	5%	1%	1%
Hispanic...........	66	80%	5%	11%	3%	2%
All Other..........	56	95%	4%	-	-	2%
Have Children......	666	89%	4%	5%	1%	1%
Encourage/Artist	523	90%	4%	5%	1%	1%
Don't Have Children	335	87%	7%	5%	1%	1%
Willing To Pay More	393	88%	5%	5%	1%	2%
Only Sometimes.....	382	88%	5%	6%	1%	1%
Hardly Ever Pay Mre	211	90%	4%	4%	1%	1%
Have Art In Home...	768	89%	5%	5%	1%	1%
Don't Have Art.....	233	88%	5%	5%	1%	1%
Choice - Choose Art	352	87%	5%	6%	1%	1%
Would Choose Money.	574	90%	5%	4%	1%	1%
Not Sure...........	75	84%	5%	7%	1%	3%
Spend $25-100/Art..	472	90%	4%	5%	*	*
Wld Spend Over $200	451	86%	6%	5%	1%	1%
Museum >2 Times Yr.	188	77%	7%	11%	1%	4%
1 or 2 Times A Yr..	301	91%	5%	3%	1%	1%
Less Than Once A Yr	236	94%	3%	3%	-	-
Don't Go To Museums	240	90%	5%	5%	*	-
Favor Mre Fed Taxes	300	86%	5%	7%	1%	1%
Wld Pay $25 More	197	85%	5%	8%	1%	2%
Pay $5-$15 More.	57	89%	9%	2%	-	-
None Of Above...	33	88%	-	9%	-	3%
Oppose Mre Fed Taxs	571	90%	5%	4%	1%	1%
Not Sure..........	130	88%	2%	7%	1%	2%

Q43. (If Outdoor Scenes Or Both In Q42) Which one, if any, of the following types of outdoor scenes appeals to you most?

	TOTAL	Forest	Lakes/ River/ Oceans	Fields /Rural Scenes	City	Houses /Bldng	None	All Equal/ Depnds	Not Sure
All Voters.........	937	19%	49%	18%	3%	5%	*	5%	1%
Northeast..........	200	19%	48%	21%	4%	3%	1%	5%	1%
South..............	315	18%	52%	18%	2%	5%	-	4%	1%
Central............	227	20%	44%	21%	4%	6%	-	5%	1%
West...............	195	21%	52%	12%	2%	5%	1%	8%	-
Male...............	446	21%	48%	17%	3%	5%	*	6%	*
Female.............	491	18%	51%	19%	3%	4%	*	4%	1%
Under 30...........	228	22%	49%	13%	5%	6%	*	4%	1%
30 to 39...........	249	19%	56%	13%	2%	4%	-	4%	1%
40 to 49...........	175	19%	44%	22%	3%	3%	1%	8%	-
50 to 64...........	150	11%	51%	27%	2%	5%	1%	3%	1%
65 And Over........	122	26%	39%	21%	-	5%	-	8%	-
High School/Less...	401	22%	48%	20%	2%	5%	-	2%	*
Some College.......	266	18%	46%	19%	4%	5%	-	8%	1%
College Graduate...	264	17%	54%	15%	3%	4%	1%	6%	1%
Post-Graduate....	96	17%	54%	11%	3%	3%	1%	8%	2%
Liberal............	292	17%	50%	17%	3%	6%	1%	5%	1%
Moderate/Other.....	193	18%	52%	15%	3%	5%	-	6%	1%
Conservative.......	452	21%	47%	21%	2%	4%	*	5%	*
Under $30K.........	324	22%	48%	20%	2%	4%	-	4%	1%
Under $20K......	148	20%	46%	21%	3%	5%	-	4%	1%
$20K to $30K.......	176	24%	49%	19%	1%	3%	-	3%	-
$30K to $40K.......	145	14%	53%	19%	6%	3%	-	5%	-
$40K to $50K.......	125	18%	46%	21%	2%	6%	1%	4%	3%
Over $50K..........	223	20%	49%	16%	3%	6%	1%	5%	-
Over $75K.......	82	16%	50%	15%	5%	6%	2%	6%	-
White..............	732	19%	49%	20%	2%	4%	*	5%	1%
Black..............	92	18%	49%	10%	12%	8%	-	3%	-
Hispanic...........	60	17%	55%	10%	3%	8%	-	5%	-
All Other..........	53	23%	43%	21%	2%	8%	-	4%	-
Have Children......	630	19%	49%	20%	2%	3%	*	6%	1%
Encourage/Artist	494	19%	49%	20%	2%	3%	*	5%	1%
Don't Have Children	307	21%	50%	15%	3%	7%	1%	4%	*
Willing To Pay More	364	21%	48%	18%	2%	7%	*	3%	1%
Only Sometimes.....	360	19%	51%	17%	3%	3%	1%	5%	1%
Hardly Ever Pay Mre	199	17%	48%	20%	4%	3%	-	8%	-
Have Art In Home...	720	19%	48%	19%	3%	4%	*	6%	1%
Don't Have Art.....	217	21%	53%	15%	2%	5%	-	3%	1%
Choice - Choose Art	329	21%	49%	15%	4%	4%	*	6%	1%
Would Choose Money.	540	18%	50%	20%	2%	6%	*	3%	1%
Not Sure..........	68	19%	41%	22%	-	1%	1%	15%	-
Spend $25-100/Art..	448	20%	50%	19%	3%	4%	-	4%	1%
Wld Spend Over $200	414	18%	50%	18%	3%	6%	*	4%	1%
Museum >2 Times Yr.	165	14%	55%	12%	5%	4%	2%	8%	1%
1 or 2 Times A Yr..	281	19%	49%	17%	2%	6%	-	5%	1%
Less Than Once A Yr	229	19%	48%	24%	2%	3%	-	3%	-
Don't Go To Museums	228	22%	48%	19%	1%	5%	-	4%	-
Favor Mre Fed Taxes	278	20%	47%	20%	1%	4%	1%	6%	1%
Wld Pay $25 More	182	18%	46%	20%	1%	4%	1%	8%	2%
Pay $5-$15 More.	52	29%	44%	17%	4%	4%	-	-	2%
None Of Above...	32	16%	53%	25%	3%	-	-	3%	-
Oppose Mre Fed Taxs	535	19%	52%	17%	4%	5%	-	3%	*
Not Sure..........	124	20%	40%	22%	2%	5%	1%	10%	-

Q44. (If Outdoor Scenes Or Both In Q42) Which season would you most like to see depicted in these paintings?

	TOTAL	Winter	Spring	Summer	Fall	All Equal/ Depnds	Not Sure
All Voters.........	937	15%	26%	16%	33%	9%	1%
Northeast..........	200	9%	28%	19%	34%	9%	2%
South..............	315	17%	28%	15%	29%	9%	1%
Central............	227	12%	21%	14%	44%	8%	*
West...............	195	22%	27%	15%	26%	10%	1%
Male...............	446	15%	23%	15%	37%	9%	1%
Female.............	491	15%	29%	16%	30%	10%	1%
Under 30...........	228	21%	25%	16%	31%	6%	1%
30 to 39...........	249	12%	23%	18%	38%	7%	2%
40 to 49...........	175	15%	29%	15%	31%	10%	1%
50 to 64...........	150	13%	31%	15%	27%	11%	2%
65 And Over........	122	11%	25%	11%	34%	18%	-
High School/Less...	401	19%	27%	15%	29%	8%	*
Some College.......	266	15%	26%	14%	35%	9%	1%
College Graduate...	264	9%	25%	17%	36%	11%	2%
Post-Graduate....	96	4%	22%	16%	41%	14%	4%
Liberal............	292	12%	23%	20%	36%	8%	2%
Moderate/Other.....	193	17%	27%	17%	28%	10%	1%
Conservative.......	452	16%	28%	13%	33%	10%	1%
Under $30K.........	324	19%	29%	15%	29%	6%	1%
Under $20K......	148	19%	32%	14%	26%	7%	1%
$20K to $30K.......	176	19%	26%	16%	32%	6%	1%
$30K to $40K.......	145	17%	26%	17%	31%	10%	1%
$40K to $50K.......	125	11%	20%	21%	36%	10%	2%
Over $50K..........	223	13%	26%	13%	35%	10%	2%
Over $75K.......	82	16%	33%	12%	26%	12%	1%
White..............	732	15%	25%	14%	35%	10%	1%
Black..............	92	17%	35%	20%	24%	4%	-
Hispanic...........	60	15%	23%	23%	27%	7%	5%
All Other..........	53	17%	30%	19%	28%	6%	-
Have Children......	630	16%	26%	15%	32%	11%	1%
Encourage/Artist	494	15%	26%	15%	31%	11%	1%
Don't Have Children	307	14%	26%	18%	36%	6%	1%
Willing To Pay More	364	16%	25%	16%	34%	9%	*
Only Sometimes.....	360	15%	29%	15%	32%	8%	2%
Hardly Ever Pay Mre	199	14%	23%	17%	35%	11%	1%
Have Art In Home...	720	15%	25%	15%	33%	10%	1%
Don't Have Art.....	217	16%	28%	18%	32%	5%	1%
Choice - Choose Art	329	16%	26%	17%	29%	11%	1%
Would Choose Money.	540	15%	26%	15%	36%	7%	1%
Not Sure...........	68	12%	26%	13%	29%	18%	1%
Spend $25-100/Art..	448	15%	27%	16%	33%	8%	1%
Wld Spend Over $200	414	16%	26%	15%	33%	9%	1%
Museum >2 Times Yr.	165	15%	28%	18%	21%	15%	3%
1 or 2 Times A Yr..	281	14%	27%	15%	36%	8%	1%
Less Than Once A Yr	229	14%	23%	14%	38%	10%	1%
Don't Go To Museums	228	19%	25%	15%	34%	7%	-
Favor Mre Fed Taxes	278	13%	32%	15%	28%	10%	2%
Wld Pay $25 More	182	12%	31%	16%	28%	10%	3%
Pay $5-15 More.	52	19%	35%	13%	29%	4%	-
None Of Above...	32	13%	34%	16%	25%	13%	-
Oppose Mre Fed Taxs	535	17%	24%	16%	37%	6%	1%
Not Sure...........	124	13%	23%	16%	25%	22%	2%

Q45. (If Indoor Scenes Or Both In Q42) Which, if any, of the following types of indoor scenes appeals to you most?

	TOTAL	Still Life/ Fruit	Still Life/ Flower	Still Life/ Object	Domstc Scene/ People	Domstc Scene/ Animls	None	All Equal/ Depnds	Not Sure
All Voters.........	99	7%	21%	6%	37%	10%	5%	6%	7%
Northeast..........	29	10%	28%	10%	34%	7%	-	7%	3%
South..............	30	7%	20%	3%	33%	20%	7%	7%	3%
Central............	22	9%	18%	5%	50%	5%	9%	-	5%
West...............	18	-	17%	6%	33%	6%	6%	11%	22%
Male...............	47	4%	17%	6%	38%	13%	4%	9%	9%
Female.............	52	10%	25%	6%	37%	8%	6%	4%	6%
Under 30...........	27	7%	11%	4%	41%	19%	7%	-	11%
30 to 39...........	27	11%	22%	11%	30%	11%	4%	4%	7%
40 to 49...........	20	-	20%	10%	50%	5%	-	10%	5%
50 to 64...........	12	8%	42%	-	33%	-	-	17%	-
65 And Over........	10	10%	30%	-	30%	10%	10%	10%	-
High School/Less...	33	9%	36%	6%	15%	18%	3%	-	12%
Some College.......	25	4%	16%	-	40%	16%	8%	8%	8%
College Graduate...	41	7%	12%	10%	54%	-	5%	10%	2%
Post-Graduate....	16	-	13%	-	63%	-	-	6%	19%
Liberal............	39	5%	23%	5%	46%	8%	-	8%	5%
Moderate/Other.....	24	-	33%	-	29%	13%	8%	4%	13%
Conservative.......	36	14%	11%	11%	33%	11%	8%	6%	6%
Under $30K.........	24	8%	38%	4%	25%	13%	4%	-	8%
Under $20K......	8	13%	50%	-	13%	-	13%	-	13%
$20K to $30K.......	16	6%	31%	6%	31%	19%	-	-	6%
$30K to $40K.......	17	12%	29%	6%	41%	-	6%	6%	-
$40K to $50K.......	18	-	11%	-	56%	17%	-	6%	11%
Over $50K..........	28	7%	11%	7%	39%	11%	7%	11%	7%
Over $75K.......	12	-	-	-	50%	17%	8%	17%	8%
White..............	76	5%	21%	5%	38%	9%	5%	8%	8%
Black..............	11	9%	27%	18%	27%	9%	9%	-	-
Hispanic...........	10	20%	10%	-	40%	20%	-	-	10%
All Other..........	2	-	50%	-	50%	-	-	-	-
Have Children......	60	8%	25%	7%	37%	5%	2%	8%	8%
Encourage/Artist	44	9%	27%	7%	34%	7%	2%	7%	7%
Don't Have Children	39	5%	15%	5%	38%	18%	10%	3%	5%
Willing To Pay More	40	5%	18%	10%	30%	13%	8%	5%	13%
Only Sometimes.....	40	8%	23%	5%	48%	5%	5%	5%	3%
Hardly Ever Pay Mre	17	12%	24%	-	29%	18%	-	12%	6%
Have Art In Home...	75	4%	21%	8%	39%	12%	5%	7%	4%
Don't Have Art.....	24	17%	21%	-	33%	4%	4%	4%	17%
Choice - Choose Art	38	5%	24%	5%	42%	5%	5%	3%	11%
Would Choose Money.	52	10%	17%	8%	35%	15%	4%	8%	4%
Not Sure...........	9	-	33%	-	33%	-	11%	11%	11%
Spend $25-100/Art..	44	9%	30%	5%	30%	14%	2%	7%	5%
Wld Spend Over $200	49	4%	14%	8%	41%	8%	8%	6%	10%
Museum >2 Times Yr.	35	3%	23%	6%	51%	-	3%	11%	3%
1 or 2 Times A Yr..	22	9%	5%	5%	32%	23%	9%	9%	9%
Less Than Once A Yr	15	7%	20%	13%	33%	7%	13%	-	7%
Don't Go To Museums	22	14%	32%	5%	23%	18%	-	-	9%
Favor Mre Fed Taxes	36	6%	17%	11%	36%	6%	6%	8%	11%
Wld Pay $25 More	25	4%	20%	12%	44%	-	-	12%	8%
Pay $5-15 More.	6	-	17%	17%	17%	17%	17%	-	17%
None Of Above...	3	-	-	-	33%	33%	-	-	33%
Oppose Mre Fed Taxs	51	4%	22%	4%	41%	14%	6%	4%	6%
Not Sure...........	12	25%	33%	-	25%	8%	-	8%	-

Q46. Do you tend to prefer paintings that are related to religion or those that are not related to religion?

	TOTAL	Are Relatd To Relign	Aren't Relatd To Relign	Both/ Depnds	Not Sure
All Voters.........	1001	20%	63%	15%	2%
Northeast..........	216	19%	67%	13%	2%
South..............	335	24%	58%	16%	3%
Central............	241	19%	63%	17%	1%
West...............	209	17%	66%	16%	1%
Male...............	475	20%	62%	17%	1%
Female.............	526	20%	63%	14%	2%
Under 30...........	247	19%	66%	14%	*
30 to 39...........	263	20%	65%	14%	*
40 to 49...........	191	15%	69%	14%	2%
50 to 64...........	154	24%	54%	18%	4%
65 And Over........	131	25%	52%	18%	5%
High School/Less...	421	29%	53%	15%	3%
Some College.......	281	14%	67%	19%	1%
College Graduate...	293	14%	73%	12%	1%
Post-Graduate....	103	13%	70%	17%	-
Liberal............	319	15%	71%	12%	2%
Moderate/Other.....	207	21%	59%	19%	1%
Conservative.......	475	23%	59%	16%	2%
Under $30K.........	343	27%	56%	15%	1%
Under $20K......	155	32%	50%	17%	1%
$20K to $30K.......	188	24%	61%	13%	2%
$30K to $40K.......	155	18%	62%	17%	3%
$40K to $50K.......	133	16%	71%	10%	3%
Over $50K..........	244	12%	71%	16%	1%
Over $75K.......	95	7%	79%	13%	1%
White..............	779	17%	66%	16%	2%
Black..............	100	33%	43%	21%	3%
Hispanic...........	66	24%	64%	11%	2%
All Other..........	56	34%	55%	9%	2%
Have Children......	666	22%	60%	17%	2%
Encourage/Artist	523	21%	59%	18%	2%
Don't Have Children	335	17%	68%	13%	1%
Willing To Pay More	393	18%	67%	14%	*
Only Sometimes.....	382	19%	63%	17%	2%
Hardly Ever Pay Mre	211	26%	55%	15%	4%
Have Art In Home...	768	18%	63%	17%	2%
Don't Have Art.....	233	26%	60%	12%	3%
Choice - Choose Art	352	17%	64%	17%	1%
Would Choose Money.	574	21%	63%	13%	2%
Not Sure..........	75	23%	48%	27%	3%
Spend $25-100/Art..	472	26%	58%	14%	2%
Wld Spend Over $200	451	15%	70%	14%	1%
Museum >2 Times Yr.	188	14%	72%	13%	2%
1 or 2 Times A Yr..	301	19%	65%	15%	1%
Less Than Once A Yr	236	16%	62%	21%	1%
Don't Go To Museums	240	30%	55%	12%	3%
Favor Mre Fed Taxes	300	19%	66%	14%	1%
Wld Pay $25 More	197	17%	69%	15%	-
Pay $5-$15 More.	57	19%	68%	12%	-
None Of Above...	33	30%	58%	9%	3%
Oppose Mre Fed Taxs	571	20%	62%	16%	2%
Not Sure..........	130	24%	55%	18%	2%

Q47. Which is closer to your view: Paintings should ideally serve some higher goal; OR paintings don't necessarily have to teach us any lessons?

	TOTAL	Should Serve Higher Goal	Don't Hve To Teach Lessns	Both/ Depnds	Not Sure
All Voters.........	1001	19%	75%	4%	1%
Northeast..........	216	18%	77%	4%	1%
South..............	335	21%	72%	6%	2%
Central............	241	16%	78%	4%	2%
West...............	209	23%	74%	2%	*
Male...............	475	20%	77%	3%	1%
Female.............	526	19%	74%	6%	2%
Under 30...........	247	27%	67%	5%	1%
30 to 39...........	263	21%	75%	4%	*
40 to 49...........	191	16%	80%	4%	-
50 to 64...........	154	14%	81%	4%	1%
65 And Over........	131	12%	79%	3%	6%
High School/Less...	421	19%	75%	3%	2%
Some College.......	281	19%	73%	7%	1%
College Graduate...	293	20%	76%	4%	*
Post-Graduate....	103	23%	72%	5%	-
Liberal............	319	24%	73%	3%	*
Moderate/Other.....	207	16%	74%	7%	3%
Conservative.......	475	18%	77%	4%	1%
Under $30K.........	343	21%	73%	4%	1%
Under $20K......	155	19%	76%	3%	2%
$20K to $30K.......	188	23%	71%	4%	1%
$30K to $40K.......	155	16%	77%	6%	-
$40K to $50K.......	133	20%	77%	2%	1%
Over $50K..........	244	20%	75%	5%	*
Over $75K.......	95	16%	75%	8%	1%
White..............	779	17%	78%	5%	1%
Black..............	100	31%	63%	2%	4%
Hispanic...........	66	30%	65%	3%	2%
All Other..........	56	25%	71%	4%	-
Have Children......	666	17%	77%	4%	2%
Encourage/Artist	523	18%	76%	5%	1%
Don't Have Children	335	24%	71%	4%	1%
Willing To Pay More	393	19%	76%	4%	1%
Only Sometimes.....	382	23%	73%	3%	1%
Hardly Ever Pay Mre	211	14%	78%	6%	2%
Have Art In Home...	768	20%	74%	5%	1%
Don't Have Art.....	233	17%	78%	3%	3%
Choice - Choose Art	352	24%	69%	6%	1%
Would Choose Money.	574	17%	78%	3%	1%
Not Sure..........	75	13%	79%	5%	3%
Spend $25-100/Art..	472	19%	77%	3%	1%
Wld Spend Over $200	451	20%	73%	5%	1%
Museum >2 Times Yr.	188	30%	62%	7%	1%
1 or 2 Times A Yr..	301	22%	73%	4%	1%
Less Than Once A Yr	236	14%	82%	3%	*
Don't Go To Museums	240	15%	80%	3%	2%
Favor Mre Fed Taxes	300	20%	73%	6%	1%
Wld Pay $25 More	197	19%	74%	7%	-
Pay $5-$15 More.	57	25%	70%	4%	2%
None Of Above...	33	21%	67%	9%	3%
Oppose Mre Fed Taxs	571	19%	77%	4%	1%
Not Sure..........	130	21%	74%	2%	4%

Q48. Which is closer to your view: I prefer paintings that are realistic-looking; OR I prefer paintings that are different-looking.

	TOTAL	Realst Lookng	Dffrnt Lookng	Both/ Depnds	Not Sure
All Voters.........	1001	60%	30%	6%	3%
Northeast..........	216	57%	32%	7%	4%
South..............	335	61%	29%	6%	4%
Central............	241	63%	28%	5%	5%
West...............	209	58%	32%	8%	2%
Male...............	475	58%	32%	7%	3%
Female.............	526	62%	29%	6%	4%
Under 30...........	247	52%	41%	5%	2%
30 to 39...........	263	62%	29%	6%	3%
40 to 49...........	191	60%	31%	6%	3%
50 to 64...........	154	68%	22%	7%	3%
65 And Over.......	131	63%	18%	9%	10%
High School/Less...	421	63%	28%	6%	4%
Some College.......	281	63%	28%	5%	3%
College Graduate...	293	53%	36%	8%	4%
Post-Graduate....	103	62%	26%	10%	2%
Liberal............	319	56%	34%	7%	3%
Moderate/Other.....	207	55%	29%	11%	5%
Conservative.......	475	65%	28%	4%	3%
Under $30K.........	343	61%	29%	6%	4%
Under $20K......	155	63%	27%	6%	5%
$20K to $30K.......	188	60%	31%	6%	3%
$30K to $40K.......	155	57%	36%	4%	3%
$40K to $50K.......	133	56%	28%	11%	5%
Over $50K..........	244	62%	31%	5%	2%
Over $75K.......	95	57%	33%	5%	5%
White..............	779	59%	30%	7%	4%
Black..............	100	68%	24%	3%	5%
Hispanic...........	66	48%	47%	5%	-
All Other..........	56	70%	25%	4%	2%
Have Children......	666	63%	28%	6%	3%
Encourage/Artist	523	63%	29%	6%	2%
Don't Have Children	335	55%	34%	6%	4%
Willing To Pay More	393	61%	30%	6%	3%
Only Sometimes.....	382	60%	31%	5%	3%
Hardly Ever Pay Mre	211	59%	30%	8%	3%
Have Art In Home...	768	58%	32%	7%	3%
Don't Have Art.....	233	66%	25%	5%	4%
Choice - Choose Art	352	58%	34%	6%	2%
Would Choose Money.	574	62%	28%	6%	4%
Not Sure..........	75	55%	28%	11%	7%
Spend $25-100/Art..	472	67%	25%	6%	3%
Wld Spend Over $200	451	54%	37%	6%	3%
Museum >2 Times Yr.	188	43%	43%	12%	3%
1 or 2 Times A Yr..	301	64%	29%	4%	3%
Less Than Once A Yr	236	60%	31%	6%	3%
Don't Go To Museums	240	69%	23%	4%	5%
Favor Mre Fed Taxes	300	55%	35%	7%	3%
Wld Pay $25 More	197	49%	42%	7%	3%
Pay $5-$15 More.	57	63%	26%	9%	2%
None Of Above...	33	70%	24%	6%	-
Oppose Mre Fed Taxes	571	64%	27%	5%	3%
Not Sure..........	130	53%	30%	10%	7%

Q49.(If Different-Looking In Q48) Do you prefer paintings that exaggerate the dimensions/reality of objects we know or that feature imaginary objects?

	TOTAL	Exgrtn Of Objcts We Knw	Imgnry Objcts	Depnds	Not Sure
All Voters.........	301	50%	36%	6%	8%
Northeast..........	70	49%	37%	6%	9%
South..............	98	49%	39%	5%	7%
Central............	67	52%	37%	3%	7%
West...............	66	53%	29%	11%	8%
Male...............	151	51%	34%	7%	8%
Female.............	150	50%	38%	5%	7%
Under 30...........	101	49%	42%	8%	2%
30 to 39...........	77	49%	38%	5%	8%
40 to 49...........	60	58%	30%	2%	10%
50 to 64...........	34	62%	21%	6%	12%
65 And Over.......	24	29%	38%	13%	21%
High School/Less...	116	46%	41%	4%	9%
Some College.......	80	50%	35%	6%	9%
College Graduate...	105	56%	30%	8%	6%
Post-Graduate....	27	59%	33%	7%	-
Liberal............	109	47%	40%	6%	6%
Moderate/Other.....	60	45%	38%	7%	10%
Conservative.......	132	56%	31%	5%	8%
Under $30K.........	101	36%	50%	9%	6%
Under $20K......	42	40%	40%	12%	7%
$20K to $30K.......	59	32%	56%	7%	5%
$30K to $40K.......	56	59%	29%	9%	4%
$40K to $50K.......	37	51%	35%	3%	11%
Over $50K..........	75	60%	27%	4%	9%
Over $75K.......	31	65%	23%	10%	3%
White..............	232	51%	33%	6%	10%
Black..............	24	42%	54%	4%	-
Hispanic...........	31	52%	39%	10%	-
All Other..........	14	50%	43%	7%	-
Have Children......	186	54%	32%	5%	9%
Encourage/Artist	153	56%	31%	6%	7%
Don't Have Children	115	45%	42%	7%	6%
Willing To Pay More	116	55%	36%	3%	5%
Only Sometimes.....	118	48%	36%	7%	8%
Hardly Ever Pay Mre	63	46%	33%	10%	11%
Have Art In Home...	242	53%	33%	7%	7%
Don't Have Art.....	59	39%	49%	2%	10%
Choice - Choose Art	120	55%	34%	6%	5%
Would Choose Money.	160	47%	39%	4%	10%
Not Sure..........	21	52%	19%	24%	5%
Spend $25-100/Art..	117	44%	38%	7%	12%
Wld Spend Over $200	167	54%	36%	5%	5%
Museum >2 Times Yr.	81	56%	33%	4%	7%
1 or 2 Times A Yr..	86	56%	33%	7%	5%
Less Than Once A Yr	74	45%	39%	9%	7%
Don't Go To Museums	54	43%	39%	4%	15%
Favor Mre Fed Taxes	106	53%	36%	7%	5%
Wld Pay $25 More	82	51%	38%	9%	2%
Pay $5-$15 More.	15	67%	20%	-	13%
None Of Above...	8	50%	50%	-	-
Oppose Mre Fed Taxes	156	49%	37%	5%	10%
Not Sure..........	39	51%	33%	8%	8%

Q50. (If Different-Looking In Q48) Do you prefer seeing bold, stark designs or more playful, whimsical designs?

	TOTAL	Bold, Stark Desgns	Plyfl/ Whmscl Desgns	Depnds	Not Sure
All Voters.........	301	39%	49%	7%	5%
Northeast..........	70	39%	50%	6%	6%
South.............	98	38%	47%	10%	5%
Central...........	67	42%	48%	6%	4%
West..............	66	38%	52%	6%	5%
Male..............	151	44%	40%	11%	5%
Female............	150	33%	57%	4%	5%
Under 30..........	101	40%	51%	5%	4%
30 to 39..........	77	52%	35%	9%	4%
40 to 49..........	60	37%	48%	8%	7%
50 to 64..........	34	26%	59%	9%	6%
65 And Over.......	24	17%	67%	8%	8%
High School/Less...	116	38%	51%	3%	9%
Some College.......	80	41%	44%	11%	4%
College Graduate...	105	38%	50%	10%	2%
Post-Graduate....	27	41%	44%	15%	-
Liberal...........	109	48%	42%	7%	3%
Moderate/Other.....	60	33%	48%	8%	10%
Conservative.......	132	34%	55%	7%	5%
Under $30K.........	101	38%	52%	6%	4%
Under $20K......	42	31%	62%	2%	5%
$20K to $30K.......	59	42%	46%	8%	3%
$30K to $40K.......	56	41%	45%	5%	9%
$40K to $50K.......	37	46%	43%	5%	5%
Over $50K..........	75	39%	45%	12%	4%
Over $75K.......	31	39%	45%	13%	3%
White.............	232	38%	50%	7%	5%
Black.............	24	29%	54%	13%	4%
Hispanic..........	31	55%	32%	6%	6%
All Other..........	14	36%	64%	-	-
Have Children......	186	32%	54%	8%	6%
Encourage/Artist	153	31%	56%	7%	6%
Don't Have Children	115	50%	41%	6%	3%
Willing To Pay More	116	41%	46%	10%	3%
Only Sometimes.....	118	37%	53%	4%	5%
Hardly Ever Pay Mre	63	40%	46%	6%	8%
Have Art In Home...	242	37%	50%	9%	4%
Don't Have Art.....	59	46%	44%	-	10%
Choice - Choose Art	120	38%	49%	10%	3%
Would Choose Money.	160	41%	49%	5%	6%
Not Sure..........	21	29%	48%	10%	14%
Spend $25-100/Art..	117	37%	51%	4%	8%
Wld Spend Over $200	167	40%	47%	10%	2%
Museum >2 Times Yr.	81	49%	36%	10%	5%
1 or 2 Times A Yr..	86	33%	57%	7%	3%
Less Than Once A Yr	74	36%	54%	9%	-
Don't Go To Museums	54	41%	44%	2%	13%
Favor Mre Fed Taxes	106	39%	53%	8%	1%
Wld Pay $25 More	82	41%	50%	9%	-
Pay $5-$15 More.	15	40%	53%	-	7%
None Of Above...	8	13%	75%	13%	-
Oppose Mre Fed Taxs	156	39%	47%	6%	8%
Not Sure..........	39	38%	46%	10%	5%

Q51. (If Different-Looking In Q48) Do you tend to favor paintings with sharp angles or ones with soft curves?

	TOTAL	Sharp Angles	Soft Curves	Depnds	Not Sure
All Voters.........	301	22%	66%	9%	3%
Northeast..........	70	16%	74%	9%	1%
South.............	98	30%	57%	10%	3%
Central...........	67	21%	69%	6%	4%
West..............	66	17%	70%	11%	3%
Male..............	151	26%	58%	13%	3%
Female............	150	17%	75%	5%	3%
Under 30..........	101	34%	55%	8%	3%
30 to 39..........	77	19%	66%	9%	5%
40 to 49..........	60	17%	73%	8%	2%
50 to 64..........	34	6%	79%	12%	3%
65 And Over.......	24	13%	79%	8%	-
High School/Less...	116	17%	72%	5%	5%
Some College.......	80	23%	60%	14%	4%
College Graduate...	105	26%	65%	10%	-
Post-Graduate....	27	22%	59%	19%	-
Liberal...........	109	29%	61%	7%	2%
Moderate/Other.....	60	12%	65%	15%	8%
Conservative.......	132	20%	71%	8%	2%
Under $30K.........	101	28%	63%	6%	3%
Under $20K......	42	33%	60%	5%	2%
$20K to $30K.......	59	24%	66%	7%	3%
$30K to $40K.......	56	14%	68%	13%	5%
$40K to $50K.......	37	22%	65%	11%	3%
Over $50K..........	75	20%	69%	9%	1%
Over $75K.......	31	16%	74%	10%	-
White.............	232	18%	69%	9%	3%
Black.............	24	46%	33%	17%	4%
Hispanic..........	31	29%	68%	3%	-
All Other..........	14	21%	79%	-	-
Have Children......	186	17%	73%	8%	3%
Encourage/Artist	153	16%	73%	8%	3%
Don't Have Children	115	30%	57%	10%	3%
Willing To Pay More	116	29%	61%	8%	2%
Only Sometimes.....	118	19%	69%	8%	4%
Hardly Ever Pay Mre	63	11%	76%	10%	3%
Have Art In Home...	242	22%	66%	10%	2%
Don't Have Art.....	59	20%	68%	7%	5%
Choice - Choose Art	120	23%	65%	10%	2%
Would Choose Money.	160	21%	68%	8%	4%
Not Sure..........	21	19%	62%	14%	5%
Spend $25-100/Art..	117	16%	71%	6%	7%
Wld Spend Over $200	167	26%	63%	11%	-
Museum >2 Times Yr.	81	30%	56%	11%	4%
1 or 2 Times A Yr..	86	22%	69%	8%	1%
Less Than Once A Yr	74	19%	73%	8%	-
Don't Go To Museums	54	15%	72%	6%	7%
Favor Mre Fed Taxes	106	25%	66%	7%	2%
Wld Pay $25 More	82	26%	66%	7%	1%
Pay $5-$15 More.	15	27%	67%	-	7%
None Of Above...	8	25%	63%	13%	-
Oppose Mre Fed Taxs	156	19%	68%	10%	4%
Not Sure..........	39	23%	62%	13%	3%

Q52. (If Different-Looking In Q48) Which patterns do you like better: geometric patterns or more random, uneven patterns?

	TOTAL	Geome-tric Pattrn	More Random Pattrn	Depnds	Not Sure
All Voters.........	301	30%	62%	5%	4%
Northeast..........	70	24%	71%	3%	1%
South..............	98	32%	57%	8%	3%
Central............	67	31%	55%	4%	9%
West...............	66	30%	65%	3%	2%
Male...............	151	32%	59%	5%	4%
Female.............	150	27%	65%	5%	3%
Under 30...........	101	37%	58%	2%	3%
30 to 39...........	77	27%	65%	5%	3%
40 to 49...........	60	25%	67%	3%	5%
50 to 64...........	34	26%	56%	9%	9%
65 And Over........	24	25%	67%	8%	-
High School/Less...	116	33%	57%	3%	8%
Some College.......	80	28%	66%	4%	3%
College Graduate...	105	28%	64%	9%	-
Post-Graduate....	27	19%	70%	11%	-
Liberal............	109	28%	67%	5%	-
Moderate/Other.....	60	18%	60%	8%	13%
Conservative.......	132	36%	58%	4%	2%
Under $30K.........	101	40%	52%	4%	4%
Under $20K......	42	40%	52%	2%	5%
$20K to $30K.......	59	39%	53%	5%	3%
$30K to $40K.......	56	21%	68%	5%	5%
$40K to $50K.......	37	27%	59%	14%	-
Over $50K..........	75	27%	71%	1%	1%
Over $75K.......	31	16%	81%	3%	-
White..............	232	28%	63%	5%	4%
Black..............	24	46%	42%	4%	8%
Hispanic...........	31	29%	65%	6%	-
All Other..........	14	29%	71%	-	-
Have Children......	186	29%	61%	6%	4%
Encourage/Artist	153	30%	61%	7%	2%
Don't Have Children	115	30%	63%	3%	3%
Willing To Pay More	116	35%	59%	3%	3%
Only Sometimes.....	118	28%	61%	7%	4%
Hardly Ever Pay Mre	63	22%	67%	6%	5%
Have Art In Home...	242	29%	63%	5%	3%
Don't Have Art.....	59	31%	58%	5%	7%
Choice - Choose Art	120	32%	60%	6%	3%
Would Choose Money.	160	29%	63%	4%	4%
Not Sure...........	21	24%	62%	10%	5%
Spend $25-100/Art..	117	32%	57%	5%	6%
Wld Spend Over $200	167	30%	65%	5%	1%
Museum >2 Times Yr.	81	28%	59%	10%	2%
1 or 2 Times A Yr..	86	34%	62%	3%	1%
Less Than Once A Yr	74	28%	66%	4%	1%
Don't Go To Museums	54	24%	65%	-	11%
Favor Mre Fed Taxes	106	27%	65%	7%	1%
Wld Pay $25 More	82	26%	68%	6%	-
Pay $5-$15 More.	15	27%	67%	-	7%
None Of Above...	8	50%	25%	25%	-
Oppose Mre Fed Taxs	156	31%	62%	3%	4%
Not Sure...........	39	31%	54%	8%	8%

Q53. Do you like to see expressive brush-strokes on the canvas or do you prefer that the surface of the canvas be smooth, more like a photograph?

	TOTAL	Prefer Seeing Canvas Brush-Stroke	Prefer Canvas Looks Smooth	Depnds	Not Sure
All Voters.........	1001	53%	35%	10%	2%
Northeast..........	216	50%	34%	12%	3%
South..............	335	53%	37%	8%	2%
Central............	241	54%	34%	10%	2%
West...............	209	56%	33%	11%	*
Male...............	475	49%	37%	12%	2%
Female.............	526	57%	32%	9%	2%
Under 30...........	247	55%	38%	6%	1%
30 to 39...........	263	49%	37%	13%	1%
40 to 49...........	191	54%	33%	10%	3%
50 to 64...........	154	54%	32%	11%	3%
65 And Over........	131	60%	24%	11%	5%
High School/Less...	421	51%	39%	7%	2%
Some College.......	281	54%	34%	11%	1%
College Graduate...	293	56%	28%	13%	3%
Post-Graduate....	103	53%	26%	17%	4%
Liberal............	319	55%	33%	9%	2%
Moderate/Other.....	207	48%	34%	14%	3%
Conservative.......	475	54%	36%	9%	1%
Under $30K.........	343	54%	36%	8%	2%
Under $20K......	155	51%	41%	6%	1%
$20K to $30K.......	188	56%	32%	10%	2%
$30K to $40K.......	155	54%	35%	8%	2%
$40K to $50K.......	133	59%	29%	11%	2%
Over $50K..........	244	55%	32%	10%	2%
Over $75K.......	95	54%	31%	14%	2%
White..............	779	54%	34%	11%	2%
Black..............	100	50%	41%	7%	2%
Hispanic...........	66	53%	36%	9%	2%
All Other..........	56	54%	36%	9%	2%
Have Children......	666	54%	34%	10%	2%
Encourage/Artist	523	55%	33%	10%	2%
Don't Have Children	335	53%	35%	10%	2%
Willing To Pay More	393	53%	37%	9%	1%
Only Sometimes.....	382	54%	35%	10%	2%
Hardly Ever Pay Mre	211	55%	31%	11%	4%
Have Art In Home...	768	57%	30%	10%	2%
Don't Have Art.....	233	41%	48%	9%	2%
Choice - Choose Art	352	56%	31%	11%	2%
Would Choose Money.	574	52%	37%	9%	2%
Not Sure...........	75	51%	33%	13%	3%
Spend $25-100/Art..	472	48%	40%	9%	3%
Wld Spend Over $200	451	60%	29%	10%	1%
Museum >2 Times Yr.	188	59%	26%	13%	3%
1 or 2 Times A Yr..	301	58%	31%	10%	1%
Less Than Once A Yr	236	52%	40%	6%	1%
Don't Go To Museums	240	46%	42%	10%	3%
Favor Mre Fed Taxes	300	54%	35%	10%	1%
Wld Pay $25 More	197	57%	31%	10%	2%
Pay $5-$15 More.	57	53%	37%	11%	-
None Of Above...	33	45%	44%	9%	-
Oppose Mre Fed Taxs	571	52%	36%	9%	2%
Not Sure...........	130	55%	26%	15%	4%

Q54. Do you prefer paintings with thick, textured surfaces
 or with smooth, flat surfaces?

	TOTAL	Thick, Txturd Surfce	Smooth /Flat Surfce	Depnds	Not Sure
All Voters.........	1001	40%	42%	15%	3%
Northeast..........	216	37%	43%	17%	3%
South..............	335	40%	43%	15%	2%
Central............	241	43%	39%	15%	2%
West...............	209	41%	42%	14%	3%
Male...............	475	39%	43%	16%	2%
Female.............	526	41%	40%	15%	3%
Under 30...........	247	40%	49%	11%	1%
30 to 39...........	263	43%	43%	14%	1%
40 to 49...........	191	38%	43%	17%	2%
50 to 64...........	154	42%	37%	18%	3%
65 And Over........	131	38%	31%	21%	9%
High School/Less...	421	40%	46%	10%	3%
Some College.......	281	37%	44%	17%	2%
College Graduate...	293	44%	33%	19%	3%
Post-Graduate....	103	40%	27%	30%	3%
Liberal............	319	44%	37%	16%	3%
Moderate/Other.....	207	31%	43%	21%	4%
Conservative.......	475	42%	44%	12%	1%
Under $30K.........	343	42%	43%	13%	3%
Under $20K......	155	37%	46%	14%	3%
$20K to $30K.......	188	46%	40%	12%	2%
$30K to $40K.......	155	41%	45%	13%	2%
$40K to $50K.......	133	46%	34%	17%	3%
Over $50K..........	244	39%	44%	14%	2%
Over $75K.......	95	40%	42%	15%	3%
White..............	779	41%	39%	17%	3%
Black..............	100	40%	53%	5%	2%
Hispanic...........	66	35%	55%	8%	3%
All Other..........	56	38%	43%	20%	-
Have Children......	666	39%	42%	15%	3%
Encourage/Artist	523	41%	40%	17%	2%
Don't Have Children	335	42%	41%	15%	1%
Willing To Pay More	393	42%	43%	13%	2%
Only Sometimes.....	382	43%	42%	14%	2%
Hardly Ever Pay Mre	211	35%	41%	21%	3%
Have Art In Home...	768	42%	38%	17%	2%
Don't Have Art.....	233	36%	53%	8%	3%
Choice - Choose Art	352	43%	38%	16%	3%
Would Choose Money.	574	41%	43%	13%	2%
Not Sure...........	75	24%	47%	27%	3%
Spend $25-100/Art..	472	38%	48%	12%	3%
Wld Spend Over $200	451	46%	37%	15%	2%
Museum >2 Times Yr.	188	40%	31%	27%	2%
1 or 2 Times A Yr..	301	44%	39%	15%	2%
Less Than Once A Yr	236	40%	45%	12%	3%
Don't Go To Museums	240	36%	51%	10%	3%
Favor Mre Fed Taxes	300	44%	37%	17%	2%
Wld Pay $25 More	197	45%	35%	17%	3%
Pay $5-$15 More.	57	49%	37%	14%	-
None Of Above...	33	39%	42%	18%	-
Oppose Mre Fed Taxs	571	40%	45%	13%	2%
Not Sure...........	130	33%	38%	22%	6%

Q55. Do you like to see the colors blend into each other or do you
 like it when different colors are kept separate?

	TOTAL	Prefer Colors Blnded	Prefer Colors Kept Separt	Depnds	Not Sure
All Voters.........	1001	68%	18%	11%	2%
Northeast..........	216	70%	13%	14%	3%
South..............	335	69%	21%	8%	1%
Central............	241	67%	21%	10%	2%
West...............	209	66%	17%	15%	2%
Male...............	475	64%	20%	13%	2%
Female.............	526	72%	16%	10%	2%
Under 30...........	247	68%	23%	9%	*
30 to 39...........	263	70%	18%	11%	2%
40 to 49...........	191	66%	20%	12%	2%
50 to 64...........	154	69%	16%	12%	2%
65 And Over........	131	66%	13%	15%	7%
High School/Less...	421	74%	16%	7%	2%
Some College.......	281	68%	19%	12%	1%
College Graduate...	293	60%	22%	16%	2%
Post-Graduate....	103	59%	17%	20%	3%
Liberal............	319	70%	17%	12%	2%
Moderate/Other.....	207	64%	14%	18%	3%
Conservative.......	475	69%	21%	8%	2%
Under $30K.........	343	70%	20%	8%	2%
Under $20K......	155	68%	25%	5%	2%
$20K to $30K.......	188	72%	16%	10%	2%
$30K to $40K.......	155	68%	16%	13%	3%
$40K to $50K.......	133	69%	14%	14%	3%
Over $50K..........	244	64%	23%	12%	1%
Over $75K.......	95	58%	25%	15%	2%
White..............	779	67%	18%	13%	2%
Black..............	100	77%	19%	3%	1%
Hispanic...........	66	68%	23%	8%	2%
All Other..........	56	70%	18%	13%	-
Have Children......	666	69%	18%	12%	2%
Encourage/Artist	523	68%	18%	12%	2%
Don't Have Children	335	67%	20%	11%	2%
Willing To Pay More	393	66%	23%	10%	1%
Only Sometimes.....	382	71%	16%	12%	2%
Hardly Ever Pay Mre	211	68%	15%	13%	4%
Have Art In Home...	768	68%	17%	13%	2%
Don't Have Art.....	233	70%	21%	8%	1%
Choice - Choose Art	352	68%	17%	13%	2%
Would Choose Money.	574	70%	19%	9%	2%
Not Sure...........	75	57%	17%	21%	4%
Spend $25-100/Art..	472	71%	19%	8%	1%
Wld Spend Over $200	451	67%	18%	12%	2%
Museum >2 Times Yr.	188	57%	20%	19%	3%
1 or 2 Times A Yr..	301	68%	19%	11%	1%
Less Than Once A Yr	236	75%	15%	8%	2%
Don't Go To Museums	240	70%	19%	8%	3%
Favor Mre Fed Taxes	300	65%	18%	15%	2%
Wld Pay $25 More	197	64%	18%	16%	2%
Pay $5-$15 More.	57	67%	23%	9%	2%
None Of Above...	33	67%	15%	18%	-
Oppose Mre Fed Taxs	571	70%	19%	9%	2%
Not Sure...........	130	65%	16%	15%	4%

Q56. Which would you say you prefer: when the artist uses more vibrant shades, paler shades, or darker shades of color?

	TOTAL	Prefer More Vibrnt Shades	Prefer Paler Shades	Prefer Darker Shades	Depnds	Not Sure
All Voters.........	1001	36%	32%	22%	9%	1%
Northeast..........	216	38%	31%	20%	9%	1%
South..............	335	38%	29%	24%	7%	1%
Central............	241	31%	38%	21%	9%	2%
West...............	209	37%	28%	22%	11%	2%
Male...............	475	37%	24%	28%	10%	1%
Female.............	526	35%	38%	17%	8%	2%
Under 30...........	247	36%	23%	37%	4%	*
30 to 39...........	263	41%	27%	23%	9%	*
40 to 49...........	191	37%	32%	19%	9%	3%
50 to 64...........	154	31%	42%	10%	16%	2%
65 And Over.......	131	32%	47%	8%	11%	3%
High School/Less...	421	33%	34%	24%	7%	2%
Some College.......	281	36%	30%	23%	9%	1%
College Graduate...	293	40%	29%	18%	12%	1%
Post-Graduate....	103	40%	22%	17%	20%	1%
Liberal............	319	40%	25%	24%	9%	2%
Moderate/Other.....	207	31%	34%	19%	15%	1%
Conservative.......	475	36%	35%	22%	7%	1%
Under $30K.........	343	37%	31%	24%	6%	2%
Under $20K......	155	32%	35%	26%	4%	3%
$20K to $30K.......	188	40%	27%	23%	7%	2%
$30K to $40K.......	155	41%	30%	21%	7%	1%
$40K to $50K.......	133	34%	35%	22%	9%	1%
Over $50K..........	244	36%	28%	23%	11%	1%
Over $75K.......	95	36%	28%	23%	12%	1%
White..............	779	34%	34%	21%	10%	1%
Black..............	100	52%	23%	19%	4%	2%
Hispanic...........	66	35%	27%	27%	9%	2%
All Other..........	56	38%	21%	29%	9%	4%
Have Children......	666	36%	36%	17%	10%	2%
Encourage/Artist	523	38%	34%	16%	10%	1%
Don't Have Children	335	36%	23%	32%	7%	1%
Willing To Pay More	393	37%	30%	25%	7%	1%
Only Sometimes.....	382	37%	32%	20%	9%	1%
Hardly Ever Pay Mre	211	32%	32%	20%	13%	3%
Have Art In Home...	768	37%	32%	21%	9%	1%
Don't Have Art.....	233	33%	32%	23%	9%	3%
Choice - Choose Art	352	36%	30%	24%	9%	1%
Would Choose Money.	574	36%	34%	21%	7%	2%
Not Sure...........	75	35%	23%	17%	21%	4%
Spend $25-100/Art..	472	36%	34%	22%	7%	2%
Wld Spend Over $200	451	37%	31%	23%	8%	1%
Museum >2 Times Yr.	188	37%	21%	21%	19%	2%
1 or 2 Times A Yr..	301	37%	34%	23%	6%	1%
Less Than Once A Yr	236	35%	34%	20%	10%	1%
Don't Go To Museums	240	36%	35%	21%	5%	3%
Favor Mre Fed Taxes	300	42%	31%	19%	7%	1%
Wld Pay $25 More	197	43%	29%	19%	8%	1%
Pay $5-$15 More.	57	49%	30%	19%	2%	-
None Of Above...	33	27%	42%	15%	15%	-
Oppose Mre Fed Taxs	571	35%	30%	25%	8%	2%
Not Sure...........	130	26%	38%	16%	16%	3%

Q57. Do you enjoy paintings that have a more serious or a more festive mood?

	TOTAL	Serius	Festve	Depnds	Not Sure
All Voters.........	1001	37%	49%	12%	3%
Northeast..........	216	31%	51%	16%	2%
South..............	335	40%	47%	12%	2%
Central............	241	38%	47%	10%	5%
West...............	209	36%	51%	12%	1%
Male...............	475	40%	45%	13%	2%
Female.............	526	34%	52%	12%	3%
Under 30...........	247	44%	47%	9%	-
30 to 39...........	263	38%	51%	10%	1%
40 to 49...........	191	34%	52%	11%	4%
50 to 64...........	154	34%	47%	16%	3%
65 And Over.......	131	30%	48%	15%	7%
High School/Less...	421	39%	49%	9%	2%
Some College.......	281	37%	47%	14%	2%
College Graduate...	293	32%	50%	15%	3%
Post-Graduate....	103	34%	44%	17%	5%
Liberal............	319	34%	53%	12%	2%
Moderate/Other.....	207	38%	38%	19%	5%
Conservative.......	475	38%	51%	10%	2%
Under $30K.........	343	38%	51%	8%	3%
Under $20K......	155	41%	46%	10%	3%
$20K to $30K.......	188	36%	55%	7%	2%
$30K to $40K.......	155	38%	46%	14%	2%
$40K to $50K.......	133	32%	53%	13%	2%
Over $50K..........	244	39%	49%	9%	3%
Over $75K.......	95	41%	46%	9%	3%
White..............	779	36%	50%	12%	3%
Black..............	100	43%	46%	9%	2%
Hispanic...........	66	36%	47%	17%	-
All Other..........	56	36%	43%	18%	4%
Have Children......	666	34%	51%	12%	3%
Encourage/Artist	523	33%	52%	12%	2%
Don't Have Children	335	42%	44%	12%	2%
Willing To Pay More	393	38%	49%	11%	2%
Only Sometimes.....	382	36%	49%	12%	3%
Hardly Ever Pay Mre	211	36%	49%	13%	2%
Have Art In Home...	768	37%	49%	12%	2%
Don't Have Art.....	233	36%	47%	12%	5%
Choice - Choose Art	352	34%	49%	15%	2%
Would Choose Money.	574	39%	49%	9%	3%
Not Sure...........	75	29%	45%	20%	5%
Spend $25-100/Art..	472	36%	51%	10%	2%
Wld Spend Over $200	451	37%	48%	13%	2%
Museum >2 Times Yr.	188	37%	42%	19%	3%
1 or 2 Times A Yr..	301	37%	49%	13%	2%
Less Than Once A Yr	236	37%	52%	10%	1%
Don't Go To Museums	240	36%	52%	7%	5%
Favor Mre Fed Taxes	300	39%	47%	11%	2%
Wld Pay $25 More	197	38%	47%	13%	3%
Pay $5-$15 More.	57	42%	51%	7%	-
None Of Above...	33	39%	48%	12%	-
Oppose Mre Fed Taxs	571	37%	50%	11%	2%
Not Sure...........	130	31%	45%	21%	4%

Q58. How about the painting itself -- do you like it to be busy and contain a lot of people or objects, or do you like it to be as simple as possible?

	TOTAL	Busy	Simple	Depnds	Not Sure
All Voters.........	1001	17%	71%	11%	1%
Northeast..........	216	15%	73%	12%	*
South..............	335	19%	67%	13%	1%
Central............	241	15%	76%	8%	1%
West...............	209	19%	69%	11%	1%
Male...............	475	18%	68%	13%	1%
Female.............	526	17%	73%	9%	1%
Under 30...........	247	22%	68%	9%	*
30 to 39...........	263	18%	70%	11%	1%
40 to 49...........	191	17%	70%	13%	1%
50 to 64...........	154	12%	75%	12%	1%
65 And Over.......	131	9%	77%	9%	5%
High School/Less...	421	16%	75%	8%	1%
Some College.......	281	16%	73%	11%	1%
College Graduate...	293	21%	63%	14%	2%
Post-Graduate....	103	25%	55%	18%	1%
Liberal............	319	18%	70%	10%	1%
Moderate/Other.....	207	16%	67%	15%	2%
Conservative.......	475	17%	73%	9%	1%
Under $30K.........	343	18%	73%	8%	1%
Under $20K......	155	14%	79%	6%	1%
$20K to $30K.......	188	22%	68%	9%	2%
$30K to $40K.......	155	20%	70%	10%	1%
$40K to $50K.......	133	19%	68%	12%	2%
Over $50K..........	244	14%	72%	13%	1%
Over $75K.......	95	18%	66%	14%	2%
White..............	779	15%	73%	11%	1%
Black..............	100	23%	62%	13%	2%
Hispanic...........	66	23%	68%	8%	2%
All Other..........	56	23%	66%	9%	2%
Have Children......	666	16%	72%	11%	1%
Encourage/Artist	523	17%	71%	11%	1%
Don't Have Children	335	19%	69%	10%	1%
Willing To Pay More	393	17%	72%	10%	2%
Only Sometimes.....	382	19%	70%	10%	1%
Hardly Ever Pay Mre	211	13%	72%	14%	1%
Have Art In Home...	768	18%	70%	12%	1%
Don't Have Art.....	233	15%	76%	8%	2%
Choice - Choose Art	352	17%	68%	14%	1%
Would Choose Money.	574	17%	74%	7%	1%
Not Sure...........	75	16%	57%	21%	5%
Spend $25-100/Art..	472	17%	75%	7%	1%
Wld Spend Over $200	451	18%	68%	14%	1%
Museum >2 Times Yr.	188	18%	60%	19%	3%
1 or 2 Times A Yr..	301	21%	69%	11%	-
Less Than Once A Yr	236	16%	75%	9%	*
Don't Go To Museums	240	13%	79%	7%	1%
Favor Mre Fed Taxes	300	17%	71%	10%	1%
Wld Pay $25 More	197	16%	70%	13%	2%
Pay $5-$15 More.	57	25%	72%	4%	-
None Of Above...	33	12%	76%	12%	-
Oppose Mre Fed Taxs	571	19%	71%	9%	1%
Not Sure...........	130	10%	70%	18%	2%

Q59. How about the size of paintings: do you prefer larger paintings or smaller paintings?

	TOTAL	Larger	Smallr	Depnds	Not Sure
All Voters.........	1001	41%	34%	23%	2%
Northeast..........	216	38%	33%	28%	1%
South..............	335	43%	35%	21%	1%
Central............	241	37%	39%	21%	4%
West...............	209	45%	27%	26%	2%
Male...............	475	42%	33%	24%	2%
Female.............	526	40%	35%	23%	2%
Under 30...........	247	57%	28%	13%	1%
30 to 39...........	263	43%	36%	19%	2%
40 to 49...........	191	36%	32%	30%	3%
50 to 64...........	154	32%	35%	31%	3%
65 And Over.......	131	25%	38%	34%	3%
High School/Less...	421	37%	40%	21%	2%
Some College.......	281	45%	29%	24%	2%
College Graduate...	293	43%	29%	26%	2%
Post-Graduate....	103	41%	20%	37%	2%
Liberal............	319	43%	32%	23%	2%
Moderate/Other.....	207	38%	32%	27%	3%
Conservative.......	475	40%	36%	22%	2%
Under $30K.........	343	42%	38%	19%	1%
Under $20K......	155	41%	37%	19%	3%
$20K to $30K.......	188	43%	38%	19%	-
$30K to $40K.......	155	41%	37%	19%	3%
$40K to $50K.......	133	42%	33%	21%	4%
Over $50K..........	244	44%	26%	29%	1%
Over $75K.......	95	45%	20%	33%	2%
White..............	779	36%	36%	26%	2%
Black..............	100	56%	25%	16%	3%
Hispanic...........	66	59%	30%	11%	-
All Other..........	56	52%	29%	20%	-
Have Children......	666	36%	35%	27%	2%
Encourage/Artist	523	37%	34%	27%	2%
Don't Have Children	335	50%	32%	16%	2%
Willing To Pay More	393	42%	31%	24%	3%
Only Sometimes.....	382	42%	35%	21%	1%
Hardly Ever Pay Mre	211	35%	38%	25%	2%
Have Art In Home...	768	42%	32%	25%	2%
Don't Have Art.....	233	37%	42%	18%	3%
Choice - Choose Art	352	42%	27%	29%	2%
Would Choose Money.	574	42%	39%	18%	1%
Not Sure...........	75	27%	27%	40%	7%
Spend $25-100/Art..	472	35%	43%	21%	1%
Wld Spend Over $200	451	50%	25%	24%	2%
Museum >2 Times Yr.	188	37%	21%	39%	3%
1 or 2 Times A Yr..	301	51%	30%	17%	2%
Less Than Once A Yr	236	39%	40%	20%	1%
Don't Go To Museums	240	32%	45%	22%	2%
Favor Mre Fed Taxes	300	42%	32%	25%	1%
Wld Pay $25 More	197	40%	32%	27%	1%
Pay $5-$15 More.	57	47%	30%	23%	-
None Of Above...	33	48%	33%	18%	-
Oppose Mre Fed Taxs	571	42%	36%	20%	3%
Not Sure...........	130	34%	30%	35%	2%

Q60. (If Larger In Q59) Would that be the size of a diswasher,
a full-size refrigerator, or a full wall?

	TOTAL	Dish-washer	Full-size Refrig-eratr	Full Wall	Depnds	Not Sure
All Voters.........	407	67%	17%	11%	2%	2%
Northeast..........	82	71%	13%	12%	1%	2%
South..............	143	66%	17%	12%	3%	2%
Central............	88	67%	18%	9%	2%	3%
West...............	94	67%	20%	11%	1%	1%
Male...............	199	61%	21%	14%	3%	2%
Female.............	208	73%	13%	9%	2%	3%
Under 30...........	142	66%	15%	15%	2%	1%
30 to 39...........	113	67%	22%	8%	1%	2%
40 to 49...........	68	68%	18%	9%	4%	1%
50 to 64...........	49	80%	12%	6%	2%	-
65 And Over.......	33	52%	15%	18%	3%	12%
High School/Less...	154	60%	21%	14%	2%	2%
Some College.......	127	76%	10%	10%	1%	3%
College Graduate...	126	67%	19%	8%	4%	2%
Post-Graduate....	42	67%	21%	5%	5%	2%
Liberal............	137	69%	16%	9%	4%	2%
Moderate/Other.....	79	67%	15%	11%	3%	4%
Conservative.......	191	66%	19%	12%	1%	2%
Under $30K.........	144	66%	19%	11%	2%	2%
Under $20K......	64	64%	20%	13%	2%	2%
$20K to $30K.......	80	68%	18%	10%	3%	3%
$30K to $40K.......	64	67%	13%	11%	3%	6%
$40K to $50K.......	56	73%	9%	14%	2%	2%
Over $50K..........	107	66%	22%	9%	1%	1%
Over $75K.......	43	67%	26%	7%	-	-
White..............	283	70%	17%	9%	2%	2%
Black..............	56	57%	16%	18%	5%	4%
Hispanic...........	39	64%	21%	13%	-	3%
All Other..........	29	69%	14%	14%	3%	-
Have Children......	241	71%	15%	10%	2%	3%
Encourage/Artist	195	69%	15%	9%	3%	4%
Don't Have Children	166	62%	21%	13%	2%	1%
Willing To Pay More	166	57%	21%	15%	4%	2%
Only Sometimes.....	161	72%	16%	7%	1%	3%
Hardly Ever Pay Mre	74	80%	11%	9%	-	-
Have Art In Home...	321	68%	17%	11%	2%	2%
Don't Have Art.....	86	65%	20%	12%	1%	2%
Choice - Choose Art	147	68%	14%	13%	2%	3%
Would Choose Money.	240	67%	18%	11%	2%	2%
Not Sure..........	20	65%	25%	-	10%	-
Spend $25-100/Art..	165	70%	15%	12%	1%	2%
Wld Spend Over $200	226	68%	17%	10%	2%	2%
Museum >2 Times Yr.	70	64%	21%	10%	4%	-
1 or 2 Times A Yr..	153	70%	16%	10%	3%	1%
Less Than Once A Yr	93	67%	16%	10%	2%	5%
Don't Go To Museums	76	66%	17%	14%	-	3%
Favor Mre Fed Taxes	125	65%	18%	14%	3%	1%
Wld Pay $25 More	78	62%	19%	15%	3%	1%
Pay $5-$15 More.	27	67%	11%	19%	4%	-
None Of Above...	16	69%	25%	-	6%	-
Oppose Mre Fed Taxs	238	69%	18%	10%	2%	1%
Not Sure..........	44	66%	11%	9%	2%	11%

Q61. (If Smaller In Q59) Would that be the size of a nineteen-inch
television set, a magazine, or a paperback book?

	TOTAL	19" TV	A Magzne	Paper-back Book	Depnds	Not Sure
All Voters.........	339	69%	24%	4%	2%	1%
Northeast..........	71	63%	27%	6%	3%	1%
South..............	118	72%	21%	4%	2%	1%
Central............	93	65%	28%	5%	-	2%
West...............	57	77%	19%	-	4%	-
Male...............	155	68%	24%	5%	2%	1%
Female.............	184	70%	24%	3%	2%	2%
Under 30...........	70	76%	19%	3%	-	3%
30 to 39...........	95	72%	21%	5%	2%	-
40 to 49...........	61	74%	23%	2%	-	2%
50 to 64...........	54	74%	22%	-	2%	2%
65 And Over.......	50	50%	36%	8%	6%	-
High School/Less...	170	66%	28%	3%	2%	2%
Some College.......	81	64%	23%	7%	4%	1%
College Graduate...	85	81%	15%	4%	-	-
Post-Graduate....	21	86%	14%	-	-	-
Liberal............	103	75%	18%	3%	3%	1%
Moderate/Other.....	66	65%	26%	5%	3%	2%
Conservative.......	170	67%	26%	5%	1%	1%
Under $30K.........	130	67%	25%	5%	2%	2%
Under $20K......	58	64%	26%	3%	3%	3%
$20K to $30K.......	72	69%	25%	6%	-	-
$30K to $40K.......	58	69%	26%	2%	3%	-
$40K to $50K.......	44	68%	23%	5%	2%	2%
Over $50K..........	64	77%	17%	5%	-	2%
Over $75K.......	19	84%	11%	-	-	5%
White..............	278	69%	25%	3%	1%	1%
Black..............	25	64%	20%	16%	-	-
Hispanic...........	20	75%	15%	5%	5%	-
All Other..........	16	69%	25%	-	6%	-
Have Children......	232	69%	25%	3%	2%	1%
Encourage/Artist	180	69%	23%	4%	2%	1%
Don't Have Children	107	70%	22%	6%	1%	1%
Willing To Pay More	121	72%	21%	5%	2%	1%
Only Sometimes.....	134	66%	25%	4%	2%	2%
Hardly Ever Pay Mre	81	68%	27%	4%	1%	-
Have Art In Home...	242	72%	20%	3%	2%	2%
Don't Have Art.....	97	61%	33%	6%	-	-
Choice - Choose Art	95	77%	15%	5%	2%	1%
Would Choose Money.	224	67%	29%	4%	*	*
Not Sure..........	20	55%	15%	5%	15%	10%
Spend $25-100/Art..	205	66%	26%	4%	2%	1%
Wld Spend Over $200	111	77%	18%	4%	-	1%
Museum >2 Times Yr.	39	74%	21%	3%	3%	-
1 or 2 Times A Yr..	91	75%	14%	8%	2%	1%
Less Than Once A Yr	94	66%	30%	2%	1%	1%
Don't Go To Museums	107	65%	29%	3%	2%	1%
Favor Mre Fed Taxes	96	73%	20%	5%	1%	1%
Wld Pay $25 More	64	77%	16%	6%	-	2%
Pay $5-$15 More.	17	71%	29%	-	-	-
None Of Above...	11	55%	36%	-	9%	-
Oppose Mre Fed Taxes	204	66%	27%	4%	2%	1%
Not Sure..........	39	74%	18%	3%	3%	3%

Q62. Do you prefer paintings of famous people, or ones of more ordinary people, or does it make no difference to you at all?

	TOTAL	Famous People	Ordnry People	Makes No Dfrnce	Not Sure
All Voters.........	1001	6%	41%	50%	3%
Northeast..........	216	7%	43%	46%	4%
South..............	335	7%	42%	48%	3%
Central............	241	6%	44%	47%	3%
West...............	209	6%	33%	60%	2%
Male...............	475	8%	37%	52%	3%
Female.............	526	5%	44%	48%	3%
Under 30...........	247	5%	37%	57%	2%
30 to 39...........	263	6%	50%	41%	3%
40 to 49...........	191	5%	43%	50%	2%
50 to 64...........	154	6%	40%	51%	3%
65 And Over........	131	10%	28%	55%	7%
High School/Less...	421	8%	36%	53%	4%
Some College.......	281	5%	42%	50%	2%
College Graduate...	293	5%	48%	45%	2%
Post-Graduate....	103	8%	44%	46%	3%
Liberal............	319	7%	43%	48%	3%
Moderate/Other.....	207	8%	36%	51%	4%
Conservative.......	475	5%	42%	51%	2%
Under $30K.........	343	9%	38%	51%	2%
Under $20K......	155	10%	37%	48%	4%
$20K to $30K.......	188	8%	38%	53%	1%
$30K to $40K.......	155	4%	45%	50%	1%
$40K to $50K.......	133	6%	38%	53%	3%
Over $50K..........	244	4%	46%	49%	2%
Over $75K.......	95	3%	42%	53%	2%
White..............	779	6%	43%	49%	3%
Black..............	100	9%	28%	58%	5%
Hispanic...........	66	11%	38%	50%	2%
All Other..........	56	7%	38%	55%	–
Have Children......	666	6%	42%	50%	3%
Encourage/Artist	523	6%	43%	50%	2%
Don't Have Children	335	8%	39%	50%	3%
Willing To Pay More	393	5%	40%	53%	2%
Only Sometimes.....	382	8%	41%	48%	2%
Hardly Ever Pay Mre	211	6%	41%	48%	5%
Have Art In Home...	768	6%	42%	49%	2%
Don't Have Art.....	233	7%	36%	52%	5%
Choice - Choose Art	352	8%	41%	49%	2%
Would Choose Money.	574	5%	43%	49%	2%
Not Sure...........	75	8%	24%	59%	9%
Spend $25-100/Art..	472	7%	38%	53%	2%
Wld Spend Over $200	451	6%	46%	46%	2%
Museum >2 Times Yr.	188	6%	45%	44%	5%
1 or 2 Times A Yr..	301	7%	39%	52%	1%
Less Than Once A Yr	236	4%	45%	49%	2%
Don't Go To Museums	240	7%	38%	53%	3%
Favor Mre Fed Taxes	300	7%	44%	48%	2%
Wld Pay $25 More	197	4%	47%	48%	2%
Pay $5-$15 More.	57	12%	37%	49%	2%
None Of Above...	33	12%	42%	42%	3%
Oppose Mre Fed Taxs	571	6%	41%	50%	4%
Not Sure...........	130	5%	35%	56%	3%

Q63. (If Famous People In Q62) Do you prefer figures from a long time ago, or more recent figures?

	TOTAL	Histrc Figure	More Recent Figure	Depnds	Not Sure
All Voters.........	63	56%	14%	22%	8%
Northeast..........	15	53%	7%	33%	7%
South..............	22	55%	9%	27%	9%
Central............	14	57%	21%	14%	7%
West...............	12	58%	25%	8%	8%
Male...............	37	57%	16%	22%	5%
Female.............	26	54%	12%	23%	12%
Under 30...........	12	58%	33%	–	8%
30 to 39...........	16	44%	6%	38%	13%
40 to 49...........	10	70%	10%	20%	–
50 to 64...........	9	44%	11%	33%	11%
65 And Over........	13	62%	8%	23%	8%
High School/Less...	33	45%	21%	27%	6%
Some College.......	15	67%	13%	13%	7%
College Graduate...	15	67%	–	20%	13%
Post-Graduate....	8	63%	–	25%	13%
Liberal............	21	57%	14%	19%	10%
Moderate/Other.....	17	47%	12%	29%	12%
Conservative.......	25	60%	16%	20%	4%
Under $30K.........	31	52%	19%	23%	6%
Under $20K......	16	63%	13%	25%	–
$20K to $30K.......	15	40%	27%	20%	13%
$30K to $40K.......	6	50%	17%	33%	–
$40K to $50K.......	8	50%	13%	25%	13%
Over $50K..........	9	67%	11%	11%	11%
Over $75K.......	3	67%	–	–	33%
White..............	43	56%	16%	21%	7%
Black..............	9	67%	11%	11%	11%
Hispanic...........	7	29%	14%	57%	–
All Other..........	4	75%	–	–	25%
Have Children......	37	57%	16%	22%	5%
Encourage/Artist	29	62%	14%	21%	3%
Don't Have Children	26	54%	12%	23%	12%
Willing To Pay More	19	58%	16%	21%	5%
Only Sometimes.....	31	48%	19%	23%	10%
Hardly Ever Pay Mre	12	67%	–	25%	8%
Have Art In Home...	46	57%	15%	22%	7%
Don't Have Art.....	17	53%	12%	24%	12%
Choice - Choose Art	27	63%	15%	19%	4%
Would Choose Money.	30	47%	13%	27%	13%
Not Sure...........	6	67%	17%	17%	–
Spend $25-100/Art..	33	55%	15%	18%	12%
Wld Spend Over $200	25	60%	16%	24%	–
Museum >2 Times Yr.	11	55%	9%	18%	18%
1 or 2 Times A Yr..	22	59%	14%	27%	–
Less Than Once A Yr	10	70%	10%	10%	10%
Don't Go To Museums	16	56%	19%	19%	6%
Favor Mre Fed Taxes	21	62%	14%	19%	5%
Wld Pay $25 More	8	63%	–	38%	–
Pay $5-$15 More.	7	71%	29%	–	–
None Of Above...	4	50%	25%	–	25%
Oppose Mre Fed Taxs	35	54%	11%	23%	11%
Not Sure...........	7	43%	29%	29%	–

Q64. (If Ordinary Or No Difference In Q62) Do you prefer paintings which are predominantly of children, of women, of men, or doesn't it matter?

	TOTAL	Chldrn	Women	Men	Doesnt Matter	Not Sure
All Voters.........	909	11%	6%	2%	77%	4%
Northeast..........	193	13%	5%	2%	78%	2%
South..............	304	8%	6%	4%	77%	5%
Central............	219	13%	5%	2%	74%	5%
West...............	193	11%	6%	1%	78%	4%
Male...............	423	7%	9%	2%	78%	5%
Female.............	486	15%	3%	2%	76%	4%
Under 30...........	231	7%	9%	2%	81%	1%
30 to 39...........	240	13%	5%	3%	77%	3%
40 to 49...........	178	10%	8%	2%	72%	7%
50 to 64...........	141	11%	2%	2%	79%	6%
65 And Over........	109	17%	-	3%	75%	6%
High School/Less...	372	15%	7%	2%	72%	5%
Some College.......	259	11%	5%	3%	76%	5%
College Graduate...	273	5%	5%	2%	84%	3%
Post-Graduate....	92	4%	4%	1%	87%	3%
Liberal............	288	9%	6%	2%	81%	2%
Moderate/Other.....	181	10%	8%	2%	73%	7%
Conservative.......	440	13%	5%	3%	76%	4%
Under $30K.........	304	13%	6%	2%	75%	4%
Under $20K......	133	17%	4%	1%	71%	7%
$20K to $30K.......	171	9%	8%	3%	77%	2%
$30K to $40K.......	147	13%	7%	2%	73%	4%
$40K to $50K.......	121	10%	7%	3%	77%	2%
Over $50K..........	231	9%	3%	3%	81%	3%
Over $75K.......	90	10%	4%	3%	78%	4%
White..............	713	11%	5%	3%	77%	4%
Black..............	86	10%	8%	-	78%	3%
Hispanic...........	58	9%	9%	2%	81%	-
All Other..........	52	12%	6%	4%	73%	6%
Have Children......	611	13%	3%	2%	77%	4%
Encourage/Artist	483	14%	4%	2%	76%	4%
Don't Have Children	298	6%	10%	3%	77%	4%
Willing To Pay More	365	12%	6%	2%	75%	4%
Only Sometimes.....	342	8%	5%	3%	81%	3%
Hardly Ever Pay Mre	189	15%	5%	2%	74%	5%
Have Art In Home...	704	11%	6%	2%	77%	4%
Don't Have Art.....	205	12%	6%	2%	76%	4%
Choice - Choose Art	317	9%	6%	2%	78%	5%
Would Choose Money.	530	12%	5%	3%	77%	3%
Not Sure...........	62	11%	6%	2%	69%	11%
Spend $25-100/Art..	428	14%	6%	3%	75%	2%
Wld Spend Over $200	415	8%	6%	2%	79%	5%
Museum >2 Times Yr.	168	7%	10%	1%	80%	4%
1 or 2 Times A Yr..	275	12%	5%	2%	77%	4%
Less Than Once A Yr	222	13%	6%	3%	73%	5%
Don't Go To Museums	217	12%	4%	2%	78%	4%
Favor Mre Fed Taxes	274	8%	8%	3%	75%	5%
Wld Pay $25 More	186	9%	9%	3%	75%	4%
Pay $5-$15 More.	49	8%	6%	4%	78%	4%
None Of Above...	28	7%	11%	4%	68%	11%
Oppose Mre Fed Taxs	516	12%	4%	2%	77%	4%
Not Sure...........	119	10%	4%	3%	82%	2%

Q65. Thinking of the paintings of people that you have liked, for the most part were the figures working, at leisure, or were they posed portraits?

	TOTAL	Workng	At Leisur	Portrt	Not Sure
All Voters.........	1001	23%	43%	27%	7%
Northeast..........	216	16%	46%	31%	7%
South..............	335	22%	45%	27%	6%
Central............	241	22%	49%	22%	7%
West...............	209	31%	32%	30%	7%
Male...............	475	25%	41%	28%	6%
Female.............	526	21%	46%	26%	7%
Under 30...........	247	19%	48%	30%	4%
30 to 39...........	263	20%	53%	24%	3%
40 to 49...........	191	28%	40%	25%	7%
50 to 64...........	154	27%	38%	25%	10%
65 And Over........	131	24%	26%	34%	16%
High School/Less...	421	22%	40%	32%	7%
Some College.......	281	23%	46%	25%	6%
College Graduate...	293	25%	46%	23%	6%
Post-Graduate....	103	28%	40%	23%	9%
Liberal............	319	21%	45%	28%	7%
Moderate/Other.....	207	20%	43%	29%	7%
Conservative.......	475	25%	43%	25%	7%
Under $30K.........	343	23%	41%	31%	6%
Under $20K......	155	24%	39%	30%	7%
$20K to $30K.......	188	22%	43%	31%	4%
$30K to $40K.......	155	23%	48%	26%	3%
$40K to $50K.......	133	22%	47%	22%	10%
Over $50K..........	244	25%	45%	25%	6%
Over $75K.......	95	27%	46%	21%	5%
White..............	779	24%	44%	25%	7%
Black..............	100	16%	35%	41%	8%
Hispanic...........	66	20%	50%	27%	3%
All Other..........	56	21%	48%	27%	4%
Have Children......	666	23%	42%	27%	8%
Encourage/Artist	523	23%	43%	27%	7%
Don't Have Children	335	22%	45%	28%	5%
Willing To Pay More	393	23%	44%	27%	7%
Only Sometimes.....	382	21%	47%	27%	4%
Hardly Ever Pay Mre	211	23%	39%	27%	10%
Have Art In Home...	768	23%	44%	27%	6%
Don't Have Art.....	233	20%	41%	29%	9%
Choice - Choose Art	352	21%	45%	29%	4%
Would Choose Money.	574	22%	44%	26%	8%
Not Sure...........	75	35%	28%	25%	12%
Spend $25-100/Art..	472	22%	43%	29%	5%
Wld Spend Over $200	451	24%	45%	24%	6%
Museum >2 Times Yr.	188	30%	36%	26%	9%
1 or 2 Times A Yr..	301	24%	42%	29%	5%
Less Than Once A Yr	236	22%	50%	23%	5%
Don't Go To Museums	240	18%	46%	30%	6%
Favor Mre Fed Taxes	300	26%	39%	29%	6%
Wld Pay $25 More	197	23%	42%	29%	6%
Pay $5-$15 More.	57	35%	35%	25%	5%
None Of Above...	33	24%	33%	33%	9%
Oppose Mre Fed Taxs	571	22%	46%	26%	6%
Not Sure...........	130	17%	44%	28%	11%

Q66. Which do you think you like better, a painting of one person or of a group of people?

	TOTAL	One Person	Group	Depnds	Not Sure
All Voters.........	1001	34%	48%	15%	3%
Northeast..........	216	30%	51%	16%	3%
South..............	335	35%	49%	13%	2%
Central............	241	36%	44%	15%	4%
West...............	209	36%	44%	17%	2%
Male...............	475	33%	48%	15%	4%
Female.............	526	35%	48%	15%	2%
Under 30...........	247	39%	49%	10%	2%
30 to 39...........	263	31%	53%	14%	2%
40 to 49...........	191	35%	50%	14%	1%
50 to 64...........	154	38%	40%	16%	7%
65 And Over........	131	33%	38%	24%	5%
High School/Less...	421	40%	44%	13%	3%
Some College.......	281	34%	49%	15%	2%
College Graduate...	293	28%	51%	19%	3%
Post-Graduate....	103	29%	49%	17%	5%
Liberal............	319	33%	51%	15%	1%
Moderate/Other.....	207	26%	50%	20%	5%
Conservative.......	475	39%	44%	13%	3%
Under $30K.........	343	40%	46%	12%	2%
Under $20K......	155	43%	39%	14%	4%
$20K to $30K.......	188	38%	51%	10%	1%
$30K to $40K.......	155	33%	50%	14%	3%
$40K to $50K.......	133	36%	48%	14%	2%
Over $50K..........	244	30%	49%	19%	2%
Over $75K.......	95	28%	52%	18%	2%
White..............	779	34%	47%	16%	3%
Black..............	100	33%	54%	9%	4%
Hispanic...........	66	44%	41%	14%	2%
All Other..........	56	30%	54%	13%	4%
Have Children......	666	34%	46%	17%	3%
Encourage/Artist	523	36%	44%	18%	2%
Don't Have Children	335	34%	51%	12%	3%
Willing To Pay More	393	35%	50%	13%	3%
Only Sometimes.....	382	35%	46%	17%	2%
Hardly Ever Pay Mre	211	33%	46%	16%	4%
Have Art In Home...	768	34%	47%	17%	2%
Don't Have Art.....	233	36%	49%	11%	4%
Choice - Choose Art	352	37%	47%	16%	1%
Would Choose Money.	574	34%	49%	13%	3%
Not Sure...........	75	21%	41%	27%	11%
Spend $25-100/Art..	472	36%	48%	14%	2%
Wld Spend Over $200	451	34%	50%	14%	2%
Museum >2 Times Yr.	188	34%	40%	24%	2%
1 or 2 Times A Yr..	301	34%	50%	14%	2%
Less Than Once A Yr	236	34%	51%	12%	2%
Don't Go To Museums	240	36%	48%	13%	3%
Favor Mre Fed Taxes	300	38%	44%	17%	1%
Wld Pay $25 More	197	39%	42%	18%	1%
Pay $5-$15 More.	57	44%	51%	5%	-
None Of Above...	33	27%	45%	24%	3%
Oppose Mre Fed Taxs	571	32%	51%	14%	3%
Not Sure...........	130	34%	42%	18%	6%

Q67. Would you say that you prefer paintings in which the person or people are nude, partially clothed or fully clothed?

	TOTAL	Nude	Partly Clothd	Fully Clothd	Depnds	Not Sure
All Voters.........	1001	3%	13%	68%	13%	1%
Northeast..........	216	4%	14%	66%	15%	*
South..............	335	2%	13%	70%	14%	1%
Central............	241	5%	12%	70%	10%	2%
West...............	209	3%	15%	64%	16%	2%
Male...............	475	5%	17%	59%	17%	3%
Female.............	526	2%	11%	76%	11%	*
Under 30...........	247	4%	22%	64%	10%	*
30 to 39...........	263	5%	16%	68%	11%	1%
40 to 49...........	191	4%	10%	66%	19%	1%
50 to 64...........	154	1%	6%	72%	16%	4%
65 And Over........	131	2%	5%	76%	14%	3%
High School/Less...	421	5%	12%	75%	7%	1%
Some College.......	281	3%	16%	64%	15%	1%
College Graduate...	293	2%	13%	62%	20%	2%
Post-Graduate....	103	3%	12%	57%	24%	4%
Liberal............	319	6%	17%	58%	19%	-
Moderate/Other.....	207	5%	11%	65%	16%	3%
Conservative.......	475	1%	12%	76%	8%	2%
Under $30K.........	343	4%	13%	71%	12%	1%
Under $20K......	155	3%	8%	77%	10%	1%
$20K to $30K.......	188	5%	16%	65%	13%	1%
$30K to $40K.......	155	4%	15%	68%	13%	-
$40K to $50K.......	133	4%	17%	66%	12%	2%
Over $50K..........	244	2%	14%	65%	17%	2%
Over $75K.......	95	2%	20%	56%	19%	3%
White..............	779	3%	13%	69%	14%	1%
Black..............	100	4%	16%	70%	7%	3%
Hispanic...........	66	11%	17%	62%	11%	-
All Other..........	56	2%	18%	63%	16%	2%
Have Children......	666	3%	10%	72%	14%	1%
Encourage/Artist	523	2%	10%	71%	15%	1%
Don't Have Children	335	5%	20%	60%	12%	2%
Willing To Pay More	393	3%	16%	67%	13%	2%
Only Sometimes.....	382	4%	12%	71%	13%	1%
Hardly Ever Pay Mre	211	3%	13%	67%	15%	2%
Have Art In Home...	768	3%	14%	66%	15%	1%
Don't Have Art.....	233	4%	11%	74%	8%	3%
Choice - Choose Art	352	4%	17%	62%	17%	1%
Would Choose Money.	574	3%	12%	73%	10%	1%
Not Sure...........	75	3%	8%	60%	23%	7%
Spend $25-100/Art..	472	3%	12%	76%	8%	1%
Wld Spend Over $200	451	4%	16%	61%	17%	1%
Museum >2 Times Yr.	188	4%	16%	51%	28%	1%
1 or 2 Times A Yr..	301	3%	17%	65%	14%	1%
Less Than Once A Yr	236	4%	12%	73%	9%	1%
Don't Go To Museums	240	3%	10%	80%	6%	2%
Favor Mre Fed Taxes	300	6%	14%	59%	21%	*
Wld Pay $25 More	197	7%	15%	52%	25%	1%
Pay $5-$15 More.	57	7%	7%	75%	11%	-
None Of Above...	33	3%	18%	61%	18%	-
Oppose Mre Fed Taxs	571	2%	13%	72%	10%	2%
Not Sure...........	130	2%	14%	71%	11%	3%

Q68. Do you agree or disagree with the following statement:
I only like to look at art that makes me happy.

	TOTAL	Agree	Disagr	Not Sure
All Voters.........	1001	60%	39%	1%
Northeast..........	216	61%	38%	1%
South..............	335	62%	36%	1%
Central............	241	58%	41%	1%
West...............	209	56%	43%	1%
Male...............	475	56%	42%	2%
Female.............	526	63%	36%	1%
Under 30...........	247	55%	45%	*
30 to 39...........	263	55%	44%	*
40 to 49...........	191	53%	45%	2%
50 to 64...........	154	68%	31%	1%
65 And Over........	131	75%	23%	2%
High School/Less...	421	71%	28%	1%
Some College.......	281	55%	44%	1%
College Graduate...	293	48%	51%	1%
Post-Graduate....	103	46%	53%	1%
Liberal............	319	54%	45%	*
Moderate/Other.....	207	58%	39%	3%
Conservative.......	475	64%	35%	1%
Under $30K.........	343	66%	33%	1%
Under $20K......	155	71%	28%	1%
$20K to $30K.......	188	63%	37%	1%
$30K to $40K.......	155	57%	43%	-
$40K to $50K.......	133	52%	47%	1%
Over $50K..........	244	51%	48%	2%
Over $75K.......	95	46%	54%	-
White..............	779	58%	41%	1%
Black..............	100	66%	31%	3%
Hispanic...........	66	58%	41%	2%
All Other..........	56	68%	29%	4%
Have Children......	666	63%	35%	2%
Encourage/Artist	523	62%	37%	1%
Don't Have Children	335	53%	47%	*
Willing To Pay More	393	59%	41%	*
Only Sometimes.....	382	59%	40%	1%
Hardly Ever Pay Mre	211	64%	33%	3%
Have Art In Home...	768	57%	42%	1%
Don't Have Art.....	233	70%	29%	2%
Choice - Choose Art	352	53%	45%	1%
Would Choose Money.	574	63%	36%	1%
Not Sure..........	75	61%	33%	5%
Spend $25-100/Art..	472	70%	29%	1%
Wld Spend Over $200	451	47%	51%	1%
Museum >2 Times Yr.	188	41%	58%	1%
1 or 2 Times A Yr..	301	54%	45%	1%
Less Than Once A Yr	236	65%	34%	*
Don't Go To Museums	240	74%	25%	1%
Favor Mre Fed Taxes	300	52%	47%	1%
Wld Pay $25 More	197	45%	54%	2%
Pay $5-$15 More.	57	65%	35%	-
None Of Above...	33	67%	33%	-
Oppose Mre Fed Taxs	571	63%	36%	1%
Not Sure..........	130	62%	35%	2%

Q69. Do you agree or disagree with the following statement: Art can be
beautiful even if it doesn't look like anything you see in the real world.

	TOTAL	Agree	Disagr	Not Sure
All Voters.........	1001	82%	17%	2%
Northeast..........	216	87%	13%	*
South..............	335	81%	17%	2%
Central............	241	79%	20%	1%
West...............	209	82%	16%	2%
Male...............	475	80%	19%	1%
Female.............	526	83%	15%	2%
Under 30...........	247	94%	6%	-
30 to 39...........	263	84%	15%	*
40 to 49...........	191	82%	17%	1%
50 to 64...........	154	69%	29%	1%
65 And Over........	131	68%	24%	8%
High School/Less...	421	79%	18%	2%
Some College.......	281	81%	18%	1%
College Graduate...	293	86%	13%	1%
Post-Graduate....	103	84%	15%	1%
Liberal............	319	87%	13%	*
Moderate/Other.....	207	80%	14%	6%
Conservative.......	475	79%	20%	1%
Under $30K.........	343	82%	16%	2%
Under $20K......	155	78%	19%	3%
$20K to $30K.......	188	86%	14%	1%
$30K to $40K.......	155	83%	16%	1%
$40K to $50K.......	133	83%	17%	1%
Over $50K..........	244	86%	14%	1%
Over $75K.......	95	88%	12%	-
White..............	779	80%	19%	1%
Black..............	100	86%	9%	5%
Hispanic...........	66	86%	14%	-
All Other..........	56	93%	7%	-
Have Children......	666	78%	20%	2%
Encourage/Artist	523	80%	19%	2%
Don't Have Children	335	89%	10%	1%
Willing To Pay More	393	81%	18%	1%
Only Sometimes.....	382	84%	15%	1%
Hardly Ever Pay Mre	211	79%	18%	3%
Have Art In Home...	768	84%	15%	2%
Don't Have Art.....	233	75%	23%	2%
Choice - Choose Art	352	89%	11%	1%
Would Choose Money.	574	78%	21%	2%
Not Sure..........	75	77%	16%	7%
Spend $25-100/Art..	472	78%	20%	2%
Wld Spend Over $200	451	86%	12%	1%
Museum >2 Times Yr.	188	92%	7%	1%
1 or 2 Times A Yr..	301	83%	16%	1%
Less Than Once A Yr	236	83%	17%	*
Don't Go To Museums	240	72%	25%	4%
Favor Mre Fed Taxes	300	88%	10%	2%
Wld Pay $25 More	197	89%	11%	1%
Pay $5-$15 More.	57	89%	7%	4%
None Of Above...	33	85%	12%	3%
Oppose Mre Fed Taxs	571	78%	21%	1%
Not Sure..........	130	85%	12%	3%

Q70. Do you agree or disagree with the following statement:
Art should be relaxing to look at, not all jumbled up and confusing.

	TOTAL	Agree	Disagr	Not Sure
All Voters.........	1001	77%	22%	1%
Northeast..........	216	81%	19%	-
South..............	335	77%	21%	1%
Central............	241	76%	23%	1%
West...............	209	76%	23%	1%
Male...............	475	78%	21%	1%
Female.............	526	77%	22%	1%
Under 30...........	247	69%	31%	-
30 to 39...........	263	76%	23%	1%
40 to 49...........	191	76%	24%	-
50 to 64...........	154	84%	13%	3%
65 And Over........	131	88%	10%	2%
High School/Less...	421	84%	15%	1%
Some College.......	281	79%	21%	1%
College Graduate...	293	67%	32%	1%
Post-Graduate....	103	66%	33%	1%
Liberal............	319	69%	31%	*
Moderate/Other.....	207	78%	20%	2%
Conservative.......	475	83%	16%	1%
Under $30K.........	343	80%	19%	1%
Under $20K......	155	84%	15%	1%
$20K to $30K.......	188	78%	22%	1%
$30K to $40K.......	155	76%	23%	1%
$40K to $50K.......	133	79%	20%	1%
Over $50K..........	244	72%	27%	*
Over $75K.......	95	69%	31%	-
White..............	779	77%	22%	1%
Black..............	100	80%	19%	1%
Hispanic...........	66	67%	33%	-
All Other..........	56	86%	14%	-
Have Children......	666	81%	18%	1%
Encourage/Artist	523	80%	19%	1%
Don't Have Children	335	70%	30%	*
Willing To Pay More	393	76%	23%	1%
Only Sometimes.....	382	77%	23%	*
Hardly Ever Pay Mre	211	80%	18%	2%
Have Art In Home...	768	75%	24%	1%
Don't Have Art.....	233	85%	15%	*
Choice - Choose Art	352	73%	26%	1%
Would Choose Money.	574	79%	20%	1%
Not Sure..........	75	85%	13%	1%
Spend $25-100/Art..	472	85%	14%	1%
Wld Spend Over $200	451	69%	30%	1%
Museum >2 Times Yr.	188	58%	41%	1%
1 or 2 Times A Yr..	301	76%	23%	*
Less Than Once A Yr	236	77%	21%	2%
Don't Go To Museums	240	93%	6%	*
Favor Mre Fed Taxes	300	71%	28%	1%
Wld Pay $25 More	197	65%	34%	1%
Pay $5-$15 More.	57	81%	19%	-
None Of Above...	33	82%	18%	-
Oppose Mre Fed Taxes	571	80%	19%	1%
Not Sure..........	130	82%	18%	1%

Q71. Do you agree or disagree with the following statement: I generally
prefer paintings and drawings that are predominantly black and white.

	TOTAL	Agree	Disagr	Not Sure
All Voters.........	1001	11%	87%	2%
Northeast..........	216	6%	93%	2%
South..............	335	10%	87%	3%
Central............	241	16%	83%	1%
West...............	209	11%	87%	1%
Male...............	475	12%	87%	1%
Female.............	526	10%	88%	2%
Under 30...........	247	17%	82%	1%
30 to 39...........	263	10%	88%	2%
40 to 49...........	191	9%	90%	1%
50 to 64...........	154	6%	91%	3%
65 And Over........	131	9%	85%	5%
High School/Less...	421	15%	82%	3%
Some College.......	281	9%	90%	1%
College Graduate...	293	7%	91%	1%
Post-Graduate....	103	10%	88%	2%
Liberal............	319	12%	87%	1%
Moderate/Other.....	207	11%	87%	2%
Conservative.......	475	10%	88%	3%
Under $30K.........	343	14%	85%	1%
Under $20K......	155	17%	81%	2%
$20K to $30K.......	188	12%	87%	1%
$30K to $40K.......	155	8%	91%	1%
$40K to $50K.......	133	11%	88%	2%
Over $50K..........	244	8%	90%	2%
Over $75K.......	95	11%	86%	3%
White..............	779	9%	90%	2%
Black..............	100	17%	79%	4%
Hispanic...........	66	20%	79%	2%
All Other..........	56	21%	77%	2%
Have Children......	666	10%	88%	2%
Encourage/Artist	523	10%	89%	1%
Don't Have Children	335	13%	85%	2%
Willing To Pay More	393	14%	84%	2%
Only Sometimes.....	382	10%	89%	1%
Hardly Ever Pay Mre	211	7%	90%	3%
Have Art In Home...	768	10%	89%	2%
Don't Have Art.....	233	15%	83%	2%
Choice - Choose Art	352	11%	88%	1%
Would Choose Money.	574	11%	87%	2%
Not Sure..........	75	5%	87%	8%
Spend $25-100/Art..	472	11%	88%	1%
Wld Spend Over $200	451	11%	88%	1%
Museum >2 Times Yr.	188	12%	86%	2%
1 or 2 Times A Yr..	301	11%	88%	1%
Less Than Once A Yr	236	10%	89%	1%
Don't Go To Museums	240	11%	86%	3%
Favor Mre Fed Taxes	300	12%	86%	2%
Wld Pay $25 More	197	11%	88%	2%
Pay $5-$15 More.	57	19%	81%	-
None Of Above...	33	3%	91%	6%
Oppose Mre Fed Taxes	571	11%	87%	2%
Not Sure..........	130	8%	89%	2%

Q72. If given the choice -- a sum of money or a piece of art that you genuinely
liked & which was of equal value to the money, which would you choose?

	TOTAL	Art	Money	Not Sure
All Voters........	1001	35%	57%	7%
Northeast..........	216	38%	55%	7%
South..............	335	32%	62%	6%
Central............	241	33%	59%	8%
West...............	209	40%	52%	9%
Male...............	475	36%	55%	9%
Female.............	526	34%	59%	6%
Under 30...........	247	37%	58%	4%
30 to 39...........	263	34%	60%	6%
40 to 49...........	191	38%	55%	7%
50 to 64...........	154	32%	60%	8%
65 And Over........	131	34%	52%	15%
High School/Less...	421	28%	64%	8%
Some College.......	281	41%	53%	6%
College Graduate...	293	40%	52%	8%
Post-Graduate....	103	43%	50%	8%
Liberal............	319	44%	51%	6%
Moderate/Other.....	207	35%	54%	11%
Conservative.......	475	30%	63%	7%
Under $30K.........	343	32%	60%	8%
Under $20K......	155	30%	61%	9%
$20K to $30K.......	188	34%	60%	6%
$30K to $40K.......	155	34%	59%	8%
$40K to $50K.......	133	32%	64%	5%
Over $50K..........	244	46%	48%	7%
Over $75K.......	95	47%	44%	8%
White..............	779	33%	59%	8%
Black..............	100	40%	56%	4%
Hispanic...........	66	44%	48%	8%
All Other..........	56	48%	45%	7%
Have Children......	666	34%	58%	8%
Encourage/Artist	523	35%	57%	8%
Don't Have Children	335	38%	56%	6%
Willing To Pay More	393	38%	55%	7%
Only Sometimes.....	382	34%	60%	7%
Hardly Ever Pay Mre	211	33%	56%	11%
Have Art In Home...	768	38%	54%	8%
Don't Have Art.....	233	26%	67%	7%
Choice - Choose Art	352	100%	-	-
Would Choose Money.	574	-	100%	-
Not Sure...........	75	-	-	100%
Spend $25-100/Art..	472	25%	69%	6%
Wld Spend Over $200	451	45%	49%	6%
Museum >2 Times Yr.	188	54%	39%	7%
1 or 2 Times A Yr..	301	44%	50%	6%
Less Than Once A Yr	236	29%	64%	7%
Don't Go To Museums	240	20%	72%	8%
Favor Mre Fed Taxes	300	44%	51%	5%
Wld Pay $25 More	197	49%	48%	3%
Pay $5-$15 More.	57	42%	54%	4%
None Of Above...	33	27%	67%	6%
Oppose Mre Fed Taxs	571	30%	62%	7%
Not Sure...........	130	35%	51%	14%

Q73. Which one of the following would be the most important to you
in deciding how much money you would spend on a painting?

	TOTAL	Size Of The Piece	Fame Of The Artist	The Medium	Degree You Like Paintg	Whethr Think Incrse Value	Depnds	Not Sure
All Voters........	1001	3%	7%	5%	62%	16%	4%	3%
Northeast..........	216	4%	8%	6%	61%	14%	4%	3%
South..............	335	3%	7%	6%	60%	17%	3%	4%
Central............	241	1%	4%	7%	67%	14%	3%	4%
West...............	209	3%	7%	3%	58%	19%	6%	4%
Male...............	475	3%	7%	5%	60%	19%	4%	3%
Female.............	526	3%	6%	6%	63%	14%	4%	4%
Under 30...........	247	4%	8%	6%	63%	15%	4%	*
30 to 39...........	263	3%	5%	3%	64%	21%	2%	3%
40 to 49...........	191	2%	5%	6%	65%	14%	5%	3%
50 to 64...........	154	2%	8%	6%	57%	19%	3%	5%
65 And Over........	131	5%	8%	7%	55%	11%	5%	9%
High School/Less...	421	4%	7%	6%	53%	21%	4%	5%
Some College.......	281	3%	6%	5%	65%	15%	3%	3%
College Graduate...	293	2%	7%	4%	69%	10%	5%	2%
Post-Graduate....	103	-	10%	2%	73%	8%	4%	4%
Liberal............	319	3%	7%	7%	65%	13%	3%	2%
Moderate/Other.....	207	3%	8%	6%	56%	14%	7%	6%
Conservative.......	475	3%	6%	4%	62%	19%	4%	3%
Under $30K.........	343	4%	7%	8%	52%	20%	4%	4%
Under $20K......	155	6%	6%	9%	47%	22%	5%	6%
$20K to $30K.......	188	3%	9%	7%	56%	19%	3%	3%
$30K to $40K.......	155	2%	3%	6%	63%	20%	4%	3%
$40K to $50K.......	133	2%	8%	3%	68%	15%	2%	2%
Over $50K..........	244	2%	7%	2%	70%	13%	4%	1%
Over $75K.......	95	2%	5%	2%	73%	12%	5%	1%
White..............	779	2%	5%	5%	65%	15%	4%	4%
Black..............	100	7%	11%	11%	43%	23%	1%	4%
Hispanic...........	66	2%	15%	6%	55%	20%	2%	2%
All Other..........	56	2%	11%	4%	57%	20%	4%	4%
Have Children......	666	3%	6%	6%	62%	16%	4%	4%
Encourage/Artist	523	3%	7%	7%	63%	15%	3%	3%
Don't Have Children	335	2%	7%	5%	62%	18%	4%	3%
Willing To Pay More	393	2%	7%	5%	61%	18%	4%	3%
Only Sometimes.....	382	4%	7%	6%	63%	15%	4%	2%
Hardly Ever Pay Mre	211	2%	6%	5%	60%	18%	3%	6%
Have Art In Home...	768	2%	7%	5%	65%	14%	4%	3%
Don't Have Art.....	233	5%	6%	6%	49%	23%	4%	6%
Choice - Choose Art	352	1%	8%	6%	64%	14%	4%	2%
Would Choose Money.	574	4%	6%	5%	60%	18%	3%	4%
Not Sure...........	75	3%	3%	4%	61%	15%	8%	7%
Spend $25-100/Art..	472	5%	6%	6%	60%	18%	3%	3%
Wld Spend Over $200	451	1%	8%	5%	65%	16%	4%	1%
Museum >2 Times Yr.	188	2%	11%	5%	63%	12%	6%	2%
1 or 2 Times A Yr..	301	2%	7%	7%	65%	15%	3%	1%
Less Than Once A Yr	236	3%	4%	4%	65%	17%	3%	4%
Don't Go To Museums	240	4%	5%	5%	56%	20%	3%	6%
Favor Mre Fed Taxes	300	4%	6%	6%	64%	15%	3%	2%
Wld Pay $25 More	197	3%	6%	5%	68%	14%	3%	1%
Pay $5-$15 More.	57	5%	7%	9%	61%	16%	-	2%
None Of Above...	33	3%	6%	6%	55%	21%	3%	6%
Oppose Mre Fed Taxs	571	3%	7%	5%	61%	17%	5%	3%
Not Sure...........	130	2%	7%	5%	58%	17%	4%	8%

Q74. What is the most amount of money you would consider spending
on a piece of art you really like?

	TOTAL	$25 -50	$50- 100	$200 -500	$500- 1000	$1000 -3000	Over $3000	Not Sure
All Voters.........	1001	20%	27%	28%	9%	3%	5%	8%
Northeast..........	216	21%	27%	25%	11%	4%	3%	9%
South..............	335	21%	25%	29%	9%	4%	6%	7%
Central............	241	24%	28%	27%	6%	1%	5%	9%
West...............	209	14%	28%	29%	11%	4%	5%	8%
Male...............	475	20%	24%	27%	10%	4%	6%	8%
Female.............	526	20%	29%	28%	8%	2%	4%	7%
Under 30...........	247	17%	33%	31%	10%	2%	3%	4%
30 to 39...........	263	20%	27%	31%	10%	3%	3%	6%
40 to 49...........	191	16%	25%	27%	9%	6%	10%	6%
50 to 64...........	154	22%	23%	25%	9%	3%	6%	11%
65 And Over........	131	27%	24%	21%	7%	3%	4%	15%
High School/Less...	421	31%	30%	22%	6%	1%	2%	8%
Some College.......	281	16%	29%	30%	9%	5%	4%	8%
College Graduate...	293	10%	21%	34%	14%	5%	9%	8%
Post-Graduate....	103	9%	20%	29%	17%	5%	13%	8%
Liberal............	319	15%	31%	27%	12%	4%	5%	7%
Moderate/Other.....	207	22%	27%	28%	5%	2%	5%	12%
Conservative.......	475	23%	24%	28%	9%	3%	5%	7%
Under $30K.........	343	32%	27%	24%	6%	1%	3%	6%
Under $20K......	155	41%	25%	17%	5%	3%	3%	6%
$20K to $30K.......	188	25%	29%	30%	7%	1%	3%	5%
$30K to $40K.......	155	20%	36%	24%	7%	3%	3%	6%
$40K to $50K.......	133	11%	30%	36%	13%	2%	5%	3%
Over $50K..........	244	7%	21%	36%	15%	7%	9%	6%
Over $75K.......	95	3%	15%	37%	17%	7%	13%	8%
White..............	779	21%	26%	28%	9%	3%	5%	8%
Black..............	100	16%	34%	26%	9%	6%	4%	5%
Hispanic...........	66	24%	29%	24%	11%	–	8%	5%
All Other..........	56	13%	21%	34%	13%	7%	4%	9%
Have Children......	666	22%	26%	26%	9%	3%	6%	8%
Encourage/Artist	523	22%	26%	26%	9%	3%	6%	8%
Don't Have Children	335	17%	30%	30%	10%	4%	3%	7%
Willing To Pay More	393	13%	24%	34%	10%	5%	6%	7%
Only Sometimes.....	382	22%	32%	27%	7%	1%	3%	7%
Hardly Ever Pay Mre	211	31%	24%	16%	11%	3%	5%	10%
Have Art In Home...	768	17%	25%	31%	10%	4%	6%	7%
Don't Have Art.....	233	32%	33%	17%	5%	2%	1%	9%
Choice - Choose Art	352	12%	22%	33%	13%	5%	8%	8%
Would Choose Money.	574	26%	30%	25%	7%	2%	3%	5%
Not Sure..........	75	15%	24%	21%	8%	4%	3%	25%
Spend $25-100/Art..	472	43%	57%	–	–	–	–	–
Wld Spend Over $200	451	–	–	61%	20%	7%	11%	–
Museum >2 Times Yr.	188	11%	14%	28%	14%	8%	15%	10%
1 or 2 Times A Yr..	301	12%	26%	40%	12%	3%	3%	4%
Less Than Once A Yr	236	19%	32%	29%	8%	3%	2%	7%
Don't Go To Museums	240	38%	33%	14%	3%	–	2%	10%
Favor Mre Fed Taxes	300	16%	23%	31%	13%	4%	7%	6%
Wld Pay $25 More	197	10%	21%	31%	17%	6%	9%	6%
Pay $5-$15 More.	57	25%	30%	39%	4%	–	2%	2%
None Of Above...	33	39%	21%	21%	3%	3%	3%	9%
Oppose Mre Fed Taxs	571	21%	30%	27%	8%	3%	4%	7%
Not Sure..........	130	26%	22%	21%	8%	4%	3%	16%

Q75. Favorability Rating: Pablo Picasso.

	TOTAL	TOTAL FAVRBL	Very Favrbl	Favrbl	Unfavr	Very Unfavr	TOTAL UNFAVR	Never Heard	Don't Know
All Voters.........	1001	64%	20%	45%	14%	5%	19%	5%	11%
Northeast..........	216	69%	22%	48%	13%	2%	16%	4%	11%
South..............	335	61%	19%	42%	15%	5%	20%	6%	13%
Central............	241	61%	20%	41%	11%	7%	18%	9%	12%
West...............	209	68%	19%	49%	18%	5%	23%	3%	5%
Male...............	475	66%	21%	45%	15%	4%	19%	6%	9%
Female.............	526	63%	19%	44%	14%	6%	20%	5%	12%
Under 30...........	247	76%	23%	53%	10%	3%	13%	5%	6%
30 to 39...........	263	67%	18%	49%	14%	5%	19%	5%	8%
40 to 49...........	191	68%	21%	47%	17%	3%	20%	1%	10%
50 to 64...........	154	51%	18%	34%	16%	10%	26%	10%	12%
65 And Over........	131	49%	15%	34%	18%	5%	23%	8%	21%
High School/Less...	421	61%	16%	45%	10%	4%	14%	9%	17%
Some College.......	281	64%	22%	42%	19%	4%	23%	5%	9%
College Graduate...	293	72%	23%	48%	16%	7%	24%	1%	3%
Post-Graduate....	103	70%	29%	41%	19%	10%	29%	–	1%
Liberal............	319	71%	26%	45%	14%	5%	19%	3%	8%
Moderate/Other.....	207	65%	20%	45%	11%	3%	14%	8%	13%
Conservative.......	475	60%	16%	45%	16%	6%	22%	7%	11%
Under $30K.........	343	62%	18%	44%	14%	4%	18%	9%	11%
Under $20K......	155	58%	15%	43%	12%	5%	16%	12%	14%
$20K to $30K.......	188	65%	20%	46%	15%	4%	19%	6%	10%
$30K to $40K.......	155	68%	23%	45%	12%	6%	18%	5%	9%
$40K to $50K.......	133	65%	19%	46%	18%	5%	23%	2%	11%
Over $50K..........	244	72%	21%	51%	16%	5%	20%	2%	5%
Over $75K.......	95	73%	20%	53%	18%	5%	23%	2%	2%
White..............	779	63%	18%	45%	16%	5%	21%	5%	11%
Black..............	100	61%	19%	42%	6%	3%	9%	12%	18%
Hispanic...........	66	82%	32%	50%	11%	2%	12%	3%	3%
All Other..........	56	66%	29%	38%	13%	9%	21%	5%	7%
Have Children......	666	60%	19%	41%	16%	5%	21%	7%	12%
Encourage/Artist	523	61%	21%	40%	16%	5%	21%	6%	11%
Don't Have Children	335	74%	22%	52%	11%	4%	16%	3%	8%
Willing To Pay More	393	67%	21%	46%	14%	7%	21%	4%	8%
Only Sometimes.....	382	67%	19%	48%	15%	3%	18%	5%	11%
Hardly Ever Pay Mre	211	55%	19%	36%	16%	6%	21%	9%	15%
Have Art In Home...	768	65%	20%	45%	16%	4%	20%	4%	10%
Don't Have Art.....	233	61%	18%	42%	9%	7%	16%	9%	14%
Choice - Choose Art	352	68%	24%	44%	17%	6%	22%	4%	5%
Would Choose Money.	574	63%	17%	46%	13%	5%	17%	7%	14%
Not Sure..........	75	61%	23%	39%	17%	4%	21%	3%	15%
Spend $25-100/Art..	472	58%	15%	43%	14%	4%	18%	9%	14%
Wld Spend Over $200	451	72%	25%	47%	16%	5%	21%	1%	6%
Museum >2 Times Yr.	188	80%	35%	45%	12%	6%	18%	1%	1%
1 or 2 Times A Yr..	301	72%	18%	54%	16%	4%	20%	4%	5%
Less Than Once A Yr	236	59%	16%	43%	20%	7%	27%	3%	11%
Don't Go To Museums	240	50%	13%	37%	10%	5%	15%	12%	24%
Favor Mre Fed Taxes	300	71%	24%	47%	14%	5%	19%	4%	6%
Wld Pay $25 More	197	72%	22%	49%	15%	6%	21%	1%	6%
Pay $5-$15 More.	57	72%	28%	44%	16%	–	16%	7%	5%
None Of Above...	33	67%	27%	39%	3%	6%	9%	15%	9%
Oppose Mre Fed Taxs	571	63%	18%	45%	15%	5%	20%	6%	11%
Not Sure..........	130	55%	16%	39%	12%	5%	17%	8%	19%

Q76. Favorability Rating: Norman Rockwell.

	TOTAL	TOTAL FAVRBL	Very Favrbl	Favrbl	Unfavr	Very Unfavr	TOTAL UNFAVR	Never Heard	Don't Know
All Voters.........	1001	81%	43%	38%	5%	2%	7%	6%	6%
Northeast..........	216	79%	44%	35%	6%	3%	9%	6%	7%
South..............	335	79%	37%	42%	5%	1%	6%	8%	7%
Central............	241	82%	50%	32%	5%	2%	6%	7%	5%
West...............	209	86%	45%	41%	5%	2%	7%	2%	5%
Male...............	475	81%	44%	38%	5%	2%	7%	6%	6%
Female.............	526	81%	43%	37%	5%	2%	7%	6%	6%
Under 30...........	247	71%	36%	36%	7%	4%	11%	9%	9%
30 to 39...........	263	82%	46%	36%	3%	2%	5%	6%	7%
40 to 49...........	191	86%	44%	42%	6%	1%	7%	3%	3%
50 to 64...........	154	82%	45%	37%	6%	1%	6%	8%	3%
65 And Over........	131	85%	47%	38%	3%	1%	4%	5%	7%
High School/Less...	421	78%	41%	37%	3%	1%	4%	9%	9%
Some College.......	281	83%	44%	38%	5%	2%	7%	6%	4%
College Graduate...	293	83%	46%	38%	9%	2%	11%	3%	3%
Post-Graduate....	103	82%	50%	32%	13%	2%	15%	2%	2%
Liberal............	319	80%	41%	39%	7%	2%	9%	5%	5%
Moderate/Other.....	207	79%	41%	38%	5%	2%	7%	7%	7%
Conservative.......	475	82%	46%	36%	4%	1%	5%	7%	6%
Under $30K.........	343	77%	39%	38%	4%	3%	7%	9%	7%
Under $20K......	155	72%	33%	39%	5%	2%	7%	12%	9%
$20K to $30K.......	188	81%	45%	37%	3%	3%	6%	7%	5%
$30K to $40K.......	155	79%	46%	33%	5%	3%	8%	7%	6%
$40K to $50K.......	133	86%	47%	39%	6%	1%	7%	2%	5%
Over $50K..........	244	87%	47%	40%	6%	1%	7%	3%	3%
Over $75K.......	95	87%	40%	47%	8%	1%	9%	1%	2%
White..............	779	84%	47%	37%	5%	1%	7%	4%	5%
Black..............	100	66%	24%	42%	4%	1%	5%	15%	14%
Hispanic...........	66	67%	33%	33%	8%	3%	11%	15%	8%
All Other..........	56	75%	38%	38%	2%	7%	9%	13%	4%
Have Children......	666	83%	43%	39%	5%	1%	6%	6%	5%
Encourage/Artist	523	84%	46%	39%	4%	2%	6%	6%	4%
Don't Have Children	335	77%	43%	34%	6%	3%	9%	7%	7%
Willing To Pay More	393	82%	45%	37%	5%	2%	7%	5%	6%
Only Sometimes.....	382	83%	42%	41%	5%	1%	6%	6%	4%
Hardly Ever Pay Mre	211	76%	43%	33%	5%	3%	8%	8%	9%
Have Art In Home...	768	82%	45%	37%	6%	2%	8%	5%	5%
Don't Have Art.....	233	78%	39%	39%	2%	1%	3%	9%	9%
Choice - Choose Art	352	80%	45%	35%	6%	3%	9%	6%	4%
Would Choose Money.	574	81%	42%	39%	5%	1%	6%	6%	7%
Not Sure...........	75	83%	44%	39%	5%	-	5%	5%	7%
Spend $25-100/Art..	472	79%	43%	35%	4%	2%	6%	8%	7%
Wld Spend Over $200	451	83%	44%	40%	6%	2%	8%	4%	4%
Museum >2 Times Yr.	188	78%	38%	40%	12%	4%	15%	4%	3%
1 or 2 Times A Yr..	301	83%	47%	36%	4%	2%	6%	7%	4%
Less Than Once A Yr	236	87%	51%	36%	3%	1%	4%	5%	4%
Don't Go To Museums	240	77%	39%	38%	3%	1%	4%	9%	10%
Favor Mre Fed Taxes	300	80%	43%	38%	8%	3%	11%	4%	5%
Wld Pay $25 More	197	82%	46%	36%	9%	4%	13%	3%	3%
Pay $5-$15 More.	57	82%	40%	42%	11%	-	11%	2%	5%
None Of Above...	33	70%	27%	42%	-	6%	6%	12%	12%
Oppose Mre Fed Taxs	571	83%	46%	37%	4%	1%	5%	6%	6%
Not Sure...........	130	74%	34%	40%	3%	2%	5%	12%	9%

Q77. Favorability Rating: Jackson Pollock.

	TOTAL	TOTAL FAVRBL	Very Favrbl	Favrbl	Unfavr	Very Unfavr	TOTAL UNFAVR	Never Heard	Don't Know
All Voters.........	1001	15%	4%	11%	6%	1%	7%	49%	28%
Northeast..........	216	17%	4%	13%	8%	3%	11%	42%	30%
South..............	335	15%	4%	10%	6%	1%	7%	50%	27%
Central............	241	14%	3%	11%	5%	1%	6%	51%	29%
West...............	209	16%	4%	11%	5%	*	5%	52%	27%
Male...............	475	17%	5%	12%	6%	1%	7%	49%	27%
Female.............	526	14%	3%	11%	6%	2%	8%	49%	29%
Under 30...........	247	15%	3%	11%	6%	1%	8%	50%	28%
30 to 39...........	263	16%	2%	14%	4%	1%	5%	52%	27%
40 to 49...........	191	20%	6%	14%	4%	2%	6%	48%	27%
50 to 64...........	154	15%	6%	9%	9%	1%	10%	49%	26%
65 And Over........	131	10%	3%	7%	8%	2%	9%	47%	34%
High School/Less...	421	9%	2%	8%	5%	2%	7%	57%	27%
Some College.......	281	15%	4%	10%	6%	1%	7%	46%	32%
College Graduate...	293	25%	7%	18%	8%	1%	9%	41%	25%
Post-Graduate....	103	27%	8%	19%	8%	2%	10%	32%	31%
Liberal............	319	20%	5%	15%	7%	1%	8%	45%	26%
Moderate/Other.....	207	14%	3%	11%	5%	3%	9%	47%	30%
Conservative.......	475	13%	3%	9%	5%	1%	6%	52%	29%
Under $30K.........	343	11%	3%	8%	4%	2%	6%	56%	27%
Under $20K......	155	10%	2%	8%	3%	2%	5%	60%	25%
$20K to $30K.......	188	12%	4%	7%	5%	2%	7%	52%	29%
$30K to $40K.......	155	15%	3%	12%	5%	1%	6%	48%	31%
$40K to $50K.......	133	16%	2%	14%	11%	-	11%	46%	27%
Over $50K..........	244	25%	7%	18%	6%	2%	8%	44%	23%
Over $75K.......	95	28%	8%	20%	7%	3%	11%	40%	21%
White..............	779	15%	4%	12%	6%	1%	7%	50%	28%
Black..............	100	22%	7%	15%	3%	3%	6%	43%	29%
Hispanic...........	66	15%	5%	11%	9%	-	9%	50%	26%
All Other..........	56	4%	-	4%	7%	2%	9%	52%	36%
Have Children......	666	15%	4%	11%	6%	2%	7%	50%	27%
Encourage/Artist	523	17%	5%	12%	6%	1%	7%	50%	26%
Don't Have Children	335	16%	3%	13%	7%	1%	8%	47%	30%
Willing To Pay More	393	18%	6%	13%	4%	2%	5%	50%	26%
Only Sometimes.....	382	14%	3%	11%	6%	1%	7%	49%	30%
Hardly Ever Pay Mre	211	13%	2%	10%	9%	2%	11%	45%	31%
Have Art In Home...	768	18%	5%	13%	6%	2%	8%	46%	28%
Don't Have Art.....	233	8%	*	8%	5%	1%	6%	59%	27%
Choice - Choose Art	352	21%	5%	16%	6%	2%	8%	44%	26%
Would Choose Money.	574	12%	3%	9%	6%	1%	7%	53%	28%
Not Sure...........	75	13%	4%	9%	5%	1%	7%	44%	36%
Spend $25-100/Art..	472	9%	1%	8%	5%	2%	7%	54%	31%
Wld Spend Over $200	451	23%	7%	16%	7%	1%	9%	43%	26%
Museum >2 Times Yr.	188	34%	11%	23%	13%	3%	16%	31%	19%
1 or 2 Times A Yr..	301	20%	4%	15%	6%	1%	7%	48%	26%
Less Than Once A Yr	236	9%	1%	8%	4%	*	4%	53%	34%
Don't Go To Museums	240	3%	1%	2%	3%	2%	5%	62%	30%
Favor Mre Fed Taxes	300	25%	7%	18%	5%	2%	7%	44%	25%
Wld Pay $25 More	197	29%	7%	22%	6%	2%	8%	42%	21%
Pay $5-$15 More.	57	14%	4%	11%	2%	4%	5%	47%	33%
None Of Above...	33	15%	9%	6%	6%	-	6%	55%	24%
Oppose Mre Fed Taxs	571	12%	3%	9%	6%	1%	8%	51%	29%
Not Sure...........	130	8%	3%	5%	5%	2%	7%	53%	32%

Q78. Favorability Rating: Salvador Dali.

	TOTAL	TOTAL FAVRBL	Very Favrbl	Favrbl	Unfavr	Very Unfavr	TOTAL UNFAVR	Never Heard	Don't Know
All Voters.........	1001	32%	9%	23%	12%	5%	17%	31%	20%
Northeast..........	216	37%	10%	27%	12%	6%	18%	26%	19%
South..............	335	31%	10%	21%	11%	4%	15%	35%	20%
Central............	241	29%	8%	21%	10%	5%	15%	34%	22%
West...............	209	30%	8%	22%	16%	5%	22%	29%	20%
Male...............	475	35%	10%	24%	12%	4%	16%	31%	18%
Female.............	526	29%	8%	21%	12%	6%	18%	32%	22%
Under 30...........	247	34%	15%	20%	8%	2%	10%	34%	22%
30 to 39...........	263	30%	5%	25%	9%	3%	12%	39%	19%
40 to 49...........	191	35%	12%	24%	17%	6%	23%	22%	20%
50 to 64...........	154	28%	4%	24%	14%	8%	23%	31%	18%
65 And Over........	131	29%	8%	21%	17%	5%	22%	29%	20%
High School/Less...	421	20%	5%	15%	8%	4%	12%	43%	25%
Some College.......	281	35%	11%	24%	14%	3%	17%	28%	21%
College Graduate...	293	45%	13%	32%	16%	7%	23%	19%	13%
Post-Graduate....	103	48%	12%	36%	17%	8%	24%	14%	15%
Liberal............	319	39%	13%	27%	11%	5%	16%	27%	18%
Moderate/Other.....	207	32%	10%	23%	14%	5%	18%	29%	20%
Conservative.......	475	26%	6%	20%	13%	4%	17%	36%	22%
Under $30K.........	343	27%	8%	19%	9%	4%	13%	39%	21%
Under $20K......	155	23%	8%	15%	8%	5%	13%	43%	21%
$20K to $30K.......	188	30%	8%	22%	10%	3%	13%	36%	20%
$30K to $40K.......	155	26%	5%	22%	10%	3%	12%	37%	25%
$40K to $50K.......	133	26%	6%	20%	18%	6%	24%	29%	21%
Over $50K..........	244	47%	14%	33%	14%	7%	21%	19%	13%
Over $75K.......	95	58%	23%	35%	14%	5%	19%	13%	11%
White..............	779	32%	10%	22%	13%	5%	18%	30%	19%
Black..............	100	29%	3%	26%	7%	2%	9%	33%	29%
Hispanic...........	66	36%	11%	26%	12%	–	12%	36%	15%
All Other..........	56	27%	7%	20%	11%	5%	16%	36%	21%
Have Children......	666	28%	7%	21%	13%	6%	18%	34%	20%
Encourage/Artist	523	29%	8%	21%	12%	7%	19%	33%	19%
Don't Have Children	335	39%	13%	26%	11%	3%	14%	27%	20%
Willing To Pay More	393	33%	10%	23%	11%	5%	17%	30%	20%
Only Sometimes.....	382	34%	8%	25%	12%	4%	16%	31%	20%
Hardly Ever Pay Mre	211	25%	8%	17%	14%	5%	19%	34%	23%
Have Art In Home...	768	35%	10%	25%	13%	5%	18%	28%	18%
Don't Have Art.....	233	19%	5%	14%	11%	2%	13%	42%	27%
Choice - Choose Art	352	42%	13%	29%	13%	5%	18%	26%	15%
Would Choose Money.	574	24%	6%	18%	13%	5%	17%	36%	23%
Not Sure...........	75	41%	11%	31%	8%	4%	12%	21%	25%
Spend $25-100/Art..	472	22%	5%	17%	11%	4%	15%	39%	25%
Wld Spend Over $200	451	41%	13%	28%	15%	6%	21%	24%	15%
Museum >2 Times Yr.	188	53%	18%	36%	15%	8%	23%	13%	11%
1 or 2 Times A Yr.	301	41%	11%	29%	14%	5%	18%	28%	14%
Less Than Once A Yr	236	26%	5%	21%	14%	4%	17%	33%	24%
Don't Go To Museums	240	12%	3%	8%	8%	4%	12%	48%	29%
Favor Mre Fed Taxes	300	42%	13%	29%	10%	5%	15%	28%	15%
Wld Pay $25 More	197	48%	12%	36%	10%	6%	15%	24%	13%
Pay $5-$15 More.	57	33%	14%	19%	12%	5%	18%	30%	19%
None Of Above...	33	24%	15%	9%	9%	3%	12%	45%	18%
Oppose Mre Fed Taxs	571	27%	8%	19%	15%	5%	19%	33%	21%
Not Sure...........	130	28%	5%	24%	7%	3%	10%	35%	27%

Q79. Favorability Rating: Leroy Neiman.

	TOTAL	TOTAL FAVRBL	Very Favrbl	Favrbl	Unfavr	Very Unfavr	TOTAL UNFAVR	Never Heard	Don't Know
All Voters.........	1001	25%	5%	20%	7%	3%	10%	40%	26%
Northeast..........	216	27%	5%	23%	9%	3%	13%	36%	24%
South..............	335	22%	4%	18%	5%	2%	8%	43%	27%
Central............	241	22%	4%	17%	6%	2%	8%	41%	29%
West...............	209	30%	6%	23%	9%	3%	12%	37%	21%
Male...............	475	27%	6%	22%	8%	3%	12%	36%	25%
Female.............	526	22%	4%	18%	6%	2%	8%	43%	26%
Under 30...........	247	20%	4%	16%	5%	3%	9%	47%	24%
30 to 39...........	263	25%	4%	21%	8%	2%	10%	40%	25%
40 to 49...........	191	35%	8%	26%	10%	3%	13%	28%	24%
50 to 64...........	154	25%	3%	21%	5%	3%	8%	42%	25%
65 And Over........	131	21%	4%	17%	5%	2%	7%	40%	32%
High School/Less...	421	18%	3%	15%	5%	2%	7%	48%	28%
Some College.......	281	26%	4%	22%	8%	3%	11%	33%	30%
College Graduate...	293	33%	8%	25%	9%	3%	12%	35%	19%
Post-Graduate....	103	32%	10%	22%	12%	5%	17%	31%	20%
Liberal............	319	24%	5%	19%	8%	3%	11%	40%	25%
Moderate/Other.....	207	22%	4%	18%	8%	3%	12%	39%	27%
Conservative.......	475	26%	5%	21%	6%	2%	8%	40%	25%
Under $30K.........	343	21%	3%	17%	5%	2%	7%	48%	25%
Under $20K......	155	17%	1%	15%	5%	1%	6%	55%	22%
$20K to $30K.......	188	24%	5%	19%	6%	2%	8%	41%	27%
$30K to $40K.......	155	19%	2%	17%	7%	4%	11%	39%	30%
$40K to $50K.......	133	29%	4%	26%	10%	2%	12%	35%	23%
Over $50K..........	244	36%	9%	26%	9%	3%	12%	31%	21%
Over $75K.......	95	36%	12%	24%	15%	4%	19%	27%	18%
White..............	779	26%	5%	21%	7%	2%	9%	40%	25%
Black..............	100	25%	5%	20%	7%	4%	11%	35%	29%
Hispanic...........	66	14%	5%	9%	14%	2%	15%	42%	29%
All Other..........	56	25%	2%	23%	5%	4%	9%	41%	25%
Have Children......	666	26%	5%	21%	6%	2%	9%	40%	25%
Encourage/Artist	523	24%	5%	19%	7%	2%	9%	41%	25%
Don't Have Children	335	23%	5%	18%	8%	3%	12%	39%	26%
Willing To Pay More	393	28%	6%	22%	8%	4%	11%	37%	24%
Only Sometimes.....	382	24%	3%	21%	7%	2%	9%	41%	26%
Hardly Ever Pay Mre	211	21%	6%	15%	6%	3%	9%	42%	28%
Have Art In Home...	768	26%	5%	21%	7%	3%	9%	40%	25%
Don't Have Art.....	233	19%	4%	15%	8%	3%	11%	41%	29%
Choice - Choose Art	352	30%	6%	24%	9%	3%	12%	37%	21%
Would Choose Money.	574	22%	4%	18%	6%	2%	8%	42%	28%
Not Sure...........	75	16%	4%	12%	9%	4%	13%	36%	35%
Spend $25-100/Art..	472	18%	3%	15%	6%	2%	8%	46%	28%
Wld Spend Over $200	451	32%	7%	25%	9%	3%	12%	32%	23%
Museum >2 Times Yr.	188	34%	9%	26%	14%	5%	19%	30%	17%
1 or 2 Times A Yr.	301	32%	6%	26%	6%	3%	9%	36%	23%
Less Than Once A Yr	236	23%	3%	20%	4%	2%	6%	41%	30%
Don't Go To Museums	240	12%	2%	10%	7%	2%	8%	50%	30%
Favor Mre Fed Taxes	300	29%	6%	24%	10%	3%	13%	38%	20%
Wld Pay $25 More	197	32%	6%	27%	12%	3%	15%	36%	17%
Pay $5-$15 More.	57	26%	4%	23%	9%	4%	12%	37%	25%
None Of Above...	33	21%	12%	9%	6%	–	6%	55%	18%
Oppose Mre Fed Taxs	571	23%	4%	19%	7%	3%	9%	40%	27%
Not Sure...........	130	19%	5%	14%	2%	2%	5%	45%	32%

Q80. Favorability Rating: Claude Monet.

	TOTAL	TOTAL FAVRBL	Very Favrbl	Favrbl	Unfavr	Very Unfavr	TOTAL UNFAVR	Never Heard	Don't Know
All Voters.........	1001	57%	24%	33%	4%	1%	5%	21%	16%
Northeast..........	216	65%	28%	37%	2%	3%	5%	13%	18%
South..............	335	53%	21%	31%	5%	1%	5%	26%	16%
Central............	241	55%	25%	30%	4%	1%	5%	23%	17%
West...............	209	58%	22%	36%	5%	2%	7%	20%	14%
Male...............	475	55%	22%	33%	4%	1%	5%	24%	16%
Female.............	526	59%	25%	34%	4%	2%	6%	19%	17%
Under 30...........	247	60%	26%	35%	4%	2%	6%	18%	15%
30 to 39...........	263	53%	18%	35%	3%	1%	4%	25%	17%
40 to 49...........	191	62%	29%	34%	7%	-	7%	15%	16%
50 to 64...........	154	58%	25%	33%	3%	1%	5%	25%	12%
65 And Over........	131	51%	24%	27%	2%	2%	4%	24%	21%
High School/Less...	421	40%	11%	29%	4%	2%	6%	31%	23%
Some College.......	281	63%	26%	37%	4%	1%	5%	16%	15%
College Graduate...	293	75%	39%	36%	4%	1%	5%	12%	8%
Post-Graduate....	103	79%	38%	41%	4%	-	4%	11%	7%
Liberal............	319	62%	29%	33%	3%	2%	5%	18%	15%
Moderate/Other.....	207	55%	22%	33%	4%	2%	6%	24%	15%
Conservative......	475	55%	21%	33%	4%	1%	5%	22%	18%
Under $30K.........	343	48%	15%	33%	5%	3%	8%	27%	17%
Under $20K......	155	42%	15%	26%	6%	3%	9%	32%	17%
$20K to $30K.......	188	53%	15%	38%	3%	4%	7%	22%	18%
$30K to $40K.......	155	53%	25%	28%	4%	2%	6%	22%	19%
$40K to $50K.......	133	62%	23%	38%	3%	-	3%	20%	16%
Over $50K..........	244	75%	36%	39%	4%	-	4%	11%	10%
Over $75K.......	95	79%	41%	38%	7%	-	7%	5%	8%
White..............	779	59%	25%	35%	4%	1%	5%	20%	15%
Black.............	100	46%	17%	29%	5%	3%	8%	24%	22%
Hispanic...........	66	44%	26%	18%	-	5%	5%	33%	18%
All Other..........	56	59%	23%	36%	2%	4%	5%	18%	18%
Have Children......	666	54%	23%	32%	4%	1%	5%	23%	17%
Encourage/Artist	523	55%	25%	30%	5%	2%	6%	24%	15%
Don't Have Children	335	63%	26%	37%	4%	2%	6%	17%	14%
Willing To Pay More	393	60%	28%	32%	4%	1%	5%	21%	13%
Only Sometimes.....	382	58%	21%	37%	4%	2%	6%	20%	17%
Hardly Ever Pay Mre	211	50%	22%	28%	3%	2%	5%	23%	22%
Have Art In Home...	768	63%	28%	35%	4%	2%	5%	17%	15%
Don't Have Art.....	233	39%	10%	28%	4%	1%	6%	33%	22%
Choice - Choose Art	352	66%	29%	37%	4%	3%	6%	18%	9%
Would Choose Money.	574	52%	20%	31%	4%	1%	5%	23%	20%
Not Sure...........	75	57%	24%	33%	7%	-	7%	16%	20%
Spend $25-100/Art..	472	45%	15%	30%	5%	2%	7%	27%	21%
Wld Spend Over $200	451	71%	33%	39%	3%	1%	4%	14%	11%
Museum >2 Times Yr.	188	81%	39%	43%	3%	3%	6%	10%	3%
1 or 2 Times A Yr..	301	73%	33%	40%	3%	1%	3%	16%	8%
Less Than Once A Yr	236	52%	20%	32%	5%	2%	7%	19%	22%
Don't Go To Museums	240	28%	6%	22%	5%	2%	7%	36%	28%
Favor Mre Fed Taxes	300	67%	32%	36%	3%	2%	4%	18%	11%
Wld Pay $25 More	197	75%	35%	40%	2%	2%	4%	15%	7%
Pay $5-$15 More.	57	58%	26%	32%	5%	2%	7%	18%	18%
None Of Above...	33	42%	24%	18%	3%	3%	6%	39%	12%
Oppose Mre Fed Taxs	571	54%	20%	33%	5%	2%	6%	22%	18%
Not Sure...........	130	48%	22%	27%	3%	1%	4%	25%	22%

Q81. Favorability Rating: Rembrandt.

	TOTAL	TOTAL FAVRBL	Very Favrbl	Favrbl	Unfavr	Very Unfavr	TOTAL UNFAVR	Never Heard	Don't Know
All Voters.........	1001	79%	32%	46%	5%	1%	7%	6%	8%
Northeast..........	216	81%	38%	43%	6%	1%	6%	6%	7%
South..............	335	76%	27%	48%	5%	1%	6%	8%	10%
Central............	241	78%	32%	46%	6%	2%	8%	6%	8%
West...............	209	84%	36%	47%	5%	2%	7%	5%	4%
Male...............	475	80%	33%	46%	6%	1%	7%	7%	7%
Female.............	526	78%	32%	47%	5%	2%	7%	6%	9%
Under 30...........	247	72%	26%	46%	5%	1%	6%	12%	10%
30 to 39...........	263	83%	25%	58%	6%	2%	7%	5%	6%
40 to 49...........	191	82%	41%	41%	6%	2%	8%	3%	7%
50 to 64...........	154	82%	34%	48%	4%	2%	6%	6%	6%
65 And Over........	131	76%	44%	32%	5%	2%	6%	7%	11%
High School/Less...	421	72%	26%	46%	6%	1%	7%	10%	11%
Some College.......	281	79%	35%	44%	6%	2%	9%	5%	7%
College Graduate...	293	88%	39%	49%	4%	1%	5%	3%	4%
Post-Graduate....	103	89%	39%	50%	3%	1%	4%	2%	5%
Liberal............	319	82%	34%	47%	7%	2%	8%	5%	5%
Moderate/Other.....	207	75%	33%	42%	4%	1%	6%	8%	12%
Conservative......	475	79%	31%	48%	5%	1%	7%	7%	8%
Under $30K.........	343	76%	30%	46%	5%	1%	6%	11%	7%
Under $20K......	155	71%	34%	37%	5%	1%	6%	14%	8%
$20K to $30K.......	188	80%	27%	53%	5%	1%	6%	9%	5%
$30K to $40K.......	155	79%	31%	48%	5%	1%	6%	6%	9%
$40K to $50K.......	133	83%	28%	55%	6%	2%	8%	2%	8%
Over $50K..........	244	85%	38%	47%	5%	3%	8%	1%	6%
Over $75K.......	95	86%	37%	49%	5%	2%	7%	1%	5%
White..............	779	81%	32%	49%	5%	2%	7%	5%	7%
Black.............	100	64%	34%	30%	8%	-	8%	15%	13%
Hispanic...........	66	80%	32%	48%	5%	2%	6%	6%	8%
All Other..........	56	71%	36%	36%	4%	4%	7%	7%	14%
Have Children......	666	80%	34%	46%	5%	2%	7%	6%	7%
Encourage/Artist	523	82%	38%	44%	5%	1%	6%	5%	6%
Don't Have Children	335	77%	29%	48%	6%	1%	7%	7%	9%
Willing To Pay More	393	79%	33%	46%	7%	1%	8%	5%	8%
Only Sometimes.....	382	81%	34%	47%	4%	2%	6%	6%	7%
Hardly Ever Pay Mre	211	77%	30%	47%	5%	2%	7%	8%	9%
Have Art In Home...	768	81%	35%	46%	5%	2%	7%	5%	7%
Don't Have Art.....	233	71%	24%	47%	6%	1%	8%	10%	12%
Choice - Choose Art	352	83%	39%	43%	4%	3%	7%	5%	5%
Would Choose Money.	574	76%	28%	48%	6%	1%	7%	7%	9%
Not Sure...........	75	79%	32%	47%	9%	1%	11%	4%	7%
Spend $25-100/Art..	472	74%	27%	47%	6%	1%	8%	9%	10%
Wld Spend Over $200	451	86%	39%	47%	4%	1%	6%	3%	5%
Museum >2 Times Yr.	188	89%	47%	41%	6%	2%	7%	3%	1%
1 or 2 Times A Yr..	301	85%	40%	45%	4%	1%	5%	6%	4%
Less Than Once A Yr	236	81%	28%	53%	6%	1%	7%	5%	8%
Don't Go To Museums	240	66%	19%	48%	7%	1%	8%	10%	16%
Favor Mre Fed Taxes	300	82%	35%	47%	6%	2%	8%	6%	4%
Wld Pay $25 More	197	84%	35%	49%	8%	3%	10%	3%	3%
Pay $5-$15 More.	57	77%	35%	42%	7%	-	7%	12%	4%
None Of Above...	33	76%	30%	45%	-	-	-	18%	6%
Oppose Mre Fed Taxs	571	80%	31%	49%	5%	2%	7%	6%	8%
Not Sure...........	130	68%	33%	35%	3%	1%	4%	9%	18%

Q82. Favorability Rating: Andy Warhol.

	TOTAL	TOTAL FAVRBL	Very Favrbl	Favrbl	Unfavr	Very Unfavr	TOTAL UNFAVR	Never Heard	Don't Know
All Voters.........	1001	33%	9%	24%	21%	12%	33%	18%	16%
Northeast..........	216	39%	12%	27%	20%	13%	33%	13%	15%
South..............	335	30%	9%	21%	22%	9%	31%	21%	18%
Central............	241	31%	10%	22%	16%	16%	32%	20%	17%
West...............	209	33%	7%	27%	25%	11%	36%	18%	12%
Male...............	475	38%	11%	27%	20%	11%	31%	17%	15%
Female.............	526	28%	7%	21%	21%	13%	35%	20%	17%
Under 30...........	247	39%	12%	27%	17%	8%	25%	21%	15%
30 to 39...........	263	34%	10%	25%	21%	10%	31%	19%	16%
40 to 49...........	191	36%	10%	25%	27%	13%	40%	9%	15%
50 to 64...........	154	31%	5%	26%	19%	16%	34%	19%	16%
65 And Over........	131	16%	5%	11%	24%	17%	40%	24%	19%
High School/Less...	421	27%	5%	22%	16%	7%	24%	29%	21%
Some College.......	281	33%	11%	22%	23%	17%	40%	14%	14%
College Graduate...	293	41%	13%	28%	26%	14%	40%	9%	10%
Post-Graduate....	103	41%	11%	30%	26%	15%	41%	6%	13%
Liberal............	319	41%	14%	28%	22%	12%	34%	13%	12%
Moderate/Other.....	207	32%	8%	24%	15%	13%	28%	21%	19%
Conservative.......	475	27%	7%	21%	23%	12%	35%	21%	17%
Under $30K.........	343	30%	8%	22%	18%	9%	27%	28%	15%
Under $20K......	155	24%	8%	16%	17%	6%	23%	37%	15%
$20K to $30K.......	188	36%	9%	27%	19%	11%	30%	20%	15%
$30K to $40K.......	155	32%	6%	26%	19%	12%	30%	17%	21%
$40K to $50K.......	133	32%	11%	20%	25%	17%	41%	10%	17%
Over $50K..........	244	39%	10%	28%	27%	14%	41%	11%	9%
Over $75K.......	95	41%	9%	32%	28%	17%	45%	8%	5%
White..............	779	31%	8%	23%	23%	13%	36%	18%	15%
Black.............	100	38%	9%	29%	11%	7%	18%	21%	23%
Hispanic..........	66	39%	15%	24%	20%	6%	26%	23%	12%
All Other..........	56	34%	11%	23%	14%	18%	32%	13%	21%
Have Children......	666	30%	8%	23%	20%	13%	33%	20%	17%
Encourage/Artist	523	32%	9%	23%	20%	12%	32%	20%	16%
Don't Have Children	335	38%	12%	26%	22%	11%	33%	16%	13%
Willing To Pay More	393	37%	11%	26%	20%	12%	32%	17%	14%
Only Sometimes.....	382	33%	8%	25%	21%	12%	32%	19%	16%
Hardly Ever Pay Mre	211	26%	9%	17%	22%	13%	35%	20%	19%
Have Art In Home...	768	34%	10%	25%	22%	13%	35%	16%	15%
Don't Have Art.....	233	27%	7%	21%	17%	9%	26%	27%	20%
Choice - Choose Art	352	38%	12%	27%	22%	13%	35%	16%	11%
Would Choose Money.	574	29%	8%	22%	21%	11%	32%	21%	18%
Not Sure..........	75	32%	8%	24%	20%	13%	33%	16%	19%
Spend $25-100/Art..	472	28%	7%	22%	19%	10%	29%	24%	18%
Wld Spend Over $200	451	39%	12%	27%	25%	14%	38%	12%	12%
Museum >2 Times Yr.	188	46%	17%	29%	24%	14%	38%	8%	9%
1 or 2 Times A Yr..	301	38%	11%	27%	25%	12%	37%	15%	10%
Less Than Once A Yr	236	28%	6%	22%	19%	15%	35%	19%	18%
Don't Go To Museums	240	21%	3%	18%	18%	8%	25%	28%	25%
Favor Mre Fed Taxes	300	42%	11%	31%	24%	10%	34%	13%	11%
Wld Pay $25 More	197	43%	11%	32%	28%	9%	37%	10%	10%
Pay $5-$15 More.	57	40%	4%	37%	21%	11%	32%	18%	11%
None Of Above...	33	39%	18%	21%	12%	12%	24%	21%	15%
Oppose Mre Fed Taxs	571	30%	8%	22%	21%	13%	35%	20%	15%
Not Sure..........	130	24%	8%	15%	11%	13%	24%	22%	30%

Q83. Favorability Rating: Georgia O'Keeffe.

	TOTAL	TOTAL FAVRBL	Very Favrbl	Favrbl	Unfavr	Very Unfavr	TOTAL UNFAVR	Never Heard	Don't Know
All Voters.........	1001	30%	11%	19%	3%	2%	5%	39%	26%
Northeast..........	216	35%	13%	22%	3%	2%	5%	36%	25%
South..............	335	29%	10%	19%	3%	3%	6%	39%	27%
Central............	241	26%	9%	17%	5%	2%	7%	43%	24%
West...............	209	33%	14%	19%	4%	*	4%	37%	26%
Male...............	475	27%	9%	18%	4%	2%	6%	41%	26%
Female.............	526	33%	13%	19%	3%	2%	5%	37%	25%
Under 30...........	247	35%	12%	23%	6%	2%	9%	32%	25%
30 to 39...........	263	29%	10%	19%	3%	3%	5%	42%	24%
40 to 49...........	191	33%	10%	23%	3%	3%	5%	35%	27%
50 to 64...........	154	29%	14%	14%	1%	-	1%	47%	23%
65 And Over........	131	21%	10%	11%	2%	2%	5%	46%	29%
High School/Less...	421	16%	4%	12%	4%	2%	6%	50%	28%
Some College.......	281	33%	12%	20%	4%	1%	5%	35%	28%
College Graduate...	293	48%	21%	27%	3%	2%	5%	27%	20%
Post-Graduate....	103	45%	18%	26%	2%	2%	4%	23%	28%
Liberal............	319	42%	20%	22%	4%	2%	5%	31%	22%
Moderate/Other.....	207	24%	10%	14%	5%	3%	8%	41%	27%
Conservative.......	475	25%	6%	19%	2%	2%	4%	43%	28%
Under $30K.........	343	25%	7%	17%	4%	1%	5%	47%	23%
Under $20K......	155	21%	6%	15%	5%	1%	6%	57%	16%
$20K to $30K.......	188	28%	8%	20%	3%	2%	5%	38%	29%
$30K to $40K.......	155	26%	10%	17%	1%	1%	2%	39%	33%
$40K to $50K.......	133	29%	12%	17%	4%	2%	5%	38%	29%
Over $50K..........	244	43%	17%	27%	5%	3%	7%	30%	20%
Over $75K.......	95	45%	21%	24%	7%	3%	11%	24%	20%
White..............	779	30%	11%	19%	3%	2%	5%	40%	26%
Black.............	100	33%	9%	24%	6%	5%	11%	30%	26%
Hispanic..........	66	29%	18%	11%	3%	3%	6%	41%	24%
All Other..........	56	30%	16%	14%	2%	2%	4%	39%	27%
Have Children......	666	26%	11%	15%	2%	2%	4%	44%	26%
Encourage/Artist	523	27%	12%	15%	2%	2%	4%	44%	24%
Don't Have Children	335	37%	12%	25%	6%	2%	8%	30%	25%
Willing To Pay More	393	35%	13%	22%	4%	2%	6%	37%	22%
Only Sometimes.....	382	27%	10%	17%	3%	2%	5%	39%	29%
Hardly Ever Pay Mre	211	25%	10%	15%	3%	3%	6%	42%	27%
Have Art In Home...	768	34%	14%	20%	3%	2%	5%	35%	25%
Don't Have Art.....	233	17%	3%	13%	4%	2%	6%	51%	27%
Choice - Choose Art	352	39%	18%	20%	4%	2%	6%	34%	21%
Would Choose Money.	574	25%	7%	18%	3%	2%	5%	42%	28%
Not Sure..........	75	25%	8%	17%	4%	3%	7%	36%	32%
Spend $25-100/Art..	472	21%	6%	15%	3%	2%	5%	47%	27%
Wld Spend Over $200	451	42%	17%	25%	4%	2%	6%	29%	24%
Museum >2 Times Yr.	188	57%	31%	27%	4%	4%	8%	23%	12%
1 or 2 Times A Yr..	301	39%	13%	26%	4%	2%	5%	33%	24%
Less Than Once A Yr	236	20%	5%	15%	3%	2%	5%	43%	33%
Don't Go To Museums	240	11%	2%	10%	3%	1%	4%	55%	30%
Favor Mre Fed Taxes	300	40%	19%	21%	3%	2%	5%	33%	22%
Wld Pay $25 More	197	46%	21%	25%	4%	2%	6%	31%	17%
Pay $5-$15 More.	57	30%	16%	14%	-	4%	4%	33%	33%
None Of Above...	33	30%	21%	9%	3%	3%	6%	42%	21%
Oppose Mre Fed Taxs	571	26%	8%	18%	4%	2%	5%	41%	27%
Not Sure..........	130	23%	6%	17%	4%	2%	6%	43%	28%

Q84. If you could pick one type of person you'd most enjoy having dinner with, who would you choose?

	TOTAL	Artist	TV Or Movie Actor	Author	Sports Star	Other	None	Not Sure
All Voters.........	1001	14%	25%	29%	24%	1%	3%	4%
Northeast..........	216	15%	29%	33%	18%	*	1%	4%
South..............	335	13%	28%	26%	26%	1%	4%	4%
Central............	241	15%	26%	27%	25%	1%	2%	4%
West..............	209	17%	16%	31%	26%	1%	4%	5%
Male..............	475	14%	21%	25%	31%	1%	3%	5%
Female.............	526	15%	29%	32%	17%	1%	3%	3%
Under 30...........	247	16%	32%	20%	29%	*	*	2%
30 to 39...........	263	13%	29%	30%	22%	*	3%	3%
40 to 49...........	191	16%	21%	30%	23%	2%	5%	3%
50 to 64...........	154	14%	21%	34%	22%	-	3%	6%
65 And Over.......	131	13%	15%	32%	23%	2%	6%	9%
High School/Less...	421	11%	31%	19%	28%	1%	5%	5%
Some College.......	281	15%	24%	31%	23%	1%	3%	3%
College Graduate...	293	18%	17%	40%	20%	-	1%	3%
Post-Graduate....	103	15%	16%	47%	17%	-	2%	5%
Liberal............	319	20%	24%	29%	22%	*	2%	2%
Moderate/Other.....	207	13%	23%	32%	21%	1%	3%	7%
Conservative.......	475	11%	27%	27%	26%	1%	4%	4%
Under $30K.........	343	13%	31%	23%	25%	2%	2%	4%
Under $20K......	155	14%	30%	19%	25%	3%	2%	7%
$20K to $30K.......	188	13%	31%	27%	24%	1%	2%	2%
$30K to $40K.......	155	15%	25%	26%	26%	-	5%	3%
$40K to $50K.......	133	14%	23%	27%	30%	-	3%	3%
Over $50K..........	244	14%	18%	39%	24%	1%	2%	2%
Over $75K.......	95	17%	17%	36%	26%	1%	1%	2%
White..............	779	13%	24%	32%	22%	1%	3%	4%
Black..............	100	15%	28%	20%	33%	-	1%	3%
Hispanic...........	66	21%	35%	17%	24%	-	2%	2%
All Other..........	56	27%	21%	13%	32%	-	4%	4%
Have Children......	666	14%	23%	30%	23%	1%	4%	5%
Encourage/Artist	523	15%	23%	31%	21%	1%	3%	5%
Don't Have Children	335	16%	28%	26%	26%	1%	1%	2%
Willing To Pay More	393	17%	24%	23%	30%	*	2%	5%
Only Sometimes.....	382	13%	25%	34%	23%	1%	3%	2%
Hardly Ever Pay Mre	211	14%	29%	29%	16%	2%	5%	4%
Have Art In Home...	768	17%	23%	32%	21%	1%	3%	4%
Don't Have Art.....	233	6%	33%	19%	32%	1%	4%	6%
Choice - Choose Art	352	22%	17%	35%	19%	1%	2%	4%
Would Choose Money.	574	10%	30%	26%	27%	1%	3%	3%
Not Sure...........	75	12%	23%	23%	24%	1%	7%	11%
Spend $25-100/Art..	472	9%	34%	21%	28%	1%	3%	3%
Wld Spend Over $200	451	20%	18%	37%	19%	1%	2%	4%
Museum >2 Times Yr.	188	32%	16%	36%	11%	-	3%	3%
1 or 2 Times A Yr..	301	15%	20%	38%	23%	1%	2%	2%
Less Than Once A Yr	236	10%	27%	28%	25%	2%	3%	4%
Don't Go To Museums	240	6%	35%	15%	32%	*	4%	7%
Favor Mre Fed Taxes	300	22%	20%	34%	19%	*	2%	3%
Wld Pay $25 More	197	27%	16%	38%	16%	-	1%	3%
Pay $5-$15 More.	57	15%	33%	26%	26%	2%	2%	4%
None Of Above...	33	21%	21%	24%	21%	-	6%	6%
Oppose Mre Fed Taxs	571	11%	28%	26%	27%	1%	4%	4%
Not Sure...........	130	12%	25%	28%	23%	1%	3%	8%

Q85. How often would you say that you go to art museums?

	TOTAL	More/ Two Times A Year	One Or Two Times A Year	Less Than Once A Year	Not At All	Depnds	Not Sure
All Voters.........	1001	19%	30%	24%	24%	2%	1%
Northeast..........	216	19%	32%	25%	22%	2%	*
South..............	335	19%	30%	22%	26%	2%	2%
Central............	241	17%	26%	25%	27%	4%	1%
West..............	209	21%	33%	24%	19%	2%	*
Male..............	475	20%	31%	23%	24%	2%	*
Female.............	526	18%	29%	25%	24%	3%	2%
Under 30...........	247	17%	38%	23%	19%	2%	1%
30 to 39...........	263	17%	29%	26%	24%	2%	2%
40 to 49...........	191	25%	25%	24%	24%	3%	-
50 to 64...........	154	20%	26%	21%	29%	4%	-
65 And Over.......	131	15%	32%	22%	26%	1%	4%
High School/Less...	421	10%	22%	24%	39%	3%	2%
Some College.......	281	19%	34%	26%	16%	4%	1%
College Graduate...	293	31%	38%	21%	10%	1%	-
Post-Graduate....	103	34%	34%	25%	7%	-	-
Liberal............	319	26%	32%	20%	20%	2%	-
Moderate/Other.....	207	22%	27%	20%	26%	5%	1%
Conservative.......	475	12%	30%	28%	26%	2%	2%
Under $30K.........	343	11%	30%	24%	30%	2%	2%
Under $20K......	155	9%	28%	22%	35%	3%	3%
$20K to $30K.......	188	13%	31%	26%	26%	2%	1%
$30K to $40K.......	155	16%	28%	30%	25%	1%	-
$40K to $50K.......	133	19%	29%	21%	26%	4%	2%
Over $50K..........	244	30%	35%	18%	14%	2%	-
Over $75K.......	95	42%	29%	17%	9%	2%	-
White..............	779	19%	28%	25%	25%	2%	1%
Black..............	100	16%	35%	24%	21%	2%	2%
Hispanic...........	66	24%	33%	20%	21%	2%	-
All Other..........	56	16%	41%	14%	21%	5%	2%
Have Children......	666	17%	29%	24%	27%	3%	1%
Encourage/Artist	523	18%	31%	24%	24%	2%	1%
Don't Have Children	335	23%	33%	23%	19%	1%	1%
Willing To Pay More	393	21%	32%	22%	22%	3%	1%
Only Sometimes.....	382	16%	32%	25%	22%	3%	1%
Hardly Ever Pay Mre	211	20%	23%	23%	30%	1%	2%
Have Art In Home...	768	21%	33%	25%	19%	1%	1%
Don't Have Art.....	233	11%	22%	20%	39%	7%	1%
Choice - Choose Art	352	29%	37%	19%	13%	1%	-
Would Choose Money.	574	13%	26%	26%	30%	3%	2%
Not Sure...........	75	19%	25%	23%	27%	4%	3%
Spend $25-100/Art..	472	10%	24%	25%	36%	3%	1%
Wld Spend Over $200	451	27%	39%	22%	10%	1%	*
Museum >2 Times Yr.	188	100%	-	-	-	-	-
1 or 2 Times A Yr..	301	-	100%	-	-	-	-
Less Than Once A Yr	236	-	-	100%	-	-	-
Don't Go To Museums	240	-	-	-	100%	-	-
Favor Mre Fed Taxes	300	30%	31%	20%	17%	2%	1%
Wld Pay $25 More	197	36%	28%	21%	13%	1%	1%
Pay $5-$15 More.	57	14%	40%	21%	21%	4%	-
None Of Above...	33	27%	24%	12%	33%	3%	-
Oppose Mre Fed Taxs	571	14%	31%	25%	27%	2%	1%
Not Sure...........	130	15%	25%	26%	28%	5%	1%

Q86. (Less/Once A Yr Or Not At All In Q85) Is the following a reason why you
don't go to museums more often: There is not an art museum in my area.

	TOTAL	Major Reason	Minor Reason	Not Reason At All	Not Sure
All Voters.........	476	34%	15%	49%	2%
Northeast..........	100	31%	12%	55%	2%
South..............	160	40%	13%	44%	3%
Central............	126	34%	17%	48%	1%
West...............	90	29%	19%	50%	2%
Male...............	221	30%	17%	51%	2%
Female.............	255	38%	13%	47%	2%
Under 30...........	104	32%	19%	49%	-
30 to 39...........	133	35%	15%	50%	1%
40 to 49...........	90	36%	12%	52%	-
50 to 64...........	77	38%	13%	43%	6%
65 And Over........	63	37%	14%	43%	6%
High School/Less...	265	34%	14%	49%	2%
Some College.......	119	37%	18%	45%	-
College Graduate...	89	33%	15%	48%	4%
Post-Graduate....	33	33%	30%	33%	3%
Liberal............	126	32%	15%	52%	1%
Moderate/Other.....	95	32%	15%	52%	2%
Conservative.......	255	37%	15%	45%	3%
Under $30K.........	186	40%	16%	42%	2%
Under $20K......	88	41%	15%	44%	-
$20K to $30K.......	98	39%	17%	40%	4%
$30K to $40K.......	86	29%	15%	53%	2%
$40K to $50K.......	62	42%	10%	48%	-
Over $50K..........	80	34%	16%	49%	1%
Over $75K.......	25	40%	36%	24%	-
White..............	384	35%	15%	47%	2%
Black..............	45	24%	9%	62%	4%
Hispanic...........	27	52%	11%	37%	-
All Other..........	20	20%	25%	55%	-
Have Children......	335	36%	14%	48%	3%
Encourage/Artist	249	36%	14%	47%	3%
Don't Have Children	141	32%	18%	50%	-
Willing To Pay More	174	32%	17%	50%	1%
Only Sometimes.....	181	38%	15%	45%	2%
Hardly Ever Pay Mre	111	34%	10%	52%	4%
Have Art In Home...	338	34%	16%	48%	2%
Don't Have Art.....	138	36%	12%	51%	1%
Choice - Choose Art	115	28%	18%	52%	2%
Would Choose Money.	324	36%	14%	48%	2%
Not Sure...........	37	38%	14%	43%	5%
Spend $25-100/Art..	291	35%	13%	49%	2%
Wld Spend Over $200	145	35%	17%	46%	1%
Museum >2 Times Yr.	-	-	-	-	-
1 or 2 Times A Yr..	-	-	-	-	-
Less Than Once A Yr	236	34%	15%	49%	2%
Don't Go To Museums	240	35%	15%	48%	3%
Favor Mre Fed Taxes	111	34%	14%	51%	1%
Wld Pay $25 More	68	38%	13%	49%	-
Pay $5-$15 More.	24	29%	13%	58%	-
None Of Above...	15	27%	13%	60%	-

Q87. (Less/Once A Yr Or Not At All In Q85) Is the following a reason why you
don't go to museums more often: I don't have enough spare time.

	TOTAL	Major Reason	Minor Reason	Not Reason At All	Not Sure
All Voters.........	476	44%	19%	36%	1%
Northeast..........	100	46%	18%	32%	4%
South..............	160	44%	18%	36%	2%
Central............	126	44%	20%	36%	-
West...............	90	40%	21%	39%	-
Male...............	221	44%	21%	33%	1%
Female.............	255	43%	17%	38%	2%
Under 30...........	104	49%	27%	24%	-
30 to 39...........	133	53%	20%	26%	1%
40 to 49...........	90	44%	21%	34%	-
50 to 64...........	77	38%	8%	52%	3%
65 And Over........	63	21%	13%	60%	6%
High School/Less...	265	45%	15%	37%	2%
Some College.......	119	44%	20%	36%	-
College Graduate...	89	40%	28%	29%	2%
Post-Graduate....	33	33%	30%	33%	3%
Liberal............	126	48%	17%	33%	1%
Moderate/Other.....	95	39%	16%	42%	3%
Conservative.......	255	43%	21%	35%	1%
Under $30K.........	186	42%	18%	38%	2%
Under $20K......	88	42%	15%	42%	1%
$20K to $30K.......	98	42%	21%	35%	2%
$30K to $40K.......	86	52%	19%	28%	1%
$40K to $50K.......	62	47%	15%	39%	-
Over $50K..........	80	41%	29%	29%	1%
Over $75K.......	25	36%	40%	24%	-
White..............	384	45%	19%	35%	1%
Black..............	45	38%	24%	36%	2%
Hispanic...........	27	44%	7%	44%	4%
All Other..........	20	30%	30%	40%	-
Have Children......	335	41%	17%	40%	2%
Encourage/Artist	249	42%	18%	38%	2%
Don't Have Children	141	50%	25%	25%	1%
Willing To Pay More	174	48%	18%	34%	1%
Only Sometimes.....	181	44%	23%	32%	1%
Hardly Ever Pay Mre	111	40%	13%	44%	4%
Have Art In Home...	338	45%	20%	34%	1%
Don't Have Art.....	138	40%	18%	40%	2%
Choice - Choose Art	115	48%	18%	32%	2%
Would Choose Money.	324	42%	20%	37%	1%
Not Sure...........	37	43%	16%	38%	3%
Spend $25-100/Art..	291	46%	18%	35%	2%
Wld Spend Over $200	145	41%	25%	33%	1%
Museum >2 Times Yr.	-	-	-	-	-
1 or 2 Times A Yr..	-	-	-	-	-
Less Than Once A Yr	236	52%	23%	24%	1%
Don't Go To Museums	240	36%	15%	47%	2%
Favor Mre Fed Taxes	111	52%	14%	32%	2%
Wld Pay $25 More	68	54%	16%	28%	1%
Pay $5-$15 More.	24	46%	13%	42%	-
None Of Above...	15	53%	7%	40%	-
Oppose Mre Fed Taxs	295	42%	22%	35%	1%
Not Sure...........	70	39%	13%	46%	3%

Q88. (Less/Once A Yr Or Not At All In Q85) Is the following a reason why you don't go to museums more often: I don't feel comfortable/know about art.

	TOTAL	Major Reason	Minor Reason	Not Reason At All	Not Sure
All Voters.........	476	24%	21%	54%	1%
Northeast..........	100	24%	22%	51%	3%
South..............	160	26%	15%	58%	2%
Central............	126	30%	23%	47%	-
West...............	90	13%	26%	61%	-
Male...............	221	28%	19%	52%	1%
Female.............	255	21%	22%	55%	2%
Under 30...........	104	24%	21%	55%	-
30 to 39...........	133	21%	20%	59%	1%
40 to 49...........	90	18%	26%	57%	-
50 to 64...........	77	21%	16%	61%	3%
65 And Over........	63	41%	22%	33%	3%
High School/Less...	265	29%	20%	50%	1%
Some College.......	119	22%	22%	55%	1%
College Graduate...	89	12%	21%	64%	2%
Post-Graduate....	33	9%	18%	70%	3%
Liberal............	126	21%	23%	54%	2%
Moderate/Other.....	95	31%	16%	52%	2%
Conservative.......	255	23%	21%	55%	1%
Under $30K.........	186	25%	19%	54%	2%
Under $20K......	88	34%	15%	50%	1%
$20K to $30K.......	98	17%	22%	58%	2%
$30K to $40K.......	86	29%	26%	45%	-
$40K to $50K.......	62	18%	18%	65%	-
Over $50K..........	80	14%	25%	60%	1%
Over $75K.......	25	12%	32%	56%	-
White..............	384	25%	21%	53%	1%
Black..............	45	29%	16%	53%	2%
Hispanic...........	27	11%	15%	67%	7%
All Other..........	20	20%	30%	50%	-
Have Children......	335	25%	22%	51%	1%
Encourage/Artist	249	24%	22%	53%	2%
Don't Have Children	141	23%	16%	60%	1%
Willing To Pay More	174	19%	22%	58%	1%
Only Sometimes.....	181	22%	22%	56%	1%
Hardly Ever Pay Mre	111	35%	17%	45%	3%
Have Art In Home...	338	20%	21%	59%	1%
Don't Have Art.....	138	35%	20%	42%	3%
Choice - Choose Art	115	17%	22%	59%	2%
Would Choose Money.	324	26%	20%	52%	1%
Not Sure..........	37	27%	19%	51%	3%
Spend $25-100/Art..	291	30%	22%	47%	1%
Wld Spend Over $200	145	12%	19%	67%	1%
Museum >2 Times Yr.	-	-	-	-	-
1 or 2 Times A Yr..	-	-	-	-	-
Less Than Once A Yr	236	17%	22%	61%	1%
Don't Go To Museums	240	32%	20%	47%	2%
Favor Mre Fed Taxes	111	23%	23%	54%	1%
Wld Pay $25 More	68	12%	24%	63%	1%
Pay $5-$15 More.	24	33%	17%	50%	-
None Of Above...	15	40%	27%	33%	-
Oppose Mre Fed Taxs	295	24%	21%	54%	1%
Not Sure..........	70	27%	16%	54%	3%

Q89. (Less/Once A Yr Or Not At All In Q85) Is the following a reason why you don't go to museums more often: The cost of admission is too expensive.

	TOTAL	Major Reason	Minor Reason	Not Reason At All	Not Sure
All Voters.........	476	11%	22%	62%	5%
Northeast..........	100	12%	26%	57%	5%
South..............	160	11%	17%	67%	6%
Central............	126	13%	16%	67%	4%
West...............	90	7%	37%	52%	4%
Male...............	221	8%	24%	64%	4%
Female.............	255	13%	21%	60%	5%
Under 30...........	104	12%	27%	61%	1%
30 to 39...........	133	10%	22%	65%	4%
40 to 49...........	90	10%	22%	63%	4%
50 to 64...........	77	8%	19%	65%	8%
65 And Over........	63	19%	21%	51%	10%
High School/Less...	265	13%	24%	58%	5%
Some College.......	119	9%	19%	66%	6%
College Graduate...	89	8%	21%	69%	2%
Post-Graduate....	33	3%	27%	67%	3%
Liberal............	126	10%	24%	59%	8%
Moderate/Other.....	95	7%	19%	67%	6%
Conservative.......	255	13%	23%	62%	3%
Under $30K.........	186	18%	19%	59%	4%
Under $20K......	88	30%	19%	48%	3%
$20K to $30K.......	98	8%	19%	68%	4%
$30K to $40K.......	86	13%	26%	55%	7%
$40K to $50K.......	62	2%	27%	69%	2%
Over $50K..........	80	3%	25%	69%	4%
Over $75K.......	25	8%	36%	56%	-
White..............	384	12%	24%	59%	5%
Black..............	45	11%	9%	78%	2%
Hispanic...........	27	-	11%	81%	7%
All Other..........	20	5%	35%	60%	-
Have Children......	335	11%	23%	60%	5%
Encourage/Artist	249	11%	22%	61%	6%
Don't Have Children	141	10%	20%	67%	4%
Willing To Pay More	174	7%	26%	64%	3%
Only Sometimes.....	181	10%	22%	62%	6%
Hardly Ever Pay Mre	111	17%	18%	59%	5%
Have Art In Home...	338	9%	23%	64%	4%
Don't Have Art.....	138	17%	21%	57%	6%
Choice - Choose Art	115	7%	17%	71%	4%
Would Choose Money.	324	12%	24%	59%	6%
Not Sure..........	37	14%	24%	62%	-
Spend $25-100/Art..	291	14%	26%	55%	5%
Wld Spend Over $200	145	3%	18%	75%	3%
Museum >2 Times Yr.	-	-	-	-	-
1 or 2 Times A Yr..	-	-	-	-	-
Less Than Once A Yr	236	7%	22%	68%	3%
Don't Go To Museums	240	15%	22%	56%	7%
Favor Mre Fed Taxes	111	11%	20%	65%	5%
Wld Pay $25 More	68	9%	19%	71%	1%
Pay $5-$15 More.	24	13%	13%	67%	8%
None Of Above...	15	20%	33%	40%	7%
Oppose Mre Fed Taxs	295	10%	26%	60%	4%
Not Sure..........	70	16%	11%	64%	9%

Q90. (Less/Once A Yr Or Not At All In Q85) Is the following a reason why you don't go to museums more often: I simply don't enjoy looking at art.

	TOTAL	Major Reason	Minor Reason	Not Reason At All	Not Sure
All Voters.........	476	12%	21%	65%	1%
Northeast..........	100	9%	21%	67%	3%
South..............	160	9%	22%	67%	2%
Central............	126	17%	19%	64%	-
West...............	90	14%	23%	62%	-
Male...............	221	14%	22%	62%	1%
Female.............	255	10%	20%	68%	2%
Under 30...........	104	13%	22%	65%	-
30 to 39...........	133	13%	17%	70%	1%
40 to 49...........	90	11%	28%	61%	-
50 to 64...........	77	12%	18%	69%	1%
65 And Over........	63	11%	25%	59%	5%
High School/Less...	265	11%	23%	64%	2%
Some College.......	119	13%	20%	66%	1%
College Graduate...	89	13%	18%	67%	1%
Post-Graduate....	33	12%	18%	70%	-
Liberal............	126	13%	18%	67%	2%
Moderate/Other.....	95	13%	18%	67%	2%
Conservative.......	255	11%	24%	64%	1%
Under $30K.........	186	9%	22%	68%	2%
Under $20K......	88	11%	19%	68%	1%
$20K to $30K.......	98	6%	23%	68%	2%
$30K to $40K.......	86	13%	23%	63%	1%
$40K to $50K.......	62	16%	19%	65%	-
Over $50K..........	80	18%	20%	63%	-
Over $75K.......	25	24%	20%	56%	-
White..............	384	13%	23%	63%	1%
Black..............	45	7%	11%	80%	2%
Hispanic...........	27	7%	11%	74%	7%
All Other..........	20	25%	15%	60%	-
Have Children......	335	12%	21%	66%	1%
Encourage/Artist	249	9%	21%	68%	2%
Don't Have Children	141	13%	23%	63%	1%
Willing To Pay More	174	12%	22%	65%	1%
Only Sometimes.....	181	9%	21%	69%	1%
Hardly Ever Pay Mre	111	14%	20%	63%	3%
Have Art In Home...	338	10%	17%	72%	1%
Don't Have Art.....	138	17%	30%	50%	3%
Choice - Choose Art	115	6%	12%	79%	3%
Would Choose Money.	324	14%	25%	60%	1%
Not Sure...........	37	16%	14%	70%	-
Spend $25-100/Art..	291	15%	25%	58%	1%
Wld Spend Over $200	145	6%	15%	78%	1%
Museum >2 Times Yr.	-	-	-	-	-
1 or 2 Times A Yr..	-	-	-	-	-
Less Than Once A Yr	236	6%	20%	73%	1%
Don't Go To Museums	240	19%	22%	58%	2%
Favor Mre Fed Taxes	111	7%	16%	76%	1%
Wld Pay $25 More	68	4%	15%	79%	1%
Pay $5-$15 More.	24	13%	17%	71%	-
None Of Above...	15	13%	20%	67%	-
Oppose Mre Fed Taxs	295	15%	25%	59%	1%
Not Sure...........	70	9%	14%	74%	3%

Q91. Would you favor or oppose spending more money in federal taxes than we do on the arts?

	TOTAL	Favor	Oppose	Not Sure
All Voters.........	1001	30%	57%	13%
Northeast..........	216	31%	54%	16%
South..............	335	29%	60%	11%
Central............	241	27%	58%	15%
West...............	209	33%	56%	11%
Male...............	475	33%	56%	10%
Female.............	526	27%	58%	16%
Under 30...........	247	29%	59%	12%
30 to 39...........	263	33%	59%	8%
40 to 49...........	191	35%	56%	9%
50 to 64...........	154	29%	53%	18%
65 And Over........	131	23%	54%	23%
High School/Less...	421	25%	59%	16%
Some College.......	281	26%	62%	12%
College Graduate...	293	41%	49%	10%
Post-Graduate....	103	39%	47%	15%
Liberal............	319	43%	49%	8%
Moderate/Other.....	207	27%	52%	21%
Conservative.......	475	23%	65%	13%
Under $30K.........	343	29%	58%	13%
Under $20K......	155	27%	57%	16%
$20K to $30K.......	188	31%	59%	10%
$30K to $40K.......	155	33%	54%	14%
$40K to $50K.......	133	27%	62%	11%
Over $50K..........	244	34%	58%	8%
Over $75K.......	95	40%	52%	8%
White..............	779	29%	59%	12%
Black..............	100	33%	51%	16%
Hispanic...........	66	26%	59%	15%
All Other..........	56	38%	45%	18%
Have Children......	666	29%	58%	13%
Encourage/Artist	523	31%	56%	13%
Don't Have Children	335	33%	55%	12%
Willing To Pay More	393	32%	55%	12%
Only Sometimes.....	382	29%	59%	12%
Hardly Ever Pay Mre	211	28%	58%	14%
Have Art In Home...	768	33%	55%	12%
Don't Have Art.....	233	19%	65%	16%
Choice - Choose Art	352	38%	49%	13%
Would Choose Money.	574	27%	62%	11%
Not Sure...........	75	20%	56%	24%
Spend $25-100/Art..	472	25%	62%	13%
Wld Spend Over $200	451	37%	53%	10%
Museum >2 Times Yr.	188	47%	42%	11%
1 or 2 Times A Yr..	301	31%	58%	11%
Less Than Once A Yr	236	25%	60%	14%
Don't Go To Museums	240	21%	64%	15%
Favor Mre Fed Taxes	300	100%	-	-
Wld Pay $25 More	197	100%	-	-
Pay $5-$15 More.	57	100%	-	-
None Of Above...	33	100%	-	-
Oppose Mre Fed Taxs	571	-	100%	-
Not Sure...........	130	-	-	100%

Q92. (If Favor In Q91) Would you be willing to pay an extra $25
 a year in federal taxes to support the arts?

	TOTAL	Yes, $25 More	Yes, $15 More	Yes, $10 More	Yes, $5 More	No, No More	Not Sure
All Voters.........	300	66%	10%	6%	3%	11%	4%
Northeast..........	66	71%	5%	9%	3%	8%	5%
South..............	98	59%	14%	3%	4%	15%	4%
Central............	66	58%	9%	11%	5%	11%	8%
West...............	70	77%	10%	1%	1%	9%	1%
Male...............	159	65%	11%	5%	4%	11%	3%
Female.............	141	66%	9%	6%	3%	11%	6%
Under 30..........	71	61%	14%	8%	4%	13%	-
30 to 39...........	87	69%	8%	7%	1%	10%	5%
40 to 49...........	67	75%	9%	3%	4%	9%	-
50 to 64...........	44	68%	9%	5%	-	11%	7%
65 And Over........	30	47%	10%	3%	10%	10%	20%
High School/Less...	105	52%	10%	9%	6%	15%	8%
Some College.......	74	68%	12%	4%	3%	14%	-
College Graduate...	120	76%	8%	4%	2%	6%	4%
Post-Graduate....	40	78%	10%	8%	3%	3%	-
Liberal............	137	75%	9%	4%	1%	10%	-
Moderate/Other.....	56	64%	7%	5%	5%	13%	5%
Conservative.......	107	54%	13%	7%	5%	11%	9%
Under $30K.........	101	57%	10%	8%	6%	15%	4%
Under $20K......	42	48%	10%	12%	12%	14%	5%
$20K to $30K.......	59	64%	10%	5%	2%	15%	3%
$30K to $40K.......	51	73%	14%	-	2%	6%	6%
$40K to $50K.......	36	69%	17%	8%	-	3%	3%
Over $50K..........	82	80%	6%	5%	2%	4%	2%
Over $75K.......	38	76%	13%	3%	3%	3%	3%
White..............	229	68%	8%	6%	3%	10%	5%
Black..............	33	45%	21%	6%	9%	15%	3%
Hispanic...........	17	82%	12%	-	-	6%	-
All Other..........	21	57%	10%	10%	5%	19%	-
Have Children......	191	66%	9%	4%	4%	10%	6%
Encourage/Artist	163	70%	8%	4%	5%	9%	4%
Don't Have Children	109	64%	12%	8%	2%	12%	2%
Willing To Pay More	127	69%	9%	6%	2%	9%	5%
Only Sometimes.....	110	62%	13%	5%	5%	11%	4%
Hardly Ever Pay Mre	59	66%	5%	7%	2%	15%	5%
Have Art In Home...	256	67%	10%	5%	3%	10%	5%
Don't Have Art.....	44	57%	11%	7%	7%	16%	2%
Choice - Choose Art	132	73%	10%	5%	4%	7%	2%
Would Choose Money.	153	61%	10%	7%	3%	14%	4%
Not Sure...........	15	40%	13%	-	-	13%	33%
Spend $25-100/Art..	116	53%	11%	8%	8%	17%	3%
Wld Spend Over $200	165	75%	10%	5%	1%	6%	4%
Museum >2 Times Yr.	89	79%	8%	1%	-	10%	2%
1 or 2 Times A Yr..	93	60%	15%	8%	2%	9%	6%
Less Than Once A Yr	60	70%	12%	5%	3%	7%	3%
Don't Go To Museums	51	51%	4%	10%	10%	22%	4%
Favor Mre Fed Taxes	300	66%	10%	6%	3%	11%	4%
Wld Pay $25 More	197	100%	-	-	-	-	-
Pay $5-$15 More.	57	-	53%	30%	18%	-	-
None Of Above...	33	-	-	-	-	100%	-
Oppose Mre Fed Taxs	-	-	-	-	-	-	-
Not Sure..........	-	-	-	-	-	-	-

Q93. Do you think that average citizens should or should not have a say
 in determining which works of art are appropriate to be displayed in public?

	TOTAL	Should Have A Say	Shldnt Have A Say	Not Sure
All Voters.........	1001	67%	27%	6%
Northeast..........	216	65%	28%	7%
South..............	335	67%	25%	8%
Central............	241	69%	27%	4%
West...............	209	67%	30%	4%
Male...............	475	65%	29%	6%
Female.............	526	68%	25%	6%
Under 30..........	247	68%	28%	4%
30 to 39...........	263	67%	29%	5%
40 to 49...........	191	64%	31%	5%
50 to 64...........	154	69%	23%	7%
65 And Over........	131	67%	21%	12%
High School/Less...	421	71%	22%	7%
Some College.......	281	64%	31%	5%
College Graduate...	293	66%	29%	5%
Post-Graduate....	103	61%	28%	11%
Liberal............	319	61%	34%	5%
Moderate/Other.....	207	63%	27%	10%
Conservative.......	475	73%	23%	5%
Under $30K.........	343	73%	21%	6%
Under $20K......	155	72%	21%	6%
$20K to $30K.......	188	74%	20%	6%
$30K to $40K.......	155	68%	27%	5%
$40K to $50K.......	133	64%	29%	8%
Over $50K..........	244	62%	35%	3%
Over $75K.......	95	54%	42%	4%
White..............	779	67%	27%	6%
Black..............	100	63%	32%	5%
Hispanic...........	66	64%	30%	6%
All Other..........	56	75%	16%	9%
Have Children......	666	67%	27%	7%
Encourage/Artist	523	68%	26%	6%
Don't Have Children	335	67%	28%	5%
Willing To Pay More	393	66%	30%	4%
Only Sometimes.....	382	68%	25%	7%
Hardly Ever Pay Mre	211	65%	27%	7%
Have Art In Home...	768	66%	28%	6%
Don't Have Art.....	233	69%	25%	6%
Choice - Choose Art	352	65%	30%	5%
Would Choose Money.	574	68%	26%	6%
Not Sure...........	75	72%	20%	8%
Spend $25-100/Art..	472	71%	22%	7%
Wld Spend Over $200	451	64%	32%	4%
Museum >2 Times Yr.	188	51%	43%	6%
1 or 2 Times A Yr..	301	70%	25%	5%
Less Than Once A Yr	236	72%	22%	5%
Don't Go To Museums	240	69%	24%	8%
Favor Mre Fed Taxes	300	62%	32%	6%
Wld Pay $25 More	197	59%	37%	4%
Pay $5-$15 More.	57	67%	23%	11%
None Of Above...	33	76%	18%	6%
Oppose Mre Fed Taxs	571	70%	26%	5%
Not Sure..........	130	65%	23%	12%

Q94. (Collapsed) If you had unlimited resources and could commission your
favorite artist to paint anything you wanted, what would it be?

	All Rspndt	TOTAL	Pictur Of Myself /Famly	Natur/ Lndscp /Mount Scene	Pictur Anmls/ Wldlf/ My Pet	Seascp /Ocean View/ Wtrfls	Anythg Artist Wishes /Style	Ordnry Peopl/ Chldrn /Hmles	House /Barn	Relgus Scene/ Crucfc /Chrch	West/ Indian Art/ Tribe	Car Or Motor- cycle	Sports Hero/ Athlet	The City/ Tall Bldgs	Other	Don't Know
All Voters.........	100%	1001	27%	25%	8%	7%	5%	5%	2%	2%	1%	1%	1%	1%	4%	11%
White..............	100%	216	25%	27%	6%	7%	4%	6%	2%	2%	-	1%	-	1%	6%	13%
		335	31%	26%	8%	7%	4%	2%	2%	1%	*	1%	*	1%	5%	12%
Have Art In Home...	100%	241	28%	22%	10%	5%	4%	7%	3%	3%	2%	*	-	3%	3%	10%
		209	22%	25%	8%	10%	7%	4%	2%	*	3%	2%	3%	1%	3%	9%
Have Children......	100%															
Would Choose Money.	100%	475	23%	24%	9%	9%	5%	4%	2%	2%	1%	1%	1%	2%	6%	11%
Oppose Mre Fed Taxs	100%	526	31%	25%	8%	6%	4%	6%	2%	1%	1%	1%	1%	1%	3%	11%
Female.............	100%															
Encourage/Artist	100%	247	27%	23%	10%	6%	5%	4%	2%	2%	-	2%	2%	2%	5%	10%
Conservative.......	100%	263	27%	24%	8%	10%	3%	4%	2%	2%	*	1%	*	2%	6%	10%
		191	28%	26%	5%	6%	6%	7%	5%	2%	1%	-	1%	2%	2%	9%
Male...............	100%	154	29%	27%	9%	8%	3%	3%	1%	3%	3%	-	1%	1%	2%	12%
		131	26%	26%	8%	4%	8%	3%	2%	1%	3%	1%	-	2%	3%	15%
Spend $25-100/Art..	100%															
Wld Spend Over $200	100%	421	32%	21%	10%	5%	4%	4%	2%	1%	1%	1%	1%	1%	4%	12%
		281	25%	25%	9%	9%	5%	4%	3%	2%	-	2%	1%	2%	4%	9%
High School/Less...	100%	293	23%	30%	4%	8%	5%	5%	3%	2%	2%	1%	*	1%	5%	11%
		103	29%	30%	5%	4%	7%	5%	1%	2%	2%	-	-	1%	3%	12%
Willing To Pay More	100%															
Only Sometimes.....	100%	319	24%	26%	8%	7%	8%	7%	1%	1%	1%	1%	1%	2%	6%	10%
		207	26%	22%	11%	4%	4%	6%	2%	1%	1%	1%	-	2%	5%	14%
Choice - Choose Art	100%	475	31%	25%	7%	8%	3%	3%	4%	2%	1%	1%	1%	1%	3%	11%
Under $30K.........	100%	343	30%	26%	6%	6%	4%	5%	1%	2%	1%	1%	1%	2%	4%	10%
Don't Have Children	100%	155	32%	25%	9%	3%	6%	4%	1%	3%	1%	1%	1%	3%	5%	8%
South..............	100%	188	28%	27%	4%	9%	2%	6%	2%	2%	2%	2%	2%	1%	4%	11%
		155	25%	26%	11%	6%	6%	4%	1%	1%	-	2%	-	-	3%	15%
Liberal............	100%	133	29%	24%	9%	7%	2%	5%	5%	2%	1%	1%	2%	2%	3%	9%
1 or 2 Times A Yr..	100%	244	27%	26%	9%	9%	4%	5%	2%	2%	1%	-	1%	1%	5%	9%
		95	27%	21%	7%	14%	5%	3%	2%	-	2%	-	-	2%	3%	13%
Favor Mre Fed Taxes	100%															
College Graduate...	100%	779	26%	26%	9%	8%	5%	4%	2%	2%	1%	1%	*	1%	4%	11%
Some College.......	100%	100	40%	18%	2%	3%	1%	10%	2%	1%	-	2%	3%	4%	8%	6%
30 to 39...........	100%	66	29%	20%	12%	6%	5%	8%	2%	3%	-	2%	-	-	5%	11%
		56	21%	20%	4%	5%	2%	5%	2%	4%	2%	-	4%	2%	5%	25%
Under 30...........	100%															
Over $50K..........	100%	666	32%	24%	7%	6%	4%	5%	2%	2%	1%	1%	*	1%	4%	10%
Central............	100%	523	33%	26%	7%	7%	4%	5%	2%	2%	1%	1%	1%	1%	4%	9%
Don't Go To Museums	100%	335	17%	25%	10%	9%	6%	4%	2%	2%	1%	1%	1%	2%	5%	13%
Less Than Once A Yr	100%															
Don't Have Art.....	100%	393	29%	22%	8%	7%	7%	4%	3%	3%	1%	1%	2%	2%	3%	9%
		382	27%	29%	6%	9%	3%	5%	2%	1%	*	1%	1%	2%	4%	12%
Northeast..........	100%	211	25%	22%	11%	5%	4%	5%	3%	1%	2%	1%	-	1%	6%	12%
Hardly Ever Pay Mre	100%															
West..............	100%	768	27%	26%	8%	7%	5%	5%	2%	2%	1%	1%	1%	2%	4%	10%
Moderate/Other.....	100%	233	28%	22%	9%	7%	3%	5%	2%	2%	1%	1%	1%	1%	6%	13%
Wld Pay $25 More	100%															
40 to 49...........	100%	352	25%	26%	8%	7%	5%	5%	3%	3%	1%	1%	1%	2%	5%	10%
		574	29%	24%	8%	8%	4%	4%	2%	1%	1%	1%	1%	2%	4%	11%
Museum >2 Times Yr.	100%	75	27%	24%	7%	3%	11%	4%	3%	-	1%	1%	-	-	4%	16%
$20K to $30K.......	100%															
Under $20K......	100%	472	28%	28%	9%	6%	3%	5%	2%	1%	1%	1%	*	3%	3%	10%
$30K to $40K.......	100%	451	28%	23%	7%	8%	6%	5%	2%	2%	1%	1%	1%	1%	5%	10%
50 to 64...........	100%															
$40K to $50K.......	100%	188	27%	23%	9%	9%	10%	5%	2%	1%	1%	-	-	1%	4%	9%
65 And Over........	100%	301	24%	30%	8%	6%	5%	6%	1%	2%	*	1%	2%	2%	4%	9%
Not Sure...........	100%	236	27%	28%	7%	6%	3%	5%	3%	1%	2%	1%	*	1%	5%	10%
Post-Graduate....	100%	240	30%	19%	7%	7%	3%	3%	3%	3%	1%	1%	*	3%	5%	15%
Black..............	100%															
Over $75K.......	100%	300	23%	28%	7%	8%	5%	7%	1%	2%	*	*	2%	1%	5%	10%
Not Sure...........	100%	197	21%	29%	6%	10%	6%	6%	1%	3%	1%	-	2%	1%	7%	9%
Hispanic...........	100%	57	26%	26%	11%	5%	5%	11%	-	2%	-	-	2%	2%	2%	9%
Pay $5-$15 More.	100%	33	33%	18%	6%	3%	6%	3%	3%	-	-	3%	6%	-	6%	12%
All Other..........	100%	571	29%	23%	9%	8%	4%	4%	3%	2%	1%	1%	*	2%	4%	11%
None Of Above...	100%	130	30%	25%	9%	3%	6%	2%	2%	-	2%	2%	-	1%	4%	13%

Q95. Age.

	TOTAL	Under 25	25-29	30-34	35-39	40-44	45-49	50-54	55-59	60-64	65 And Over
All Voters.........	1001	14%	11%	14%	12%	11%	8%	6%	5%	4%	13%
Northeast..........	216	14%	11%	15%	12%	8%	11%	4%	4%	3%	15%
South..............	335	12%	12%	16%	13%	11%	7%	7%	5%	4%	11%
Central............	241	10%	10%	16%	15%	11%	7%	7%	6%	5%	12%
West...............	209	22%	9%	8%	8%	12%	10%	6%	5%	5%	15%
Male...............	475	14%	11%	15%	11%	10%	9%	6%	6%	5%	11%
Female.............	526	13%	10%	13%	13%	11%	8%	6%	4%	4%	15%
Under 30...........	247	56%	44%	-	-	-	-	-	-	-	-
30 to 39...........	263	-	-	54%	46%	-	-	-	-	-	-
40 to 49...........	191	-	-	-	-	55%	45%	-	-	-	-
50 to 64...........	154	-	-	-	-	-	-	39%	32%	29%	-
65 And Over........	131	-	-	-	-	-	-	-	-	-	100%
High School/Less...	421	17%	9%	12%	11%	8%	9%	6%	5%	4%	17%
Some College.......	281	17%	9%	18%	11%	12%	7%	6%	4%	5%	10%
College Graduate...	293	7%	15%	15%	14%	13%	10%	5%	5%	5%	10%
Post-Graduate....	103	3%	13%	18%	12%	15%	10%	9%	8%	5%	9%
Liberal............	319	18%	11%	15%	12%	14%	7%	3%	5%	3%	10%
Moderate/Other.....	207	16%	9%	11%	10%	9%	8%	8%	4%	6%	14%
Conservative.......	475	10%	11%	15%	13%	9%	10%	7%	5%	5%	15%
Under $30K.........	343	20%	14%	15%	9%	7%	5%	5%	3%	3%	19%
Under $20K......	155	16%	11%	12%	8%	7%	6%	4%	5%	6%	25%
$20K to $30K.......	188	23%	17%	16%	10%	6%	4%	5%	2%	2%	14%
$30K to $40K.......	155	12%	11%	15%	15%	14%	5%	7%	6%	5%	9%
$40K to $50K.......	133	11%	12%	17%	16%	9%	12%	5%	6%	4%	9%
Over $50K..........	244	10%	10%	13%	15%	16%	13%	9%	5%	5%	4%
Over $75K.......	95	14%	6%	16%	12%	15%	15%	9%	5%	4%	4%
White..............	779	12%	11%	13%	12%	10%	9%	7%	6%	5%	14%
Black..............	100	22%	12%	17%	11%	12%	6%	3%	3%	3%	11%
Hispanic...........	66	23%	9%	18%	15%	15%	-	5%	2%	6%	6%
All Other..........	56	16%	13%	14%	14%	14%	9%	5%	-	2%	9%
Have Children......	666	5%	7%	13%	13%	12%	11%	8%	6%	6%	17%
Encourage/Artist	523	5%	8%	14%	13%	13%	10%	8%	6%	6%	15%
Don't Have Children	335	32%	18%	16%	10%	9%	3%	1%	2%	1%	6%
Willing To Pay More	393	18%	10%	15%	11%	11%	10%	6%	3%	5%	10%
Only Sometimes.....	382	13%	14%	13%	13%	12%	7%	7%	7%	3%	11%
Hardly Ever Pay Mre	211	9%	6%	14%	14%	8%	9%	4%	6%	5%	22%
Have Art In Home...	768	14%	12%	14%	12%	11%	9%	6%	5%	4%	12%
Don't Have Art.....	233	13%	7%	15%	13%	9%	7%	6%	6%	5%	16%
Choice - Choose Art	352	16%	10%	13%	12%	14%	7%	7%	5%	3%	13%
Would Choose Money.	574	13%	12%	15%	12%	9%	9%	6%	5%	5%	12%
Not Sure...........	75	8%	7%	12%	9%	9%	8%	4%	5%	7%	25%
Spend $25-100/Art..	472	16%	10%	14%	12%	8%	9%	5%	5%	4%	14%
Wld Spend Over $200	451	12%	13%	15%	12%	13%	9%	7%	4%	4%	10%
Museum >2 Times Yr.	188	16%	6%	11%	12%	16%	10%	6%	5%	5%	11%
1 or 2 Times A Yr..	301	17%	14%	14%	11%	11%	5%	6%	2%	5%	14%
Less Than Once A Yr	236	10%	14%	17%	12%	9%	10%	5%	6%	3%	12%
Don't Go To Museums	240	13%	8%	13%	14%	8%	11%	6%	7%	6%	14%
Favor Mre Fed Taxes	300	15%	9%	13%	16%	12%	10%	6%	5%	4%	10%
Wld Pay $25 More	197	15%	7%	15%	16%	15%	10%	6%	6%	4%	7%
Pay $5-$15 More.	57	16%	18%	7%	18%	11%	9%	4%	5%	2%	12%
None Of Above...	33	15%	12%	12%	15%	3%	15%	6%	3%	6%	9%
Oppose Mre Fed Taxs	571	13%	12%	15%	12%	10%	8%	5%	4%	5%	12%
Not Sure...........	130	15%	8%	11%	6%	8%	5%	9%	8%	5%	23%

Q96. What was the last grade of school you completed?

	TOTAL	Grade School /Less	Some High School	High School Grad	Voc/ Trade School	Some Cllg/ 2-Yr. Cllg	4 Year Collge Grad	Post- Grad	Refusd
All Voters.........	1001	3%	8%	31%	4%	24%	19%	10%	1%
Northeast..........	216	2%	7%	29%	4%	25%	20%	10%	2%
South..............	335	4%	8%	32%	4%	21%	21%	10%	-
Central............	241	2%	9%	37%	4%	22%	15%	11%	*
West...............	209	2%	7%	27%	2%	33%	19%	10%	*
Male...............	475	2%	7%	32%	4%	23%	20%	12%	1%
Female.............	526	3%	9%	31%	3%	26%	18%	9%	1%
Under 30...........	247	1%	10%	34%	2%	27%	20%	6%	*
30 to 39..........	263	*	8%	29%	5%	27%	20%	12%	-
40 to 49..........	191	-	4%	33%	3%	25%	21%	13%	-
50 to 64..........	154	5%	6%	31%	3%	24%	16%	14%	1%
65 And Over........	131	14%	13%	29%	5%	16%	15%	7%	2%
High School/Less...	421	7%	19%	74%	-	-	-	-	-
Some College.......	281	-	-	-	13%	87%	-	-	-
College Graduate...	293	-	-	-	-	-	65%	35%	-
Post-Graduate....	103	-	-	-	-	-	-	100%	-
Liberal............	319	1%	7%	29%	3%	24%	22%	13%	1%
Moderate/Other.....	207	4%	8%	35%	7%	22%	14%	9%	1%
Conservative.......	475	4%	9%	31%	2%	26%	19%	9%	-
Under $30K.........	343	6%	15%	39%	4%	22%	11%	2%	-
Under $20K......	155	10%	21%	36%	6%	17%	8%	1%	-
$20K to $30K.......	188	3%	11%	41%	3%	26%	13%	3%	-
$30K to $40K.......	155	1%	5%	37%	3%	26%	16%	12%	-
$40K to $50K.......	133	-	4%	34%	6%	23%	24%	10%	-
Over $50K..........	244	*	1%	18%	2%	29%	30%	20%	-
Over $75K.......	95	-	2%	9%	1%	29%	32%	26%	-
White..............	779	3%	7%	31%	4%	25%	20%	10%	1%
Black.............	100	5%	11%	37%	-	23%	16%	8%	-
Hispanic...........	66	-	14%	26%	2%	29%	20%	11%	-
All Other..........	56	-	7%	32%	11%	18%	11%	20%	2%
Have Children......	666	3%	9%	33%	4%	24%	17%	10%	1%
Encourage/Artist	523	2%	8%	33%	5%	24%	18%	9%	1%
Don't Have Children	335	1%	7%	28%	3%	26%	23%	12%	*
Willing To Pay More	393	1%	8%	29%	3%	25%	23%	11%	1%
Only Sometimes.....	382	2%	6%	33%	5%	27%	18%	9%	*
Hardly Ever Pay Mre	211	7%	12%	33%	3%	20%	14%	9%	1%
Have Art In Home...	768	2%	7%	28%	4%	25%	22%	12%	1%
Don't Have Art.....	233	6%	13%	42%	3%	23%	9%	3%	1%
Choice - Choose Art	352	2%	4%	27%	3%	30%	20%	13%	1%
Would Choose Money.	574	3%	10%	34%	3%	22%	18%	9%	1%
Not Sure...........	75	3%	11%	31%	5%	17%	21%	11%	1%
Spend $25-100/Art..	472	4%	11%	39%	3%	24%	13%	6%	*
Wld Spend Over $200	451	2%	5%	23%	4%	26%	26%	14%	*
Museum >2 Times Yr.	188	1%	5%	17%	3%	24%	30%	19%	1%
1 or 2 Times A Yr..	301	1%	3%	27%	4%	28%	25%	12%	*
Less Than Once A Yr	236	2%	6%	34%	3%	28%	15%	11%	1%
Don't Go To Museums	240	6%	18%	45%	3%	17%	9%	3%	*
Favor Mre Fed Taxes	300	2%	8%	24%	4%	21%	27%	13%	*
Wld Pay $25 More	197	3%	7%	18%	4%	22%	30%	16%	1%
Pay $5-$15 More.	57	-	9%	37%	4%	21%	16%	14%	-
None Of Above...	33	3%	12%	33%	6%	24%	18%	3%	-
Oppose Mre Fed Taxs	571	2%	7%	35%	4%	27%	17%	8%	1%
Not Sure...........	130	5%	13%	32%	3%	22%	12%	12%	1%

Q97. Do you have children?

	TOTAL	Yes	No
All Voters.........	1001	67%	33%
Northeast..........	216	61%	39%
South..............	335	70%	30%
Central............	241	69%	31%
West...............	209	64%	36%
Male...............	475	61%	39%
Female.............	526	71%	29%
Under 30...........	247	32%	68%
30 to 39..........	263	67%	33%
40 to 49..........	191	80%	20%
50 to 64..........	154	89%	11%
65 And Over........	131	84%	16%
High School/Less...	421	71%	29%
Some College.......	281	65%	35%
College Graduate...	293	61%	39%
Post-Graduate....	103	62%	38%
Liberal............	319	62%	38%
Moderate/Other.....	207	64%	36%
Conservative.......	475	71%	29%
Under $30K.........	343	63%	37%
Under $20K......	155	67%	33%
$20K to $30K.......	188	60%	40%
$30K to $40K.......	155	69%	31%
$40K to $50K.......	133	63%	37%
Over $50K..........	244	68%	32%
Over $75K.......	95	69%	31%
White..............	779	67%	33%
Black.............	100	76%	24%
Hispanic...........	66	64%	36%
All Other..........	56	45%	55%
Have Children......	666	100%	-
Encourage/Artist	523	100%	-
Don't Have Children	335	-	100%
Willing To Pay More	393	62%	38%
Only Sometimes.....	382	66%	34%
Hardly Ever Pay Mre	211	77%	23%
Have Art In Home...	768	66%	34%
Don't Have Art.....	233	68%	32%
Choice - Choose Art	352	64%	36%
Would Choose Money.	574	67%	33%
Not Sure...........	75	75%	25%
Spend $25-100/Art..	472	67%	33%
Wld Spend Over $200	451	65%	35%
Museum >2 Times Yr.	188	60%	40%
1 or 2 Times A Yr..	301	63%	37%
Less Than Once A Yr	236	67%	33%
Don't Go To Museums	240	74%	26%
Favor Mre Fed Taxes	300	64%	36%
Wld Pay $25 More	197	64%	36%
Pay $5-$15 More.	57	58%	42%
None Of Above...	33	61%	39%
Oppose Mre Fed Taxs	571	68%	32%
Not Sure...........	130	68%	32%

Q98. (If Have Children) If your child wanted to be an artist, would you encourage your child, discourage your child, or wouldn't it matter to you?

	TOTAL	Encour -age	Disco- urage	Wlnd't Matter	Depnds	Not Sure
All Voters........	666	79%	2%	18%	1%	1%
Northeast..........	132	79%	2%	18%	1%	1%
South..............	234	84%	2%	13%	1%	*
Central............	167	71%	4%	23%	1%	1%
West...............	133	78%	-	17%	2%	2%
Male...............	290	81%	1%	15%	1%	1%
Female.............	376	77%	2%	19%	1%	1%
Under 30...........	80	84%	3%	8%	1%	5%
30 to 39...........	175	82%	2%	15%	1%	-
40 to 49...........	153	80%	-	20%	1%	-
50 to 64...........	137	75%	2%	21%	1%	-
65 And Over........	110	69%	3%	24%	3%	2%
High School/Less...	301	76%	2%	20%	1%	1%
Some College.......	182	81%	2%	16%	1%	1%
College Graduate...	178	80%	2%	16%	2%	1%
Post-Graduate....	64	73%	3%	23%	-	-
Liberal............	199	83%	-	17%	1%	-
Moderate/Other.....	132	70%	1%	27%	2%	-
Conservative.......	335	79%	3%	14%	1%	2%
Under $30K.........	217	84%	1%	14%	*	1%
Under $20K......	104	83%	-	15%	1%	1%
$20K to $30K.......	113	85%	2%	12%	-	1%
$30K to $40K.......	107	80%	3%	15%	1%	1%
$40K to $50K.......	84	76%	2%	19%	1%	1%
Over $50K..........	166	77%	2%	18%	2%	1%
Over $75K.......	66	71%	2%	21%	5%	2%
White..............	523	76%	2%	20%	1%	1%
Black..............	76	86%	3%	9%	1%	1%
Hispanic...........	42	90%	-	10%	-	-
All Other..........	25	84%	4%	12%	-	-
Have Children......	666	79%	2%	18%	1%	1%
Encourage/Artist	523	100%	-	-	-	-
Don't Have Children	-	-	-	-	-	-
Willing To Pay More	244	78%	1%	18%	1%	1%
Only Sometimes.....	252	81%	2%	16%	1%	*
Hardly Ever Pay Mre	162	75%	4%	19%	1%	1%
Have Art In Home...	507	80%	2%	16%	1%	1%
Don't Have Art.....	159	73%	1%	23%	1%	2%
Choice - Choose Art	224	83%	1%	14%	1%	1%
Would Choose Money.	386	77%	2%	19%	1%	1%
Not Sure...........	56	73%	2%	23%	2%	-
Spend $25-100/Art..	317	80%	2%	16%	1%	1%
Wld Spend Over $200	293	78%	2%	17%	1%	1%
Museum >2 Times Yr.	112	84%	3%	12%	2%	-
1 or 2 Times A Yr..	191	85%	2%	12%	1%	1%
Less Than Once A Yr	158	78%	2%	17%	1%	1%
Don't Go To Museums	177	71%	1%	25%	1%	2%
Favor Mre Fed Taxes	191	85%	-	14%	1%	-
Wld Pay $25 More	127	90%	-	9%	1%	-
Pay $5-$15 More.	33	82%	-	18%	-	-
None Of Above...	20	75%	-	25%	-	-
Oppose Mre Fed Taxs	386	76%	3%	18%	2%	2%
Not Sure...........	89	75%	2%	21%	1%	-

Q99. (If Have Children) If your child wanted to marry an artist, would you encourage your child, discourage your child, or wouldn't it matter to you?

	TOTAL	Encour -age	Disco- urage	Wlnd't Matter	Depnds	Not Sure
All Voters.........	666	26%	3%	65%	5%	2%
Northeast..........	132	32%	5%	57%	6%	1%
South..............	234	22%	2%	71%	3%	2%
Central............	167	23%	2%	66%	6%	2%
West...............	133	31%	2%	59%	6%	2%
Male...............	290	24%	3%	68%	3%	2%
Female.............	376	27%	2%	63%	6%	1%
Under 30...........	80	30%	1%	58%	6%	5%
30 to 39...........	175	23%	3%	69%	5%	1%
40 to 49...........	153	23%	2%	71%	5%	-
50 to 64...........	137	26%	1%	68%	4%	-
65 And Over........	110	27%	5%	58%	5%	5%
High School/Less...	301	24%	2%	69%	3%	2%
Some College.......	182	27%	3%	64%	6%	1%
College Graduate...	178	27%	4%	61%	7%	2%
Post-Graduate....	64	20%	5%	64%	9%	2%
Liberal............	199	32%	2%	63%	3%	1%
Moderate/Other.....	132	28%	3%	62%	6%	1%
Conservative.......	335	21%	3%	67%	6%	2%
Under $30K.........	217	25%	2%	65%	6%	1%
Under $20K......	104	24%	1%	69%	4%	2%
$20K to $30K.......	113	26%	4%	62%	8%	1%
$30K to $40K.......	107	32%	3%	60%	3%	3%
$40K to $50K.......	84	24%	5%	64%	6%	1%
Over $50K..........	166	23%	2%	69%	4%	1%
Over $75K.......	66	26%	3%	61%	9%	2%
White..............	523	26%	3%	65%	5%	1%
Black..............	76	22%	3%	66%	5%	4%
Hispanic...........	42	29%	-	62%	10%	-
All Other..........	25	32%	-	64%	4%	-
Have Children......	666	26%	3%	65%	5%	2%
Encourage/Artist	523	32%	2%	61%	4%	1%
Don't Have Children	-	-	-	-	-	-
Willing To Pay More	244	29%	2%	65%	3%	2%
Only Sometimes.....	252	24%	2%	66%	6%	2%
Hardly Ever Pay Mre	162	25%	5%	62%	6%	1%
Have Art In Home...	507	26%	3%	64%	6%	2%
Don't Have Art.....	159	25%	3%	68%	3%	1%
Choice - Choose Art	224	32%	1%	60%	5%	2%
Would Choose Money.	386	24%	3%	67%	5%	2%
Not Sure...........	56	20%	7%	70%	4%	-
Spend $25-100/Art..	317	25%	3%	66%	5%	1%
Wld Spend Over $200	293	26%	3%	64%	5%	2%
Museum >2 Times Yr.	112	36%	4%	56%	4%	-
1 or 2 Times A Yr..	191	27%	3%	63%	5%	2%
Less Than Once A Yr	158	24%	2%	65%	8%	2%
Don't Go To Museums	177	19%	3%	73%	2%	2%
Favor Mre Fed Taxes	191	32%	1%	64%	3%	1%
Wld Pay $25 More	127	32%	1%	65%	2%	-
Pay $5-$15 More.	33	27%	-	67%	3%	3%
None Of Above...	20	40%	-	55%	5%	-
Oppose Mre Fed Taxs	386	25%	4%	63%	6%	2%
Not Sure...........	89	18%	-	74%	6%	2%

Q100. Are you from a Spanish-speaking background or something else?

	TOTAL	Hispnc	White	Black/ Africn Amercn	Asian/ Orient	Middle Eastrn /Arabc	Smthng Else	Refusd
All Voters.........	1001	7%	78%	10%	1%	1%	3%	1%
Northeast..........	216	6%	79%	8%	1%	*	5%	1%
South..............	335	5%	73%	16%	1%	1%	3%	1%
Central............	241	7%	83%	7%	1%	1%	*	1%
West...............	209	10%	78%	6%	1%	*	3%	1%
Male...............	475	7%	78%	9%	1%	1%	3%	1%
Female.............	526	7%	77%	11%	2%	1%	2%	1%
Under 30...........	247	9%	71%	14%	1%	1%	4%	*
30 to 39...........	263	8%	75%	11%	2%	1%	2%	1%
40 to 49...........	191	5%	79%	9%	2%	1%	3%	1%
50 to 64...........	154	5%	86%	6%	-	1%	2%	-
65 And Over........	131	3%	85%	8%	1%	-	2%	1%
High School/Less...	421	6%	76%	13%	1%	*	3%	*
Some College.......	281	7%	79%	8%	2%	1%	2%	-
College Graduate...	293	7%	79%	8%	1%	1%	2%	2%
Post-Graduate....	103	7%	75%	8%	2%	1%	4%	4%
Liberal............	319	8%	74%	13%	1%	1%	3%	1%
Moderate/Other.....	207	7%	76%	10%	2%	*	3%	1%
Conservative.......	475	5%	81%	8%	1%	*	3%	1%
Under $30K.........	343	7%	76%	12%	1%	1%	3%	1%
Under $20K......	155	4%	80%	14%	-	1%	2%	-
$20K to $30K.......	188	10%	72%	11%	2%	1%	4%	1%
$30K to $40K.......	155	4%	75%	13%	4%	1%	4%	-
$40K to $50K.......	133	8%	80%	6%	1%	-	3%	2%
Over $50K..........	244	8%	81%	9%	1%	-	2%	*
Over $75K.......	95	8%	82%	8%	1%	-	-	-
White..............	779	-	100%	-	-	-	-	-
Black..............	100	-	-	100%	-	-	-	-
Hispanic...........	66	100%	-	-	-	-	-	-
All Other..........	56	-	-	-	23%	13%	48%	16%
Have Children......	666	6%	79%	11%	*	1%	2%	*
Encourage/Artist	523	7%	76%	12%	1%	1%	2%	*
Don't Have Children	335	7%	76%	7%	3%	1%	3%	2%
Willing To Pay More	393	6%	78%	9%	1%	1%	4%	1%
Only Sometimes.....	382	8%	77%	10%	2%	1%	2%	1%
Hardly Ever Pay Mre	211	7%	77%	11%	1%	*	3%	*
Have Art In Home...	768	6%	79%	10%	1%	1%	3%	1%
Don't Have Art.....	233	9%	73%	12%	2%	*	3%	1%
Choice - Choose Art	352	8%	73%	11%	1%	1%	5%	1%
Would Choose Money.	574	6%	80%	10%	2%	*	2%	1%
Not Sure..........	75	7%	83%	5%	-	1%	3%	1%
Spend $25-100/Art..	472	7%	78%	11%	1%	*	1%	1%
Wld Spend Over $200	451	6%	77%	10%	1%	1%	4%	1%
Museum >2 Times Yr.	188	9%	78%	9%	1%	1%	3%	-
1 or 2 Times A Yr..	301	7%	73%	12%	1%	1%	4%	1%
Less Than Once A Yr	236	6%	81%	10%	1%	*	1%	1%
Don't Go To Museums	240	6%	80%	9%	1%	1%	2%	1%
Favor Mre Fed Taxes	300	6%	76%	11%	1%	2%	4%	1%
Wld Pay $25 More	197	7%	79%	8%	-	2%	4%	1%
Pay $5-$15 More.	57	4%	67%	21%	4%	2%	4%	-
None Of Above...	33	3%	70%	15%	3%	3%	3%	3%
Oppose Mre Fed Taxs	571	7%	80%	9%	1%	*	2%	1%
Not Sure..........	130	8%	72%	12%	2%	1%	4%	2%

Q101. Ideology.

	TOTAL	TOTAL LIBERL	Liberl	Modert Liberl	MODERT	Modert Consrv	Consrv	TOTAL CONSRV	Other	Not Sure
All Voters.........	1001	32%	23%	8%	14%	11%	36%	47%	2%	5%
Northeast..........	216	35%	28%	7%	14%	10%	34%	44%	2%	5%
South..............	335	32%	23%	9%	13%	12%	39%	50%	1%	4%
Central............	241	30%	20%	10%	15%	9%	36%	45%	2%	7%
West...............	209	31%	23%	8%	15%	15%	33%	48%	2%	4%
Male...............	475	32%	22%	10%	13%	11%	38%	49%	2%	3%
Female.............	526	32%	24%	7%	15%	12%	34%	46%	1%	6%
Under 30...........	247	37%	28%	10%	13%	12%	30%	41%	2%	6%
30 to 39...........	263	33%	27%	7%	13%	13%	37%	50%	2%	3%
40 to 49...........	191	35%	26%	9%	12%	13%	34%	47%	2%	4%
50 to 64...........	154	23%	14%	9%	18%	6%	46%	53%	3%	4%
65 And Over........	131	24%	16%	8%	15%	13%	40%	53%	1%	7%
High School/Less...	421	28%	20%	8%	15%	12%	37%	49%	2%	6%
Some College.......	281	31%	21%	9%	14%	10%	38%	48%	2%	5%
College Graduate...	293	38%	29%	9%	13%	12%	33%	45%	1%	2%
Post-Graduate....	103	42%	30%	12%	15%	16%	24%	40%	2%	2%
Liberal............	319	100%	73%	27%	-	-	-	-	-	-
Moderate/Other.....	207	-	-	-	68%	-	-	-	9%	23%
Conservative.......	475	-	-	-	-	24%	76%	100%	-	-
Under $30K.........	343	30%	23%	7%	13%	11%	38%	49%	2%	6%
Under $20K......	155	28%	21%	8%	12%	11%	39%	50%	1%	8%
$20K to $30K.......	188	32%	25%	7%	14%	11%	37%	48%	3%	4%
$30K to $40K.......	155	38%	28%	10%	15%	8%	35%	43%	1%	3%
$40K to $50K.......	133	35%	26%	8%	13%	14%	37%	50%	-	2%
Over $50K..........	244	31%	21%	10%	16%	14%	36%	50%	1%	3%
Over $75K.......	95	27%	22%	5%	14%	15%	38%	53%	2%	4%
White..............	779	30%	23%	8%	14%	12%	38%	50%	2%	4%
Black..............	100	40%	29%	11%	15%	11%	28%	39%	2%	4%
Hispanic...........	66	39%	24%	15%	9%	9%	30%	39%	3%	9%
All Other..........	56	32%	23%	9%	14%	11%	32%	43%	-	11%
Have Children......	666	30%	22%	8%	14%	11%	39%	50%	2%	4%
Encourage/Artist	523	32%	22%	9%	12%	11%	40%	51%	2%	4%
Don't Have Children	335	36%	27%	9%	15%	12%	30%	42%	1%	6%
Willing To Pay More	393	34%	25%	9%	12%	12%	36%	48%	1%	5%
Only Sometimes.....	382	32%	23%	10%	17%	12%	34%	46%	1%	4%
Hardly Ever Pay Mre	211	28%	23%	6%	12%	9%	42%	51%	3%	5%
Have Art In Home...	768	34%	25%	9%	14%	11%	35%	46%	2%	4%
Don't Have Art.....	233	24%	18%	7%	15%	12%	39%	52%	2%	7%
Choice - Choose Art	352	39%	31%	8%	13%	11%	29%	40%	2%	6%
Would Choose Money.	574	28%	20%	9%	14%	12%	40%	52%	2%	4%
Not Sure..........	75	24%	15%	9%	21%	12%	33%	45%	3%	7%
Spend $25-100/Art..	472	31%	22%	9%	14%	10%	38%	48%	2%	5%
Wld Spend Over $200	451	33%	25%	8%	13%	14%	35%	48%	1%	4%
Museum >2 Times Yr.	188	45%	36%	9%	16%	9%	23%	31%	4%	4%
1 or 2 Times A Yr..	301	34%	26%	9%	14%	11%	36%	48%	1%	4%
Less Than Once A Yr	236	27%	17%	10%	12%	13%	43%	56%	1%	4%
Don't Go To Museums	240	26%	19%	8%	13%	13%	38%	51%	2%	8%
Favor Mre Fed Taxes	300	46%	35%	10%	12%	8%	28%	36%	2%	5%
Wld Pay $25 More	197	52%	41%	11%	11%	8%	22%	29%	2%	6%
Pay $5-$15 More.	57	35%	30%	5%	14%	9%	39%	47%	2%	2%
None Of Above...	33	42%	24%	18%	9%	9%	27%	36%	9%	3%
Oppose Mre Fed Taxs	571	27%	19%	8%	14%	13%	41%	54%	1%	3%
Not Sure..........	130	21%	16%	5%	19%	15%	32%	46%	2%	12%

Q102. Family Income.

	TOTAL	Less $20K	20-30	30-40	40-50	50-75	Over $75K	Refusd
All Voters.........	1001	15%	19%	15%	13%	15%	9%	13%
Northeast..........	216	14%	19%	15%	13%	17%	9%	13%
South..............	335	15%	19%	16%	12%	14%	10%	13%
Central............	241	20%	17%	16%	12%	14%	7%	15%
West...............	209	13%	20%	14%	17%	15%	12%	9%
Male..............	475	14%	18%	16%	13%	16%	10%	12%
Female.............	526	17%	20%	15%	13%	13%	9%	13%
Under 30...........	247	17%	30%	15%	12%	12%	8%	6%
30 to 39...........	263	12%	19%	18%	17%	16%	10%	9%
40 to 49...........	191	10%	10%	16%	15%	23%	15%	12%
50 to 64...........	154	14%	10%	18%	12%	18%	12%	16%
65 And Over........	131	29%	21%	11%	9%	5%	3%	23%
High School/Less...	421	25%	25%	16%	12%	9%	3%	12%
Some College.......	281	13%	19%	16%	14%	16%	10%	12%
College Graduate...	293	5%	11%	15%	15%	23%	19%	12%
Post-Graduate....	103	2%	6%	17%	13%	24%	24%	14%
Liberal............	319	14%	19%	18%	14%	15%	8%	11%
Moderate/Other.....	207	16%	18%	14%	10%	14%	9%	19%
Conservative.......	475	16%	19%	14%	14%	15%	11%	11%
Under $30K.........	343	45%	55%	-	-	-	-	-
Under $20K......	155	100%	-	-	-	-	-	-
$20K to $30K.......	188	-	100%	-	-	-	-	-
$30K to $40K.......	155	-	-	100%	-	-	-	-
$40K to $50K.......	133	-	-	-	100%	-	-	-
Over $50K..........	244	-	-	-	-	61%	39%	-
Over $75K.......	95	-	-	-	-	-	100%	-
White..............	779	16%	17%	15%	14%	15%	10%	13%
Black..............	100	21%	20%	20%	8%	13%	8%	10%
Hispanic...........	66	9%	27%	9%	17%	17%	12%	9%
All Other..........	56	7%	25%	23%	13%	11%	2%	20%
Have Children......	666	16%	17%	16%	13%	15%	10%	14%
Encourage/Artist	523	16%	18%	16%	12%	15%	9%	12%
Don't Have Children	335	15%	22%	14%	15%	15%	9%	10%
Willing To Pay More	393	12%	16%	15%	15%	17%	13%	12%
Only Sometimes.....	382	15%	21%	16%	14%	15%	8%	10%
Hardly Ever Pay Mre	211	22%	21%	16%	8%	10%	6%	16%
Have Art In Home...	768	14%	18%	16%	12%	17%	11%	12%
Don't Have Art.....	233	21%	21%	15%	16%	8%	3%	15%
Choice - Choose Art	352	13%	18%	15%	12%	19%	13%	10%
Would Choose Money.	574	17%	20%	16%	15%	13%	7%	13%
Not Sure...........	75	19%	16%	16%	8%	11%	11%	20%
Spend $25-100/Art..	472	22%	22%	18%	12%	11%	4%	12%
Wld Spend Over $200	451	9%	17%	13%	16%	20%	16%	9%
Museum >2 Times Yr.	188	7%	13%	13%	13%	18%	21%	14%
1 or 2 Times A Yr..	301	15%	20%	14%	13%	19%	9%	10%
Less Than Once A Yr	236	14%	21%	20%	12%	12%	7%	14%
Don't Go To Museums	240	23%	20%	16%	14%	11%	4%	12%
Favor Mre Fed Taxes	300	14%	20%	17%	12%	15%	13%	10%
Wld Pay $25 More	197	10%	19%	19%	13%	19%	15%	6%
Pay $5-$15 More.	57	25%	18%	14%	16%	7%	12%	9%
None Of Above...	33	18%	27%	9%	3%	6%	3%	33%
Oppose Mre Fed Taxs	571	15%	19%	15%	15%	16%	9%	11%
Not Sure...........	130	19%	15%	16%	11%	9%	6%	24%

Q103. Gender.

	TOTAL	Male	Female
All Voters.........	1001	47%	53%
Northeast..........	216	47%	53%
South..............	335	47%	53%
Central............	241	48%	52%
West...............	209	48%	52%
Male..............	475	100%	-
Female.............	526	-	100%
Under 30...........	247	49%	51%
30 to 39...........	263	48%	52%
40 to 49...........	191	47%	53%
50 to 64...........	154	51%	49%
65 And Over........	131	41%	59%
High School/Less...	421	46%	54%
Some College.......	281	46%	54%
College Graduate...	293	51%	49%
Post-Graduate....	103	54%	46%
Liberal............	319	48%	52%
Moderate/Other.....	207	43%	57%
Conservative.......	475	49%	51%
Under $30K.........	343	44%	56%
Under $20K......	155	43%	57%
$20K to $30K.......	188	45%	55%
$30K to $40K.......	155	49%	51%
$40K to $50K.......	133	48%	52%
Over $50K..........	244	52%	48%
Over $75K.......	95	52%	48%
White..............	779	48%	52%
Black..............	100	44%	56%
Hispanic...........	66	47%	53%
All Other..........	56	50%	50%
Have Children......	666	44%	56%
Encourage/Artist	523	45%	55%
Don't Have Children	335	55%	45%
Willing To Pay More	393	53%	47%
Only Sometimes.....	382	42%	58%
Hardly Ever Pay Mre	211	46%	54%
Have Art In Home...	768	48%	52%
Don't Have Art.....	233	46%	54%
Choice - Choose Art	352	49%	51%
Would Choose Money.	574	46%	54%
Not Sure...........	75	55%	45%
Spend $25-100/Art..	472	44%	56%
Wld Spend Over $200	451	50%	50%
Museum >2 Times Yr.	188	50%	50%
1 or 2 Times A Yr..	301	50%	50%
Less Than Once A Yr	236	45%	55%
Don't Go To Museums	240	48%	53%
Favor Mre Fed Taxes	300	53%	47%
Wld Pay $25 More	197	53%	47%
Pay $5-$15 More.	57	56%	44%
None Of Above...	33	55%	45%
Oppose Mre Fed Taxs	571	47%	53%
Not Sure...........	130	37%	63%

Region.

	TOTAL	North -east	South	Centrl	West
All Voters.........	1001	22%	33%	24%	21%
Northeast..........	216	100%	-	-	-
South..............	335	-	100%	-	-
Central............	241	-	-	100%	-
West...............	209	-	-	-	100%
Male...............	475	21%	33%	24%	21%
Female.............	526	22%	34%	24%	21%
Under 30...........	247	22%	32%	20%	26%
30 to 39...........	263	22%	37%	28%	13%
40 to 49...........	191	21%	32%	22%	24%
50 to 64...........	154	16%	35%	27%	22%
65 And Over........	131	25%	28%	23%	24%
High School/Less...	421	19%	35%	28%	18%
Some College.......	281	23%	30%	22%	26%
College Graduate...	293	23%	35%	22%	20%
Post-Graduate....	103	21%	33%	25%	20%
Liberal............	319	24%	34%	23%	20%
Moderate/Other.....	207	22%	29%	29%	21%
Conservative.......	475	20%	36%	23%	21%
Under $30K.........	343	21%	34%	26%	20%
Under $20K......	155	19%	33%	30%	17%
$20K to $30K.......	188	22%	34%	22%	22%
$30K to $40K.......	155	21%	35%	25%	19%
$40K to $50K.......	133	20%	30%	23%	27%
Over $50K..........	244	23%	33%	20%	24%
Over $75K.......	95	20%	36%	17%	27%
White..............	779	22%	32%	26%	21%
Black..............	100	18%	53%	17%	12%
Hispanic...........	66	20%	26%	24%	30%
All Other..........	56	27%	34%	16%	23%
Have Children......	666	20%	35%	25%	20%
Encourage/Artist	523	20%	37%	23%	20%
Don't Have Children	335	25%	30%	22%	23%
Willing To Pay More	393	19%	33%	25%	24%
Only Sometimes.....	382	24%	33%	25%	19%
Hardly Ever Pay Mre	211	24%	35%	22%	19%
Have Art In Home...	768	23%	34%	22%	22%
Don't Have Art.....	233	18%	33%	32%	18%
Choice - Choose Art	352	23%	30%	23%	24%
Would Choose Money.	574	21%	36%	25%	19%
Not Sure...........	75	21%	28%	27%	24%
Spend $25-100/Art..	472	22%	33%	27%	19%
Wld Spend Over $200	451	21%	35%	21%	23%
Museum >2 Times Yr.	188	22%	33%	21%	23%
1 or 2 Times A Yr..	301	23%	33%	21%	23%
Less Than Once A Yr	236	22%	31%	25%	21%
Don't Go To Museums	240	20%	36%	28%	17%
Favor Mre Fed Taxes	300	22%	33%	22%	23%
Wld Pay $25 More	197	24%	29%	19%	27%
Pay $5-$15 More.	57	19%	37%	28%	16%
None Of Above...	33	15%	45%	21%	18%
Oppose Mre Fed Taxs	571	20%	35%	24%	20%
Not Sure...........	130	26%	28%	28%	18%

ACKNOWLEDGMENTS

At one point in the interview at the front of this book Alex Melamid jokes, "Nobody can prove to me that the painting made from this American poll is worse than Ross Bleckner's piece, for instance. . . . And I think that it's a better picture, because there was more effort put into it. So many people worked—I don't know, more than 1,001." Put in those terms, this book is the culmination of thousands of people's time and energy—everyone who asked the questions, and everyone who answered. But among those who are not nameless, the first thanks must go to Peter Meyer, the executive director of The Nation Institute, and Victor Navasky, now editorial director and publisher of The Nation, who were in on this project from its earliest stages and whose creative intelligence, persistence, and impish appreciation of the unknown were vital in getting the American poll off the ground. Without them and the board of trustees of The Nation Institute, probably no one today would know what America, or the world, really wants in art.

Komar and Melamid are especially grateful to those persons and institutions that helped fund the American poll, chiefly Robert Abrams, Joan Davidson and the J. M. Kaplan Fund, as well as Jane Lombard, Ben Sonnenberg and the Grand Street Foundation, Gifford Phillips, and Laila Twigg-Smith. Chase Manhattan Bank was most generous in supporting the Dia Center's work to put Komar and Melamid's "People's Choice" on the World Wide Web.

At Marttila & Kiley, Inc., John Marttila waived his skepticism and his retail fee and was heroic in formulating a questionnaire that would satisfy the concerns and quirks of the artists, Peter, Victor, some of the funders, others of us at The Nation—and still meet his professional interest as a pollster. Natalie Wigotsky was a good organizer and sport in a process that, in different ways, was new for everyone involved. I would also like to thank Richard Berkowitz for assistance in some final preparations for this book.

Although John Marttila conducted the focus groups, their members were brought together by Bette Dyzel of Bette Dyzel & Associates, and she and the people at the Manhattan Opinion Center deserve thanks for all of their efforts. Bette was wonderful in helping me later locate Lorraine Abramowitz, Thelma Armstrong, and Regina Martino, who all graciously allowed me to visit their homes, look at their art (or, in Lorraine's case, her adamantly bare white walls), and interview them.

What praise and thankful words could be sufficient for Matthew Armstrong? His organization of events in Ithaca, with the help of Joel Jablonski and the workers at the Herbert F. Johnson Museum, was brilliant, and absolutely realized Komar and Melamid's wishes for a real public discussion about art. Beyond that, he has been a good friend, a trusted adviser, and a reliable source of jokes. The events in Ithaca were sponsored by the Goldsen Fund: Images in Society, and by the New York State Council for the Humanities, the Cornell University Art Department, and The Ithaca Times. A nod as well to former Mayor Ben Nichols, to Reverend Philip Snyder of St. John's Episcopal Church, and to the people of Ithaca who took part in the meetings.

John Bunge of the Department of Social Statistics, New York State School of Industrial and Labor Relations at Cornell, and Adrienne Freeman-Gallant made thinking about statistics an unexpected intellectual pleasure, and Alex, Vitaly, and I are indebted to them for their time and creativity. Also thanks to the students in John's fall 1994 Sampling class.

Internationally, the artists are most grateful to the people and institutions that arranged, conducted, and sponsored the polls and that exhibited "The People's Choice" locally:

In China—Ji-qiang Rong was instrumental in organizing the survey, interpreting the results, and translating them into English. Poll by a research group composed by Ji-qiang Rong and the Roper Center for Public Opinion Research, and by Professors Guo-ming Yu and Xia-yang Liu, directors of the Public Opinion Research Institute, People's University of China. Field work by CCTV Survey Network, China Central Television.

In Denmark—Poll by Vilstrup Research. Sponsored by Nikolaj Contemporary Arts Center, Copenhagen. Special thanks to Kasper Vilstrup and to Morten Lerhard, who curated the show.

In Finland—Poll by Research International (Helsinki). Sponsored by the Museum of Contemporary Art, Helsinki. Special thanks to museum director, Tuula Arkio.

In France—Poll by Jean-François Tchernia and Françoise Lebreton with Research International (Paris). Special thanks to Jacqueline Klugman of Passage de Retz in Paris, who sponsored the poll and put on the show.

In Iceland—Poll by Hagvangur, Inc. Special thanks to Hannes Sigurdsson, who arranged for the poll and for the show at the Municipal Museum of Reykjavik.

In Kenya—Poll by Research International (Nairobi).

In Russia—Poll by ULTEX Services A.O. Sponsored by New Found Quality. Special thanks to Marat Guelman, Komar and Melamid's longtime friend and dealer in Moscow, at the Guelman Gallery, and to the Center for Contemporary Arts.

In Turkey—Poll by DAP Pazarlama Arastirmaliari A.S. Sponsored by Istanbul Foundation for Culture and Arts. Special thanks to Rene Block, curator of the Istanbul Biennale, who showed the pictures and also helped organize the poll.

In Ukraine—Poll by Reyting. Organized by Merkyuri Glob-Ukraina with the help of the Guelman Gallery. Special thanks to Tanya Savadova, who arranged for the poll and for the exhibition at the State Museum of Ukrainian Art.

Retrospectively, Komar and Melamid wish to thank director Gino Rodriguez and the people at the Alternative Museum in New York City, where "The People's Choice" began, with the exhibition of America's Most Wanted and Unwanted. Prospectively, they wish to thank director Mark Scheps and curator Evelyn Weiss of the Ludwig Museum in Köln, where "The People's Choice" will culminate, in an exhibition of Most Wanted and Unwanted paintings from all of the countries polled.

Additionally, the artists give a bow to Hein Eberson, who has been energetic in Amsterdam; to Erdmute Beha, who has followed the project from Germany; to Peter Kobia, a Kenyan artist in America whose insights were most helpful in making Kenya's Most Wanted; and to the people at the Dia Center for the Arts who were responsible for organizing and executing "The People's Choice" site on the World Wide Web: Lynn Cooke, curator; Michael Govan; director, and Sara Tucker, who put in endless hours getting the site up and monitoring it throughout its run. In connection with the Website, thanks also to Manuel Gonzales at Chase Manhattan Bank.

From the early days of this project there have been a number of people whose help, advice, enthusiasm, comradeship, have made a huge difference in times of need, creative and otherwise. They include Katya Arnold, Anna and Alex Halberstadt (the latter for translation), Jill Ciment, Ed Yankov, Paul Chudy (who generated the paint-by-numbers version of America's Most Wanted which first appeared on the cover of the March 14, 1994, issue of The Nation), Dan Vendetti and Howard Grier (who together interpreted some of the statistics from the American poll into stunningly creative graphs which Komar and Melamid made into the paintings shown on pages 34, 37, 39, 41, 44, and 56), James Dee (who made color transparencies of the artwork and who, by pure random chance, was also among the 1,001 Americans polled), Paul Hechinger, and Jane Bausman.

At The Nation and The Nation Institute many hands participated in making the poll, the magazine issue that first featured the results, and even the opening exhibition. Chief among them are Katrina vanden Heuvel, Richard Lingeman, Jane Sharples, Sauna Trinkle, Sandy McCroskey, Emily Gordon, Jill Petty, David Alzipedi, and Kio Stark. The magazine is lucky to have Arthur Danto as its art critic, and I was thrilled that he agreed to contribute to the book. As the project continued, I also received a timely assist from Max Block, Tom Gogola, Scott Handleman, John Holtz, Art Winslow, Sandy Wood, and Jonathan Taylor, who was also a trusty reader. Thank you all. And thanks, too, to Chris Calhoun, an old friend and colleague, who acted as agent for this book.

There is probably no more patient man alive than Jonathan Galassi of Farrar, Straus and Giroux; and Alex, Vitaly, and I are most grateful for his understanding, continued encouragement, and sense of humor in a project that has twisted and turned more times than any of us expected at the outset. I also want to thank Ethan Nosowsky for his thoughtful and ever-engaged editing; Barbara de Wilde, whose pleasure in the subject translated into the book's beautiful cover and design; and everyone at FSG who had a hand in this.

Deborah Rust, who made the map on pages 86–87 and the Poll Space "map" on page 88, was great fun to work with, and collaborated in my schemes with zest and imagination.

Finally, I am indebted in ways large and small to a few people whose conversation is a constant delight and was, over the course of this book, an influence, a refuge, a road to surprise. Alex Cockburn, Ben Sonnenberg, Vania Del Borgo, Zia Jaffrey, Dennis Selby, Lu Ming, John Scagliotti, Edward Said—thank you. For Alex and Vitaly, there aren't words enough to express my respect and happy gratitude. And as at the beginning so at the end a salute, but this time for unfailing wit and friendship, to Peter Meyer.

—J.W.

ART CREDITS

1. *Factory for the Production of Blue Smoke*, 1975. Oil on canvas, 84½ x 39¼ in. Collection of Alfred and Pie Friendly

2. *Type Preferences by Race*, 1994. Acrylic on canvas, 48 x 84 in.

3. *Style Preferences by Sex*, 1994. Acrylic on canvas, 48 x 84 in.

4. *Size Preferences by Education (Small)*, 1994. Acrylic on canvas, 48 x 84 in.

5. *Art in the Home by Household Income*, 1994. Acrylic on canvas, 48 x 84 in.

6–9. Installation views from Paris exhibition of "The People's Choice,"1995. Various graphs from French poll, wood and tempera, tabletop size. Executed by staff of Passage de Retz. Photograph by Jean-Luc Mabit

10. *Size Preferences by Education (Large)*, 1994. Acrylic on canvas, 48 x 84 in.

11. *What Is Your Favorite Color?*, 1994. Acrylic on canvas, 48 x 60 in.

12. *Color Therapeutics*, 1975. Oil on wood, 25 panels, each 1⅝ in. square. Collection of Robert and Maryse Boxer

13. From *The Pennysaver*, Ithaca, New York, October 19-26, 1994

14. Photograph by Doug Hicks, Ithaca, New York, October 27, 1994

15. Photograph by Alexander Melamid, New York City, 1996

16. *Ithaca's Most Wanted*, 1995. Acrylic and oil on canvas, 60 x 112 in.

17–18. Computer graphics by Deborah Rust

19. *Russia's Most Unwanted*, 1994. Oil on canvas, 53 x 24 in.

20. *Russia's Most Wanted*, 1994. Oil on canvas, 16 x 20 in.

21. *Ukraine's Most Unwanted*, 1994. Mixed media on canvas, 53 x 24 in.

22. *Ukraine's Most Wanted*, 1994. Oil on canvas, 16 x 20 in.

23. *France's Most Unwanted*, 1995. Oil on canvas, 82½ x 20 in.

24. *France's Most Wanted*, 1995. Oil on canvas, 16 x 22 in.

25. *Kenya's Most Unwanted*, 1996. Mixed media on wood, 5½ x 8 in.

26. *Kenya's Most Wanted*, 1996. Oil on canvas, 16 x 26 in.

27. *Finland's Most Unwanted*, 1995. Mixed media on canvas, 6 x 8 in.

28. *Finland's Most Wanted*, 1995. Oil on canvas, 28 x 48 in.

29. *America's Most Unwanted*, 1994. Tempera and oil on canvas, 5½ x 8½ in.

30. *America's Most Wanted*, 1994. Oil and acrylic on canvas, 24 x 32 in.

31. *Iceland's Most Unwanted*, 1995. Acrylic on wood, 5½ x 8½ in.

32. *Iceland's Most Wanted*, 1995. Oil on canvas, 26 x 38 in.

33. *Denmark's Most Unwanted*, 1995. Oil on canvas, 10 x 8 in.

34. *Denmark's Most Wanted*, 1995. Oil on canvas, 28 x 48 in.

35. *Turkey's Most Unwanted*, 1995. Acrylic on wood, 5½ x 8½ in.

36. *Turkey's Most Wanted*, 1995. Oil on canvas, 26 x 38 in.

37. *China's Most Unwanted*, 1996. Mixed media on wood, 5½ x 8½ in.

38. *China's Most Wanted*, 1996. Oil on canvas, 90½ x 150 in.

39. Nikolai Buchomov (b. 1891)

40. *Nikolai Buchomov*, 1973. Oil on poster board, 59 panels, each 5 x 7 in.

41. *Post-Art No. 1 (Warhol)*, 1973. (From Post-Art series.) Oil on canvas, 42 x 42 in. Collection of Ronald and Frayda Feldman

42. *Post-Art No. 2 (Lichtenstein)*, 1973. (From Post-Art series.) Oil on canvas, 42 x 42 in. Collection of Robert and Maryse Boxer

43. *Painting with Renee's Footprint*, 1996. (From Ecollaboration series.) Acrylic on canvas, 126 x 192 in.

44. *The Origin of Socialist Realism*, 1982–83. (From Nostalgic Social Realism series). Oil on canvas, 72 x 84 in. Collection of Ronald and Frayda Feldman

And now the latest word,
from the nation that gave us
Rembrandt, Mondrian, and Vermeer . . .

HOLLAND'S MOST UNWANTED

1997. Acrylic on canvas, 81 x 130 in.

1997. Mixed media on canvas, 10¹/₂ x 13¹/₂ in.